Great
Expectations

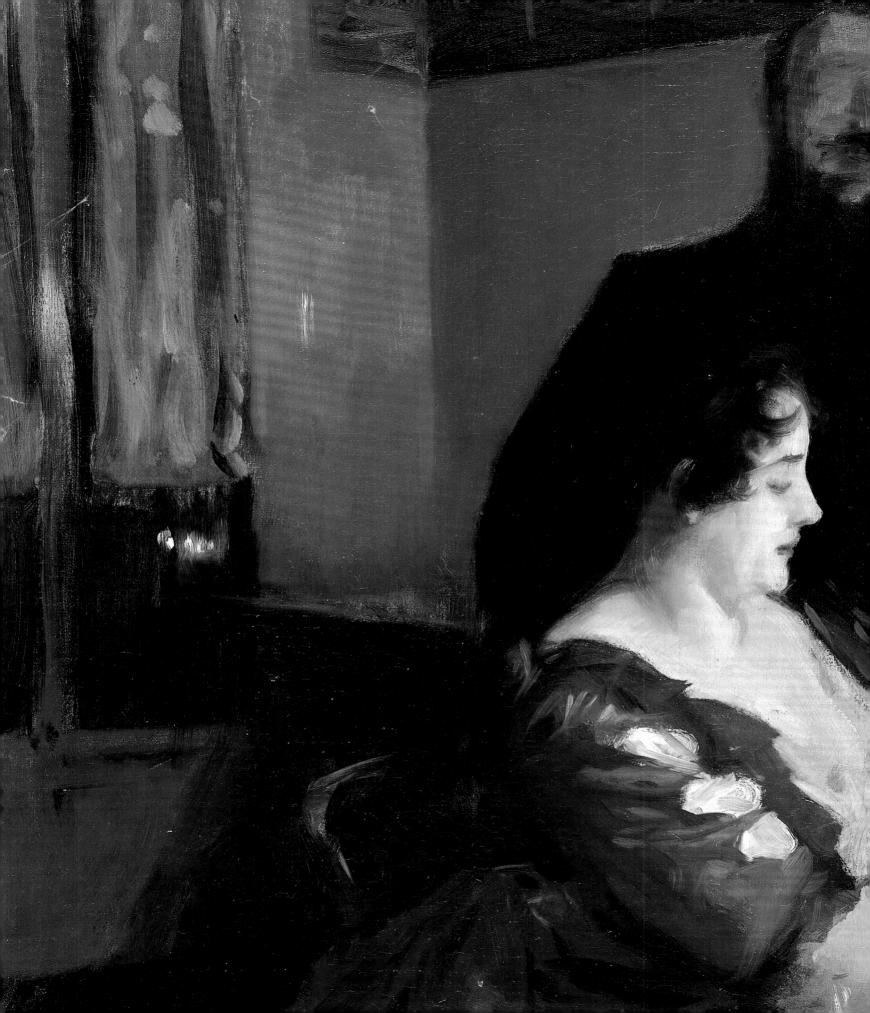

Great Expectations

JOHN SINGER SARGENT
PAINTING CHILDREN

Barbara Dayer Gallati

with contributions by
Erica E. Hirshler
Richard Ormond

BROOKLYN MUSEUM
IN ASSOCIATION WITH
BULFINCH PRESS

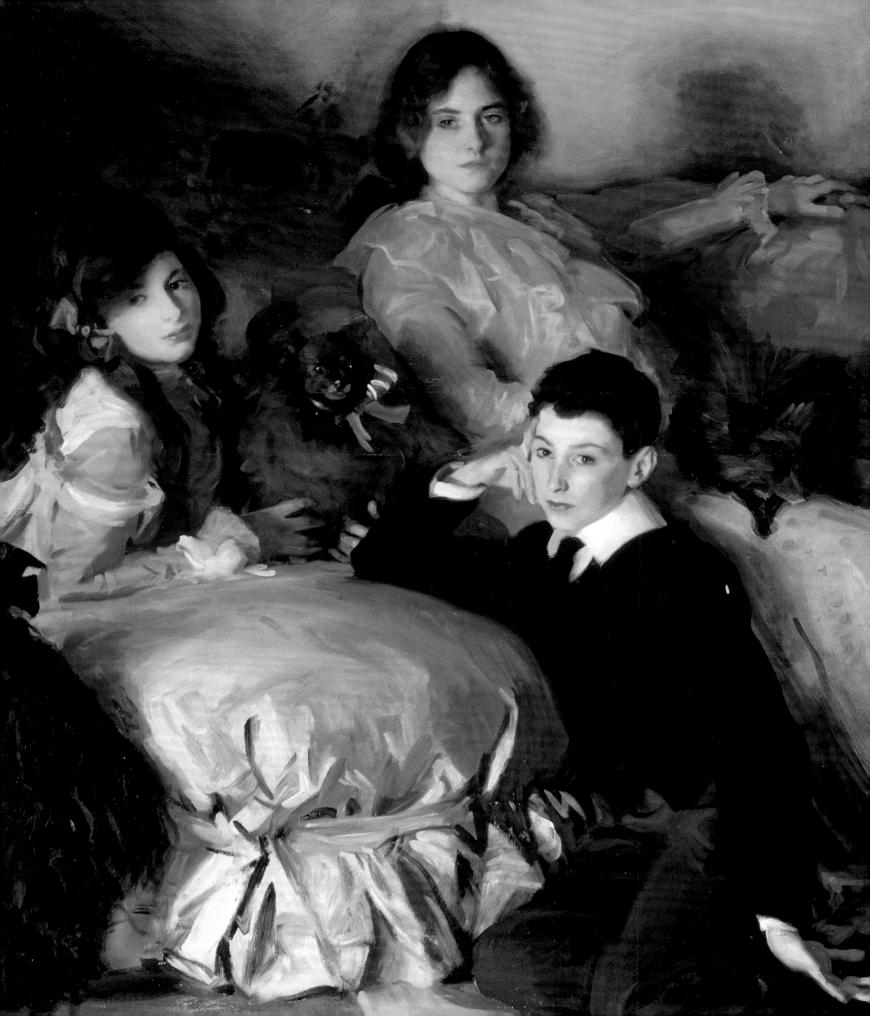

Contents

Foreword

The Brooklyn Museum takes great pleasure in presenting *Great Expectations: John Singer Sargent Painting Children*, the most recent in a long and distinguished series of exhibitions organized by the Museum that have contributed to and continue to stimulate the study of American art. *Great Expectations* provides an innovative look at the art of John Singer Sargent (1856–1925) by examining, for the first time, the prominence and meaning of child imagery in works he produced over the course of a career that is stereotypically associated with society portraiture. In addition to shedding new light on the art and professional strategies of one of our nation's most talented and best documented artists, this pioneering study investigates broader cultural territory by integrating the histories of late nineteenth- and early twentieth-century childhood and art as they are currently formulated.

It is especially gratifying that this book and the exhibition it accompanies add to the Museum's illustrious Sargent heritage. The long-standing connection between the artist and the institution is undoubtedly best known through A. Augustus Healy's leadership in the Museum's successful campaign to acquire an impressive and breathtakingly beautiful group of Sargent's watercolors in 1909, a move that made international headlines and established the Museum as a major site of Sargent holdings. Yet the Museum's strong link with Sargent was forged even before that landmark 1909 purchase and is part of the larger legacy of the enlightened vision of Healy, whose tenure as president of the Brooklyn Institute of Arts and Sciences from 1895 to 1920 brought the Museum to the forefront of collecting contemporary art. Healy's passionate quest for art that would withstand the test of time was shaped, in part, by advice from Sargent that brought about such Museum acquisitions as the famed Tissot Collection (461 works by the French painter James [Jacques-Joseph] Tissot) and Giovanni Boldini's magnificent *Portrait of James McNeill Whistler*. The combined wisdom of Sargent and Healy has stood the Museum in excellent stead, and as the Museum's director William Henry Fox wrote shortly after Sargent's death in 1925, "the Museum may claim specially close and friendly relations with the late John S. Sargent." As proof, Fox cited "his correspondence, his repeated visits to the Museum, and ... the advice he gave and the personal efforts he made to secure for the Brooklyn Museum modern painting of enduring worth." Healy deserves the greatest credit in this matter, however, for it was he who recognized not only the value of Sargent's opinions, but also the lasting significance and magnetic appeal of his art—both of which are manifest in this exhibition and catalogue.

Great Expectations: John Singer Sargent Painting Children was conceived and organized by Barbara Dayer Gallati, Curator of American Art. I extend my sincere thanks to her and to the other members of the Museum's superb staff who have brought this project forward. Special mention should be made of Richard Ormond, Director of the John Singer Sargent Catalogue Raisonné Project, and Erica E. Hirshler, Croll Senior Curator of Paintings in the Art of the Americas Department, Museum of Fine Arts, Boston, who contributed rich and illuminating essays to this catalogue.

I also wish to express my deep gratitude to the private and institutional lenders to the exhibition, all of whom have demonstrated a remarkably generous spirit in parting with important and much-loved works for the sake of this scholarly endeavor. Their enthusiasm for the project not only brings it to life at Brooklyn but also allows us to share the pleasures of Sargent's art with our two partner venues. I am especially grateful to my colleagues William J. Hennessey, Director of the Chrysler Museum of Art, Norfolk, Virginia, and John E. Buchanan, Director of the Portland Art Museum, Oregon, for their keen interest in bringing the exhibition to their visitors.

We are profoundly grateful to Jan and Warren Adelson for their exceptionally generous financial support of this exhibition. We also express our gratitude to the exhibition's Leadership Circle for additional support for the project. As this volume was going to press, the Circle's members included the Ronald H. Cordover Family Foundation, the Gilder Foundation, Michael Humphreys, the Lunder Foundation, and Ed and Deborah Shein. We are also grateful to the Federal Council on the Arts and Humanities for granting an indemnity. An endowment established at the Museum by the Iris and B. Gerald Cantor Foundation and the Andrew W. Mellon Foundation helped support research and development of this publication.

For the ongoing support of the Museum's Trustees, we extend special gratitude to Robert S. Rubin, Chairman, and to every member of our Board. Without the confidence and active engagement of our Trustees, it would not be possible to initiate and maintain the high level of publication programming exemplified by *Great Expectations: John Singer Sargent Painting Children.*

Arnold L. Lehman
Director
Brooklyn Museum

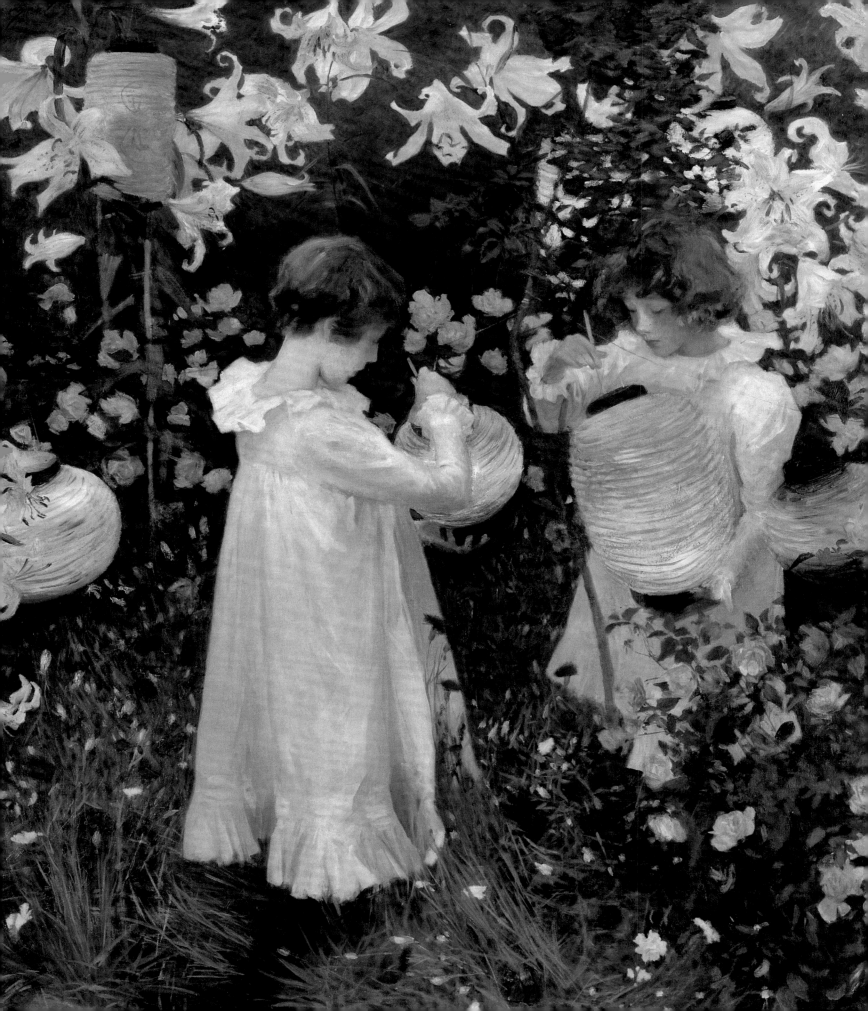

Preface and Acknowledgments

The art of John Singer Sargent invariably yields a supremely satisfying optical adventure. Indeed, the allure of mapping the mechanics of his virtuoso technique often dominates the analysis of his work and has sometimes resulted in a perception that form overpowers content in his aesthetics. Sargent's visibility as a portrait specialist has complicated matters from the earliest years of his career because the genre itself promotes interpretation based primarily on physical likeness and the facts of the sitter's biography and not necessarily on a matrix of ideas. As a wealth of recent publications devoted to the artist emphasizes, however, Sargent's artistic production extended far beyond the boundaries of portrait painting, and contemporary audiences are increasingly conscious of his artistic identity as a muralist, landscapist, watercolorist, and genre painter. And, although the proliferation of scholarship devoted to Sargent might suggest that the subject is nearing exhaustion, we are still far from reaching an understanding of the rich complexities of Sargent's life and art.

By focusing on childhood—a discrete theme that occurs throughout the length of Sargent's career and transcends the categories of genre—*Great Expectations: John Singer Sargent Painting Children* intends to encourage more extensive investigation of Sargent as a painter who was as invested in the meaning of his imagery as he was in its form. Among the theses presented here is that Sargent deployed child imagery in exhibitions to advance his professional standing; that his art yielded the uncalculated result of taking the theme of childhood to a higher plane in the hierarchy of artistic subject matter; and that his alteration of the traditional iconography of childhood may be attributed to his understanding of childhood's new, multivalent role in fin-de-siècle European and American society. The approach in *Great Expectations* relies on the integration of several histories—those of art, childhood, and Sargent himself—the fluidity of which denies the comfort of absolute answers to the questions that arise in this study. The overall aim of this book and the exhibition it accompanies is, however, to stimulate new ways of looking at Sargent's art by introducing a broad array of ideas that I hope will bring coherence to a segment of his oeuvre composed of works that are usually considered in isolation. Such an undertaking would not be conceivable without the solid foundation of modern Sargent studies, a vital area of academic pursuit that was generated largely by the groundbreaking 1970 publication of Richard Ormond's *John Singer Sargent: Paintings, Drawings, Watercolors* and advanced

OPPOSITE: Detail of plate 24

incalculably through the ongoing John Singer Sargent Catalogue Raisonné Project under his direction.

The five essays presented here address a wide range of issues. "Great Expectations: An Introduction to John Singer Sargent's Paintings of Children" provides a brief history of the ideologies that helped redefine childhood in Western culture at the end of the nineteenth century. In "Sargent's Childhood," Richard Ormond offers a detailed examination of the artist's own childhood and speculates about how Sargent's upbringing may (or may not) have contributed to the depiction of childhood in his art. "From Souvenir to High Art: Childhood on Display" charts Sargent's use of child imagery at key stages of his career in the United States, France, and England. In "'A Prince in a Royal Line of Painters': Sargent's Portraits and Posterity," Erica E. Hirshler deftly traces the old master tradition in Sargent's paintings of children and discusses the manner in which those references illuminate Sargent's professional ambitions and those of the sitters' families. "Posing Problems: Sargent's Model Children" examines the act of posing—what it may have meant to the children who sat for Sargent, and how the relationships among artist, sitters, and patrons may have shaped the creative process. In addition, a "Biographical Index of Child Sitters" is included to give information on the children whose portraits are reproduced.

Great Expectations: John Singer Sargent Painting Children is the product of the talents and dedication of many people. I thank Arnold L. Lehman, Director of the Brooklyn Museum, for his early enthusiasm for the project and his unflagging support at each phase of its development. Linda S. Ferber, Andrew Mellon Curator of American Art and Chair of the Department of American Art, has been a constant source of encouragement and good counsel, for which she has my lasting gratitude. I am also greatly indebted to Margaret Stenz, Andrew Mellon Research Associate of American Art, not only for her fine research skills but also for her good nature in lending a hand with the intricacies of acquiring rights and reproductions. Teresa A. Carbone, Curator of American Art; Sarah Snook, the department's Research Assistant; and Charnia Adelman, our volunteer departmental assistant, deserve special mention for their willingness to step in when help was needed. Others at the Museum who have played key roles in meeting the challenges presented by this project are Marc Mayer, Deputy Director for Art; Kevin Stayton, Chief Curator; Judith Frankfurt, Deputy Director for Administration; and Ken Moser, Vice Director, Collections. Elizabeth Reynolds, Chief Registrar, and Katie Welty, Registrar, merit special recognition for their ability to accomplish a daunting amount of work with a consistently high level of professionalism and good grace. Others deserving of particular mention for their contributions to this project are Hannah Mason, Exhibitions Manager; Dean Brown, Chief Photographer; Sally Williams, Public Information Officer; Matthew Yokobosky, Chief Designer; Judith Paska, Vice Director, Development; Sallie Stutz, Vice Director, Merchandising; Joel Hoffman, Vice Director, Education; and the fine people who work with them. The staff of the Museum's Art Reference Library, headed by Deirdre Lawrence, Principal Librarian/Coordinator of Research Services, was exceptionally helpful in the early stages of research. This book has benefited immeasurably from the superb

editorial and management skills of James Leggio, the Museum's Head of Publications and Editorial Services, and Joanna Ekman, Senior Editor. Once again I have had the very real pleasure of working with freelance editor Fronia W. Simpson, who, with her unique combination of intelligence, wit, and toughness, miraculously makes the editing process enjoyable. This book has offered me the privilege of working for the first time with Bulfinch Press, and I thank Michael L. Sand, Executive Editor, for his enthusiastic response to this material. Laura Lindgren deserves the highest praise for the volume's sumptuous design.

Although they are recognized elsewhere in this volume, I offer here my personal thanks to all of the lenders and funders who have made this book and the exhibition possible.

I am sincerely grateful to Richard Ormond, Director of the John Singer Sargent Catalogue Raisonné Project, and Erica E. Hirshler, Croll Senior Curator of Paintings in the Art of the Americas Department, Museum of Fine Arts, Boston, for the splendid essays they wrote for this book and for the generous spirit with which they responded to my questions about a variety of Sargent matters. Richard Ormond particularly deserves an extra measure of gratitude for the many kindnesses he extended regarding the organization of the exhibition and for the words of encouragement that he offered at critical times.

It is impossible to express the depth of my appreciation for the unstinting support that came from Adelson Galleries, Inc. Warren Adelson's invaluable contributions to this project ran the gamut from the financial to the scholarly to the practical, and it is no exaggeration to say that the exhibition would not have happened without him and other members of his gallery's exceptional team—Jan Adelson, Elizabeth Oustinoff, Richard H. Finnegan, Susan Mason, Cynthia Bird, and Caroline Owens. As the major sponsor of the Sargent Catalogue Raisonné Project and a distinguished contributor to a number of important catalogues, he has inspired and aided every aspect of contemporary Sargent scholarship. In that connection, my deep thanks also go to Elaine Kilmurray, co-author of the Sargent Catalogue Raisonné, whose knowledge of Sargent finds rare equal and whose willingness to share information and ideas finds none.

I also take this opportunity to express my appreciation for the valuable help and advice of the late Vance Jordan. His generosity and expertise contributed immeasurably to this and many other projects in which I have been involved.

To my colleagues at our partner venues—Jeff Harrison, Chief Curator, and Catherine Jordan Wass, Deputy Director for Collections, at the Chrysler Museum of Art, and Margaret Bullock, Associate Curator of American Art, and Lisa Morgan, Exhibitions Coordinator, at the Portland Art Museum—I offer my special thanks.

Great credit and gratitude also go to the following individuals, all of whom contributed substantially to the project in a variety of ways: Brian Allen, Michael Altman, Lisa Baylis Ashby, Chris Barber, Selina Bartlett, Susan Benton, Birgitte, countess of Stockton, Leslie Black, Melanie Blake, Jonathan Boos, Rod Bouc, Sylvie Brame, David Brigham, Gertrude Burgoyne, Emma Butterfield, Collin Callahan, Thomas J. Carroll, Sarah Cash, Mary Jo Claugus, Thomas Colville, Susan Conley, Tim Craven,

Elliot Bostwick Davis, Rebecca Davis, Deborah Diemente, John Dorsey, Henry Duffy, David Dufour, Diane Dyer, Mel Ellis, Trevor Fairbrother, Melissa Miller Farr, Stephanie Fawcett, Susan Faxon, Stuart Feld, Olga Ferguson, Jeff Fleming, Christopher Forbes, Ilene Susan Fort, Andrew Fotta, G. Ronald Furse, Michelle Gachette, Mr. and Mrs. Julian Ganz, Jr., Anne Gatland, Robert Goldsmith, Charlotte Grant, Matthew Green, Michael Greenbaum, Barbara Guggenheim, the earl of Halifax, Audrey Hall, Eleanor Jones Harvey, Michael Hauk, Lisa Hayes, Frederick D. Hill, James Berry Hill, Jennifer Hughes, Mr. and Mrs. Lawrence Hughes, Vicky Isley, David Fraser Jenkins, Denise J. H. Johnson, Maria T. Jones, Patricia Junker, Sarah E. Kelly, Elizabeth Kennedy, Peter Kenny, Jean-Paul Kernot, Debra Kitson, Norman Kleeblatt, Elizabeth Mankin Kornhauser, Lisa Kurtz, Monique Le Blanc, Valerie Ann Leeds, Cheryl Leibold, Kate Lester, David Levesque, Mrs. Honor Lewis, Louise Lippincott, Meredith Long, Nannette V. Maciejunes, Caroline Mackenzie, Michael Martin, Jennifer Melville, Nicole Mendelsohn, Alison Miles, Peter Mitchell, Richard Murray, Jane Myers, Gabriel Naughton, Alex Newson, Patrick Noon, John Ormond, Leonée Ormond, Matthew T. R. Percival, Courtney Rae Peterson, Katia Pisvin, Paul Provost, Richard Rand, Allison Revello, Cathy Ricciardelli, Bruce Robertson, Cheryl M. Robledo, Elayne Rush, Marc Simpson, Sir Reresby and Lady Sitwell, Sarah Skinner, Martha H. Smart, Alison Smith, David Smith, Scott Snyder, Nancy Swallow, Don Swanson, David Taylor, Norman Taylor, Dodge Thompson, Monika Tomko, Peter Trippi, William Truettner, David Turner, Teresa Vargas, Helen Walch, Tracy Walker, Malcolm Warner, Bruce Weber, H. Barbara Weinberg, Mr. and Mrs. Edward L. White, Jr., Stephen Whittle, Eric P. Widing, Leah Davis Witherow, Teresa Yoder, Sylvia Yount, Louis A. Zona, and Colleen Kollar Zorn.

In addition to the persons named here, the staffs of the following research facilities deserve recognition and thanks: Archives of American Art; Brooklyn Public Library; Connecticut Historical Society; Frick Art Reference Library; Heinz Archive and Library, National Portrait Gallery, London; Imperial War Museum; Katonah Village Library; The London Library; Manchester Historical Society; The New York Public Library; Ohrstrom Library, St. Paul's School, Concord, New Hampshire; South Cheshire Family History Society, England; and Witt Library, Courtauld Institute of Art, London.

Because of publication deadlines and space constraints, some people whose talents contributed to the success of *Great Expectations: John Singer Sargent Painting Children* could not be acknowledged on these pages. From them and any others I have inadvertently omitted here I beg forbearance.

Barbara Dayer Gallati
Curator of American Art
Brooklyn Museum

Lenders to the Exhibition

Aberdeen Art Gallery, Scotland
Addison Gallery of American Art, Phillips Academy, Andover, Massachusetts
Brooklyn Museum
The Butler Institute of American Art, Youngstown, Ohio
Carnegie Museum of Art, Pittsburgh
Katharine Serena Carson
Sterling and Francine Clark Art Institute, Williamstown, Massachusetts
Columbus Museum of Art, Ohio
Dallas Museum of Art
Des Moines Art Center, Iowa
Flint Institute of Arts, Michigan
C. Michael Kojaian
Los Angeles County Museum of Art
The Trustees of the Macmillan Estates
Manoogian Collection
The Metropolitan Museum of Art, New York
The Minneapolis Institute of Arts
Museum of Fine Arts, Boston
New Britain Museum of American Art, Connecticut
Private Collection, Courtesy of Thomas Colville
Private Collection of Mrs. Deen Day Sanders
Southampton City Art Gallery, England
Tate Gallery, London
Taylor Museum, Colorado Springs Fine Arts Center
Terra Foundation for the Arts, Daniel J. Terra Foundation
Wadsworth Atheneum Museum of Art, Hartford, Connecticut
Worcester Art Museum, Massachusetts
The Brooklyn Museum is also grateful to the lenders who wish to remain anonymous.

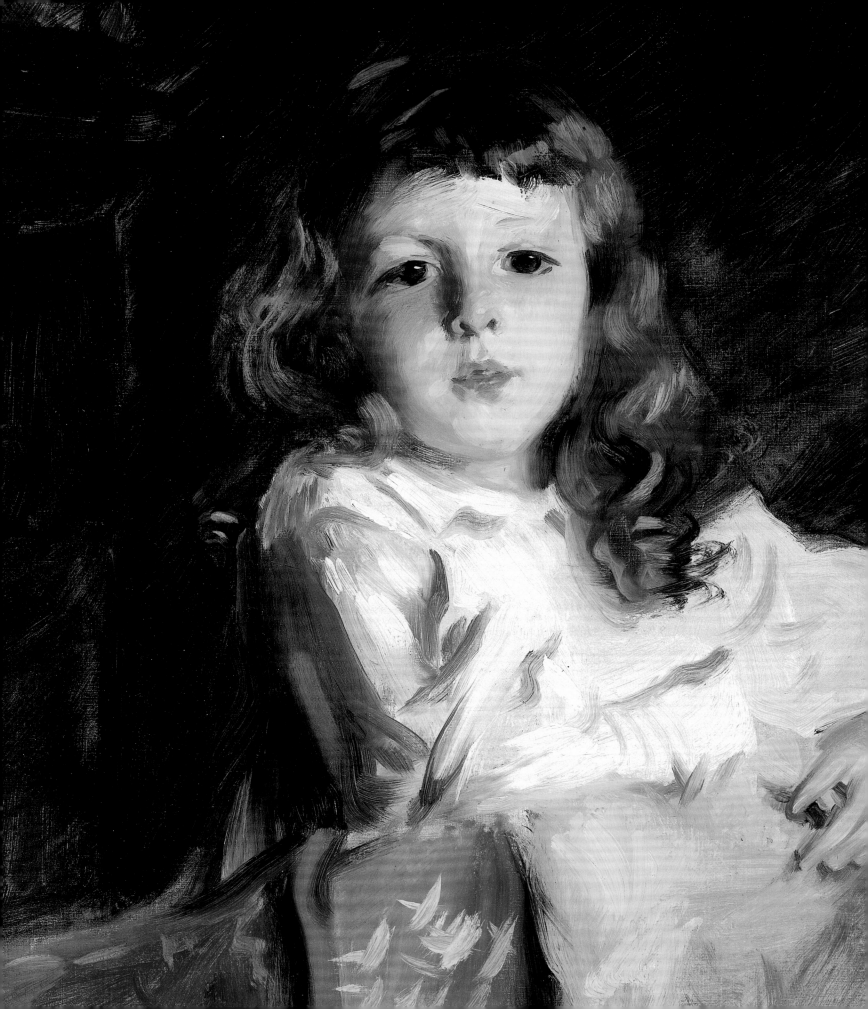

Great Expectations

An Introduction to John Singer Sargent's

Paintings of Children

BARBARA DAYER GALLATI

Great Expectations: John Singer Sargent Painting Children explores a category of subject matter that recurs throughout Sargent's oeuvre—the child. It is admittedly difficult to reconcile the fact that the artist who painted the stunning *Madame X* (fig. 1) is also the artist who, just a few years before, painted the small children on the stairway in *Ricordi di Capri* (pl. 1). But the very frequency with which Sargent depicted children—in portraits and in genre paintings—demands investigation if only to answer the question why? If we believe Charles Merrill Mount, then we need go no further, for the "passel of 'brats'" Sargent painted in France, England, and the United States functioned merely as audition pieces for parents who "wanted to see the results of a harmless experiment before risking their own portraits."[1] Mount's proposition, however, presents far too simplistic an answer, one that is easily contradicted by the facts surrounding the paintings themselves, some of which, including *Neapolitan Children Bathing* (pl. 14), *Edouard and Marie-Louise Pailleron* (pl. 20), *The Daughters of Edward Darley Boit* (pl. 21), and *Carnation, Lily, Lily, Rose* (pl. 24), are undisputed milestones in Sargent's career. Moreover, Sargent's paintings of children are unlike those of his contemporaries, an observation that prompts a series of questions whose answers depend not only on what can be discovered about these works specifically but also on the ideologies contributing to the redefinition of childhood that permeated fin-de-siècle European and American cultures and culminated in the new century's designation as the "Century of the Child."[2]

The title of this book and the exhibition it accompanies owes an obvious debt to Charles Dickens's novel *Great Expectations* (1861). Often considered among the finest

Detail of plate 4

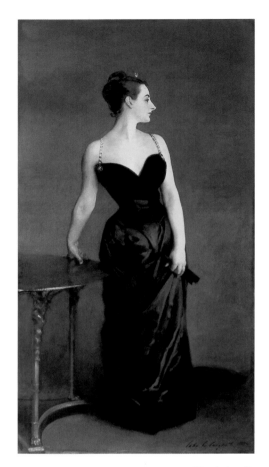

FIG. 1. *Madame X* (or *Madame Gautreau*), 1883–84, oil on canvas, 82½ x 43¼ in. (209.6 x 109.9 cm). The Metropolitan Museum of Art, New York. Arthur Hoppock Hearn Fund, 16.53.

PL. 1 (OPPOSITE). *Ricordi di Capri*, 1878, oil on panel, 13⅝ x 10⅜ in. (34.5 x 26.5 cm). Private collection. Photograph courtesy of Adelson Galleries, Inc., New York

of the Victorian author's works, it is one of many in Dickens's oeuvre that focuses on children. Driven by a detailed narrative filled with action and ironic turns of events, *Great Expectations* traces the life of Philip Pirrup (called Pip) from boyhood to manhood as it was shaped by the promise of material wealth from an anonymous benefactor. The lesson of the tale rests in the triumph of honest work over ill-gotten gains, a consequence of which is that Pip's "great expectations" can be read as analogues of hopes for a prosperous future (in both the moral and material spheres). By extension, the future-oriented meaning of "expectation" attaches to a facet of childhood that embraces, among other things, promise. In this sense, then, "great expectations" signals that Sargent's paintings of children will be investigated here in terms of how they gratified or thwarted a set of expectations associated with childhood as it was represented in art at the end of the nineteenth and beginning of the twentieth centuries. At the same time this book explores how Sargent deployed child imagery to advance his own professional standing, the uncalculated result of which helped to reposition childhood in the visual arts, taking it to a higher plane in the prevailing hierarchy of subject matter.

No less important is the provocative role that many of these child subjects take on in seeming to illuminate or intersect with Sargent's feelings about his own childhood and family life. In this regard some uncommissioned works offer intriguing scenarios on which to stage speculation about Sargent's attitudes. Perhaps no better example exists than *The Birthday Party* (or *Fête Familiale*; pl. 2), a painting whose essence lodges in the varied expectations of the family members of Sargent's friend and Paris neighbor, the painter Albert Besnard (1849–1934), as they are shown celebrating the birthday of their eldest son, Robert.[3] The informal domesticity of this conversation piece veils the psychological complexity of the subject, which, through compositional means, implies both Sargent's and the viewer's participation in this family party. This impression of inclusion is primarily conferred by the abruptly cropped table that "leaves room" for other guests just outside the pictorial space and is energized by the view across the glittering collection of still-life elements to the boy's brilliantly illuminated face. Young Robert's expression of rapt anticipation reminds us of the thrilling eventfulness of such "small" family rituals that placed us, the children that we were, at the center of attention and rewarded us for simply achieving yet another year. Sargent also directs us, again through the agency of light, to the profile portrait of Charlotte Dubray Besnard (1855–1931), whose facial contours gain added prominence by virtue of their placement against the shadowy form of her husband, who surveys the birthday ritual from a slightly detached position. A picture of maternal solicitude, Charlotte Besnard is caught in the motion of solemnly and delicately serving her son's anniversary treat. Her matronly bulk is visually connected with her son's slight figure by her extended arms—firmly molded horizontal shapes that at once stabilize the composition and seem

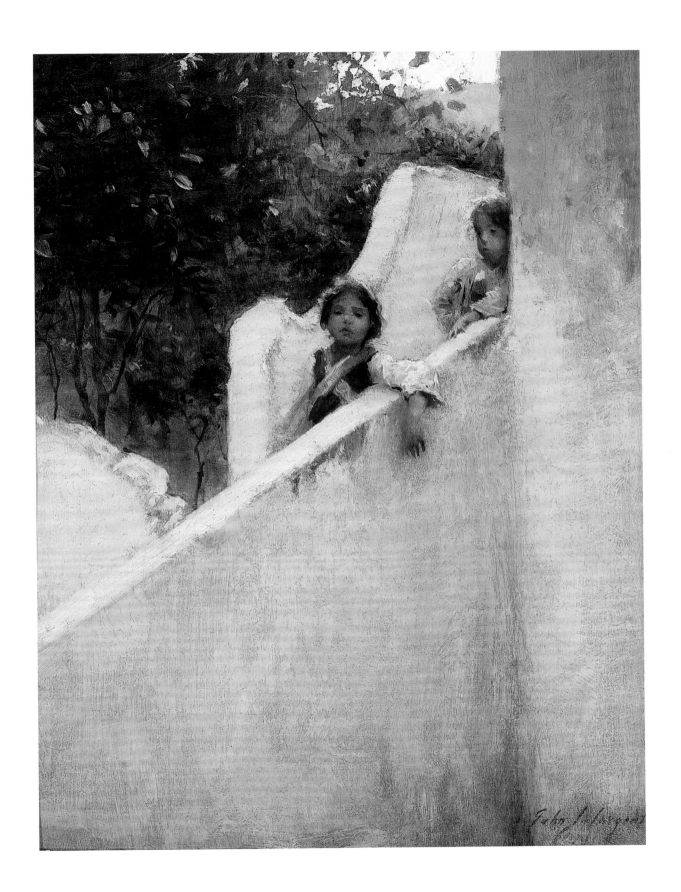

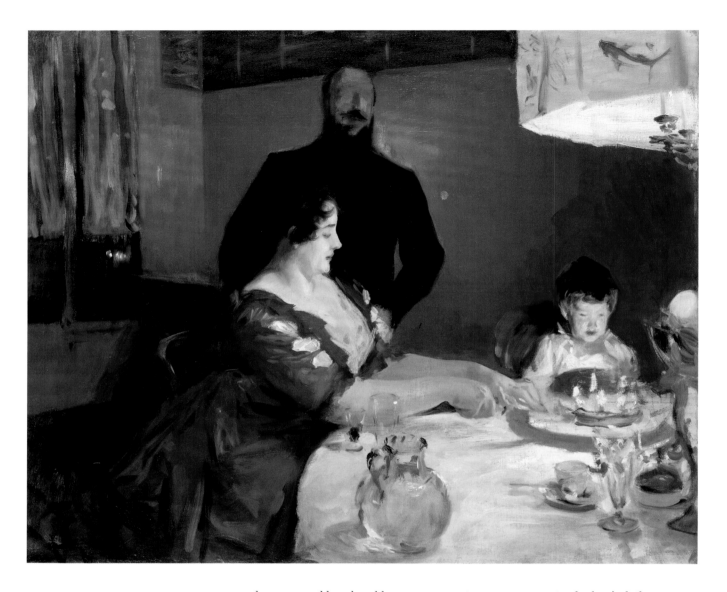

PL. 2. *The Birthday Party* (also known as *Fête Familiale*), c. 1885, oil on canvas, 24 x 29 in. (61 x 73.7 cm). The Minneapolis Institute of Arts. The Ethel Morrison and John R. Van Derlip Funds, 62.84

to stress the maternal bond and her status as primary nurturer in the boy's daily routine. Albert Besnard's position in the scheme similarly hints at the family relationships in that his abstracted, blurred presence may be interpreted as a sign of his secondary role in this stage of his son's emotional and physical development.[4] Nonetheless, Besnard's stance unmistakably denotes paternal pride and authority as he presides over the occasion. What is more, the union of parental concern is implied by the overlapping figures of the couple, intimating their shared expectations and hopes for their child.[5] Years later Besnard fondly recalled the painting, pronouncing the work a "precious souvenir" that enabled him and his wife to relive the childhood of their son who, sadly, predeceased them in the fighting of World War I.[6] Besnard's comments, although deeply personalized, correspond to the retrospective cast of mind often created by the experience of looking at any child and underscore the peculiar capacity of childhood to project our thoughts into the past as well as into the future.

Sargent's apparently deliberate care in devising this composition encourages the iconographic reading set out here. The informality of the family gathering notwithstanding, the arrangement of the figures yields a set of relationships that are far from casual and suggests that, in the process of composing this scene (probably witnessed firsthand), Sargent recaptured memories (or even constructed desired memories) of his own childhood. If this is so, is it possible to see in the conjunction of the dominant maternal figure and the vague, faceless paternal form (the latter of which is outside the child's view) echoes of Sargent's family life? Is Sargent's depiction of the mother, who presents her son with the eye-filling spectacle of the festive cake for his consumption, a restoration of his own mother, who opened his eyes to the sensuous delights of visual excitement? These questions will never be answered, but the narrative evoked by this image resonates strongly with the description of Sargent's early family life provided in Richard Ormond's essay in this volume.

THE MARGINALIZED CHILD

It is curious that *The Birthday Party*, despite its frequent reproduction, has up to now been discussed only in terms of Sargent's experimentation with Impressionist techniques.[7] This lack of comment introduces another issue that affects the reading of children in Sargent's art, that is, the marginalization of child imagery that was a by-product of traditional academic standards and gender expectations that shaped art practice in the nineteenth century. From the advent of European art academies in the seventeenth century, artistic subject matter had been consistently ranked according to levels of importance.[8] Not only did childhood not exist as a discrete subject, but children also did not conform to the ideals promulgated by academic training, which emphasized the figure in anticipation of the production of large-scale works whose recommended content related momentous historic, religious, or mythological narratives.[9] Images of the infant Jesus and child saints provided the major exceptions to this general rule, and within that category is the art of the Spaniard Bartolomé Esteban Murillo (1617–1682), whose career was founded on his paintings of the Christ Child and who later gained acclaim for his genre paintings of street urchins.[10] Apart from Murillo, however, although great artists painted great pictures of children, no great artists were particularly associated with child imagery.

Portraiture occupied a low position on the list of acceptable subjects, and its merit invariably depended on the artist's skill and reputation as well as the sitter's accomplishments. Portraits of children, therefore, had comparatively limited appeal and, when they were commissioned, were often seen to function on lower thematic and aesthetic levels since they were expected to accomplish little in advancing a family's reputation. Less inferior, of course, were images of children of royal and noble birth. These carried the weight of dynastic meaning. Sargent was patently aware of this visual tradition, as he demonstrated in the overt iconographic references to old master works in,

for example, *Lady Warwick and Her Son* (pl. 80). (See Erica E. Hirshler's essay in this volume for a discussion of Sargent's use of the dynastic mode of portraiture.)

Childhood retained its inferior status in art until the end of the eighteenth century, when, in France and England especially, it became a central motif for expressing humanity's connections with natural innocence and thereby assumed a higher station in the subject hierarchy.[11] Although the progenitors of this vigorous revision of the iconography of the child were such leading artists as Joshua Reynolds (1723–1792) and Thomas Gainsborough (1727–1788) in England and Jean-Siméon Chardin (1699–1779) in France, their emphasis on childhood was short-lived; by the mid-nineteenth century the elevated, Romantic associations linking nature and emotion with childhood had been diluted in more anecdotal strains of content that relegated childhood once again to the lesser realms of art. For mid-nineteenth-century audiences (in Europe and the United States), child imagery became expressive primarily of sentimentality rather than of great sentiment. At the same time this shift in meaning took place (which went hand in hand with the dismantling of the Grand Manner style and the rise of genre subjects), women were beginning to enter the art profession in greater numbers. This, despite the fact that women were generally excluded from the academic life classes, which would have enabled them to compete with men in the higher categories of subject matter. Presumed to be more subjective in their outlook because of biological imperatives that defined them as the weaker and more emotionally intuitive of the sexes, women were encouraged to pursue subjects believed to be appropriate to their inherent nature and experience. The association of feeling and domesticity with childhood positioned women as the ideal painters of children. In brief, then, by the time Sargent emerged as a professional artist, a genre or portrait specialty focusing on childhood was the province of women and of men of lesser talents and ambitions. As a case in point, one need only consider the comment of the novelist-critic Joris-Karl Huysmans who, after praising the works displayed by Mary Cassatt in Paris at the 1881 Independent Artists exhibition, concluded that "a woman is equipped to paint childhood. There is a special feeling men would be unable to render unless they are particularly sensitive and nervous."[12] Although women may have deemed this point of view unfounded and restrictive, Huysmans's statement was just as damning for male artists who might dare to risk their reputations (professional and masculine) by addressing too frequently a feminized subject. Comparable attitudes have held sway until recently among art historians in their efforts to formulate artist personas. In the quest to promote the heroic stature of male artists, the subject matter of childhood has been treated as a relatively unimportant thematic adjunct (if it is discussed at all), the result being the tacit understanding that painting children somehow degrades the male artist's canonical position.[13]

Sargent was unquestionably a product of the academic system. His eye was sensitized to the Western art tradition from his early childhood and his visual experience honed through formal classes beginning at

FIG. 2. *Sketch for the Joyful Mysteries, The Nativity—Three Studies of an Infant—Boston Public Library Murals* (detail), 1903–16, charcoal on paper, 18 1/2 x 24 3/16 in. (47 x 61.5 cm). Museum of Fine Arts, Boston. Gift of Miss Emily Sargent and Mrs. Violet Ormond in memory of their brother, John Singer Sargent, 28.581. Photograph © 2003 Museum of Fine Arts, Boston

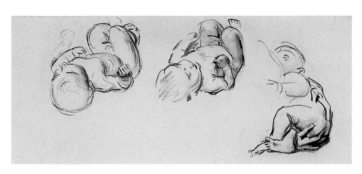

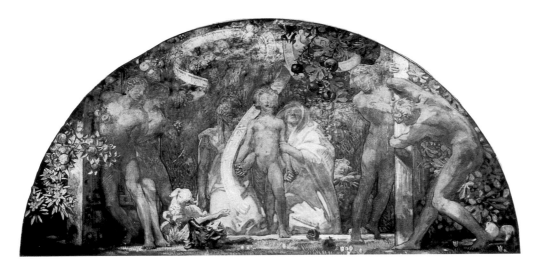

the Accademia delle Belle Arti, Florence, and culminating with intensive study at the Ecole des Beaux-Arts and in the atelier of Carolus-Duran in Paris. Sargent's allegiance to academic practice is witnessed especially in the commissions to which he devoted the most concerted and prolonged efforts of his career—the mural cycles for the Boston Public Library, the Museum of Fine Arts, Boston, and Harvard University, projects that occupied him from the early 1890s until his death. Throughout the preparation for and execution of these projects Sargent marshaled the full extent of his art-historical knowledge and academic training, applying, among other things, the traditional iconography of the child in religious art. With motifs ranging from the tenderly observed infant in the preparatory sketches for the portion of the Boston Public Library murals representing the *Joyful Mysteries* (fig. 2) to the completed lunette, *Messianic Era* (fig. 3), Sargent's murals confirm his deep understanding and use of the symbolic meaning of childhood in an academic vernacular.[14] Yet, as Sargent's art demonstrates, he also challenged himself and his audience to consider childhood as having the potential to rise to high art in the context of modernity. Measuring the effectiveness of his response to that challenge is predicated on an appreciation of the changing meaning of childhood.

THE ELASTIC VISION OF CHILDHOOD

That childhood was a central concern in nineteenth-century Western culture is demonstrated most clearly in literature. In his 1882 short story "The Point of View," Henry James had his elderly character, Miss Sturdy, lament, "[T]he young people are eating us up,—there is nothing in America but the young people. The country is made for the rising generation. . . . Longfellow wrote a charming little poem called 'The Children's Hour,' but he ought to have called it 'The Children's Century.' And by children, of course, I don't mean simple infants; I mean everything of less than twenty."[15] James as well as a host of other novelists and poets used child characters as vital mechanisms not

only for expressing sentimental plot lines but also for symbolizing the effects of social and cultural change. Within this context the ideal of the separate nature of childhood became firmly entrenched. Yet the modalities of symbolic childhood shifted several times throughout the century. In English literature, for example, Dickens's novels bridge the literary space between the "natural" child discovered in William Wordsworth's poetry and the "real" child in James's novels and short stories. Essentially, the changing concept of childhood as reflected in literary form was marked by the child's transformation from signifier to interpreter: whereas the Romantic child symbolized abstract qualities believed to be inherent in the child (for example, nature, innocence, purity), the child represented by James was a unique entity capable of interpreting (or misinterpreting) the external world according to lived experience within the limits of biological determinism. Although childhood continued to be a tool for rendering symbolic meaning, child characters were no longer simply mute abstractions of larger ideas; they were credited with or believed capable of having their own point(s) of view and capacity for independent action. The quintessential model of the disruptive "real" child is found in Mark Twain's 1884 *The Adventures of Huckleberry Finn*, in which the fourteen-year-old Huckleberry resists the "sivilizing" influences of Aunt Sally and embarks on an odyssey of self-realization. This pattern of change is acknowledged in literary studies and is enmeshed in the growing body of writing devoted to the history, psychology, and sociology of childhood, the general thrust of which is that the notion of childhood is elastic and varies according to prevailing societal values and economic conditions.[16] Chris Jenks has summarized the now dominant view of childhood: "Childhood is to be understood as a social construct, it makes reference to a social status delineated by boundaries that vary through time and from society to society but which are incorporated within the social structure and thus manifested through and formative of certain typical forms of conduct. Childhood then always relates to a particular cultural setting."[17]

Despite the seeming ubiquity of children in the cultural life of nineteenth-century Europe and North America, the job of defining a child was becoming increasingly problematic. The morphological differences that had once clearly set the borders between children and adults were no longer adequate to determine what a child was and how to treat it. This remains true: a basic dictionary definition of a child as a "boy or girl in the period before puberty"[18] offers no help when, for instance, contemporary Western society must deal with children who do not behave like children.[19] These observations are of special significance when it comes to examining Sargent's art since, as it will be seen, defining childhood was a priority in (as Jenks calls it) his "particular cultural setting."

There can be no doubt that Sargent's beliefs about childhood were shaped in part by ideas that originated in Europe in the eighteenth century. Before that time children were generally viewed as imperfect adults who required improvement to be of value. Within the dominant Christian systems of belief, children were also freighted with the burden of being reminders of original sin. In brief, the transformation of the idea of childhood was part of the economic, political, and social inheritance of what has been called the "age of revolution," a period during which childhood emerged as a primary device to communicate a revised philosophical view of mankind's nature and rights. The

writings of John Locke (1632–1704) in England and of Jean-Jacques Rousseau (1712–1778) in France are accorded significant credit for initiating the "cult of childhood" and for introducing theories of education based on their assessments of children's capacities and particular needs. The ideas of Locke (who believed that the human mind is a blank—tabula rasa—at birth) and Rousseau (who believed that childhood was to be valued as the human state closest to nature) became institutionalized in Europe (in France and England, especially) and led to the formulation of the child as the Romantic personification of unspoiled humanity.[20] As a consequence, the relationship between children and adults changed. Where adults had once been in a position of undisputed physical and moral authority, children, by virtue of their new "untainted" status, were suddenly pure conduits of intuitive or "natural" wisdom and thus could perform a redemptive role by "re-educating" the adult.[21] These emergent ideologies were variously shaded by religious beliefs (especially those stemming from the Evangelical movement in England from the 1730s to the 1830s), some of which still maintained that children entered life blighted by sin. Regardless of any of these philosophical circumstances, children were subjected to increasingly close scrutiny.[22] Sargent's particular knowledge of or subscription to these theories is unknown, but his general awareness of the philosophical mechanics underpinning the eighteenth-century transformation of childhood may be posited by his possession of a first edition of Rousseau's landmark novel, *Emile*.[23]

Certainly Sargent was familiar with the image of the Romantic child as it coalesced in late eighteenth- and early nineteenth-century art in the paintings of Reynolds, Gainsborough, and their contemporaries. Reynolds, a masterful innovator in establishing the iconography of natural childhood innocence, painted numerous fancy pictures and portraits that have achieved an unparalleled iconicity for investigations of child imagery in Georgian art as well as its impact on the art of the Victorian era. Reynolds's *Miss Penelope Boothby* (1788, fig. 4), for example, figures prominently in a variety of contemporary texts as a nostalgic sign of an Edenic condition for which adults may yearn but cannot reclaim.[24] Although Penelope Boothby died not long after her portrait was painted, she "lives" in perpetual innocence in Reynolds's painting, which enjoyed intermittent surges of popularity in the later nineteenth century beginning with its first public exhibition at South Kensington, London, in 1862. The painting was subsequently displayed at the Royal Academy winter exhibitions of old masters in 1871 and 1885, and at the London gallery of Thomas Agnew and Sons in 1899.[25] As the ghost of Penelope Boothby became manifest to the British public, her image was restaged and its meaning realigned in John Everett Millais's *Cherry Ripe* (1879, fig. 5). In this instance the young Edie Ramage took on the role of Penelope and the painting's content was injected with a modern frisson of sexuality, largely compliments of the painting's title.[26] Both paintings achieved popular and critical acclaim in the same decades of the nineteenth century for the same audience; little girls went to costume parties dressed as Penelope/Edie; reportedly six hundred thousand prints of *Cherry Ripe* were avidly purchased; and the governing motif of both works was reiterated in the works of other artists, including Charles Dodgson (Lewis Carroll), who twice photographed Xie Kitchin as Penelope Boothby in 1879.[27]

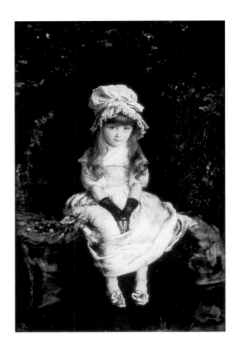

FIG. 4. Joshua Reynolds (English, 1723–1792), *Miss Penelope Boothby*, 1788, oil on canvas, 29½ x 24⅜ in. (75 x 62 cm). Private collection. Photograph courtesy of the Ashmolean Museum, Oxford

FIG. 5. John Everett Millais (English, 1829–1896), *Cherry Ripe*, 1879, oil on canvas, 53 x 35 in. (134.6 x 88.9 cm). Private collection/Bridgeman Art Library

PL. 3 (OPPOSITE). *Dorothy*, 1900, oil on canvas, 24⅛ x 19¾ in. (61.3 x 50.2 cm). Dallas Museum of Art, gift of the Leland Fikes Foundation, Inc.

The metamorphosis of Reynolds's *Miss Penelope Boothby* into Millais's *Cherry Ripe* demonstrates that the fundamental form and understanding of the Romantic child remained in place and were actually necessary for new meaning to develop. By the 1870s Reynolds's Romantic child was a cultural artifact, an image that was already consigned to the domain of memory that gathered, through the workings of Millais, an added layer of nostalgia because of its premonitory message of lost innocence. That Millais could broach such a loss in a child subject, however delicately, hints of the transition in social attitudes regarding the definition and regulation of childhood then under way. The magnitude of those changes is tellingly disclosed by the comparison of Sargent's *Dorothy* (pl. 3) with *Miss Penelope Boothby* and *Cherry Ripe*. *Dorothy* differs not only in stylistic terms but also (and primarily) in how she is presented—without sentimentality and without an elaborate setting. The impression of Dorothy's strong personality is heightened by the "unchildlike" red ground that frames her. Unlike Dorothy, Reynolds's and Millais's little girls are seated in the metaphoric lap of nature. They steal shy glances and their bodies collapse into postures that also suggest their reticence. Dorothy, by contrast, stares directly at us and sits with an air of authority, posed in a manner more reminiscent of portraits of heads of church or state than of two-year-olds. To be sure, all three paintings rely on a common device used to evince charm: the miniaturizing effect of the clothing, a mechanism usually intended to make children seem more "childlike" and vulnerable as they bear the weight of oversize headgear and voluminous dresses. Reynolds's Penelope wears a muslin gown commonly worn by girls of her era, but the fichu and mob cap denote that she is "dressed up" in emulation of adult fashion; Millais's child clearly masquerades as Reynolds's Romantic Penelope; and Sargent's Dorothy shows off the up-to-date, grand fashion of the contemporary, upper-middle-class youngster.[28] Dorothy triumphs over her predecessors, however, for she

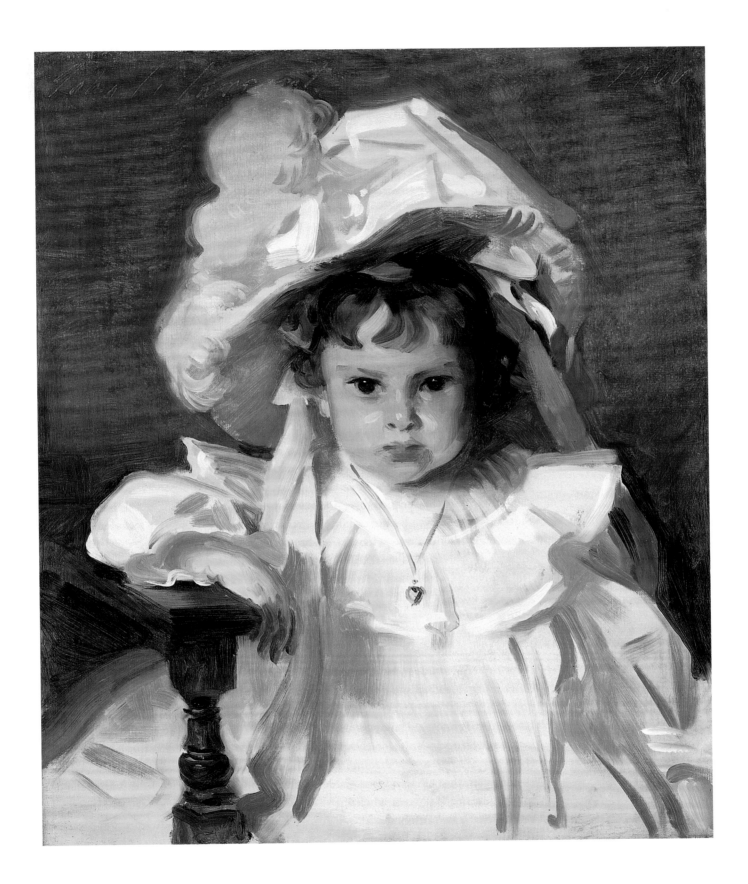

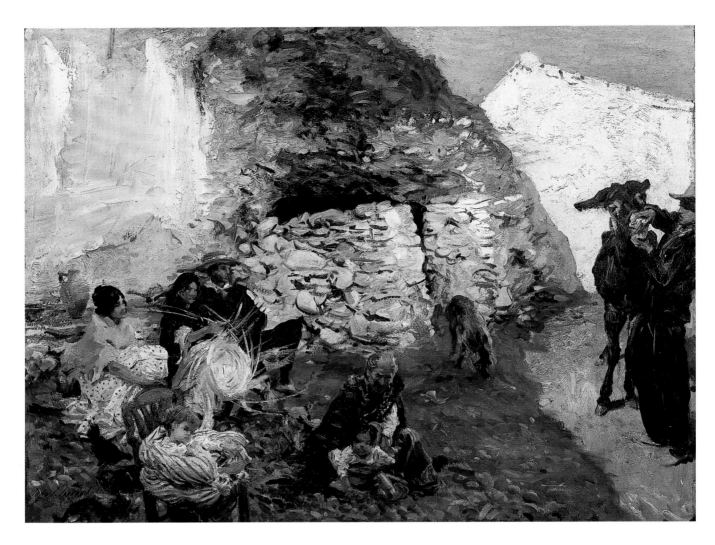

confidently, leaning on the back of a couch, secure in his place within his narrowly circumscribed and privileged world.

Yet Sargent also provides evidence of his awareness of distinctions of privilege, place, and type by featuring children in a number of genre paintings that invite consideration of a child's position in a separate, less hospitable world. Of these, *Gypsy Encampment* (pl. 5) strikes a particularly resonant chord, for the painter's seemingly dispassionate portrayal of nomadic family life prompts conjecture about the associations he may have formed between this and his own family's rootless existence. On a less personal plane, the Gypsy subject leads to a broader examination of ethnic stereotypes with respect to the idea of family and so-called primitive alternatives to the mainstream social order.[49] Does Sargent simply encourage us to see this as a spontaneously rendered view of exotic life? Or does he intend us to consider deeper themes of racial inheritance as suggested by the prominent placement of the children within an array of generations, a thematic variation of which may be read in the figure on the right who inspects a donkey as if to determine its fitness? Again, there is no easy

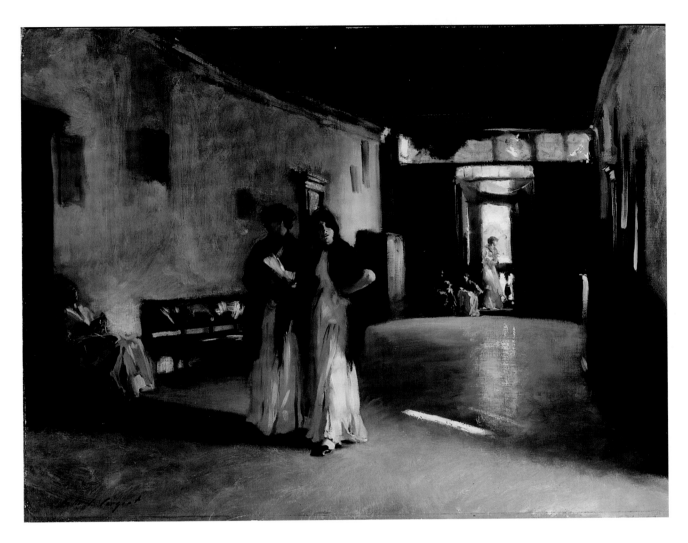

PL. 6. *Venetian Interior*, 1880–82, oil on canvas, 26⅞ x 34³/₁₆ in. (68.3 x 86.8 cm). Carnegie Museum of Art, Pittsburgh; Purchase, 20.7

answer. However, like *Gypsy Encampment*, a significant number of Sargent's genre paintings display a pattern of content that hinges on the presence of children—if not to convey specific meaning, then at least to deflect or confuse assumptions about the subject matter. In this context children domesticate the dark, ambiguous space of *Venetian Interior* (pl. 6) and invest a secular scene with religious undertones, as in *Venetian Courtyard* (Greentree Foundation), in which a woman and child are placed directly beneath a cross.

 The Tyrolese Crucifix (pl. 7) is quite possibly the most transparent example of Sargent's symbolic use of the child. It lends credence to the theory that, in some instances, the painter purposefully manipulated content through child imagery. Begun in 1914, when Sargent and his friends the English artist Adrian Stokes (1854–1935) and his German wife, Marianne (née Preindlsberger, 1855–1927), were on vacation in Austria and were detained there by the outbreak of World War I, the painting crystallizes what Richard Ormond has described as the "gloomy and premonitory mood" that gripped the artist at the time.[50] Ironically, the Austrian Tyrol had been the scene of

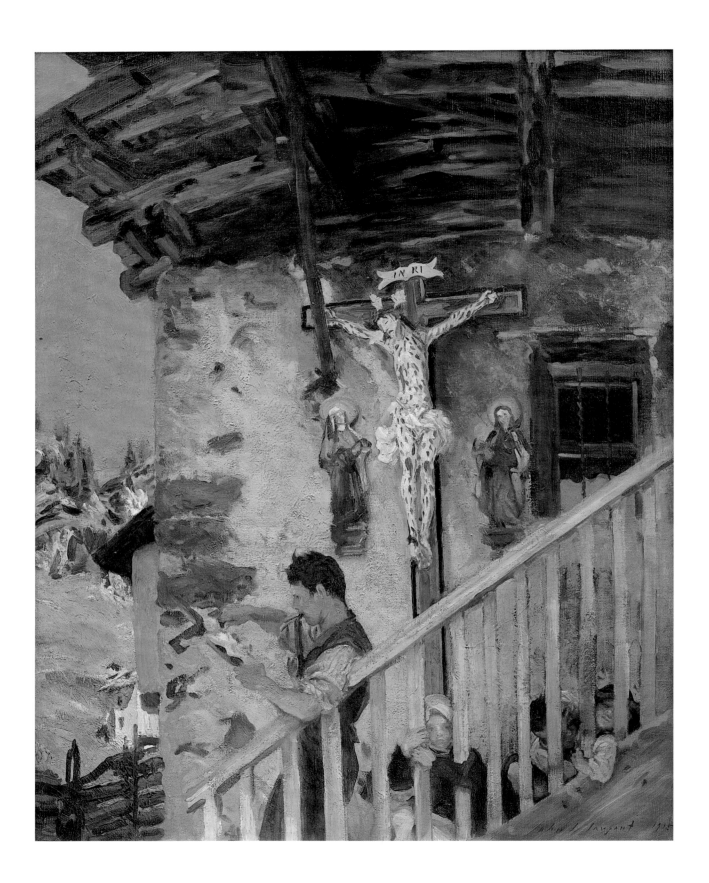

idyllic moments in the painter's youth, memories of which must have stood in stark contrast to the present and alarming perils that threatened to destroy the fabric of European life in 1914. These contrasts are vividly realized through an iconography that gives visible parallel to Sargent's own sense of confinement and at the same time questions the nature and fate of humanity. Four figures occupy the narrow area of an outer stairway belonging to a simple chalet. On the left a man is intently carving a crucifix that may soon join the other and the mourning saints that hang on the wall above the group. As Christian symbols of faith and salvation, these objects also refer to mankind's fierce cruelty and the sacrifice necessary to ensure the future of humanity. Peering through the railing (which produces a particularly prisonlike effect) is a little girl, whose glum visage assaults us with a powerful sadness. To the right, two little boys engage in playful, but nonetheless violent, struggle, their actions providing a disturbing commentary on human behavior.[51] Although Sargent's iconographic formula is simple, the meaning is harrowing in its implications of lost tradition, faithlessness, and lack of hope, all of which are transmitted through the child protagonists who already display traits mirroring the Western world's current state of turmoil.

In the end, however, the words of Henry James remind us of the difficulties in attempting to trace connections between the grand cultural picture and the work of one artist: "The painter of life has indeed his work cut out for him.... The effort really to see and really to represent is no idle business in face of the *constant* force that makes for muddlement."[52] The works considered here represent Sargent's efforts "really to see and really to represent" insofar as his subjective understanding of his subjects allowed. As unique visual experiences, they pulsate with the tensions of a time when the conventional meanings of deciphering identity and communicating content were breaking down and new ones were being formed, transformations that are abundantly manifest in Sargent's images of children.

PL. 7 (OPPOSITE). *Tyrolese Crucifix*, 1914–15, oil on canvas, 36 x 28¼ in. (91.4 x 71.8 cm). Private collection

1. Charles Merrill Mount, *John Singer Sargent: A Biography* (New York: W. W. Norton & Company, 1955), 127.

2. The source of the designation of the twentieth century as the "age" or "century of the child" is unknown, but it seems to have been common parlance by the 1880s. By 1909 it was part of the official language of social welfare advocates, standardized by the publication of Ellen Key's *The Century of the Child* (New York and London: G. P. Putnam's Sons, 1909). As Erica E. Hirshler points out in this volume, Sadakichi Hartmann, for one, pronounced the era the "age of the child" with respect to the visual arts.

3. Unless otherwise noted, basic biographical information for Sargent's sitters is taken from Richard Ormond and Elaine Kilmurray, *John Singer Sargent: The Early Portraits*; *Complete Paintings*, *Volume I* (New Haven and London: Yale University Press for the Paul Mellon Centre for Studies in British Art, 1998); and Richard Ormond and Elaine Kilmurray, *John Singer Sargent: Portraits of the 1890s*; *Complete Paintings*, *Volume II* (New Haven and London: Yale University Press for the Paul Mellon Centre for Studies in British Art, 2002).

4. For a general survey of and extensive bibliography pertaining to the structure(s) of nineteenth-century family life, see Philippe Ariès and George Duby, gen. eds., *A History of Private Life*, vol. 4, *From the Fires of Revolution to the Great War*, ed. Michelle Perrot (Cambridge, Mass., and London: Belknap Press of the Harvard University Press, 1990).

5. Ormond and Kilmurray, *John Singer Sargent: The Early Portraits*, 157. It should be noted, too, that Besnard's authority extends to his influence on Sargent, for the younger artist's style in this case follows Besnard's closely.

6. See "Echos des arts. Une lettre d'Albert Besnard et un tableau de J. Sargent," *L'Art et les Artistes*, no. 87 (May 1928), 283–84, which prints a letter from Besnard to Armand Dayot (editor of the journal) providing his memories of the painting and giving permission to reproduce it.

7. For example, the painting was included in the 1986 Sargent retrospective exhibition organized by the Whitney Museum of American Art, New York, and, although it was reproduced in the catalogue, it was not mentioned in the text. It was similarly ignored in Carter Ratcliff's *John Singer Sargent* (New York: Abbeville Press, 1982), where it was reproduced but not discussed. More recently it was reproduced in Trevor J. Fairbrother, *John Singer Sargent* (New York: Harry N. Abrams in association with the National Museum of American Art, Smithsonian Institution, 1994), where the author briefly commented on it in terms of Sargent's treatment of light in interior settings (57–58).

8. See Gill Perry and Colin Cunningham, eds., *Academies, Museums and Canons of Art* (New Haven and London: Yale University Press in association with the Open University, 1999) for a basic introduction to the history of academic art training in Europe.

9. The first substantial scholarly history of childhood is Philippe Ariès, *Centuries of Childhood: A Social History of Family Life*, trans. Robert Baldick (New York: Knopf, 1962). Although his views have not gone unchallenged, Ariès has remained the baseline authority for subsequent histories.

10. For Murillo's child subjects, see Xanthe Brooke and Peter Cherry, *Murillo: Scenes of Childhood* (London: Merrell in association with Dulwich Picture Gallery, 2001).

11. See James Christen Steward, *The New Child: British Art and the Origins of Modern Childhood, 1730–1830* (Berkeley: University Art Museum and Pacific Film Archive, University of California, Berkeley, in association with the University of Washington Press, 1995).

12. Joris-Karl Huysmans, "L'Exposition des indépendants en 1881," in *L'Art Moderne* (1884), translated and quoted in Judith A. Barter, "Mary Cassatt: Themes, Sources, and the Modern Woman," in *Mary Cassatt*, *Modern Woman*, by Barter et al. (Chicago: Art Institute of Chicago, 1998), 69. For a listing of the eleven works Cassatt displayed in the 1881 exhibition, see Charles S. Moffett et al., *The New Painting: Impressionism, 1874–1886* (San Francisco: The Fine Arts Museums of San Francisco, 1986), 353; and, for an analysis of the 1881 exhibition, see esp. Fronia E. Wissman, "Realists among the Impressionists," 337–50.

13. For a stimulating discussion of the reputations of Sargent and Cecilia Beaux along these lines, see Sarah Burns, "The 'Earnest, Untiring Worker' and the Magician of the Brush: Gender Politics in the Criticism of Cecilia Beaux and John Singer Sargent," *Oxford Art Journal* 15, no. 1 (1992), 36–53.

14. The depth of Sargent's research in connection with these commissions is admirably evaluated in Sally M. Promey, *Painting Religion in Public: John Singer Sargent's "Triumph of Religion" at the Boston Public Library* (Princeton, N.J.: Princeton University Press, 1999).

15. Henry James, "The Point of View," *Century Magazine*, December 1882. It was subsequently included in collections of his short stories: (Boston: James R. Osgood, 1883) and (London: Macmillan & Co., 1883). The text quoted here is Henry James, *Complete Stories, 1874–1884* (New York: Library of America, 1999), 536.

16. The literature on the subject of childhood is voluminous. Neil Postman cites a bibliographic survey done by Professor Lawrence Stone at Princeton University reporting that more than nine hundred articles and books on the topic were published between 1971 and 1976 compared with an average of ten publications per year throughout the 1930s. Postman, *The Disappearance of Childhood* (New York: Vintage Books, 1994), 155 n. 2. Scholarly and popular interest in child study has been on the increase since the 1970s. To account for the explosion in child studies Postman argues that the Western concept of childhood is again changing

(according to his thesis, disappearing) and, as one notion of childhood becomes obsolete, it takes on the identity of a cultural artifact, a state that invites historical investigation (5). If Postman's theory is correct, then it may be applied to the cultural conditions at the end of the nineteenth century, when the definition of childhood also shifted away from the Romantic child as evidenced by the proliferation of scientific and medical studies, commercial goods, and literary and artistic enterprises centered on childhood at the time. For the present purposes, the following books and their extensive bibliographies were especially valuable: Virginia L. Blum, *Hide and Seek: The Child between Psychoanalysis and Fiction* (Urbana and Chicago: University of Illinois Press, 1995); Hugh Cunningham, *Children and Childhood in Western Society since 1500* (London and New York: Longman, 1995); Harry Hendrick, *Children, Childhood and English Society, 1880–1990* (Cambridge and New York: Cambridge University Press, 1997); and David I. Macleod, *The Age of the Child: Children in America, 1890–1920* (New York: Twayne Publishers, 1998).

17. Chris Jenks, *Childhood* (London and New York: Routledge, 1996), 7.

18. *Webster's New World Dictionary of the American Language* (Cleveland and New York: The World Publishing Company, 1966), s.v., "child."

19. Contemporary American and British cultures are consumed with attempting to define childhood, especially with regard to the child's place within the legal system. Language usage reveals the intensely problematic nature of the endeavor. For example, a sympathetic fifteen-year-old male victim of a crime is, more often than not, referred to as a child or a boy in newspaper reports. Conversely, a fifteen-year-old male who perpetrates a crime is often stripped of the privileged space of childhood when reporters refer to him as the "alleged perpetrator" or "suspect." An extreme example of this duality is found in the language that referred to the ten-year-old boys who murdered a toddler in Manchester, England, in 1993. As Jenks points out, newspaper articles did not refer to the defendants as children but instead called them "monsters," "little devils," "evil freaks," and described them as having "adult brains" (*Childhood*, 128).

20. See Steward, *The New Child*, esp. chap. 5, "The Child Learns: Academic, Religious, and Moral Education," where he discusses the impact of Locke and Rousseau on the imaging of childhood.

21. Colin Heywood, *A History of Childhood* (Cambridge: Polity Press, 2001), 25.

22. See Catherine Robson's discussion of the often conflicting opinions of the nature of childhood, in which she concludes, "These different strains of Victorian Christianity, then, found themselves variously in contention and agreement with Romanticism's view of the child as pure and innocent, but ultimately colluded with its insistence upon

the central importance of childhood." Robson, *Men in Wonderland: The Lost Girlhood of the Victorian Gentleman* (Princeton, N.J., and Oxford: Princeton University Press, 2001), 7.

23. *Emile* was first published in France in 1762. Predicated on the idea that mankind is naturally good, the book was banned in France almost immediately and Rousseau was persecuted on the grounds that his work was impious and antireligious. Forced to take refuge outside France, Rousseau found a temporary haven in England in 1766. Sargent's four-volume leather-bound first edition was auctioned in *Catalogue of the Library of John Singer Sargent, R.A.*, Christie, Manson & Woods, London, July 29, 1925, no. 98.

24. See, for example, Anne Higonnet, *Pictures of Innocence: The History and Crisis of Ideal Childhood* (London: Thames and Hudson, 1998), 27–30.

25. See Nicholas Penny, ed., *Reynolds* (London: Royal Academy of Arts in association with Weidenfeld and Nicolson, 1986), 319; and David Mannings, *Sir Joshua Reynolds: A Complete Catalogue of His Paintings* (New Haven and London: Yale University Press, 2000), vol. 1, 95–96.

26. For recent interpretations of *Cherry Ripe*, see Laurel Bradley, "From Eden to Empire: John Everett Millais's *Cherry Ripe*," *Victorian Studies* 34 (winter 1991), 179–203; and Pamela Tamarkin Reis, "Victorian Centerfold: Another Look at Millais's *Cherry Ripe*," *Victorian Studies* 35 (winter 1992), 201–5.

27. The reliance on eighteenth- and early nineteenth-century predecessors for children's portraits heightened the already nostalgic meaning of childhood and seemed to communicate the comforting thought that children remained the simple, innocent beings the Romantics perceived them to have been. For the most part, such late nineteenth-century quotations or borrowings lent a stilted, old-fashioned quality to the paintings, as in, for example, Luke Fildes's *Jack, Son of Elmer Speed, Esq.*, of about 1897, and William Robert Symonds's 1904 *Heather* (both of which reprise Reynolds's *The Age of Innocence*), Millais's 1896 *John Neville Manners* (which relies on Thomas Lawrence's *Master Lambton*), and George A. Storey's *Good as Gold*, of about 1885, which paraphrases *Miss Penelope Boothby*.

28. Like infants' clothing in general, the puffy oversize bonnet was non–gender specific. Compare, for example, Dorothy Williamson's bonnet with that of little Jean Renoir in Pierre-Auguste Renoir's *The Artist's Family* (1896, The Barnes Foundation, Merion, Pa.).

29. For summaries of European and American "save the child" movements in the nineteenth and early twentieth centuries, see Cunningham, *Children and Childhood*, 134–62.

30. Heywood, *A History of Childhood*, 107–8.

31. For the material culture of childhood, see *A Century of Childhood, 1820–1920* (Rochester, N.Y.: The Margaret Woodbury Strong Museum, 1984); Karin Calvert, *Children in the*

House: The Material Culture of Early Childhood, 1600–1900 (Boston: Northeastern University Press, 1992); Anthony Burton, "Small Adults: Education and the Life of Children," in *The Victorian Vision: Inventing New Britain*, ed. John M. MacKenzie (London: V&A Publications, 2001), 75–95; and Chantal Georgel, *L'enfant et l'image au XIXe siècle*, Les dossiers du Musée d'Orsay (Paris, 1988).

32. The historical relationship between childhood and legislation in Europe and the United States is complex and the two cannot be separated. For instance, many of the early labor laws were passed to protect children in the workplace. Similarly, the premise behind the first laws regarding pornography and obscenity was the need to protect the minds of youth. Debates about laws regulating the work of child actors also reached the popular sphere, resulting in, among other things, Ernest Dowson's essay, "The Cult of the Child," published in the *Critic*, August 17, 1889.

33. See Marilyn R. Brown, "Introduction: Baudelaire between Rousseau and Freud," in *Picturing Children: Constructions of Childhood between Rousseau and Freud*, ed. Brown (Aldershot: Ashgate, 2002), 3 and n. 17, 14, where she offers a summary of recent publications devoted to the subject.

34. Society for the Study of Child Nature, *Chapter I: Summary of the Work for the Years 1896–1906* (New York, 1907).

35. G. Stanley Hall, *The Contents of Children's Minds on Entering School* (New York and Chicago: E. L. Kellogg & Co., 1893). Hall was a pioneer in the fields of developmental and experimental psychology in the United States. While studying in Germany he adopted the questionnaire format for research and was the first American to apply the technique, devoting it to studies of children's lies (1882) and the nature of children's knowledge (1883), later published as *The Contents of Children's Minds on Entering School*. Hall's professorships in psychology at Harvard University and the Johns Hopkins University were followed by his presidency of Clark University, Worcester, Massachusetts, where he continued to teach and publish prolifically.

36. Among the growing list of scholarly publications devoted to examining the impact of degeneration theory on late nineteenth-century Western thought are: Daniel Pick, *Faces of Degeneration: A European Disorder, c. 1848–1918* (1989; Cambridge and New York: Cambridge University Press, 1996); Stephen Arata, *Fictions of Loss in the Victorian Fin de Siecle: Identity and Empire* (Cambridge and New York: Cambridge University Press, 1996); Charles Bernheimer, *Decadent Subjects: The Idea of Decadence in Art, Literature, Philosophy, and Culture of the "Fin de Siècle" in Europe* (Baltimore and London: Johns Hopkins University Press, 2002); William Greenslade, *Degeneration, Culture and the Novel, 1880–1940* (Cambridge and New York: Cambridge University Press, 1994). For a broad investigation of the convergence of ideas that contributed to the concept of degeneration, see Valeria Finucci and Kevin Brownlee, eds., *Generation and Degeneration: Tropes of Reproduction in Literature and History from Antiquity to Early Modern Europe* (Durham, N.C., and London: Duke University Press, 2001). Also of value is Sally Ledger and Roger Luckhurst, eds., *The Fin de Siècle: A Reader in Cultural History, c. 1880–1900* (Oxford and New York: Oxford University Press, 2000).

37. See Donald C. Bellomy, " 'Social Darwinism' Revisited," *Perspectives in American History*, n.s., 1 (1984), 1–129, for a critical history of the term "Social Darwinism."

38. Max Simon Südfeld (1849–1923), who later changed his name to Nordau, was born in Budapest. Initially trained in Paris as a physician, he turned to journalism, a profession that he used as a platform for his social and political opinions. His first notable success was *The Lies of Our Civilization* (1884), an excoriating account of the failure of contemporary social institutions to serve humanity. Shortly after the publication of *Degeneration* Nordau covered the Dreyfus trial, an experience that intensified his already strong interest in Zionism.

39. Max Nordau, *Degeneration* (reprint; Lincoln and London: University of Nebraska Press, 1993), 2.

40. Interestingly, passages of Nordau's prose (for example, "over the earth the shadows creep with deepening gloom, in which all certainty is destroyed and any guess seems plausible. Forms lose their outlines, and are dissolved in a floating mist"; *Degeneration*, 6) parallel those of Karl Marx (for example, "all that is solid melts into air"; *Communist Manifesto*). Similar imagery is found throughout late nineteenth-century writing in the works of authors as varied as Mark Twain, Stephen Crane, Frank Norris, Fyodor Dostoyevsky, Edgar Saltus, and H. G. Wells, and interpreted as symptomatic of the general struggle to come to terms with modernity. For some of these connections, see George Cotkin, *Reluctant Modernism: American Thought and Culture, 1880–1900* (New York: Twayne Publishers, 1992), 144–54.

41. Albert Bushnell Hart, "Is the Puritan Race Dying Out?" *Munsey's Magazine* 45, no. 2 (May 1911), 252–55.

42. Calvert, *Children in the House*, 139.

43. Hendrick, *Children, Childhood and English Society*, 13.

44. The cultural readings of these ideas as they relate to France and Britain are extensively presented in Bernheimer, *Decadent Subjects*, and Pick, *Faces of Degeneration*. The impact of degeneration theory in the United States has not been thoroughly traced.

45. See Albert Boime, "Sargent in Paris and London: A Portrait of the Artist as Dorian Gray," in *John Singer Sargent*, ed. Patricia Hills (New York: Whitney Museum of American Art in association with Harry N. Abrams, 1986), 75–109.

46. Referring to Henry James's 1897 *What Maisie Knew*, Higonnet states, "In the late twentieth century, many children are Maisies. These Knowing children have bodies and passions of their own. They are also often aware of adult

bodies and passions, whether as mimics or only witnesses" (*Pictures of Innocence*, 207). I would argue, however, that this has been the case regardless of time or culture; the difference lodges in the general recognition of these facts by a particular class or society and how those facts may or may not be interpreted. Higonnet is correct in that a highly visible range of imagery in contemporary Western society tends to present children in a manner that suggests adult behavior to the adult viewer.

47. In her fascinating and thoughtful analysis of Sargent's *The Daughters of Edward Darley Boit* Sidlauskas states: "Eighteenth- and nineteenth-century concepts of the 'natural child' have only recently been replaced by what psychologists and sociologists call the 'invented child,' according to which the child is considered as much a social and psychological construct as a biological and developmental entity. The notion of the invented child underpins much recent research in psychology and other branches of cognitive science, as well as history, sociology, and anthropology." Susan Sidlauskas, *Body, Place, and Self in Nineteenth-Century Painting* (Cambridge and New York: Cambridge University Press, 2000), 63. Although what she says is true, an understanding of the "invented child" is predicated on a retrospective view of the myriad factors that came into play at the end of the nineteenth century that now orchestrate that concept of the child, a view that is afforded to us, but not necessarily to Sargent or his contemporaries. Thus, her reading of Sargent's *The Daughters of Edward Darley Boit* is apt for a contemporary audience but seems overdetermined as a barometer for Sargent's intentions and choices. Additional discussion is devoted to the painting in "From Souvenir to High Art: Childhood on Display," in this volume.

48. Macleod, *The Age of the Child*, 31.

49. Gypsy themes occurred in Sargent's art intermittently throughout his career and mark the intersection of his personal curiosity about them (additionally suggested by a period photograph in the Sargent Scrapbook at the Metropolitan Museum of Art) and the vogue for them that arose in Europe in the 1840s. See Mary Crawford Volk, *John Singer Sargent's "El Jaleo"* (Washington, D.C.: National Gallery of Art, 1992), where the phenomenon of the Gypsy in late nineteenth-century art is discussed and the photo from Sargent's scrapbook is reproduced (37).

50. Richard Ormond, *John Singer Sargent: Paintings, Drawings, Watercolors* (New York: Harper and Row, 1970), 77. Sargent was trapped without his papers in Austria when Britain and France declared war on Germany in August 1914. He was able to leave in November 1914, after having obtained an American passport in Vienna. *The Tyrolese Crucifix* was completed in 1915 in his London studio.

51. The motif of the tragic little girl and the fighting boys may have carried even greater personal associations for Sargent. His niece Rose-Marie was widowed when her husband, Robert André-Michel, was killed in battle at Soissons in October 1914.

52. Henry James, *What Maisie Knew*, 1909 ed.

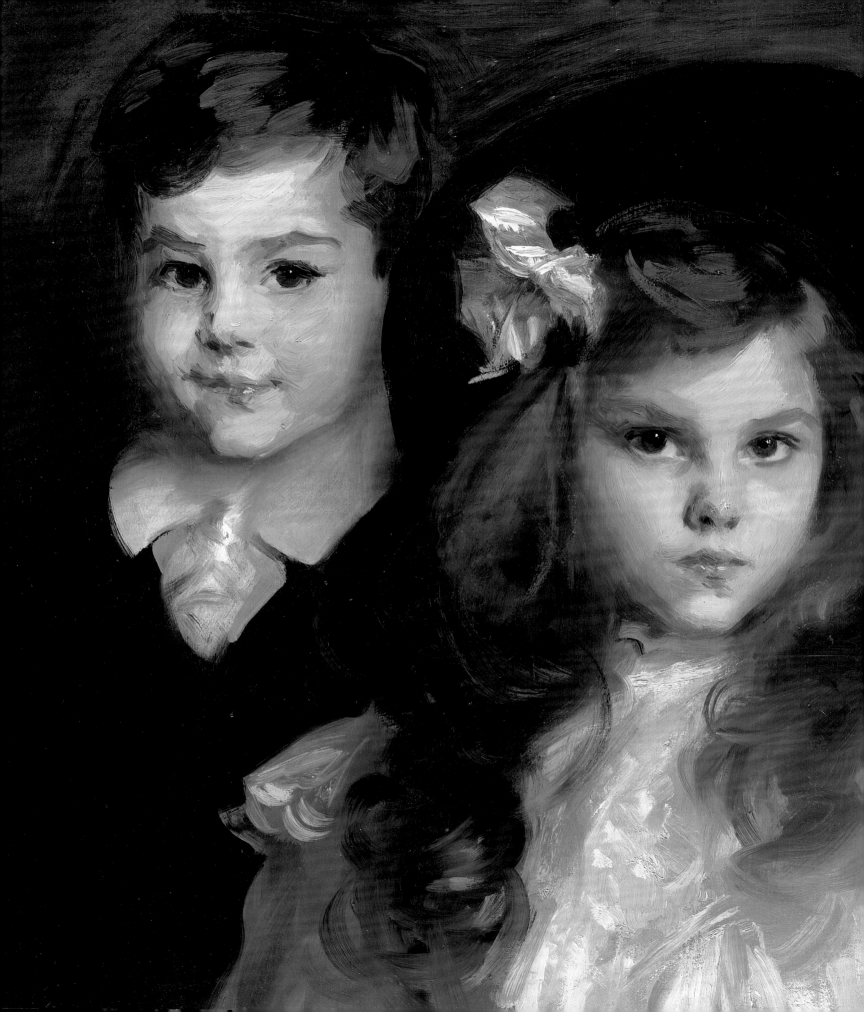

Sargent's Childhood

RICHARD ORMOND

It was John Singer Sargent's grandmother Mary Singer who first gave notice of him. Writing to her sisters from Paris on October 12, 1855, she announced the expected addition to the family party, asking them to "sympathise with us in the pleasure which we trust may be in store for us, though we rejoice with trembling. Mary [her daughter] and I are very busy as you may suppose, getting things in readiness for the little stranger who will bring his love whether he be a little *Frenchman* or *Italian*."[1] Though the baby's place of birth might be uncertain, his grandmother had no doubt as to his sex. She was right. A male child was born to Mary and Fitzwilliam Sargent in Florence, Italy, on January 12, 1856, after a difficult labor.[2]

The happy father wrote to his mother a week after the birth: "The boy is a promising one and has already turned the house upside down—made us change our dinner hour, taken possession of his grandmother's Chamber etc. He has a mountain woman to wet-nurse him and he bids fair to grow well. His grandmother is, of course, quite struck with him and watches his slightest movement very assiduously. You, who have such a weakness for babies, will be also very tickled with him. I hope you will see him some fine day. He is somewhat passionate—perhaps from having been born in Italy—and is now scolding away most tempestuously because his nurse has thought proper to give him his bath prior to allowing him to take his mid-day lunch."[3]

Neither the mountain wet-nurse nor her successors had sufficient milk to satisfy the appetite of the newcomer, and much time was spent in trying to find a woman who could. He was named John for his maternal grandfather. Mary Singer and her daughter wanted a middle name of Sargent derivation, but his father was adamant that he should be called John Singer Sargent, and so he was. At seven months old, the infant Sargent was spending most of the day out of doors in the garden of a Geneva boardinghouse. "He is quite the darling of the whole house," wrote his grandmother, "and last week he had Spanish, German, French, English and Americans—all contending for

Detail of plate 11

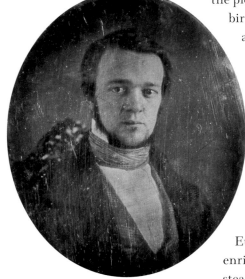

FIG. 8. Dr. Fitzwilliam Sargent,
before 1854. Private collection

the pleasure of caressing him."[4] A year later she wrote from Rome, following the birth of a second grandchild, Emily: "The baby grows nicely and bids fair to be as pretty as her brother. *That* is saying a great deal. For he is quite celebrated for his loveliness, on the Monte Pincio he holds his levée every fine day. I often wish you could see him, he is so sweet."[5]

To Americans of the mid-nineteenth century, mindful of the newness of their country, Europe represented history, tradition, romance and poetry, great art and architecture, in short all those attributes of civilization they were conscious of lacking. Proud of what their country had achieved, they were often critical of lax European habits and mores, but the attraction of the Old World as a fount of wisdom and knowledge, of style and sophistication, proved irresistible. Growing numbers of middle-class Americans braved the dangers of the Atlantic to "do" Europe, returning home better informed, more cultivated, and spiritually enriched. They were assisted by the advent of more efficient and reliable steamships to carry them across the ocean and by a growing network of railways to ease the difficulties of travel on land. A burgeoning industry of travel books and guidebooks advised prospective travelers where to go and what to see. American visitors were by and large exceptionally well informed about Europe before they ever left their native shore. Literature made Europe familiar and accessible as well as lending enchantment to somewhere exotic and far away. In a paradoxical way Europe supplied a deeply felt need for something outside the American experience, while underlining those values that made America unique. American tourists returned home with their innate sense of superiority not only intact but enhanced.[6]

Seen against this background there was nothing exceptional about the decision by Dr. Sargent to take his wife and mother-in-law to Europe. They were a typical middle-class professional couple taking time off to travel. He was a doctor, trained in Philadelphia, who had made a promising start to his career (fig. 8). He was a demonstrator of anatomy at the University of Pennsylvania, from where he had graduated in 1843, attending physician and later surgeon at Wills Hospital in Philadelphia (now Wills Eye Hospital), and the author of several medical books and treatises.[7] His family had been shipowners in Gloucester, Massachusetts, but his father was bankrupted after a series of disastrous ship losses in the 1820s.[8] His wife, Mary Newbold Singer, was descended from mercantile stock on both sides of her family. The Singers had come from Alsace-Lorraine in the early eighteenth century. In a Philadelphia directory of 1791, her grandfather Casper Singer is listed as a grocer. By 1800 her father and uncle, John and Abraham Singer, were listed as merchants at 137 Market Street and by 1825 John is classed as a "gentleman."[9] The Newbolds were also prosperous merchants of old Philadelphia stock.[10] The young couple had married in the Seventh Presbyterian Church, now the Presbyterian Tabernacle Church, on June 2, 1850,[11] when she was twenty-four and he was thirty. A year later their first child, a daughter named Mary Newbold, was born, dying two years later in July 1853, to the deep distress of her parents (fig. 9). It is probable that their journey to Europe was arranged to help Mrs. Sargent recover from this tragic loss.

An inheritance of $10,000 from her father, who had died in 1850, enabled them to contemplate a residence abroad while Dr. Sargent would not be earning.[12] Additional support came in the form of Mary Sargent's widowed mother, Mary Singer, who traveled with them. When she died in Rome in November 1859, she left her only daughter $60,000, enough to give them a decent independence.[13] In 1854 the Sargents set sail for Europe, renting their house at 518 Spruce Street in Philadelphia and Dr. Sargent taking leave of absence from Wills Hospital.

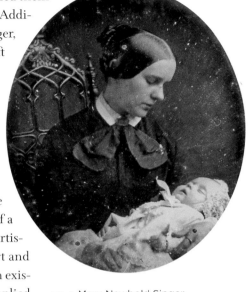

FIG. 9. Mary Newbold Singer Sargent with her daughter Mary Newbold Sargent, c. 1851. Private collection

Travel in Europe that began as an antidote and an adventure gradually became a way of life. The Sargents drifted into it until it became easier to stay than to make the effort to go home. That option was always there in theory, but as time passed there were always reasons for postponing it, and in practice they had burned their bridges long before they realized it. In the case of Mrs. Sargent it is easy to understand why she dreaded the thought of a return to Philadelphia. She was irrepressible and romantic by temperament, artistic and cultivated, restless and wayward. Europe for her spelled not only art and culture, which she loved, but liberation. She was not cut out for the humdrum existence of a middle-class housewife in Philadelphia, with all the restraints implied by such a role. Her ardent spirit craved a wider and more exciting world, and to find it she was prepared to sacrifice family, friends, community, career, and security.

Only a handful of Mrs. Sargent's letters are known in contrast to her husband's extensive surviving correspondence, but those there are convey her enthusiasm and appetite for life. Here she is describing the view from the Pic du Midi de Bigorre, one of the high mountains of the Pyrennean range, after a hazardous ascent in the summer of 1855, when she was already pregnant with Sargent: "It is useless to try to give you an idea of what we saw from it—one side a world of mountains whose snowy peaks we looked *down* upon, instead of gazing up into the blue sky for them as we had done so long, resembling more than anything else, a mighty ocean, whose colossal waves, yet foaming, had been turned into stone by the will of the Creator. On the other hand, the plains of France unrolled themselves like a rich carpet far below us, spreading away into airy distance until they melted into blue sky—a sight of luxuriant beauty never to be forgotten."[14] Only a week after the birth of her son, Mrs. Sargent was relishing the prospect of starting to sightsee in Florence "to my great satisfaction, for it has been a sort of 'fox and grapes' business, this being surrounded with the glories of modern and antique art without the ability to enjoy them." She attended the carnival, where the authorities had permitted masks for the first time in years, "and fun and frolic were the order of the day, among high and low. The Lung Arno is a favourite part of the regular course which the tide of maskers is obliged to follow, and we saw it to perfection, besides being in the procession for one afternoon, baby being not quite three weeks old! I don't know myself."[15]

It is Violet Paget, alias the writer Vernon Lee, who has left the most vivid picture of Mrs. Sargent as the inveterate sightseer and high priestess of the genius of place. In her "memoir" of Sargent, she described being rather scared of the delicate, taciturn, austere Dr. Sargent, "whereas Mrs Sargent, bubbling with sympathies and the need for sympathy, treated everyone as an equal in the expansiveness of her unquenchable youthfulness

and *joie de vivre*."[16] The Pagets, English rather than American expatriates, moved about Europe deliberately seeing nothing and carrying on their lives in one part of the Continent exactly as they did in another. By the strange chemistry of opposites, the two families became friendly, and Violet Paget was exposed to quite new influences. In the preface to her book *The Sentimental Traveller*, she paid tribute to "this most genially imperious, this most wittily courteous, this most wisely fantastic of Wandering Ladies," who asserted "the happiest moment in life was a hotel 'bus—no other, in short, than the enchanting indomitable, incomparable Mrs S–."[17] In the Sargent household, Violet "heard of rides in the Campagna, where you met brigands occasionally, and even the Serpent-in-Chief, about whom I forthwith wrote a story; I heard of excursions—my family never made excursions—to Albano and Frascati, and Horace's Sabine Farm— enchanting name! And beyond this Rome, which seemed to exist for those unlike ourselves, appeared dim outlines of other parts of the world, with magic Alhambras and Temples of Paestum and Alpine Forests; a Europe occupying other dimensions than that network of railways blobbed with hotels and custom-houses across which I was periodically hurried from inventory to inventory."[18]

There was a reverse side to all this energy and joie de vivre. Mrs. Sargent had respiratory problems and she suffered from persistent bouts of bronchitis and chronic sore throats that often kept her in bed for weeks on end. It was largely for her sake that the family spent their winters in southern Europe and attended spas and health resorts in the summer. It has to be said that an obsession with health was common to the people of this period, but in the case of the Sargents it almost amounted to a way of life. They traveled to escape from illness and to search for cures. Health was the single overriding factor that held them in Europe, long after the time had passed for them to return home. Reading Dr. Sargent's interminable catalogue of their ailments, it is surprising to find that they were ever well.

The inducements of health, culture, and freedom, aided by the presence of a private income, were sufficient reasons for Mrs. Sargent to prefer Europe to America. But the case of her husband was very different. He had a promising career as a surgeon ahead of him, and recognition and reputation to look forward to. Why, then, did he sacrifice this on the altar of his wife's ambition and allow a kind of moral collapse to take place? At first, the fiction that he was furthering his career by staying in Europe was carefully nurtured. From Pau, the fashionable resort in the Pyrenees, Mrs. Singer reported home in November 1854 that Dr. Sargent was away in Paris studying "as hard as he can, making the best use of his opportunities, so that he will not at any rate, as he says, be behind his compeers when he gets home."[19] A year later he was in Paris studying once more, and in Vienna in 1857, but by then medicine was slipping from his grasp, as he became absorbed by his family and the exigencies of a life lived constantly on the move. In the spring of 1857 he resigned his place at Wills Hospital. "He is quite convinced that it would not be wise or right to take Mary home at present," wrote Mrs. Singer, "and his prospects of usefulness here are very bright and his services highly appreciated."[20]

The die was cast. Dr. Sargent quietly abandoned his career and his prospects to support the way of life his wife had chosen, and the obsession with health which went

with it, his own included, for he suffered from chronic dyspepsia. There is something lost and melancholy about him, as if his chief reason for existence had evaporated. It can be seen in his photographs, a thin, spare figure with drooping mustache and a forlorn, resigned air. He was not without interests, following political events with a keen eye, and corresponding about them at length with his friend George Bemis. European indifference to the cause of the Union in the American Civil War roused him to write a pamphlet in its defense, which he published at his own expense in English and French.[21] Ambition had deserted him, and he found it easier to fall in with his wife's plans than to assert his right to a career and a home in America. There were moments of regret. "I am tired of this nomadic sort of life," he admitted to his mother in 1870, "the Spring comes and we strike our tents and migrate for the Summer; the Autumn returns, and we must again pack up our duds and be off to some milder region in which Emily and Mary can thrive. I wish there were some prospect of our going home and settling down among our own people and taking permanent root."[22]

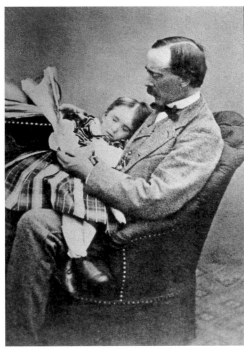

FIG. 10. Dr. Fitzwilliam Sargent with his daughter Mary "Minnie" Winthrop Sargent, c. 1865. Private collection

The Sargents' peripatetic track across Europe was marked by the seasons. The winter was spent in the south, in Florence or Rome or Nice, which were found best for respiratory and throat problems. Spring and autumn they spent traveling, often visiting major cities and resorts in northern Europe. High summer found them in the Alps or the Pyrenees escaping the heat. They lived in rented apartments, which were let furnished, and in lodging houses and hotels. According to Emily Sargent, it was only worth buying your own furniture if you knew you would go back to the same place for three years, and "by that time you have saved the price of the furniture."[23] The Sargents never decided anything more than a few weeks ahead, fixing on winter quarters as the summer came to an end, and only deciding in the spring where to spend the summer. They were not without society, for American and British expatriates followed a herdlike instinct, and there were usually friends to be found in the places where they settled. Familiar names recur in Dr. Sargent's correspondence, the Arthur Bronsons, the Eyres, del Castillos, Wattses, Admiral Case and his wife, and his distant cousins the Austins and Turner Sargents. Mrs. Sargent thrived when there were people about, and it was she who made the social calendar. Her children benefited as well, for it was in expatriate circles that their early friendships were formed. But they could not count on company, and they were often on their own living quietly. Friendship, like everything else about their lives, was temporary and provisional.

Because of his family's isolated and peripatetic existence, Sargent saw far more of his parents than most middle-class children. Nurseries and schoolrooms do not figure in the apartments they rented, nor in the hotels they patronized, and Sargent was educated at home by his father until the age of twelve. Only a year apart in age, Sargent and his sister Emily are invariably mentioned in tandem in Dr. Sargent's letters home. There were to be other additions to the family: Mary "Minnie" Winthrop, born in Nice in 1860, was always ailing and died at Pau in April 1865 (fig. 10);

FIG. 11. John Singer Sargent and his sister Emily, c. 1867. Private collection

Fitzwilliam Winthrop was born at Nice in 1867 and died suddenly and unexpectedly two years later at Kissingen in Germany; and Violet, born like her brother in Florence in 1870, was almost an afterthought, for her mother was by then forty-four. Of the two eldest children, Sargent was strong and healthy, where Emily was frail, succumbing to a spinal disease that left her back permanently deformed.[24] Emily's cheerfulness in adversity was a source of wonder to Dr. Sargent, who thought death might have been preferable to so much suffering. But at the tender age of three, Emily showed those resources of character and fortitude that would sustain her all her life. Her father would later acknowledge the "great fund of happiness" she possessed within herself.[25] Refusing to be prey to despondency or self-pity, she was one of those people who always think more of others than themselves. Her elder brother she adored. Brought up in an environment that threw them together for play, company, and solace, there grew between them a close bond of love and comradeship. The sturdy little boy was protective of his crippled sister, and she in turn gave him her devotion. A photograph of the two of them standing side by side is conventionally posed in a photographer's studio, with a draped curtain and patterned carpet (fig. 11). He, in dark trousers, cutaway jacket, and bow tie, is full face, while she, in full, dark short skirt over white pantaloons and striped stockings and white shirt, is turned slightly to her right. The hair of both is carefully groomed and smoothed down. Sargent's left hand rests limply on his sister's shoulder, but the other grasps her right hand in a gesture expressive of real feeling and affection.

One would like to think that some trace of the bond between brother and sister is to be found in Sargent's pictures of children, but the visual evidence is inconclusive. Sargent's first major essay in the genre is *Edouard and Marie-Louise Pailleron* of 1881 (pl. 20), where the figures of brother and sister appear unrelated to one another, both spatially and psychologically. However, it was a portrait deliberately composed on unconventional lines to satisfy a patron of advanced taste and to make a stir at the Salon. Much more natural is the *Garden Study of the Vickers Children* of 1884 (pl. 23), a picture of a brother and sister posed not unlike Sargent and his sister, though the children here are younger. They both hold a watering can, hand over hand on the upper handle, as they pour its contents into a potted lily. The children were no doubt asked to pose like this, but their intimacy and ease with each other seem unforced. The picture anticipates the theme of *Carnation, Lily, Lily, Rose* (pl. 24),

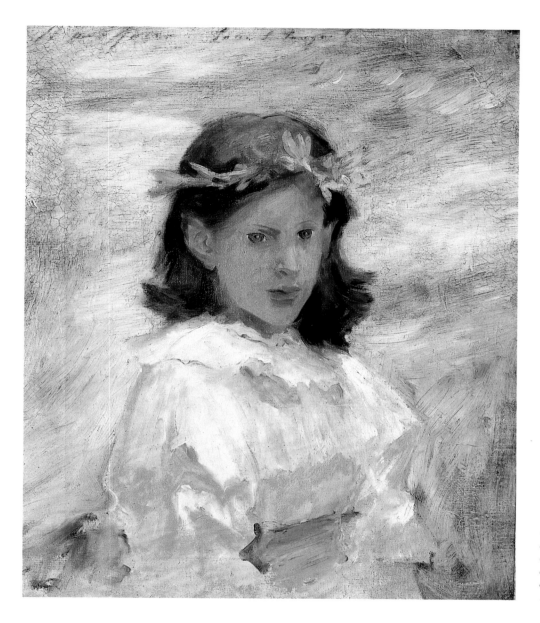

PL. 8. *Teresa Gosse*, 1885, oil on canvas, 24⅛ x 20⅛ in. (61.3 x 51 cm). Private collection. Photograph courtesy of Adelson Galleries, Inc., New York

Sargent's most poetic description of childhood. Two little girls in white are lighting Chinese lanterns at twilight in a garden of enchantment smothered in flowers and tall grasses. The convivial atmosphere generated by the colony of artists and their families in the village of Broadway in the English Cotswolds brought out a rare strain of tenderness in Sargent. He painted some of the children of the colony in images that are idealized and lyrical in mood, like the portrait sketch of Teresa Gosse (pl. 8), daughter of the English poet Edmund Gosse, with flowers in her hair. One of Sargent's most touching studies is a painting—called simply *Village Children* (pl. 9) but surely depicting the children of friends, in smocks and summer hats—which is reminiscent of pictures by Pierre-Auguste Renoir and Mary Cassatt in its warmth and naturalness. Sargent preserves something of the same spirit in his portrait *The Sons*

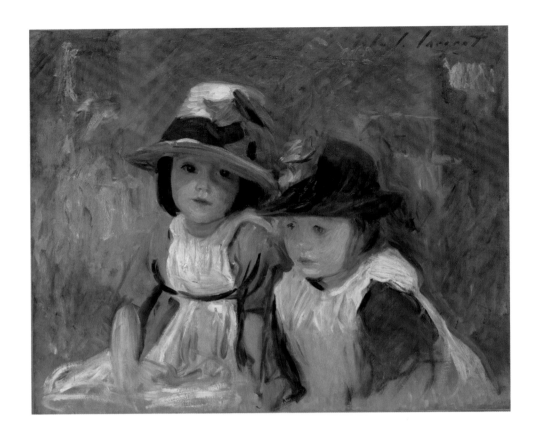

PL. 9. *Village Children*, 1890, oil on canvas, 25 x 30 in. (63.5 x 76.2 cm). Yale University Art Gallery, Edwin Austin Abbey Memorial Collection

of Mrs. Malcolm Forbes (pl. 10), painted at the same period, and more formal in composition.

It is difficult to believe that Sargent carried much memory of his own childhood into such pictures. The imagery here, much of it rural, speaks of harmonious lives and a settled order of things, which was far from his own experience. It may be that the pleasure he took in the family life of his friends in Broadway, the parties and games, picnics and outings, was all the sharper because it represented things that had been denied to him in his own childhood. The only later portrait of siblings that may, in an odd way, reflect on his childhood relationship with Emily is the 1906 portrait of his niece and nephew *Conrad and Reine Ormond* (pl. 11). The difference lies in the look and character of Reine, a striking beauty even at the age of nine, who dominates the portrait in a way that Emily could never have done.

Dr. Sargent had noted signs of a passionate nature in his infant son, and he was probably right to do so. Another observer, the young Mary Crawford, daughter of the American sculptor Thomas Crawford, came up against him when he was three. The Crawfords had an apartment in the same building in Rome as the Sargents, and Mary recalled that Mrs. Singer was dying and that Dr. Sargent treated her (Mary) for recurrent nosebleeds. She recalled Sargent as a "funny baby boy, with bright eyes and a very hot temper. . . . [he] was a pugnacious little fellow, and I got into a dreadful disgrace once for tumbling him over when he wanted to fight Marion [her sister]."[26] Mary Crawford used some of the atmosphere surrounding the death of Mrs. Singer in the opening

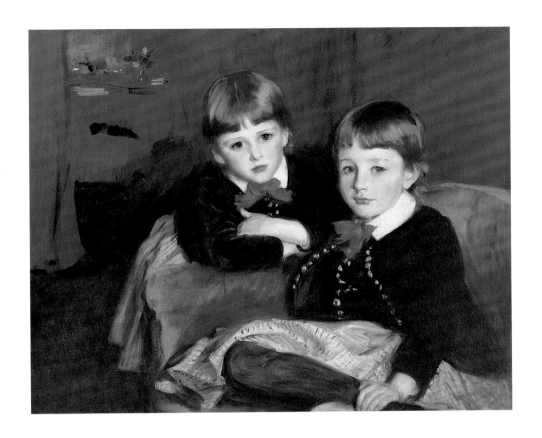

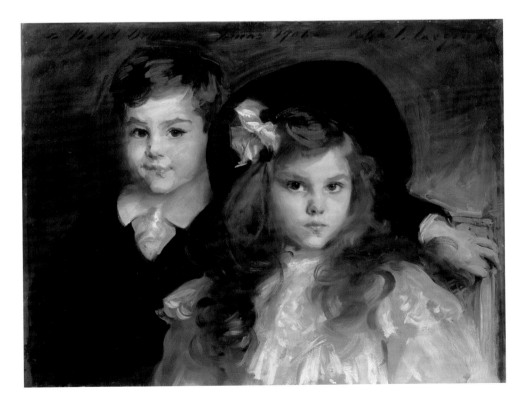

PL. 10. *The Sons of Mrs. Malcolm Forbes*, 1887–88, oil on canvas, 29½ x 35¼ in. (75 x 89.5 cm). Collection of Feyez Sarofim. Photograph courtesy of Adelson Galleries, Inc., New York

PL. 11. *Conrad and Reine Ormond*, 1906, oil on canvas, 23 x 29 in. (58.4 x 73.7 cm). Private collection. Photograph courtesy of Adelson Galleries, Inc., New York

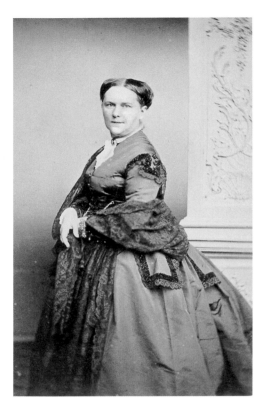

FIG. 12. Mary Newbold Singer Sargent, September 1867. Private collection

pages of her novel *A Little Grey Sheep*.[27] When roused, Sargent could still display that temper and volatility; his biographer Evan Charteris describes his fierce response to two contemporaries who tried to bully him in Florence, at once earning him immunity from persecution, and in a celebrated episode in adulthood he went back to thrash a farmer who had grossly insulted him.[28]

Early on, however, Sargent learned to control his temper and to internalize his feelings. The reserve and shyness from which he suffered all his life must have had something to do with the emotional restraints he experienced at an early age. One can gauge his relationship with his father with a fair degree of accuracy—one of trust and affection. But the key to his emotional life was his mother, and that mercurial force around which the household revolved is difficult to fathom. We know too little about her and her relationship with her children. That she imparted to her son her enthusiasm for art and culture is incontrovertible, but whether she gave him enough love and attention when he was small, as his grandmother had done, is doubtful. One senses that she was too wrapped up in her own feelings and enthusiasms, too bored by domesticity, too preoccupied with her ailments, to be warmly maternal and tender. When writing of her one-year-old son in 1857, she could not help comparing him with the beloved elder daughter who had died: "He is painfully like her to me as he lies asleep in his wicker cart, I sometimes forget time has not stood still with me and that I am looking upon my angel child. Ne'er will the sun arise on such another for me."[29] Significantly, it was Dr. Sargent, and not his wife, who was photographed holding the ailing Minnie (fig. 10). There are no photographs of Mrs. Sargent with her children. Those there are show her as a short, stocky, determined-looking woman, "wonderfully stout, bright and animated," as her husband's cousin Turner Sargent would describe her in 1867 (fig. 12).[30]

There is no evidence of tension or confrontation between Sargent and his mother. He was always a loyal and caring son, and the ties of family meant a great deal to him. But he asserted his independence and made his influence felt early on. Unlike everyone else in the household, he was physically active and robustly healthy. Dr. Sargent had trouble keeping up with his son's appetite for exercise and games. At the age of four, he was attending a gymnasium every other day,[31] at five his father reported that he was "more fond of climbing and kite flying than he is of spelling,"[32] and at eight he was regularly trotted "out for a walk on the hills."[33] His energy, his passion and talent for drawing, and by adolescence the sense that he knew what he wanted and where he was going made him something of a wonder to his aimless, drifting parents. They did not interfere with him where it mattered, and we may infer that in return he did not cause them trouble, nor did he attempt to rebel.

It is tempting to read into Sargent's portraits of mothers and children a commentary on his relationship to his mother, but his images do not reveal obvious signs of strong personal feeling. The relationship of mother and child was an obsessive theme

for many nineteenth-century painters and sculptors, not least because of its association with the religious theme of the Madonna and Child. Raphael's *Madonna della Sedia* (Pitti Palace, Florence) exemplified for many Victorians the perfect fusion of the human and divine. The image of mother and child is to be found not only in the idealized work of academics like William Bouguereau but also in the more intimate paintings of modernists like Mary Cassatt and Berthe Morisot.

Sargent painted few portraits of mothers with babies or very young children. The motif occurs in some of his figure studies of working-class women, like the watercolor of mother and child painted in Venice in the early 1880s (private collection), but it was not a theme to which he was particularly attracted. In his portraits of mothers with older children, he turned his back on conventional paradigms to assert a modern view of the relationship between the two. Mme Besnard cuts the birthday cake for her six-year-old son, in the only birthday scene Sargent ever painted, but the little boy appears oblivious of her and his shadowy father behind as he stares transfixed at the candles in *The Birthday Party* (pl. 2). In the portrait *Mrs. Edward L. Davis and Her Son Livingston Davis* (pl. 34), both figures gaze out at us with singular directness, and we are made to feel the force of two separate personalities. This is reinforced by the deliberate contrast of the mother's black dress and the boy's white sailor suit and large straw hat. Eight-year-old Livingston leans in toward his mother, his arm protectively around her waist, while her arm comes round his shoulder to clasp his hand in a gesture of mutual trust and affection. There is no evidence to suggest that Sargent identified his subjects with himself and his mother. The stiff way that Sargent holds himself in the early photograph of him with his sister Emily (fig. 11) is quite different from the fluid pose and mobile features of Livingston Davis.

Sargent's slightly later group *Mrs. Carl Meyer and Her Children* (pl. 81) appears to relegate the children to a minor supporting role and to emphasize the dominance of the mother at their expense. The expansive figure of Mrs. Meyer fills most of the picture space, and a purely psychological reading of the painting might indicate that she is a distant and uncaring parent, and that Sargent is reaching into his own past experience to chart the emotional as well as physical gap that separates her from her offspring. In fact, the children register quite strongly by occupying an area of space separate from that of their mother. The figure composition is deliberately fragmented, and then joined up by the curving back of the sofa and by Mrs. Meyer's outflung arm and hand reaching up to hold her son's hand in a delicate gesture of love and attachment, every bit as expressive as the interlinked hands of Mrs. Davis and Livingston.

The portrait *Sir George Sitwell, Lady Ida Sitwell, and Family* (pl. 51) offers little scope for interpreting the mother-child relationship, because the mother in this case appears isolated in the center of the composition. It is left to Sir George to express parental solicitude by putting an arm around the shoulders of his daughter Edith, while his two young sons, Osbert and Sacheverell, play together by themselves. The written record tells about the animosities and hostilities within the family circle. While surely intending no deliberate satire, Sargent could not escape the irony of charting such separate and dysfunctional lives.

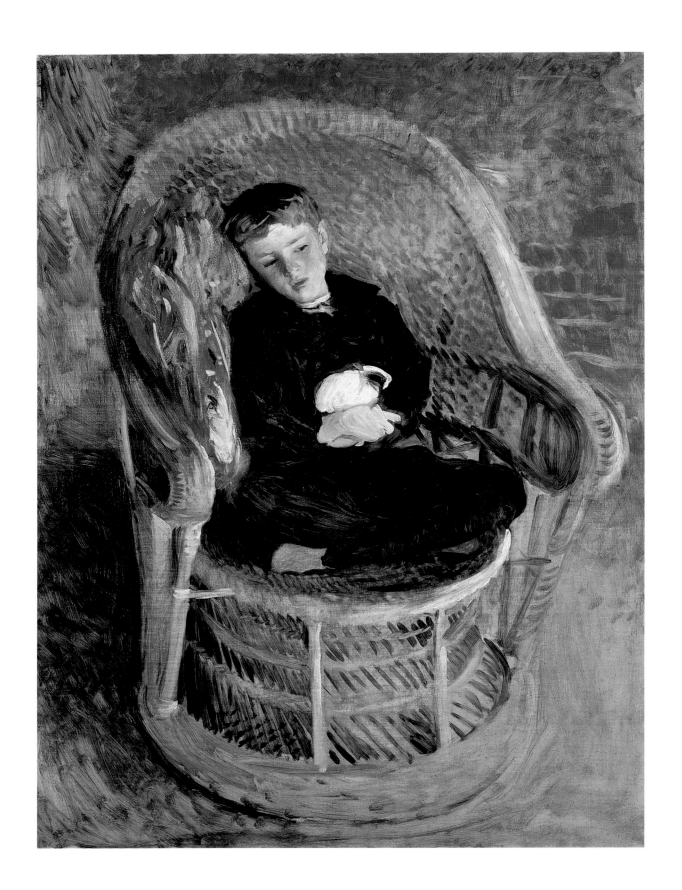

have to be 'let out' and lengthened once a month. He is studying very well and his teacher says he is quite satisfied with him."[50]

Building on this foundation, Dr. Sargent decided it was time for his son to be subjected to a more rigorous academic discipline. The family moved to Dresden in November 1871 so that Sargent could prepare for the entrance examination to the prestigious Gymnasium zum Heilige Kreuze. Illness in the family, including a mild bout of typhoid suffered by Sargent, canceled dreams of a German education, and the next winter they scuttled back to the safety and mild climate of Florence. Joseph Domengé had retired, and whether a replacement school was found is not recorded. By 1870, when Sargent was fourteen, there was less urgency about his education. His ambition to be an artist had overcome whatever scruples Dr. Sargent may have harbored as to his future career. Lee suggests that this was a bitter pill for him to have to swallow, as he had wanted his son to join the U.S. Navy, but there is no evidence of this in his letters. In October 1870 he wrote to his mother from Florence: "My boy John seems to have a strong desire to be an Artist by profession, a painter, and he shows so much evidence of talent in that direction, and taken so much pleasure in cultivating it, that we have concluded to gratify him and to keep this plan in view in his studies."[51]

Meeting Sargent in Bologna in September 1872, Lee described him as "a tall, slack, growing youth with as yet no sign of the later spick-and-span man-of-the-world appearance."[52] They spent ten days wandering through the medieval arcades of the city by moonlight, making up a "fantastic past" as they went along; they pored over prints and unreadable scores in the Music School surrounded by the portraits of forgotten eighteenth-century composers whom Lee would bring to life in her pioneering *Studies of the Eighteenth Century in Italy* (London, 1880), and they engaged in long discussions on literature and the arts: "The words 'strange, weird, fantastic' were already on his lips—and that adjective *curious*, pronounced with a long and somehow aspirated *u*, accompanied by a particular expression half of wonder and half of self-irony."[53] Here in adolescence, then, began that long love affair with things exotic, mysterious, out-of-the-way, and far-fetched that would inspire so much of what is most original in his art.

We do not know the influences bearing on Sargent's imagination at this moment of intellectual and emotional development, but a love of the bizarre and fantastic fits with a character wary of intimacy and self-revelation. It was one way of allowing Sargent to express his deeper feelings. It also goes with an isolated and precocious upbringing spent surveying things fabulous and extraordinary across the length and breadth of Europe. And it was encouraged by a wide reading of European literature, especially contemporary fiction.

The strained and mysterious figure scenes that Sargent painted during his early years in Paris reflect sophisticated French influences in both literature and art, but they also have their roots further back in his adolescence. It is, perhaps, no accident that the most haunting of all his early portraits, *The Daughters of Edward Darley Boit* (pl. 21), should have been a picture of children. Here Sargent opens a door on the intense inner life of four girls at different ages, and the web of relationships between them as a family group and between them and their absent parents. They might be characters from a

PL. 12 (OPPOSITE). *Gordon Fairchild*, 1890, oil on canvas, 53½ x 39⅜ in. (135.9 x 100 cm). Private collection. Photograph courtesy of Adelson Galleries, Inc., New York

Henry James novel, *What Maisie Knew* or *The Turn of the Screw*, so subtle and charged is individual characterization, so mysterious and even menacing the sparse, dark space they inhabit. James unsurprisingly included a brilliant critique of the portrait in his early essay on Sargent, and recent scholars have written eloquently about the individual poses of the figures, the stages of growing up they represent, Sargent's psychological reading of character, and the ambiguous structure of the space.[54] What makes the picture such a great work of art is the blending of the visual and imaginative elements within the materials of the paint itself. We see the room and feel its atmosphere, almost as if we are part of the scene unfolding before us. By 1882 Sargent had acquired the skills to turn his adolescent passion for things strange and weird into the stuff of great art.

The two older girls in *The Daughters of Edward Darley Boit* are set back within the darkness of the room's extension. The eldest, Florence, then fourteen, is shown leaning against one of the two huge Chinese vases that frame the inner niche, her face lost in shadow. We sense her adolescent moodiness and frustration from the listless, casual way she stands, in contrast to the demure attitude of her more compliant sister, Jane, who is two years younger. Sargent's sensitivity to the complexities, intensities, and uncertainties of adolescence, especially of females, is a marked feature of his portraiture. He had the example of his sisters to draw on, but there must have been things in his own past that gave him insight into the feelings and behavior of teenage girls. They can be bold and assertive like Beatrice Townsend (pl. 18) or the Honourable Victoria Stanley (pl. 46), but more commonly they are represented in moments of introspection and self-absorption, like Suzanne Poirson, the thirteen-year-old daughter of his Paris landlord (pl. 13), whose pinned-up hair, rouged lips, and fur coat belie her youth; or startled, awkward Sally Fairchild (Dr. Herbert and Elizabeth Sussman); or wishful, pensive Alice Shepard (pl. 32), another thirteen-year-old. Sargent was especially acute in charting that difficult and impressionable age between childhood and adulthood, with its conflicting pressures, restraints, expectations, and hopes. When he moved down from the upper classes to paint teenage working-class models, from Mediterranean communities, he was free to express their sultry sexuality, passion, and rebelliousness. Sargent's southern models, like Rosina Ferarra (pl. 77) and Carmela Bertagna (pl. 78), are powerfully charged and sensual characters who present a contrary vision of how young women feel and behave to their genteel counterparts. It was one that appealed to Sargent because it was unconventional, uninhibited, and exotic. We are back again to that imaginative strand of fantasy and sensation he had cultivated during adolescence, and which influenced so much of his subsequent art.

Sargent's passion for painting was marked by a deep knowledge and reverence for the art of the past, exceptional in one so young, even if he was cosmopolitan and well traveled. How many seventeen-year-olds would show such sensitivity to Greek sculpture and Renaissance painting as Sargent did in a letter to Vernon Lee of 1873: "In these Greek heads I so much admire the splendid cheek, the beautiful transitions of the cheek into the chin and the line of the jaw, and the straight oblique line of the hair. The cheek and chin are of exquisite beauty in Tintoretto's heads of a woman, those beautiful combinations of snowy skin, golden braided hair, and strings of pearls."[55] At that date

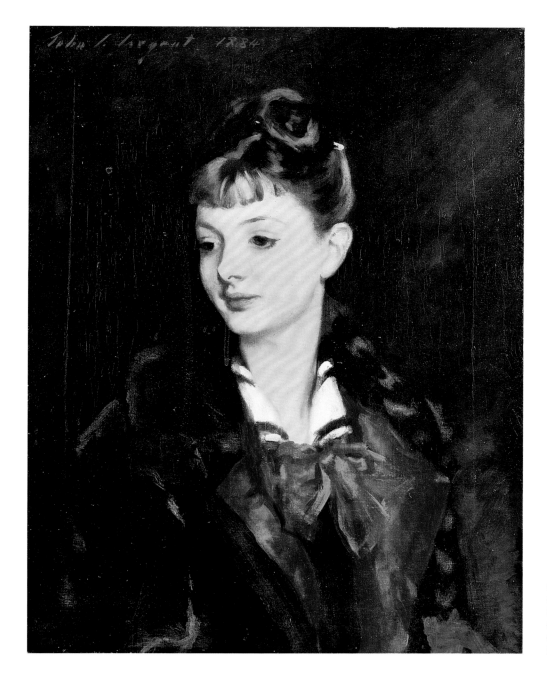

PL. 13. *Suzanne Poirson*, 1884, oil on canvas, 24¼ x 19¼ in. (61.6 x 48.9 cm). Private collection. Photograph courtesy of Adelson Galleries, Inc., New York

Tintoretto was still an acquired taste, in spite of Ruskin's championship of him, but Sargent was instinctively attracted by the intensity and waywardness of the Venetian painter's work, which he would absorb into his own. Here he is again enthusing on Tintoretto to his cousin, Mrs. Austin, in a letter of 1874:

> Since seeing that picture, I have learned in Venice to admire Tintoretto immensely and to consider him perhaps second only to Michael Angelo and Titian, whose beauties it was his aim to unite. If my artistic cousin

NOTES

ACKNOWLEDGMENTS
This essay was written during my year as the Samuel H. Kress Professor at the Center for Advanced Studies in the Visual Arts, at the National Gallery of Art, Washington, D.C. (2001–2). I am grateful to the Trustees of the Kress Foundation and the Trustees of the National Gallery of Art for their support of my research work. I must also record my thanks to Warren Adelson, the patron of the John Singer Sargent Catalogue Raisonné Project, my co-author Elaine Kilmurray, and Elizabeth Oustinoff.

ABBREVIATIONS
FWS-B Letters of Dr. Fitzwilliam Sargent to George Bemis, Massachusetts Historical Society, Boston
FWS-F Letters of Dr. Fitzwilliam Sargent to members of his family, and a few from his wife, Mary Newbold Sargent, Archives of American Art, Smithsonian Institution, Washington, D.C.
MNS Letters from Mary Newbold Singer to members of her family, and two from her daughter, Mary Newbold Sargent, private collection

1. MNS, October 12, 1855.
2. There is some confusion about the exact date of Sargent's birth, as no official documents have been traced. In a letter of January 17, 1871, Dr. Sargent wrote that his son's birthday was on January 10, but he admitted that he had a "wretched" memory (FWS-F). The same date is given in *Epes Sargent of Gloucester and His Descendants*, arranged by Emma Worcester Sargent (Boston and New York: Houghton Mifflin, 1923), 87. However, the date when Sargent and his family celebrated his birthday was January 12. See Stanley Olson, *John Singer Sargent* (London and New York: Macmillan, 1986), 2n.
3. FWS-F, January 19, 1856.
4. MNS, July 2, 1856.
5. MNS, spring 1857.
6. See William W. Stowe, *Going Abroad: European Travel in Nineteenth Century American Culture* (Princeton, N.J.: Princeton University Press, 1994), with extensive bibliography. See John Pemble, *The Mediterranean Passion: Victorians and Edwardians in the South* (Oxford: Clarendon, 1987), for the parallel British experience.
7. For details of Dr. Sargent's medical career in Philadelphia, see William Campbell Posey and Samuel Horton Brown, *The Wills Hospital of Philadelphia* (Philadelphia: J. B. Lippincott, 1931), 74–76; and *The Annual of Washington and Jefferson College* (Washington, Pa., 1890), 223–24. Dr. Sargent edited *The Principles and Practices of Modern Surgery* by Robert Druitt (Philadelphia: Lea and Blanchard, 1848); wrote the manual *On Bandaging and Other Operations of Minor Surgery* (Philadelphia: Lea and Blanchard, 1848), illustrated with his own drawings, which went through six editions; and contributed various articles to the *American Journal of the Medical Sciences*. A full bibliography is given in *Epes Sargent*, "Bibliography," 34–35.
8. See *Epes Sargent*, 78–79.
9. For the Singers, see *Colonial and Revolutionary Families of Pennsylvania*, ed. John W. Jordan (Baltimore: Genealogical Publishing, 1911), vol. 1, 592–600; *Epes Sargent*, 84–85 n. 1; and Philadelphia directories of the early nineteenth century (a good collection of these is held by the Historical Society of Pennsylvania, Philadelphia).
10. For the Newbolds, see *Colonial and Revolutionary Families of Pennsylvania*, ed. Wilfred Jordan (New York: Lewis Historical Publishing, 1939), vol. 8, 400–408; and *Epes Sargent*, 85 n. 1.
11. See Presbyterian Archives, Philadelphia, V/M146/P537r, Seventh Presbyterian Church records of communicants, baptisms and marriages, dimissions, deaths, 1843–69, Record Book B, "Records of Communicants, Baptisms and Marriages in Penn Square Presbyterian Church, Philadelphia, PA." Dr. Sargent was baptized on October 2, 1853, and he and his wife were admitted as communicants on the same day. I am grateful to the genealogist Susan S. Koelble for these details.
12. John Singer's will is held by the Philadelphia Register of Wills Archives, will no. 11 for 1851.
13. Mary Newbold's will, drafted in Rome, is held by the Philadelphia Register of Wills Archives, will no. 198 for 1860.
14. MNS, September 27, 1855.
15. MNS, February 20, 1856.
16. Vernon Lee, "J. S. S. in Memoriam," in Evan Charteris, *John Sargent* (London and New York: Charles Scribner's Sons, 1927), 237, 240.
17. Vernon Lee, *The Sentimental Traveller, Notes on Places* (London: J. Lane, 1908), 11.
18. Lee, *The Sentimental Traveller*, 13–14.
19. MNS, November 20, 1854.
20. MNS, spring 1857.
21. Dr Fitzwilliam Sargent, *England, the United States and the Southern Confederacy* (London: S. Low, Son & Co., 1863).
22. FWS-F, October 10, 1870.
23. Emily Sargent to Violet Paget, May 23, 1880, private collection.
24. See Olson, *John Singer Sargent*, 4. In 1861 Dr. Sargent contrived a little platform with springs to carry Emily's bed while traveling, but the following year London surgeons told him that confining his daughter to bed for three years had been a mistake, resulting in atrophy of the muscles. Emily began to walk again but needed corrective surgery on one of her heels, which had contracted because of inactivity. A photograph of her lying on the spring platform survives, private collection.

25. FWS-F, May 20, 1871.

26. Mrs. Hugh Fraser, *A Diplomatist's Wife in Many Lands* (London: Hutchinson & Co., 1911), vol. 1, 142.

27. Published London, 1901. The novel opens by describing the reaction of two young boys to the sight of their dying grandmother.

28. Charteris, *John Sargent*, 119–20.

29. MNS, February 20, 1856.

30. FWS-B, April 27, 1871.

31. FWS-F, December 18, 1860.

32. FWS-F, September 16, 1861.

33. Letter of c. 1863–64, quoted in Charteris, *John Sargent*, 4.

34. FWS-F, May 12, 1863.

35. Letter of c. 1863–64, quoted in Charteris, *John Sargent*, 5.

36. Letter of c. 1863–64, quoted in Charteris, *John Sargent*, 5.

37. FWS-F, January 29, 1864.

38. FWS-F, October 30, 1867.

39. Mary Hale, "The Sargent I Knew," *World Today* 50 (1927), 565.

40. Don Rafael Nuñez del Castillo was a naturalized American of Spanish-Cuban descent, who settled in San Remo on the Italian Riviera. His son Benjamin was one of Sargent's oldest and closest friends. The artist painted portraits of Don Rafael (1894, untraced) and of Ben's wife, Laura Spinola (1903, private collection).

41. See Sargent's letters to Ben del Castillo of May 18, June 22, and October 13, 1865, quoted in Charteris, *John Sargent*, 6–9.

42. Lee, in Charteris, *John Sargent*, 240.

43. Lee, in Charteris, *John Sargent*, 241–44.

44. There are ten early sketchbooks in the Fogg Art Museum, Cambridge, Mass., dating from 1868–72, mostly of Alpine subjects, nos. 1937.7.1–9 and 12. There are three sketchbooks in the Metropolitan Museum of Art, New York, dating from 1869 and 1870 (2), nos. 50.130.146–48, for which see Stephanie Herdrich and H. Barbara Weinberg, *American Drawings and Watercolors in the Metropolitan Museum of Art, John Singer Sargent* (New York: Metropolitan Museum of Art, 2000), 49–63, 65–69, nos. 9, 16–17. Both museums hold single sheets in pencil and watercolor.

45. Hale, "The Sargent I Knew," 566.

46. Private collection. Two sketchbooks of Mary Newbold Sargent are in the Metropolitan Museum of Art, New York.

47. According to Charteris, *John Sargent*, 10, Sargent worked in the studio of Welsch in Rome during the winter of 1868–69. He is almost certainly the "Germanic-American Artist of reputation," referred to by Dr. Sargent, who took Sargent on a sketching tour of the Tyrol in August 1871; see FSW-F, May 20 and August 11, 1871, and Olson, *John Singer Sargent*, 21–22.

48. FWS-F, May 10, 1869.

49. Letter of April 23, 1870, private collection.

50. FWS-F, January 1871.

51. FWS-F, October 10, 1870.

52. Lee, in Charteris, *John Sargent*, 248.

53. Lee, in Charteris, *John Sargent*, 249.

54. Henry James's essay "John S. Sargent" was published in *Harper's New Monthly Magazine* 75 (1887); see 684, 688–89. For recent critiques, see David M. Lubin, *Act of Portrayal: Eakins, Sargent, James* (New Haven and London: Yale University Press, 1985), 83–122; and Susan Sidlauskas, *Body, Place, and Self in Nineteenth-Century Painting* (Cambridge: Cambridge University Press, 2000), chap. 3, "John Singer Sargent's Interior Abysses: *The Daughters of Edward Darley Boit*," 61–90.

55. Letter of August 12, 1873, Vernon Lee Papers, Colby College Library, Waterville, Maine.

56. Letter of March 2, 1874, quoted in Charteris, *John Sargent*, 18–19.

57. See Bronzino's portrait *A Young Woman and Her Little Boy* in the National Gallery of Art, Washington, D.C., where the gesture of the mother's encircling arm and the clasped hands is similar. The picture was then in a private Paris collection and Sargent may have seen it there.

58. Walter Launt Palmer's diary entry for November 16, 1873, quoted in Maybelle Mann, *Walter Launt Palmer. Poetic Reality* (Exton, Pa.: Schiffer, 1984), 12.

59. Letter of April 25, 1874, quoted in Charteris, *John Sargent*, 19–20.

60. Letter of April 22, 1876, Vernon Lee Papers, Colby College Library, Waterville, Maine.

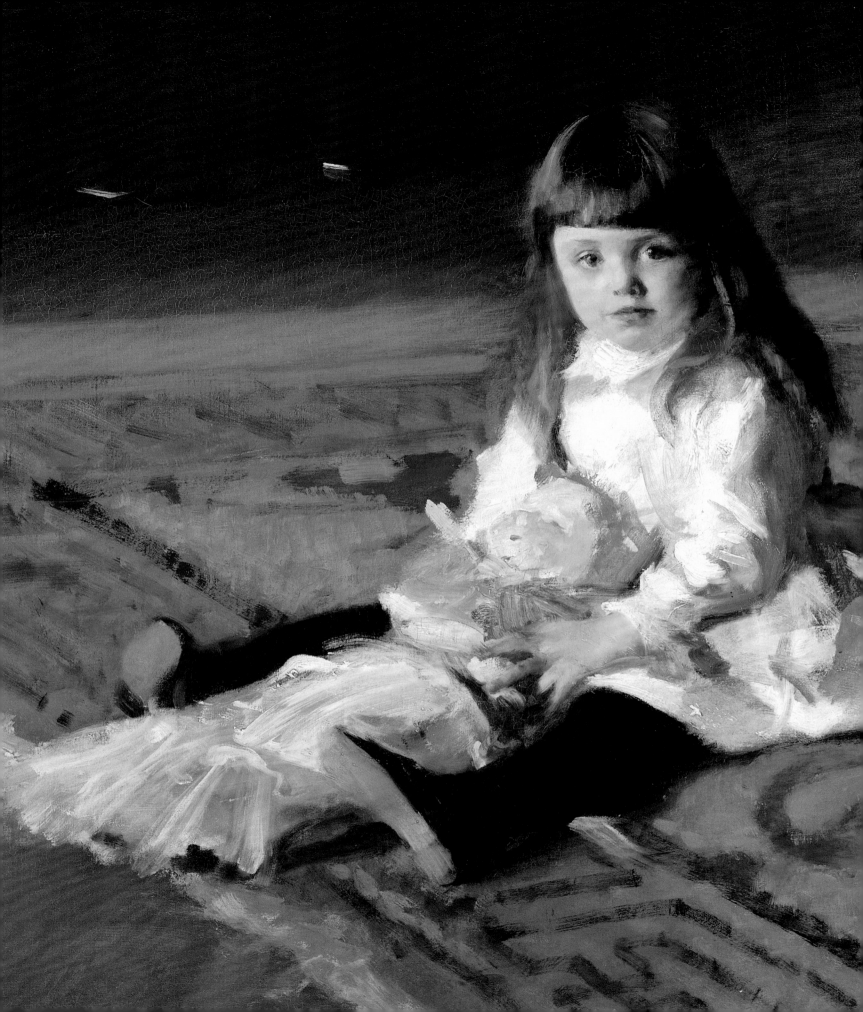

From Souvenir to High Art

Childhood on Display

BARBARA DAYER GALLATI

John Singer Sargent's early attentiveness to the fine points of calculating which of his paintings would achieve the best result for him at specific venues has recently been submitted to detailed and valuable study.[1] And, although the case has been made for Sargent's prowess as a careful career strategist, a closer look at the patterns of his early exhibition activity reveals that images of childhood played decisive roles in establishing him as a major artist in the United States, France, and England. By 1892 the American art critic Mariana G. Van Rensselaer could confidently state, "It is one of Mr. Sargent's greatest distinctions that he never fails of entire success when he has a child before him."[2] Moreover, as will be shown here, Sargent's tactical placement of his child subjects for display at major venues continued well into the twentieth century. In outlining the patterns of this history, this chapter also reveals the ways in which Sargent's depictions of children corresponded to the new cultural formations of childhood and resuscitated child imagery from the smothering effects of Victorian sentimentality.

THE UNITED STATES

Sargent's 1879 debut at the influential National Academy of Design in New York (NAD) consisted of a single canvas, *Neapolitan Children Bathing* (pl. 14). The painting is irresistible because of its winning combination of brilliant color, radiant light, varied brushwork, and enchanting little boys. Sargent seems to have focused for a time on the

Detail of plate 21

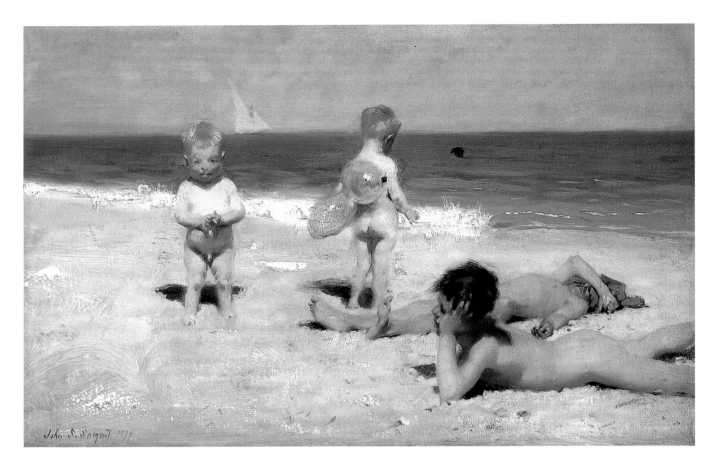

PL. 14. *Neapolitan Children Bathing*, 1879, oil on canvas, 10½ x 16¼ in. (26.8 x 41.2 cm). Sterling and Francine Clark Art Institute, Williamstown, Massachusetts, 1955.852

PL. 15 (OPPOSITE, TOP). *A Summer Idyll*, c. 1878, 12¾ x 16 in. (32.4 x 40.6 cm). Brooklyn Museum, John B. Woodward Memorial Fund, 14.558

PL. 16 (OPPOSITE, BOTTOM). *Beach at Capri*, 1878, oil on panel, 10¼ x 13¾ in. (26 x 34.9 cm). Fine Arts Museums of San Francisco, Bequest of Frederick J. Hellman to the California Palace of the Legion of Honor, 1965.32

theme, possibly because it offered one avenue in the smooth transition from studio to plein-air productions. Comparing *A Summer Idyll* (pl. 15), a fanciful studio canvas displaying three rather Puckish, pipe-playing nude boys lounging in a landscape, with *Neapolitan Children Bathing* and a related panel, *Beach at Capri* (pl. 16), supports this conclusion. In retrospect, the small *Neapolitan Children Bathing* was an odd choice to introduce the art of a young, foreign-born, foreign-trained American painter at the most powerful and conservative art institution in the United States. Most of Sargent's critical notices assured the American audience that "the feeling of luminous atmospheric glow expressed in this picture gives it a transparency and sparkle that is very remarkable, even among the dazzling productions of this young American exponent of the French school of light."[3] Many critics deemed the treatment of the little boys even more praiseworthy. The reviewer for the *New York Herald*, for example, found the painting "superb in its decorative Italian color" and concluded, "The pose of the two older boys lying on the sand is well taken, and what could be more inimitable than the fat little fellow, with his face turned to us, who timidly paws the air with a swimming stroke?"[4]

Sargent's 1879 appearance at the NAD coincided with a crucial moment in the history of the organization. The academicians were under threat from the newly formed Society of American Artists (SAA), whose initial 1878 foray into the business of

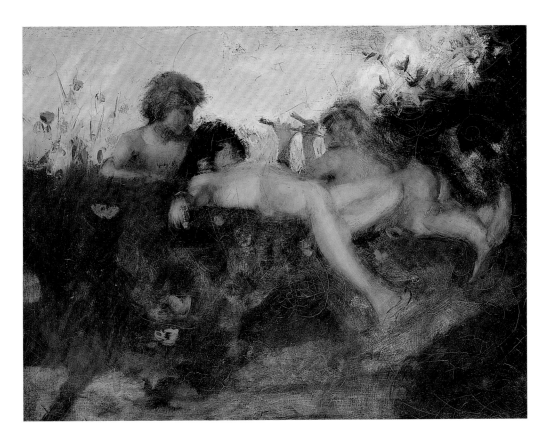

The painting's popularity notwithstanding, some negative remarks were aimed at Guy's technique: his surfaces were too smooth, his light too scientific. Nevertheless, even *A Bedtime Story*'s harshest critic determined that the "only thing that helps save the work is the faces of the children, in which a sweet infant vacuity is well given."[9] A corresponding attitude among many American critics can be detected for, putting stylistic questions aside, a work could be forgiven its technical deficiencies if the children were appealing and the narrative wholesome. An exception to this general critical attitude is found in the commentary directed at Sanford Robinson Gifford's *The Seashore* (unlocated), a painting that suffered in the eyes of one writer who claimed that "[t]he introduction of the nude figures of the boys in the surf is much to be regretted, as it gives a decided element of vulgarity to an otherwise very satisfactory work."[10] *Neapolitan Children Bathing* triumphed over its closest competitors. Its small scale excused its sketchy facture and the child subjects endeared it to the critics, who built a subtext of aesthetic simplicity and unpretentiousness on the foundation of innocent childhood play. (This last factor probably accounts for the painting's later designations as *Innocence Abroad* and *Innocents Abroad*.[11]) Where Gifford's nude boys in the surf were judged vulgar, Sargent's boys escaped such reproach; they functioned as enchanting souvenirs of European travel, "young cupids" "seen of a blazing July day from the window of a train to Castellamare."[12]

The painting's bright atmospheric palette worked to Sargent's benefit by setting his work apart from that of Munich-trained artists (among them William Merritt Chase, Walter Shirlaw, and Frank Duveneck), all of whom were criticized for their controversial bravura style that was characterized by one reviewer as "incompleteness for the sake of supposed vigor."[13] Sargent could hardly have predicted the force of the coming political battles over the power wielded by Munich-trained artists in New York, but *Neapolitan Children Bathing* served him well by separating him from the Munich faction and simultaneously positioning him, unscathed, as one of the "new men" of great promise. This, combined with the by-product of association with Italian art—Sargent's Capri and Naples paintings often prompted critics to mention the art of the Italian painter Francesco Paolo Michetti (1851–1929)—absolved the young painter from relying too closely on any one school of painting.

Despite the unqualified success of *Neapolitan Children Bathing*, Sargent refrained from exhibiting at the NAD again until 1888. The relatively few paintings he sent to the United States at the inception of his career declare his European training and residence and were distributed for display among the SAA and venues in Boston and Philadelphia. Obviously selected to demonstrate the breadth of his interests and talents, this group of paintings included a portrait of a child, *Beatrix Chapman* (destroyed during World War II), and the exquisite profile portrait *Head of Ana-Capri Girl* (pl. 77), both of which amply indicate that Sargent deemed childhood and youth worthy of his brush and important markers of his skill.[14]

Sargent's reputation in Paris as the star pupil of Carolus-Duran (born Charles Auguste Emile Durant, 1837–1917) was already firmly in place at the time of his 1879 debut at the NAD. He had entered the French master's atelier in 1874 and remained under his tutelage until the winter of 1878–79 (although he had already embarked on the transition from student to independent professional in 1877, with his first exhibit at the Paris Salon).[15] In 1879, the year of his official separation from Carolus-Duran's formal instruction, Sargent marked the occasion with the Salon showing of the now-famous portrait of his teacher (Clark Art Institute, Williamstown, Mass.), which resulted in a spate of positive reviews, the award of an honorable mention, and, according to his father, six commissions.[16]

Sargent's portrait of seven-year-old Robert de Cévrieux (pl. 17), a work inscribed "1879" but having no exhibition history during the artist's lifetime, is believed to be one of the commissions to which the painter's father had proudly referred. Although nothing is known of the circumstances of the commission or of the sitter's life, the full-length though less-than-life-size portrait of the little boy and his pet terrier reveals volumes about Sargent's art and its relationship to that of Carolus-Duran at this stage in his career. When it is juxtaposed with Carolus-Duran's 1871 portrait of the young Hector Brame (fig. 16), Sargent's *Robert de Cévrieux* confirms the influence of Carolus's training and vision: the depiction of the well-dressed boys in a full-length format, the prosaic curtained backdrop, the absence of furniture and decorative objects, the use of a few accessories for added visual and symbolic interest, and consonant painting techniques, all prove Sargent's reliance on Carolus's example. To find such similarities is not surprising. Carolus-Duran held a position of high esteem in the international art milieu, and Sargent's bid for a berth in that same sphere initially benefited from his association with his master. Conversely, no young artist of Sargent's ambition would want to be perceived as a perpetual student, and in that connection it is worth searching for differences that document the gradual separation that Sargent forged between his art and Carolus's in the late 1870s and early 1880s.

The differences hinge on matters of degree and are revealed primarily in the liveliness of Sargent's portrayal of the youngster that gives the impression of an individual personality. Carolus-Duran's Hector Brame (and, for that matter, all of his child sitters) appears to be both physically and psychically frozen into a mold of unchildlike reserve (a characteristic that generally defines nineteenth-century academic child portraiture in France). Sargent, however, endowed his subject with a semblance of motion that is achieved by the shift of weight required to counterbalance the wriggling terrier. The resulting hint of torsion introduces a slight diagonal line to the boy's body, thus enlivening the composition and child. Equally energizing is the spark of emotion playing across the youngster's face: it suggests his struggle for composure as he tries simultaneously to manage his dog and pose for his portrait. The portrait depends on the standard practice of depicting children with domestic animals, a

FIG. 16. Carolus-Duran (French, 1837–1917), *Hector Brame*, 1871. Private collection, Courtesy Brame & Lorenceau, Paris

PL. 17 (OPPOSITE). *Robert de Cévrieux*, 1879, oil on canvas, 33¼ x 18⅞ in. (84.5 x 47.9 cm). Museum of Fine Arts, Boston. The Hayden Collection—Charles Henry Hayden Fund, 22.372. Photograph © 2003 Museum of Fine Arts, Boston

device (used frequently by Carolus-Duran) that linked the concept of the unspoiled human state with natural animal instinct. The motif also commonly carried the meaning that children, like pets, require training to function appropriately in society. However, the faint tensions of physical and mental exertion visible in *Robert de Cévrieux* heighten our experience of him as a unique personality and bring to mind the child's growing mastery of his own behavior and his mastery over his pet. In this way Sargent broke the equation of child and animal life and subtly inscribed the image with an aura of energetic self-determination.

The striking portrait of Beatrice Townsend (pl. 18), the daughter of family friends of long standing, demonstrates Sargent's continued reordering of the child-animal motif. The girl is shown full-face, addressing the viewer with a level gaze. The slightly more than half-length format provides just enough information for the imagination to complete an eccentric and dynamic contrapposto pose; Beatrice's left hip juts out sharply and her right knee bends outward as she adjusts her weight against that of the dog she clutches easily to her side, her long, graceful fingers enfolding its paws to keep it contained. Beatrice governs the dog in the same way she seems to preside over her audience. Self-possessed and assured, she is a picture unto herself, requiring no cozy surroundings or sentimentalizing accessories for personal completion. Taking his inspiration from the canvases of Velázquez that he so admired, Sargent transformed Beatrice into a modern Infanta dressed in the rich blacks, whites, and coral reds of royalty and conveyed her with painterly flair and sophistication reminiscent of the Spanish master's.

Sargent's early Paris commissions included portraits of several other children, all of which may be considered relatively minor endeavors when compared with the full-length *Robert de Cévrieux*. Among them is the portrait of the solemn little Jeanne Kieffer (pl. 19), whose limpid, unswerving gaze draws the viewer's eye first to her solidly modeled face that seems to float against a ground into which the rest of her body merges.[17] This melting effect lends a transitory quality to the image, creating a visual parallel to the notion of the fleeting nature of childhood. The painting is, indeed, a souvenir in that it is a reminder that the child Sargent painted would soon be physically transformed into yet a new version of herself. The unfinished character of this painting (and others of this type in Sargent's oeuvre) may be read as a minor convention. Carolus-Duran's 1885 profile portrait of Prince Michael Orsini (fig. 17) employs a similar tactic, suggesting that the underlying aesthetic of these "souvenir" child portraits meshed with practical considerations aimed at preserving the look of the child's features while acknowledging their impermanence. Such portraits were not as a rule shown publicly, a fact that seems to have as much to do with their intimacy as it does with the politics of exhibiting larger, more imposing works that would command attention in public exhibition galleries.

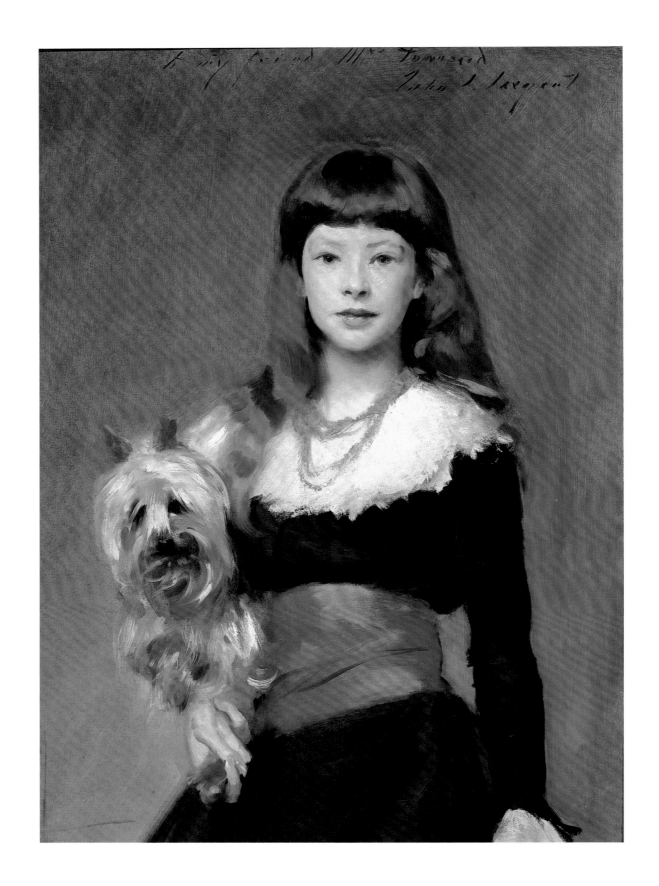

In contrast to such private works, *Edouard and Marie-Louise Pailleron* (pl. 20), a large double portrait displayed at the 1881 Paris Salon, powerfully demonstrates the complex range of Sargent's strategy of self-advancement. Implementing his increasingly daring aesthetics, he portrayed these child subjects in terms of high drama. The sitters, Edouard and Marie-Louise, were the children of Edouard Pailleron (1834–1899), a well-known Parisian essayist and playwright who had commissioned Sargent to paint his portrait (Musée des châteaux de Versailles et de Trianon, on loan to the Musée d'Orsay, Paris) and that of his wife (pl. 64) in 1879. The latter work and *Fumée d'ambre gris* (Clark Art Institute, Williamstown, Mass.) represented Sargent at the Salon of 1880, a pairing that explicitly established the young artist as a painter of the rarefied and exotic.[18] As one writer put it, Sargent's portrait of Madame Pailleron was "a bit strange in taste," yet it charmed him because it was reminiscent of the poetry of Charles Baudelaire.[19]

When *Edouard and Marie-Louise Pailleron* was introduced at the Salon as *Portrait de M. E.P. et de Mlle L.P.* the following year, it received mixed reviews. Because of

PL. 18 (OPPOSITE). *Beatrice Townsend*, 1881 or 1882, oil on canvas, 32¼ x 23 in. (81.9 x 58.4 cm). From the Collection of Mr. and Mrs. Paul Mellon

PL. 19 (ABOVE, LEFT). *Jeanne Kieffer*, 1879, oil on canvas, 18 x 15 in. (45.7 x 38.1 cm). From the private collection of Mrs. Deen Day Sanders

FIG. 17 (ABOVE, RIGHT). Carolus-Duran (French, 1837–1917), *Prince Michael Orsini*, 1885, oil on canvas, 21⅛ x 17¾ in. (53.7 x 45.1 cm). Private collection. Photograph courtesy of Hirschl & Adler Galleries, New York

PL. 20. *Edouard and Marie-Louise Pailleron*, 1881, oil on canvas, 60 x 69 in. (152.4 x 175.3 cm). Des Moines Art Center Permanent Collections; Purchased with funds bequeathed by Edith M. Usry in memory of her parents, Mr. and Mrs. George Franklin Usry, and funds from Dr. and Mrs. Peder T. Madsen Fund and Anna K. Meredith, 1976.61

Edouard Pailleron's celebrity, many members of the press would have known the children's identities (even though the catalogue omitted their names), and it is worth speculating that the reviewers' comments about the painting were colored by their relationships with Edouard Pailleron and/or François Buloz, the children's grandfather, who was the editor-owner of the influential periodical *Revue des Deux Mondes*.

Most critics persevered in describing Sargent as having inherited his style from Carolus-Duran and offered only occasional remarks about the children themselves—and then it was Marie-Louise who captured the greater measure of interest: "[T]his is evidently a family picture, and the older sitter is subordinate to the little girl. She is seen full face, dressed all in white, seated on a sofa; she takes posing so seriously that her hands are clenched from the tension of holding still, her expression as if fatigued by the light that strikes her retina. Very obedient, very vivid and serious, as befits a brave

little model, whose head, in its dull pallor, is carefully and finely modeled."[20] Another critic, writing for *La Nouvelle Revue*, declared that the painting reaffirmed Sargent's talent as it had been initially proven in his portrait of Carolus-Duran. The writer continued, citing Sargent's "felicitous inventiveness in the disposition of the two figures" and calling attention to the little girl's expression of "childish defiance."[21] In noting Marie-Louise's defiant attitude and her fatigued expression, both critics betrayed their strong reactions to the girl's image. Indeed, Marie-Louise's expression was so magnetic that writers were inspired to set up empathetic constructs of her as an individual experiencing the process of sitting for her portrait.

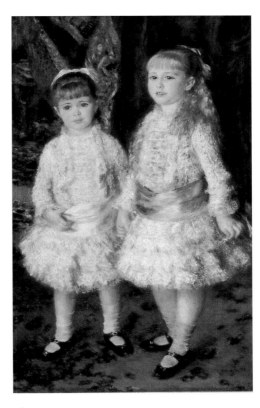

FIG. 18. Pierre-Auguste Renoir (French, 1841–1919), *Alice and Elisabeth Cahen d'Anvers* (also known as *Pink and Blue*), 1881, oil on canvas, 47¼ x 29½ in. (120 x 75 cm). Museu de Arte, São Paulo, Brazil/Bridgeman Art Library

This type of intuitive reaction was unusual in critical writing, but it held true as well for Pierre-Auguste Renoir's *Alice and Elisabeth Cahen d'Anvers* (fig. 18), a portrait of the daughters of a prominent banker that was also on view in the 1881 Salon. In the instance of the Renoir, however, the critics were insensible to the uneasiness conveyed by the image, and their opinions seem to have been conditioned by stereotypical beliefs about little girls: "The two little girls are charming for their innocence, gentleness, childlike grace, and above all, for their freshness....Their sweet little laughing faces, their blond tresses of hair, their pink and blue dresses combine to make one of the loveliest and brightest of bouquets."[22] Blinded by Renoir's pastel confection of fabric, ribbons, and frills, this writer found joy where there was none. Renoir, to be sure, was unusually truthful in portraying his sitters wilting under the stress of posing: the elder Elisabeth strains to keep her smile, and the younger Alice has a look of consummate unhappiness and frustration. Yet the critics did not recognize (or acknowledge) the small emotional drama that took place on the canvas and preferred to describe the children with their "sweet little laughing faces."

Both Sargent and Renoir portrayed children whose tensions were palpable. But, where Renoir failed to transmit those tensions to his critics, Sargent succeeded by means of dramatic lighting, rich, deep colors, exotic studio props, and the suggestion of psychological distance between brother and sister. It was mainly through Marie-Louise, however, that Sargent disabled the conventionalized response to childhood. Overt signs of stress are legible throughout her body. What is more, her unreadable expression (which might be called sphinxlike if she were an adult) also creates tension in the viewer by pulling us into the painting and simultaneously stopping us from advancing. As the critic Genevay noted, Marie-Louise overpowers her brother ("the older sitter is subordinate to the little girl"), and, in truth, she is the focus of the painting despite her older brother's presence.

The power Sargent conferred on Marie-Louise may be seen in light of a relatively new phenomenon in French culture that has been characterized as the "petite fille moderne." According to Nicole Savy, the "modern little girl" emerged first in literature about 1860 and soon usurped the heroic narrative position previously held exclusively by boys.[23] Savy elaborates on the new power commanded by the girl child: "A true heroine,

FIG. 19. Carolus-Duran (French, 1837–1917), *A Future Doge* (also called *Beppino*), 1880, oil on canvas, 39 x 31¼ in. (99.1 x 79.4 cm). Unlocated. Photograph: Frick Art Reference Library, New York

she holds the center of the plot in a novel that can even bear her name; her adventures or her misfortunes become the very substance of the narrative; she is endowed, unlike the Little Red Riding Hoods, with psychological density, with complexity and autonomy. At the same time, children's literature expanded on a large scale, the core of which rapidly attained the status of a subgenre; that of the novel directed to little girls which freely recounts their existence between motherhood and dolls. The little girl simultaneously became the subject of the novel and the audience for whom it was written."[24] Sargent endowed Marie-Louise with the same psychological density, complexity, and freedom that Savy traces in the child heroines of mid- to late nineteenth-century French literature written for both adult and child audiences. Whether he did so with an awareness of this literary trope is not known, but Edouard Pailleron's passing comment likening Sargent's presentation of his daughter to a young Joan of Arc may indicate his recognition that Sargent was painting Marie-Louise as a "petite fille moderne."[25]

Edouard and Marie-Louise Pailleron must be interpreted as part of Sargent's ongoing process of bold experimentation. In it Sargent maintained his stylistic loyalties to his teacher, Carolus-Duran, but separated himself from the firmly entrenched portrait iconographies that Carolus-Duran perpetuated—whether in society portraits or in his old-masterish *A Future Doge* (fig. 19), a portrait of a child dressed in Venetian Renaissance costume that was also on view at the 1881 Salon. Sargent was certainly not alone in trying to meld traditional with modern ways of painting and, in fact, participated in a larger process stimulated by painters of the previous generation—for example, Gustave Courbet, Edouard Manet, and Edgar Degas—whose art collectively fueled the self-conscious drive toward modernity in the art of the late nineteenth century. The problem faced by portrait specialists who wished to gain professional success centered on how to formulate a cohesive, modern artistic identity while meeting the often conflicting demands of tradition, innovation, and patrons. In the case of *Edouard and Marie-Louise Pailleron* Sargent likely predicted that he could safely push the boundaries of imaging because he could count on Edouard Pailleron's sympathetic understanding of his position in the Paris art world since the two occupied essentially the same social stratum as creator-outsiders. Certainly Sargent's portrait of Mme Pailleron, despite (or perhaps because of) its evocation of poetic strangeness, pleased his patron, for the commission for the children's portraits had followed it. The painting's high drama intersected with paternal identity, and it may be that, in the image of Marie-Louise, Sargent alluded to Pailleron's contemporaneous theatrical success with *The World Where One Grows Weary*, a play that satirized, among other things, the affectations of women who aspired to be ladies. In *Edouard and Marie-Louise Pailleron*, Sargent's representation of Marie-Louise and her apparently disaffected brother eschews the layers of pretense that pervaded other images of children and simultaneously corresponds with the ideas of their father's famous play.

Sargent's 1881 Salon entries (*Edouard and Marie-Louise Pailleron*, *Portrait of Mrs. Ramon Subercaseaux* [private collection], and two watercolors of Venetian scenes)

earned him a second-class medal, awarded specifically to the portrait of Mrs. Subercaseaux. Edouard Pailleron was reportedly so put out about the perceived snub to his children that he lobbied unsuccessfully for the medal to be transferred to their portrait, which had received greater coverage in the press.[26] The contretemps undoubtedly brought the portrait, patron, and artist additional notoriety, but it amounted to little in comparison with the flood of commentary surrounding Sargent's grand *El Jaleo* (fig. 20) displayed at the Salon the following year.[27] Although the work received mixed reviews, Sargent's monumental painting of a Spanish dancer performing with sensuous abandon secured the lion's share of critical attention. Impossible to ignore, the painting was extolled for its marvelous chiaroscuro and its "brilliant contempt for academic rules." Yet it was also deemed an aesthetic detour "far from artistic beauty and grace."[28] Despite some claims that it was the ugliest painting in the Salon, *El Jaleo* still testified to Sargent's prodigious talent, and, with his youth in mind, many reviewers forgave him what they considered an ambitious misstep, which was, after all, guided by his admiration for the great Spanish Baroque painter Diego Velázquez.

Sargent exhibited only one painting at the next Salon—*Portraits d'enfants*, now known as *The Daughters of Edward Darley Boit* (pl. 21). Although in its own way as challenging and theatrical as *El Jaleo*, the painting of four little girls in a domestic interior countered the impact of the blatantly erotic female public spectacle that had represented him the previous year.[29] Indeed, *Portraits d'enfants* proclaimed Sargent a painter of propriety, restraint, privacy, and youth. The painting had been seen previously, in Paris in late December 1882, at the Société internationale de peintres et sculpteurs, where it elicited positive remarks dedicated mainly to its technical features. Typical were the comments of the reviewer who delighted in Sargent's painterly brio and treatment of light and who also wryly stated that, while preferring "the young girl on the left with her white

FIG. 20. *El Jaleo*, 1882, oil on canvas, 7 ft. 10¼ in. x 11 ft. 5 in. (2.4 x 3.5 m). Isabella Stewart Gardner Museum, Boston

occupy, the sense of loss imposed by the absence of the father whose name frames the children (*boîte*/Boit), and ends with guesses (Lubin's own word) about Sargent's sexual ambivalence. Sidlauskas, by contrast, formulates her theories on "the expressive potency of space" and how Sargent's painted space refers to the mental interiority of the children who, in turn, outwardly embody various stages of psychological and physical development by virtue of their ages. Like their nineteenth-century predecessors, both authors of these modern studies recognize Velázquez's *Las Meninas* as the formal prototype for Sargent's portrait of the Boit children.[41] From that relatively solid point both authors depart from historical ground and take separate and often Byzantine paths toward interpreting, not the painting, but Sargent.

Without debating the conclusions reached by Lubin and Sidlauskas, it nevertheless seems right to return to *Las Meninas* for a more direct reconstruction of Sargent's thinking that led to *Portraits d'enfants*. Indeed, if *Las Meninas* was so central to the artist's formal outlook, why should its potential to generate meaning in Sargent's conscious creative process be ignored? A clue may be found in a common English translation of *Las Meninas*, "Maids-in-Waiting."[42] Indeed, Mary Louisa, Florence, Jane, and Julia Boit are all "maids-in-waiting" in the literal sense of the phrase: they appear in what is presumed to be a reception hall of their family's Paris apartment, a neutral area that demarcates the boundaries between public and private space and is, quite logically, the most appropriate place for children to await an expected arrival or departure. By sheer coincidence their ages automatically impose the structure of a growth narrative. In turn, the maturation process is symbolically underscored by the transitional nature of the hall and heightened by the placement of the two older girls at the threshold of a room whose interior, like the future, is understood to exist but remains undecipherable. Velázquez had used a similar and even more artificial construct in *The Waterseller of Seville* (fig. 22), which engages an "ages of man" theme. In it the faces of the three males are shown in three-quarter, profile, and frontal poses, which are echoed in Sargent's presentation of the four sisters.[43] Moreover, each figure in *The Waterseller* is depicted in varied conditions of light, with the face of the center figure barely visible in the dark reaches of the pictorial space. And, although this may be stretching the point, Sargent's juxtaposition of the girls with the four vases carries subtle reverberations of Velázquez's metaphoric use of the four water vessels. These are uncomplicated connections that can take us in the same directions as those taken by Lubin and Sidlauskas without having to build elaborate theoretical frameworks.[44] The primary contention here is that Sargent was at this time a young painter whose business it was to look at art consciously for the purpose of absorbing and synthesizing ideas and methods in order to devise his own technique and manner of creating content. As James wrote of Sargent's art of this period, the painter was consumed with Velázquez: "[Sargent] sees each work that he produces in a light of its own, and does not turn off successive portraits according to some well-tried receipt which has proved useful in

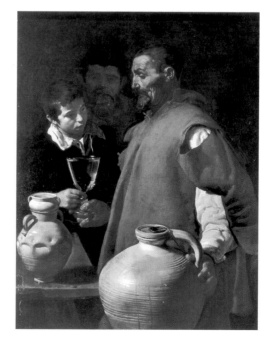

FIG. 22. Diego Rodriguez de Silva y Velázquez (Spanish, 1599–1660), *The Waterseller of Seville*, c. 1620, oil on canvas, 42 x 31⅞ in. (106.7 x 81 cm). Wellington Museum, Apsley House, London. Photograph: V&A Picture Library

the case of their predecessors; nevertheless there is one idea that pervades them all, in a different degree, and gives them a family resemblance—the idea that it would be inspiring to know just how the great Spaniard would have treated the theme."[45]

Sargent's adaptation of an essentially Spanish Baroque vision lent *Portraits d'enfants* unusual gravity. The girls were removed from a pictorial environment that explicitly denoted comfort and nurture (despite the implication of its being "home"), and their lack of interaction denied the narrative foothold so often supplied by child images. The painting's very austerity gives rise to a blankness or opacity that resists explanation and simultaneously encourages investigation—a condition that paralleled the developing notion of childhood and ultimately enabled Sargent to lift childhood to the level of high art at the Paris Salon. Indeed, as one writer, recalling *El Jaleo*, stated, "Still, the figures of the little ones, slight, with a worldly elegance entirely modern, give the true impression that retains the spirit [of the earlier painting]."[46]

ENGLAND

Sargent's hopes for continued glory in Paris were dashed with the devastatingly poor reception of *Madame X* (fig. 1) at the 1884 Salon.[47] Disappointed and disillusioned, he turned his thoughts to England as a likely ground for rehabilitating his reputation. Nevertheless, England augured to be difficult artistic territory to conquer, for this new market entailed two formidable problems: the news of the scandalous *Madame X* quickly crossed the Channel, effectively making potential patrons all the more cautious about engaging him to paint their portraits; and the insularity of the English art establishment, which was notoriously indifferent, if not antagonistic, to artists whose styles smacked of French training.[48] Sargent had already made tactical forays into England, mainly by exhibiting at the Royal Academy of Arts and less often at the Grosvenor Gallery (the bastion of English Aestheticism, where artists exhibited by invitation only) and the Fine Art Society. More often than not, his paintings—a mixture of portraits (including the stunningly vivid *Dr. Pozzi at Home* (pl. 28) and Venetian genre scenes—generated a lukewarm reception.[49] Ironically, it has been hypothesized that the artist's first notable English commission—the marvelous triple portrait *The Misses Vickers* (pl. 22)—owes its origins in part to *Portraits d'enfants*, with which it shares numerous formal characteristics. According to the most likely account, the Sheffield industrialist Colonel Thomas Vickers, in seeking an artist to paint his daughters' portrait, is believed to have sent his wife, Frances (who had studied art in France), in 1883 to Paris, where she is reported to have been attracted to Sargent's portrait of the Boit girls.[50]

The Vickers commission inaugurated Sargent's first extended visits to England and brought him his first real opportunity and incentive to survey the English art scene in depth. He arrived in late March 1884, just in time to view the major Reynolds retrospective in the company of his new friend, Henry James, with whom he also visited the studios of two of England's foremost painters, Frederic Leighton (1830–1896)

and John Everett Millais (1829–1896). Work forced his temporary return to Paris, but he was back in London by the end of May, when he doubtless saw the Royal Academy and Grosvenor Gallery exhibitions, where his portraits of Mrs. Henry White and Mrs. Thomas Wodehouse Legh were on display. The two paintings met with what must have been for Sargent a disheartening critical response, for London reviewers were almost unanimous that neither work justified the Paris reports of his great talent.[51] Nonetheless, Sargent continued making the socially and politically required motions, which included a visit to Edward Burne-Jones's studio as well as cohosting a tea party with Edwin Austin Abbey (1852–1911) that was attended by the Pre-Raphaelite artist Marie Spartali Stillman (1844–1927), a former model for Leighton and Dante Gabriel Rossetti, and the wife of the American artist-journalist William James Stillman.[52] All the while Sargent likely sought to discern trends—stylistic and thematic—that distinguished English art from the French modes with which he was most familiar.

Sargent would have noted that the child subject—historically a significant part of the high-art vocabulary in England—had maintained a marked presence, as witnessed by the sustained interest in and visibility of Reynolds's art (the primary visual

PL. 22. *The Misses Vickers*, 1884, oil on canvas, 54¼ x 72 in. (137.8 x 182.9 cm). Sheffield Galleries and Museums Trust, UK/Bridgeman Art Library

source of the "Romantic Child") and Millais's position as inheritor and contemporary champion of the Reynolds tradition.[53] But the reasons for the centrality of childhood imagery in England in the 1880s are complex and do not rest exclusively in the art-historical links between Reynolds and Millais.[54] Another factor was that child imagery functioned as a moral anodyne for the nude, which was a subject of constant and heated public debate.[55] This phenomenon is most easily discovered in the reviews of the period, which were often organized by genre and sometimes divided into subsections devoted to baby and child subjects. An especially good example of this is the *Pall Mall Gazette "Extra"* of 1886, in which the reviewer first addressed the nude and concluded that it "may well be an indispensable preliminary for a correct drawing of the human figure; but the proper place for it is the studio, not the exhibition." The writer then turned to "The Babies," saying:

> The British Matron's relief, we may now pass on to notice, is positive as well as negative. As there are fewer than ever of the nudes from which she turns with disgust, so also there are more than ever of the pictures of babyhood and other pretty domesticities in which her soul delighteth. We began to keep count of the babies, as we have done in former years, but we gave it up in despair. . . . There are little children taking "first bites" at oranges, and at apples; babies listening to "sea shells" at their ears (a flight of imagination twice attempted this year); little girls playing with lambs, puppies, kittens; and little boys saying, "Take us, daddy," and "Do take me." Such pictures do not need further description.[56]

The type of picture noted by the reviewer is exemplified in the art of the popular painter Arthur John Elsley (1860–1952), who exhibited steadily at the Royal Academy from 1878 to 1903.[57] Although a competent technician and successful in the market, Els-

ley catered to a segment of the public that fed on sentimentality and, even though his art was seen on the Academy walls, it was generally recognized by the critics to be of a decidedly lower order (fig. 23). The profusion of babies and children that flooded contemporary English art at the time was frequently the butt of humor in popular periodicals (fig. 24) and a cause for lament among serious critics. In 1885 the *Spectator*'s critic railed at length against the "baby disease," which he diagnosed as having "infected all our great artists":

FIG. 23. Arthur John Elsley (English, 1860–1952), *A Dead-Heat*, from *Academy Notes 1893 with Illustrations of the Principal Pictures at Burlington House*, ed. Henry Blackburn (London: Chatto and Windus, 1893), 100. Brooklyn Museum Library Collection

> In after-years, no doubt, 1882–1890 (say) will be spoken of as the New Renaissance of English Art, the years when our painters made the discovery that the fittest subject

for painting was costume from the Lilliputian warehouse, that the dramas of this life, and the legends of another, were not half so interesting or so beautiful as this latest production of nature and art,—infancy plus the milliner!... But, of course, there are several varieties of these, and the humorous or domestic baby must by no means be confounded with the fashionable or milliner baby. It will be noticed by careful investigators that the Academicians, such as Millais, Leighton, Sant, &c., incline to the milliner variety, while comparative outsiders prefer the narrative or sentimental species.[58]

No artist escaped the wrath of the critics in this vein, not even Leighton, the illustrious president of the Academy, whose portrait of Lady Sybil Primrose (fig. 25) was deemed an "unworthy" example of his art, which, as "a dressed-up children's picture," was "neither childlike, nor lifelike; neither admirable as a work of art, nor interesting as a bit of nature,

FIG. 24. *Guide to Select Juvenile Parties at the Royal Academy*, from *Punch, or the London Charivari*, June 16, 1883, 285. Brooklyn Museum Library Collection

but only a smoothly varnished record of infantile millinery."[59] Similarly vituperative commentary had erupted in 1884, when the respected painter Frank Holl was implored to "leave such work to feebler artists. We do not have a *man*, as well as an artist every day, and when we do, let him leave the babies alone."[60] Thus, when Sargent was entering the English cultural arena, childhood was a predominant theme that was receiving unprecedented critical attention. What had been one of the crowning glories of the English artistic tradition—the subject of childhood—had sunk to the level of saccharine, popularized imagery. The situation continued unabated and was the crux of a joke played by James McNeill Whistler, who installed all of the "baby" pictures in one gallery at the 1891 Liverpool exhibition.[61] As late as 1905 the *Spectator*'s critic called the Academy's hanging committee to task for installing Elsley's *Good Night* on the line and, invoking Sargent's name, aggressively questioned the jury's decision in accepting it for display:

The subject is of the kind familiar in Christmas numbers of illustrated papers, and upon almanacs given away with a pound of tea. The picture consists of a small child and a number of puppies,—innocuous material made unpleasant by vulgarity of treatment. Works of this kind in the trade pass by the name of "puppy pictures," and as such are advertised....What

FIG. 25. Frederic Leighton (English, 1830–1896), *Lady Sybil Primrose*, c. 1885, oil on canvas, 48 x 34¼ in. (121.9 x 87 cm). Christie's Images Ltd. 2003

interest can such an august body as the Academy have in help-ing to advertise a picture produced, not for its own sake, but for commercial reproduction?…Did the Hanging Committee consider it to be an example of serious art? If so, why is there no protest from those Academicians who, like Mr. Sargent for instance, are true artists? They certainly do not paint, and, we cannot believe, dote in secret on, "puppy pictures."[62]

It is against the backdrop of the "baby disease" and "puppy pictures" that Sargent's paintings of English children must be considered, begin-ning with *Garden Study of the Vickers Children* (pl. 23), a painting that resulted from Sargent's contact with members of the extended Vickers family while painting *The Misses Vickers*. The aesthetic divide separat-ing the two works marks a critical transition then occurring in Sargent's art and may be read as his embrace of the English art tradition coupled with an almost perverse desire to challenge that tradition by submitting the hallowed subject of English childhood to the alarmingly foreign fac-ture of Impressionism. In analyzing the differences between *The Misses Vickers* and *Garden Study of the Vickers Children*, the essential nature of the works needs mention: the first is a formal portrait and the second an experimental "study" that was not exhibited during Sargent's lifetime. For *The Misses Vickers* Sargent was obliged to produce a painting that matched the expectations of his clients. Its innova-tive character notwithstanding, it still functioned within long-established aesthetic parameters for group portraiture (it is an updated variation on Reynolds's *The Ladies Waldegrave* [1780–81, National Gallery of Scotland, Edinburgh] and Millais's *Hearts Are Trumps* [1872, Tate, London], the latter of which was shown in 1878 at the Paris Exposi-tion Universelle, where Sargent was bound to have seen it). Nonetheless, the painting's dark modernity still opened him to accusations of cleverness and painterly trickery. When *The Misses Vickers* was exhibited at the Salon in 1885 and in 1886 at the Royal Academy, English critics came to conclusions similar to the one quoted here:

> Mr. Sargent is a pseudo-Velasquez whose sense of tone is exquisite, but not chastened by fine taste, whose perception of character is searching and faithful to nature, but almost devoid of that love for grace and natural dig-nity which enabled the great Spaniard to be always gentlemanlike.… *Portrait des Misses*…needs only to be softened in its half tones and har-monised throughout to become perfection in its way. Let us hope that the very clever pupil of M. Carolus-Duran may by-and-by do justice to all his extraordinary powers and accept the refining canons of taste. As it is this group of girls seated is unjust to their evident high culture and intelligence.[63]

The perception of Sargent as the "clever pupil" of Carolus-Duran remained in force in England throughout the 1880s and was augmented by the display of the French artist's

paintings at the Academy beginning in 1883. Sargent himself had indirectly helped to maintain this subordinate view of himself by submitting examples of his art to the Academy that reinforced the teacher-pupil connection. As witnessed by *Garden Study of the Vickers Children*, however, Sargent was giving serious thought to other, more progressive (and for the English audience more subversive) aspects of French art.

Garden Study of the Vickers Children depicts Vincent Cartwright "Billy" Vickers helping his sister, Dorothy, as she waters one of the many lilies surrounding them in an otherwise mottled expanse of green grass. The children are seen from above—from an adult's standpoint—and Billy looks up from his gardening task, seemingly interrupted by another person's sudden arrival. Dorothy, however, remains intent on tending to the carefully staked white lily. The fresh informality of the scene is amplified by the affectionate relationship of the two children; their hands entwine to share the weight of the watering can. The idea of purity, so closely aligned with the lily in Victorian floral symbolism, is transferred to Dorothy, whose white dress, virginal innocence, and nurturing activity reflexively equate her with the flower. Together, the boy and girl recall an Edenic state, but, with the intrusion implied by Billy's responsive expression, the paradisaical moment is about to fade to the realm of memory.

This description relies mainly on conventional methods of reading content, and, in that respect, the painting fits squarely within the range of English subject matter that traditionally links childhood with nature. Conceptually, the painting bears a close kinship to Millais's *Lady Peggy Primrose* (fig. 26), a work that was shown in 1885 at the Royal Academy, where it was welcomed as a rare success among the morass of baby pictures.[64] Peggy Primrose and Billy and Dorothy Vickers are modern reconstructions of the Romantic Child. If formal elements are taken into account, however, Sargent's painting asserts a radical artistic statement. The broadly brushed surface, the semblance of a plein-air technique, the horizonless landscape, high viewpoint, and decorative patterning of the lilies scattered throughout the composition, all marry in a hybrid fusion of French Impressionism and English Aestheticism. Sargent's preoccupation with experimenting with Impressionist styles is not surprising, for he had arrived in Paris as a student in 1874, the year of the first exhibition of the group that had come to be known as the Impressionists, and was familiar with their art. What is remarkable, however, is that he used an Impressionist style to portray English children in a country whose aesthetic climate had not yet accepted either the new formal tenets of representation or a style that threatened to fragment a hitherto identifiably national art.[65]

The reasons for Sargent's freedom in this matter are rooted in his relationship with the children's parents. He was in close and frequent contact with Albert and Edith Vickers, whom he had presumably met through his commission for the three Vickers sisters, who were Albert Vickers's nieces. This branch of the Vickers family, living at Lavington Rectory, near Petworth in Sussex, occupied much of Sargent's attention, the most public evidence of which is the full-length portrait of Edith Vickers (Virginia Museum of Fine Arts, Richmond), which was shown at the Paris Salon in 1885 and at the Royal Academy the following year. The portrait's restraint and austerity document Sargent's retreat from the beau-monde sensibility of *Madame X*, and, as he noted, this

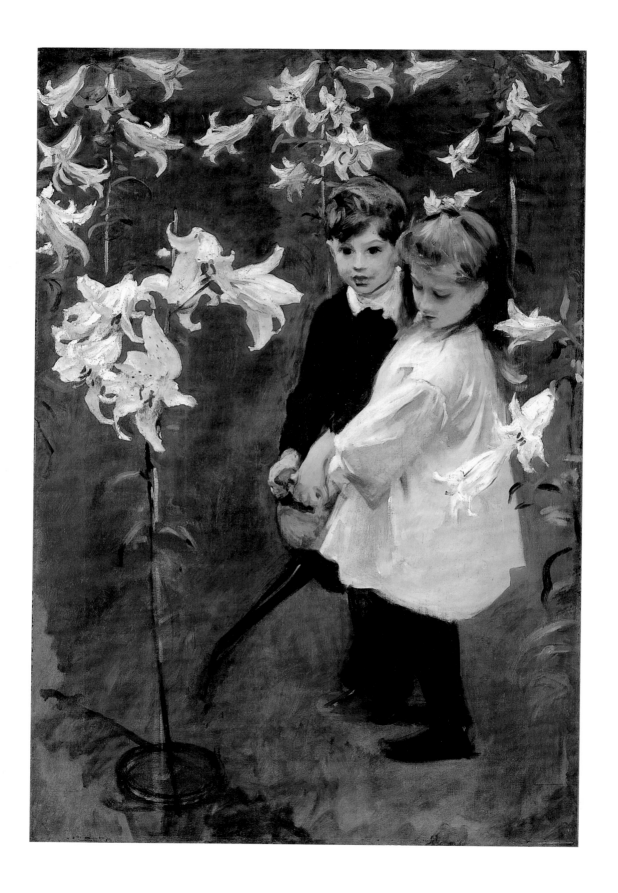

and another English portrait displayed at the 1885 Salon "rather retrieved" his reputation from the critical debacle of 1884.[66] Sargent's association with Edith and Albert Vickers was reportedly quite relaxed, and Stanley Olson's remark that "he was more friend than servant" in the Vickers family circle is revealed in the intimate, impressionistically rendered *Mr. and Mrs. Albert Vickers (A Dinner Table at Night)* (1884, Fine Arts Museums of San Francisco).[67] The divergent stylistic tactics used in works destined for the same patrons indicate the Vickerses' appreciation for the range of Sargent's artistry and, conversely, suggest his trust in them to understand his aesthetic experimentation. This laissez-faire arrangement was put to the test in 1886, when Sargent exhibited *A Study* (presumably *A Dinner Table at Night*) in the first exhibition of the controversial New English Art Club, timing that permitted alert viewers to compare this avant-garde representation of Edith with the studiously formal portrait of her that went on view at the Royal Academy a month later. In this respect, then, it is likely that Edith and Albert Vickers looked on the even more aesthetically adventurous *Garden Study of the Vickers Children* as a token of their support of—or even vicarious participation in—the artist's creative process. Still, Sargent seems to have carefully chosen the vehicle for his radical approach: viewing children from an adult's perspective neatly explains the flattened, horizonless composition. What is more, the broad sketchiness of the paint surface corresponds to the idea that children were "unfinished," constantly in the process of "becoming" (an understanding metaphorically reiterated in the children's tending to the lilies). Thus, the avant-garde elements of the painting are justified and made acceptable by the child subjects.

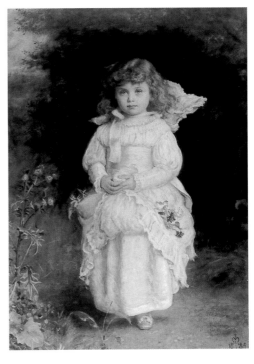

FIG. 26. John Everett Millais (English, 1829–1896), *Lady Peggy Primrose* (*Lady Margaret Primrose as a Child*), c. 1885, oil on canvas, 47½ x 33½ in. (120.6 x 85.1 cm). Private collection. Photograph: Photographic Survey, Courtauld Institute of Art, London

Garden Study of the Vickers Children surely may be seen as the prologue to Sargent's highly acclaimed and equally formally radical *Carnation, Lily, Lily, Rose* (pl. 24). This observation is not new, but it has special relevance in regard to Sargent's use of child imagery to overhaul his reputation. The circumstances of the painting's evolution from pencil sketches to completion are well documented, but they bear repeating here in part.[68] The painting originated in the same type of supportive atmosphere that Sargent had enjoyed with the Albert Vickers family, a domestic environment given shape in this instance by the American artist Frank Millet (1846–1912) and his family who lived at Farnham House (and later at Russell House), in the village of Broadway, in Worcestershire, England. The arrival in 1885 of Millet and his friend the American painter-illustrator Edwin Austin Abbey began the transformation of the sleepy, scenic hamlet into a haven for artists and writers. The influx of transient visitors and temporary residents (including the writers Henry James and Edmund Gosse, and the artists Frederick Barnard, Alfred Parsons, and Lawrence Alma-Tadema) soon qualified Broadway as an art colony. From his first visit in 1885, Sargent discovered in the homely community respite from the pressures of Paris and London. Enfolded in the warm company of friends and surrounded by a landscape so quaintly picturesque, Sargent's daily life took on the luster of a simpler, more innocent past.

PL. 23 (OPPOSITE). *Garden Study of the Vickers Children*, 1884, oil on canvas, 54¼ x 35⅞ in. (137.8 x 91.1 cm). Flint Institute of Arts, Gift of the Viola E. Bray Charitable Trust (Via Mr. and Mrs. William L. Richards), 1972.47

Sargent's romance with Broadway (for it can be taken as that) began when his spirits were at their lowest in terms of his career as a painter. Gosse, writing to Sargent's biographer Evan Charteris, described the artist's mood at Broadway in 1885:

> At this time I saw more of him than at any other time, and if I have anything worth relating it was gathered during those enchanted weeks. In the first place I must say that the moment was a transitional one in the painter's career. . . . In this juncture, it will perhaps be believed with difficulty that he talked of giving up art altogether. I remember his telling me this in one of our walks, and the astonishment it caused me. Sargent was so exclusively an artist that one could think of no other occupation. "But then," I cried, "whatever will you do?" "Oh," he answered, "I shall go into business." "What kind of business?" I asked in bewilderment. "Oh, I don't know!" with a vague wave of the hand, "or go in for music, don't you know?"[69]

Despite Sargent's depressed view of his artistic prospects, the weeks he spent at Broadway (mostly during the late summer and early autumn of 1885 and 1886) were enormously productive and bear witness to the restorative effect the place had on him. Almost at once, he began work on what would become *Carnation, Lily, Lily, Rose*. At the same time he was swept up in the lighthearted informalities of family life, activities that acted as a balm to his dampened spirits and perhaps provided him with a sense of familial permanence for the first time. Sargent practically lived with the Millets and was "quite domesticated," as James put it, and the tenor of Sargent's daily affairs became as closely approximated to a traditional family life as they ever would, made especially so by the constant presence of children.[70] Although Sargent was primarily concerned with experimenting with plein-air landscape painting (a pursuit spurred by a presumed sojourn with Claude Monet at Giverny that summer), Sargent was vulnerable to, indeed, a willing victim of, the frequent interruptions of children that sometimes spontaneously commanded his artistic attention. Emily Teresa "Tessa" Gosse (daughter of Edmund) recalled one such instance: "One day, when Sargent was painting we children came in from a picnic with bunches of autumn colchicum. He was so pleased with the colour of the mauve flowers, my red hair, white dress, that he quickly painted a sketch on canvas over a landscape."[71] The sketch (pl. 8), reportedly made on the girl's eighth birthday, possesses a lightness and freedom that magically evoke the sense of childhood's evanescence. Other, more carefully charted efforts are evident in *Garden Study with Lucia and Kate Millet* (pl. 25) in which Sargent balanced landscape elements with the figures of Millet's sister, Lucia, and his daughter, Kate. The melding of child and garden subjects (a motif Sargent first explored with the Vickers children the previous year) may be seen as part of his ongoing devotion to a particular content—the harmonious existence of the child in nature—that carried into the twentieth century. The artist's lingering pleasure in this theme is witnessed in the remarkably abstract *Gathering Blossoms, Valdemosa* (pl. 26), in which the radically cropped figures of two children inflect the uncultivated Majorcan landscape with narrative possibility.

PL. 24 (OPPOSITE). *Carnation, Lily, Lily, Rose*, 1885–86, oil on canvas, 68½ x 60½ in. (174 x 153.7 cm). Tate, London. Presented by the Trustees of the Chantrey Bequest 1887. © Tate, London, 2003

PL. 25. *Garden Study with Lucia and Kate Millet*, c. 1885, oil on canvas, 24 x 36 in. (61 x 91.4 cm). Private collection, Washington, D.C.

Although *Carnation, Lily, Lily, Rose* takes its title from "The Wreath," a song then popular, Sargent may also have derived inspiration from Robert Louis Stevenson's *A Child's Garden of Verses*, a selection of poems written expressly for children and from a child's point of view that was published in 1885.[72] That such a connection may have occurred to Sargent is entirely probable, especially since he had been in Bournemouth painting Stevenson's portrait in November 1884, when the two men had ample opportunity for lively discussions about their work. Of Stevenson's verses, "To Any Reader" seems especially provocative in summoning correspondences with Sargent's painting:

> As from the house your mother sees
> You playing round the garden trees,
> So you may see, if you will look
> Through the windows of this book,
> Another child, far, far away,
> And in another garden, play.
> But do not think you can at all,
> By knocking on the window, call
> That child to hear you. He intent
> Is all on his play-business bent.
> He does not hear; he will not look,
> Nor yet be lured out of this book.
> For, long ago, the truth to say,
> He has grown up and gone away,
> And it is but a child of air
> That lingers in the garden there.[73]

PL. 26 (OPPOSITE). *Gathering Blossoms, Valdemosa*, 1908, oil on canvas, 28 x 22 in. (71.1 x 55.9 cm). Private collection. Photograph courtesy of Vance Jordan Fine Art, New York

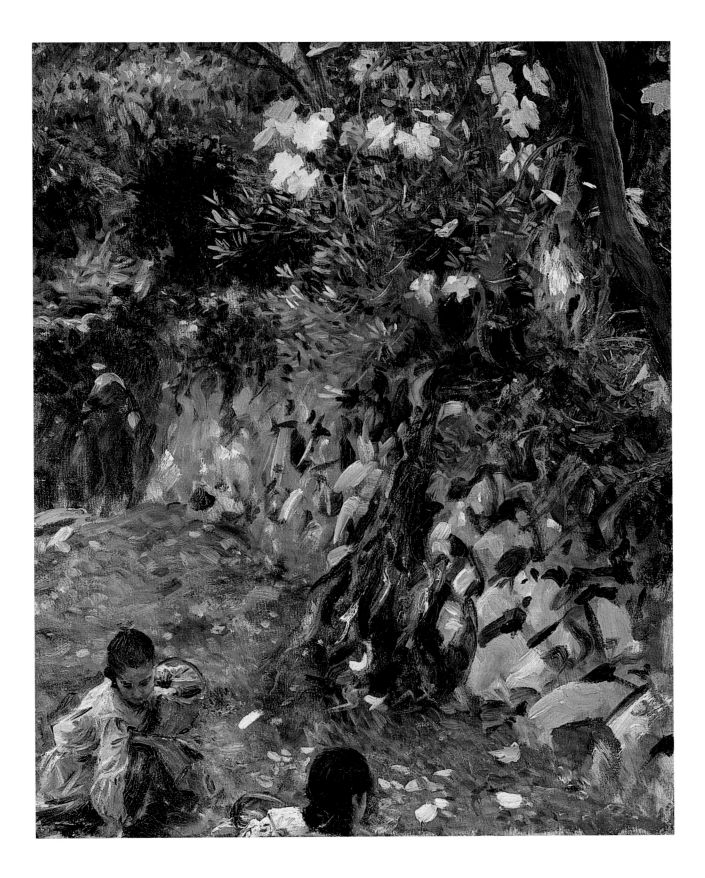

Stevenson's title alone may have been enough to add fuel to Sargent's interest in pursuing child-garden imagery in his own work. This interest had already been stimulated by his intense exploration of English art, which earlier in the year had found expression in *Garden Study of the Vickers Children*. Childhood was a likely subject for the conversations we might imagine to have taken place between Sargent and Stevenson, for Stevenson later wrote to Mark Twain that he had had *The Adventures of Huckleberry Finn* read aloud during his sittings.[74] Added to Sargent's study of the English pictorial tradition—especially that represented in the work of Reynolds and Millais—was his general predisposition to Pre-Raphaelitism, a style that, by the 1880s, had merged with the Aesthetic movement. All of these influences converge in *Carnation, Lily, Lily, Rose*, a painting whose sophisticated blend of advanced formal elements is softened by a content redolent of childhood innocence, purity, and light. At the same time, the painting works against what was becoming a tired refrain in child imagery, as witnessed by the continuation of Reynolds's "Penelope" iconography in such works as G. A. Storey's *Good as Gold*, which, when it was shown at the 1885 Royal Academy, drew the following remarks from the *Athenaeum*'s writer: "The naivete of the child's face ... is its own apology, although the picture owes a great deal too much to Reynolds's 'Penelope' as filtered through Mr. Millais's 'Cherry Ripe.' Under the boughs of a tree a little girl, wearing a mob-cap, is seated with fingers interknit in her lap; there is tact and spirit in the rendering of her soft, bright eyes, and feet crossed before her. Although the carnations are rather painty, this work is very pretty. Reduced to half its size it would be at least equally charming."[75]

In view of its Impressionist qualities it is no less than remarkable that *Carnation, Lily, Lily, Rose* was accepted by the Royal Academy for display in its 1887 annual exhibition—especially since the New English Art Club, where Sargent was deemed "a great pillar" of the organization, was the more logical place to show a work of such decidedly Impressionist leanings.[76] Just how it happened to reach the Academy walls is undocumented, but it has been theorized that the Academy's president, Frederic Leighton, quietly lobbied for securing what he called the "startling but ... brilliantly talented painting by Sargent" for the Academy exhibit by negotiating with Sargent through either Alma-Tadema or Harry Tamworth.[77] Another aspect of the scenario is offered in a 1923 article that quotes a letter from Sargent to the earl of Crewe wherein Sargent explained, "The late Mr. Wells, R.A., saw it in my studio before it was exhibited at the Academy and intimated to me that he would like to propose it for purchase by the Chantrey Fund. I declined another offer, and the picture was bought by the council on Mr. Wells's recommendation."[78] Details aside, the result was that *Carnation, Lily, Lily, Rose* was a Chantrey Bequest purchase for the national art collection.[79]

The bestowal of the Chantrey Bequest honor evinced surprise and occasional rage from the art community. The critic for the *Athenaeum* regretted the purchase and while conceding, "Of the cleverness of this *tour de force* there can be no doubt," he concluded that the "Academicians who voted by buying this picture have forgotten that the Academy is an educating body and should insist on scholarship in art."[80] The writer

said nothing about the subject and lodged his chief complaint against the handling of light. At the opposite end of the critical spectrum was Harry Quilter, a reviewer for the *Spectator*, whose admiration for the work was unqualified:

> The time is that of a summer's evening: the attempt has been to show the conflict of lights between the fading day and the (illuminated) lanterns, and its effect upon the various coloured flowers. Had Mr. Sargent only succeeded in rendering this effect truthfully as a study, he would have done a supremely difficult thing and would have deserved high praise for technical success; but he has done far more—he has succeeded in painting a picture which, despite the apparent bizarrerie of the subject, despite the audacious originality of the treatment, is purely and simply beautiful as a picture. The introduction and painting of the children's figures, the disposition of the masses of flowers and leaves with which they are surrounded, the delicately bold colouring of the roses, carnations, and lilies,—in all of these respects is this picture an exquisite work of art.... For how is it possible to describe in words that subtle rendering of brilliance and shadow, that united mystery and revelation, which render this composition so admirable. Honour to the young artist who has succeeded in combining, as we at least have never yet seen combined in a painting of this impressionist school, truth of effect and beauty of colour; who has given us in the little world of his picture the subtle mingling of fact and fancy which exists in every great work of art, and renders its subject freshly beautiful, while leaving its details true.[81]

Quilter, despite the length of his comments, professed a loss for words. This, along with his references to "mystery and revelation" in "the little world" of "fact and fancy," confirms the painting's power to enchant and confound its viewers. The image's potential to suggest meaning without providing a specific narrative stymied writers who were accustomed to such works as J. Clark's *Unexpected Visitors* (also shown at the 1887 Academy) that was lauded by the same critic who bemoaned Sargent's success with the Chantrey Council: "Very tender and good in a low, warm tone of colour is Mr. J. Clark's *Unexpected Visitors* (867), and it also possesses other qualities we look for from his sympathy with nature and domestic life. Children, having disguised themselves, appear gleefully before their grandfather. Their faces are charmingly sweet, lively, and ingenuous. It is a very pretty design very agreeably carried out."[82]

Modern art historians have subjected *Carnation, Lily, Lily, Rose* to extensive formal and iconographic analyses that have more than adequately located the painting in its cultural milieu. In the end, however, it is Quilter's characterization of the painting's space as a "little world" that seems to hold the secret of the painting's lasting appeal, for the work surreptitiously reminds the adult viewer of a distant moment in childhood, when even the smallest task or event captured one's attention to the exclusion of all

else. The solemn intensity with which the girls light their lanterns transports us back to a time when it was possible to find excitement and magic in bringing light to a dusky twilit garden whose daytime appearance is transformed into mysterious movements and sounds in the oncoming quiet of evening. The painting is a child's garden of enchantment, and our inability to describe it further is a condition of our own distance from childhood. Out of reach, like Stevenson's child of verse who "does not hear" and "will not look," the girls deny us access to the world they inhabit. Sargent, too, was complicit in excluding the viewer from the garden, for the pictorial space he constructed defies mathematical analysis and bars us from finding a spot in "real" space that would provide a rational vantage point for seeing the children as we do. Try as we might, we cannot gain entry to this illusory space of childhood.

It is doubtful that even Sargent consciously strove for this disorienting component in the painting, for in light of the numerous accounts of the picture's progress, he was in its thrall as well; his passionate devotion to the painting over a two-year period insists not only that he was troubled by the problems it presented but also that he luxuriated in them to the point that the making of *Carnation, Lily, Lily, Rose* enabled him to reclaim the sheer pleasure of painting that he had lost. As was the case with *Madame X*, Sargent painted *Carnation, Lily, Lily, Rose* for himself, and although he must have harbored hopes for its practical use in reinventing his reputation, the theme of childhood in a garden setting emerges as an almost therapeutic choice on his part, meant to exorcise the unfortunate specter haunting his recent artistic past. At the same time he further removed himself from the idols of his artistic youth—Velázquez, Frans Hals, and Carolus-Duran. By coincidence, Carolus-Duran's portrait of his daughter was displayed at the 1887 Academy, this time provoking no comparisons in the press between teacher and pupil. Using the iconography of Victorian sentiment and the formal language of Impressionism, Sargent pictured a new, inaccessible child to create a curiously unsentimental, albeit moving work of art.

By the time *Carnation, Lily, Lily, Rose* was declared Sargent's English tour de force, the painter had transformed his life. He had closed his Paris studio in 1886 and finally committed himself to a career based in England, after having flirted with the idea since receiving the Vickers family commissions in 1884. The Chantrey Fund purchase of *Carnation, Lily, Lily, Rose* proved the wisdom of his choice. Yet again the iconography of childhood played a significant role in defining him as an artist in the public eye, and, conversely, Sargent played a significant role in freeing the subject from the grip of the "baby disease" and reclaiming it for the realm of high art.

Until the 1887 display of *Carnation, Lily, Lily, Rose* at the Royal Academy, Sargent had carefully modulated his English reputation by exhibiting major figure subjects—products of his creativity and imagination—as well as portraits. After that, however, the most publicly visible product of his artistic energies was commissioned portraiture. Sargent's first major formal portrait of a child in England was *Cecil Harrison* (pl. 27), the son of his friends Robert and Helen Harrison. The artist's striking portrait of Helen Harrison (Tate, London) had been shown at the 1886 Academy (along with *The Misses Vickers* and *Mrs. Albert Vickers*), gaining less than favorable reviews

that may have resulted in part from the sitter's public persona then linked to a divorce scandal centering on her sister and the politician Sir Charles Dilke.[83] "Violently keyed" as one critic called it, the portrait showed Helen Harrison against a plain ground of light yellow tones in an unusual gauzy white dress set off by a bright red satin over-dress, a costume that suggested to another writer that she was about to take flight to the "regions of Mephistopheles."[84] Another writer found it "decidedly unpleasant" and questioned its worth as a "household companion."[85] Such published remarks about Helen Harrison's portrait seem to have been gauged to encourage moral rather than aesthetic judgments.[86] But, although Henry James provides slight evidence that Sargent may have harbored some dislike for his sitter, it is doubtful that the artist would have actively promoted such readings of the painting.[87] The Harrisons were Sargent's hosts on several occasions at their home, Shiplake Court at Henley along the Thames River, in 1887, visits that yielded a series of fresh outdoor boating scenes done in an Impressionist manner. Had they been displeased with Helen Harrison's portrait, it is unlikely that Sargent would have been invited to stay with them or permitted to paint their son.

Titled *Cecil, Son of Robert Harrison, Esq.*, the painting joined two of Sargent's recent American commissions, *Elizabeth Allen Marquand* (The Art Museum, Princeton University) and *Mrs. Edward D. Boit* (Museum of Fine Arts, Boston), at the 1888 Royal Academy summer exhibition. At the same time Sargent's *Portrait of Claude Monet* (National Academy of Design, New York) was on view at the first summer exhibition of the New Gallery.[88] The cumulative effect of these paintings emphasized Sargent's international status, and, although the portrait of Monet matched the dark naturalism of the other three, it served to remind viewers of Sargent's Impressionist connections. What is more, the four paintings featured sitters of various ages, different sexes, and disparate social positions, as if calculated to advertise the full range of Sargent's talents and appeal as a portraitist. Unlike that of his mother, Cecil Harrison's portrait attracted little attention. And, compared with Sargent's other works on view, the portrait was subdued and seemed to have little in common with the "two tunes" played by the Boit and Marquand portraits, which were interpreted as a "great flourish of bravura" and a "quiet and gracefully flowing 'Cantilene,'" respectively.[89] Yet, as the critic Claude Phillips allowed, even the "almost conventional treatment" of *Cecil Harrison* nevertheless conveyed "the intense vitality which the painter's work never lacks."[90] While Phillips and other reviewers had little to say about the Harrison portrait, their comments about other child portraits in the exhibition are revealing. Immediately following a long discussion of Sargent's contributions, Phillips critiqued the Belgian Emile Wauters's portrait *Mr. C. Somzée*, a full-length portrait of a boy with a dog (fig. 27):

> This, showing a boy dressed in a black velvet suit, with a large falling collar of lawn or some transparent white material, and holding a hoop..., while it has nothing like that real vitality, the possession of which makes Mr. Sargent, in certain moods, so near akin to Hals, is so close and avowed

FIG. 27. Emile Wauters (Belgian, 1846–1933), *Cosme Somzée*, from Paul Lambotte, *Les peintres de portraits* (Brussels: G. van Oest, 1913), unpag. Photograph: Frick Art Reference Library, New York

FIG. 28. Thomas Wilmer Dewing (American, 1851–1938), *Robert Walton Goelet*, 1886, oil on canvas, 65 x 29⅜ in. (165.1 x 74.6 cm). Private collection

an imitation of that painter's outward mastery of handling as almost to amount to a pastiche. It is undeniable that the work has very real qualities of style—somewhat too pompously brought forward—and some power of handling; but it is neither so vigorous nor so life-like as it assumes to be. A master so high among continental artists should be able to furnish something more original and more genuine.[91]

Phillips's designation of *Mr. C. Somzée* as a pastiche was also justified in iconographic terms since the painting engaged the high-art formula for presenting upper-class boyhood: the full-length format, the fancy clothing made of rich materials, and the requisite toy and dog invest the image with a Grand Manner note. Such old master elements were commonly deployed by progressive portrait painters beginning in the late 1880s (in an ironic mode that might be characterized as "pre-postmodern") and would persist especially in depictions of children, as proved by J. J. Shannon's *Sholto and Angus, Sons of Douglas Vickers, Esq.* (Sheffield City Art Galleries, England), which was shown at the Royal Academy in 1911.[92] Artists on the opposite side of the Atlantic were also constructing their own versions of the Grand Manner child for American clients. Thomas Dewing, for example, grafted the dynastic visual tradition onto his own aestheticized depictions of DeLancey Iselin Kane (1887, Museum of the

City of New York) and Robert Walton Goelet (fig. 28), works that literally bear the mark of family history and expectations in the prominently placed family crests (at the upper right corner of the Kane portrait and on the Stanford White frame of the Goelet portrait).

In the context of the Wauters and Dewing portraits, Sargent's *Cecil Harrison* provides a refreshingly unpretentious picture of a boy, yet it retains the high-art imprint of the Grand Manner. The painting is atypically dramatic for a child's portrait, and, surprisingly, it has strong formal affinities with Sargent's earlier *Dr. Pozzi at Home* (pl. 28), his debut painting at the Royal Academy in 1882. Marking the canvas with a rich, low-keyed palette and strong contrasts of light and dark, Sargent forces the viewer to focus on Cecil's face and hands—the most expressive and critical areas of the portrait that may hint at his individuality. These highlighted areas are the primary means to gauge personality in the absence of the standard child-defining accoutrements of toys, pets, or elaborate settings. The boy's contrapposto stance energizes the anonymous space he occupies, an interior setting that is merely suggested by paneling, the starkness of which is relieved slightly by the active brushwork describing the rug. There is an odd combination of readiness and apprehension in the figure; the confidence implied by his stance is counteracted by his slightly anxious, fixed glance that invites narrative explication but does not furnish it. Cecil's gaze takes us outside the frame to an area beyond our sight (and, therefore, knowledge), thus arming the portrait with associations lodged in the potential held by the child's unknown adult future. Astute viewers who remembered *Dr. Pozzi* and the portrait of the boy's mother may have considered Cecil's image in terms of his as yet unformed moral character. The transliteration of Pozzi's exquisite decadence into the drama of boyhood and the memory of Helen Harrison's part in a seamy public scandal would certainly have colored the reception of the painting for those attuned to such things. Even if that were not the case, Sargent's portrayal of Cecil Harrison emphasizes the inaccessibility of the boy's thoughts, thereby infusing the portrait with an unusual naturalism compared with other contemporary portraits of boys.

For the majority of the viewers, however, *Cecil Harrison* likely derived meaning from the current, international fashion of dressing boys in sailor suits, a mode that contributed greatly to the idea that the future was carried in the child's image. The sailor suit conceptually placed male youngsters in a position of "preparedness" for their roles as either captains of industry or the military while capitalizing on the precocity of a child dressed in imitation of an adult. Such meaning was implicit and corresponded with then prevailing child-rearing attitudes especially with respect to middle- and upper-class English boys, who were literally in training for "national" manhood from the beginnings of their formal schooling. These values were reinforced in the novels and stories of heroic deeds recommended for boys' leisure reading that would help build the "moral armour" needed for adulthood.[93] Popular periodicals featured articles about the preferred literature for youngsters of both sexes. One such article, "What Boys Read," appeared in the *Fortnightly Review* and summarized the state of fiction for boys, concluding:

PL. 27 (OVERLEAF, LEFT). *Cecil Harrison* (also known as *The Late Major E. C. Harrison as a Boy*), c. 1888, oil on canvas, 68 x 32⅞ in. (172.7 x 83.5 cm). Southampton City Art Gallery, Hampshire, UK/Bridgeman Art Library

PL. 28 (OVERLEAF, RIGHT). *Dr. Pozzi at Home*, 1881, oil on canvas, 79⅜ x 40¼ in. (201.6 x 102.2 cm). The Armand Hammer Collection, Gift of the Armand Hammer Foundation. UCLA Hammer Museum, Los Angeles, California

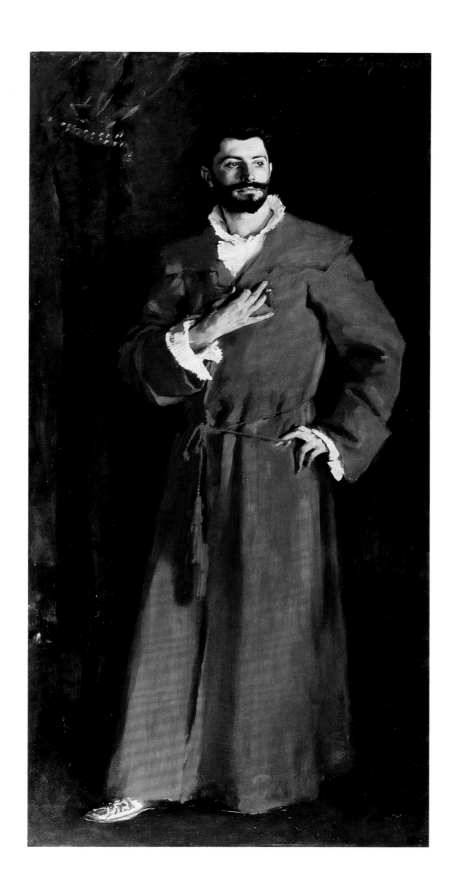

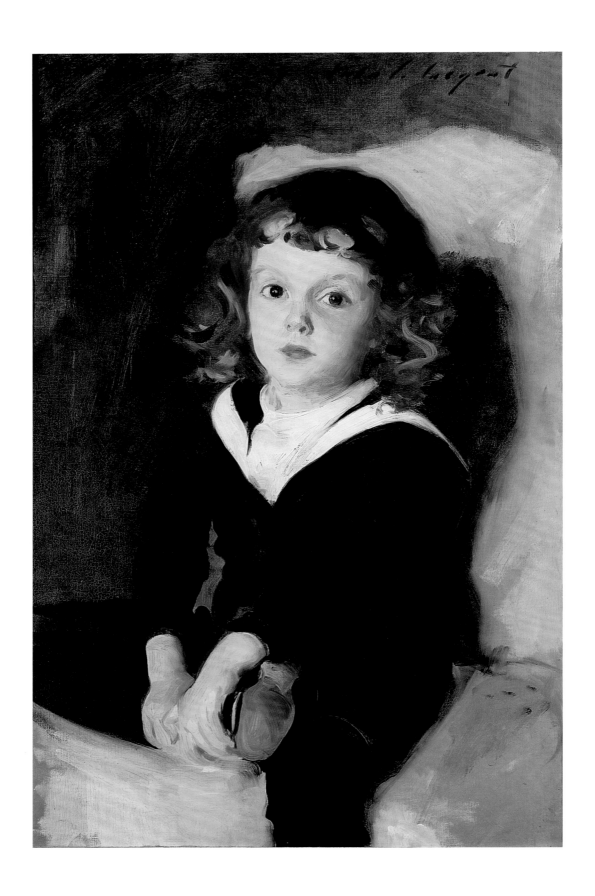

The modern youth compensates himself for the absence of the adventures and general excitement which characterized the times of Drake or Nelson, Clive or Wellington, by devouring the stories of "the brave days of old" poured forth annually from the printing-press. It is impossible to overrate the importance of the influence of such a supply on the national character and culture. Mind, equally with body, will develop according to what it feeds on; and just as the strength or weakness of a man's muscle depends upon whether he leads a healthy or a vicious life, so will the strength or weakness of his moral sense largely depend upon whether he reads in his youth that which is pure or that which is foul.[94]

The fare in juvenile fiction for boys emphasized character building and dutiful ingenuity through military exploits (in, for example, Jules Verne's *Dick Sands, the Boy Captain*). At the same time, fiction took its young readers to the far reaches of the empire (a specialty of W. H. G. Kingston's books *The Iron Horse, The Pirate City*, and *Under the Waves*), simultaneously instilling national pride and providing lessons in history and geography.[95] Although, on one level, the vision of a child in mock naval dress registered as merely the young male's fashion alternative to the big hat for little girls, it encompassed the gendered attitudes that governed the notion of training children for adulthood. In some quarters this betokened a premature loss of childhood, a phenomenon that was gaining greater attention in the press at the time. As one essayist for the *Spectator* put it, "Let us not so admire children that we banish childhood: the child is only blessed so long as he is childlike. When we make him our equal, we drag him from the Eden we perforce quitted long ago, to which neither he nor we can return."[96]

Cecil Harrison, by virtue of the portrait's formality and size, takes a commanding place in a group of Sargent's portraits of boys in sailor outfits, notable examples of which are *Laurence Millet* (pl. 29) and *Caspar Goodrich* (pl. 30). The three portraits illustrate the distinct divisions in Sargent's approach to child portraits. *Cecil Harrison*, as has been shown, was designed for friends who were also important clients. Since it was destined for a domestic interior in which Sargent's striking portrait of the boy's mother was already installed, the artist perhaps sought to "match" the existing work with another that carried similar aesthetic weight. In contrast, the painting of Laurence Millet grew from a different set of circumstances derived from Sargent's affection for the Millet family: the portrait was undoubtedly a gift, as it is inscribed to the boy's mother, Lily, into whose home life Sargent had been welcomed at Broadway. As a work of art, Laurence's portrait occupies a middle ground between *Cecil Harrison* and *Caspar Goodrich*. It is sizable, yet intimate. The four-year-old boy is seen at close range, seated informally with his hands gripping the bent leg he pulls toward him in childlike fashion. His responsive expression leads us to believe that his easy familiarity with Sargent allowed for a natural emotional reaction that enlivens his features during what was assuredly a session or two that required him to muster the self-discipline to sit still. The ironic element of discipline is further insinuated by the sailor suit, an outfit that forecasts the disciplined life ahead of him but here registers as a coy masquerade of

PL. 29 (OPPOSITE). *Laurence Millet*, 1887, oil on canvas, 29 x 20 in. (73.7 x 50.8 cm). Private collection

his adult future. The pose (if we can consider it a pose in the face of its apparent naturalism) signals Sargent's desire to provide a work that would be appreciated by the boy's parents as a private and unceremonious image that was nonetheless executed with the signature flourishes of the master painter. *Caspar Goodrich*, by contrast, is a painting of a slightly older child whose containment—emotional and physical—already appears to be a part of his personality. Seen from above in a manner foreshadowing the composition of the more famous portrait of Mrs. Hugh Hammersley (fig. 54), the boy gazes upward with authority, unintimidated by the experience of sitting under the artist's examining eye. If Laurence Millet's sailor suit was only a fashionable caprice that created an antithetical note to childhood, Caspar Goodrich's demeanor instructs us that he assumes a role that is not only defined by his uniform but is also a part of his family's history. His parents, Rear Admiral Caspar Goodrich and his wife, Florence, were old family friends with whom Sargent stayed in Newport, Rhode Island, in 1887, during his first professional sojourn in the United States. Like the painting of Laurence Millet, Caspar Goodrich's portrait was probably a private token of friendship, in this case given as an expression of thanks for his parents' hospitality. More than that, it hints of a child whose upbringing was shaped by a father who reveled in naval tradition and instilled that tradition in his boy. The almost unnerving authority exuded by Caspar Goodrich is derived both from his pose and from the calm, calculating expression with which he returns his observer's gaze.

Caspar Goodrich became a signature Sargent work for the American audience, despite its sketchy facture and the fact that the painting's subject was "merely" a child. It derived respect partly from the power of the Goodrich name, which added a gloss of propriety to Sargent's reputation when the painting was shown in 1888 in his first one-man exhibition at Boston's St. Botolph Club, where it was displayed among other portraits that likewise bore the names of America's aristocracy.[97] Although it was not featured in the exhibition reviews for the 1888 showing, *Caspar Goodrich* and other images of children probably placated those members of the Boston audience who were reportedly stunned by Sargent's irreverent treatment of his adult sitters. As one critic explained, "Boston propriety has not yet got over the start Mr. John D. [*sic*] Sargent's exhibition … gave it; it fairly jumped at the first sight, and on second thoughts did not know whether it ought to feel really shocked or only amused. It is still undecided … whether it was insulted or delighted. … He actually presented people in attitudes and costumes that were never seen in serious, costly portraits before, and the painting was done in an irreverently rapid, off-hand, dashing manner of clever brushwork."[98] Remarks about social expectations and family position permeated critical commentary and included references to Sargent's descent from "one of the most distinguished of old Boston families."[99] Conservative Bostonians were suspicious of his sincerity. (As one critic stated, Sargent "sometimes … outwhistles Whistler in affectation and eccentricity."[100]) Yet the rapid, summary brushwork that made some viewers uneasy seemed somehow appropriate for the portraits of Caspar Goodrich and Ruth Sears Bacon (pl. 63).[101] The question was raised whether Sargent was even concerned with creating likeness, and that, coupled with comments about the commercial aspect of portraiture, linked him with

PL. 30 (OPPOSITE). *Caspar Goodrich*, c. 1887, oil on canvas, 26 x 19 in. (66 x 48.2 cm). Collection of C. Michael Kojaian

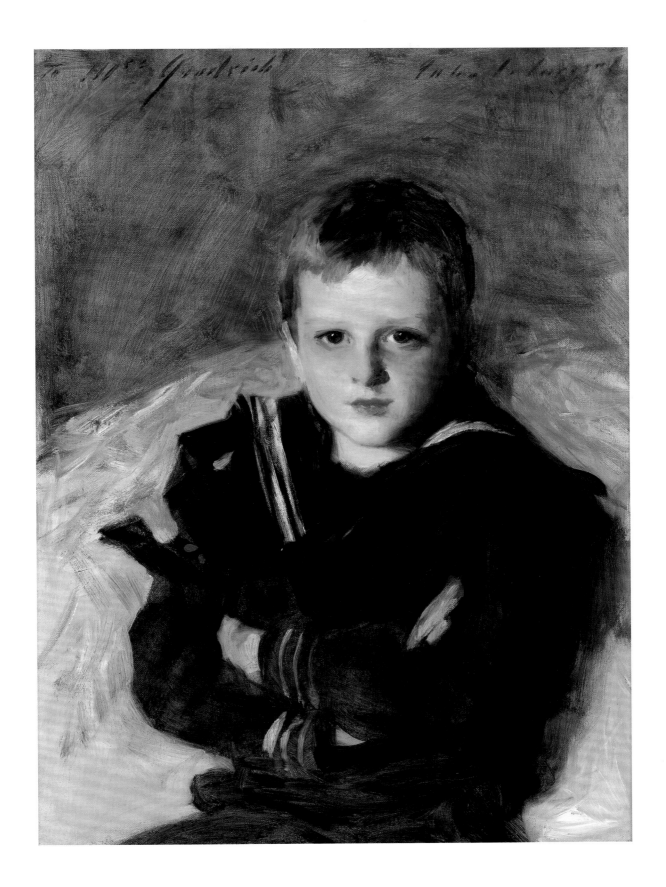

other artists "who cross the Atlantic to deplete our pockets at the expense of our vanity."[102] As a case in point, the columnist Montague Marks, writing as Montezuma, reported that "Mrs. M. F. [Mrs. Malcolm Forbes], of Boston, after giving Mr. Sargent a large sum of money for painting her children, found the picture so unsatisfactory that she banished it to the garret."[103] Published statements such as these bound Sargent's art with the ideas of family name, wealth, nationalistic feeling, and artistic integrity. In such a context, the display of portraits of children belonging to prominent families helped relieve doubts about his suitability as an artist, for they advertised that the "best" people had entrusted their children to his hand.

DOMESTICATING AN AMERICAN REPUTATION

PL. 31 (OPPOSITE). *Cara Burch*, 1888, oil on canvas, 29½ x 24½ in. (74.9 x 62.2 cm). New Britain Museum of American Art. Charles F. Smith Fund, 1942.2

FIG. 29. *Mrs. Charles E. Inches (Louise Pomeroy)*, 1887, oil on canvas, 34 x 23⅞ in. (86.4 x 60.6 cm). Museum of Fine Arts, Boston. Anonymous gift in memory of Mrs. Charles Inches' daughter, Louise Brimmer Inches Seton, 1991.926. Photograph © 2003 Museum of Fine Arts, Boston

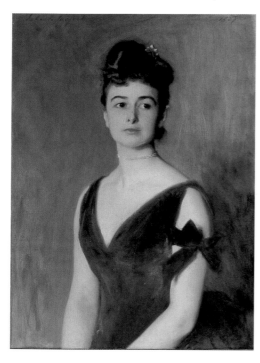

Sargent's mindfulness of the capacity of child imagery to tip the delicate balance of opinion in his favor is demonstrated in his American exhibition pattern from the 1888 St. Botolph exhibition until the 1893 Chicago World's Columbian Exposition, where four of the nine paintings by him depicted children.[104] This public emphasis on his paintings of youthful sitters suggests a subtle campaign to domesticate his reputation for American viewers who were sensitive to the artist's unconventional, "irreverent" treatments of adult sitters.

In 1888 Sargent returned to exhibiting at the NAD, nearly a decade after having debuted at that venue with *Neapolitan Children Bathing* (pl. 14). The reason for his inactivity at the NAD has not been pinpointed, but the resumption of his participation there may reflect the political détente achieved that year between the SAA and the NAD, resulting in the exhibition of works by the more radical SAA elements at the Academy. Heralded as a great success credited to the "new angel of reform," the NAD's 1888 spring annual drew reviews that tended to assess the works according to the artists' professional affiliations.[105] The *Art Amateur* placed Sargent at the head of the artists "without official titles" (meaning outside the NAD membership) and deemed his portrait of Mrs. Inches "alert, handsome, and somewhat self-assertive" and his two Venetian street scenes as the best "sketches" ever to be displayed at the Academy.[106]

In 1889 Sargent showed only three works in New York: *Mrs. Marquand* and *Mrs. F. D. Millet* at the SAA, and *Cara Burch* (pl. 31) at the NAD. The last was a portrait of the daughter of Robert Burch, managing editor of the *Brooklyn Daily Eagle*, and his wife, the former Lizette Montmollin. Although they were not related by blood, Sargent and Cara Burch shared an aunt, and it was probably through that indirect family connection that the portrait came to be arranged.[107] *Cara Burch* deserves comparison with *Mrs. Charles E. Inches* (fig. 29), for even though it portrays a ten-year-old girl, the painting lays claim to the same

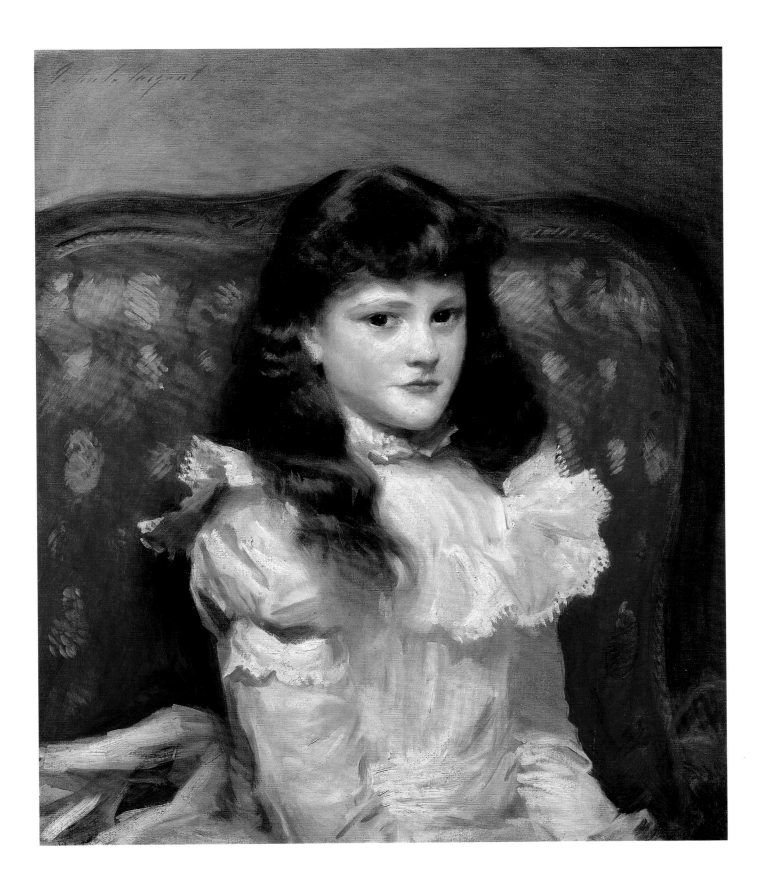

FIG. 30. Abbott Handerson Thayer (American, 1849–1921), *Brother and Sister* (Mary and Gerald Thayer), 1889, 36¼ x 28⅜ in. (92.1 x 72.1 cm). Smithsonian American Art Museum, Washington, D.C./ Art Resource, NY

description dispensed to the portrait of Mrs. Inches—Cara Burch also qualifies as "alert, handsome, and somewhat self-assertive." Both figures are cropped slightly below the waist and are positioned at similar three-quarter angles within the pictorial space. Neither composition includes the hands, those potentially expressive elements that ordinarily provide crucial information about the sitter.[108] Surprisingly, the child's portrait registers with greater intensity for several reasons, not the least of which is her sober, examining expression that betrays her distinct (and perhaps uneasy) awareness of being observed. That intensity is augmented because she is placed close to the picture plane, anchored there in a sliver of space closed off by the upholstered back of the settee that frames her form. The spatial containment of Cara Burch's figure and the directness of her gaze exert an impression of enforced discipline and control, a perception amplified by her erect posture. Both factors combine to form a frank admission that the child is posed "on best behavior." The confession of the pose, as it were, is a refreshingly truthful device that suits the notion that children are guileless and unable to dissemble. In contrast, the distanced, abstracted gaze of Mrs. Inches is meant to suggest that she is not posing—a visual friction that underscores the portrait as a subjective construction created by both artist and sitter.

The critics had little to say about *Cara Burch*, perhaps because it was so straightforward, so lacking in regard to the common fictions of representation. As the reviewer for the *New York Times* remarked, the painting was, with others displayed in a corridor, "hung, with no little cruelty, too near the spectator." The writer continued, "It has charming work on [the] sofa, white-starched and ironed frock, and ruddy cheeks, . . . Though not by any means the best work we have had from this clever hand, it has excellent points."[109] Indeed, there is no romance or pathos in this portrait, something that critics persistently appreciated and expected in child imagery, as witnessed by comments directed at Abbott Thayer's *Brother and Sister* (fig. 30), a work shown at the 1889 SAA exhibition that opened just two days after the NAD display had closed: "Mr. Thayer is at his best in the 'Portrait of Brother and Sister,' than which anything more radically different from the work of Mr. Sargent it would be difficult to conceive. . . . One learns to look through the mannered and somewhat unpleasant technique, and one is rewarded by finding a depth and purity of sentiment which is delightful. One feels the charm of the wistful, childish faces, and one forgives everything else."[110] Another reviewer determined that Thayer's painting was a "wholly delightful piece of work, each face mournful and even wild in expression, as of children who had experienced a great sorrow, but each painted with charming vigor and life. Their sad wild brown eyes and unkempt brown hair give to this young sister and her little brother a most ideal, indeed almost a tragic look!"[111] *Cara Burch* discouraged such readings, partly because of its alignment with society portraiture, but just as likely because of the vivid aura of personality emanating from it. The sharp lighting, bright palette, and direct, examining expression, all served to lodge the image in the present rather than in a timeless,

nostalgic region evocative of childhood. Again, a comment originally directed at *Mrs. Inches* may justifiably also describe *Cara Burch*: "a strong American type of beauty, alert, clear-eyed, firm, and a trifle hard."[112]

Sargent returned to the United States in late 1889. That year he had relatively few commissions and did not exhibit much, although he had been appointed Chevalier of the French Legion of Honor for his showing at the 1889 Paris Exposition Universelle. In contrast, 1890 brought Sargent an almost unceasing flow of American commissions and unprecedented visibility for his art. While maintaining a strong profile in London and Paris, Sargent also sent a staggering number and variety of works to exhibitions in Boston, New York, Chicago, Philadelphia, and Worcester, Massachusetts. With typical finesse, the artist ensured that audiences were guaranteed as complete and dramatic a range of his art as possible. It is in this light that the particular effectiveness and purpose of *Alice Vanderbilt Shepard* (pl. 32) and *Caspar Goodrich* (pl. 30) may be calculated, for the two were among the seven works representing Sargent at the 1890 SAA exhibition that also included his portrait of the infamous Spanish dancer Carmencita (fig. 31).[113] Sargent's uncommissioned portrait of the flashy entertainer registered as a vulgar, but artistic, account of the exotic woman who had fascinated Paris audiences at the 1889 Exposition Universelle and later in New York. Sargent was not immune to the woman's talent for spectacular performance and hired her to dance at a private party in William Merritt Chase's Tenth Street Studio to entice his prized Boston patron Isabella Stewart Gardner to buy the portrait. The painting went unsold, and, when it was shown at the SAA, critics responded to it violently. As one put it, the painting suffered from "too much haste and 'trop d'esprit'" and concluded: "Consequently, in this white-faced, painted, mysterious, evil-looking beauty, with her hands on her hips, her head thrown back and her magnificent yellow dress, he has suggested a whole lot of things that Carmencita herself suggests only vaguely, if at all, and omitted a number of more human and attractive ones that she really possesses."[114] Even critics who applauded the sensational work found the dancer's pose "audacious and provocative."[115] The showy vulgarity of *Carmencita* was not the sole impetus of critical objection; the vibrant Impressionism of *Summer Morning* (also known as *A Morning Walk*, 1888, private collection) offended reviewers on stylistic grounds, and, as one reviewer proposed, "in this case there is a hardness of touch and shrillness of color that might have barred the picture from the exhibition had it been signed by another name."[116]

Such remarks targeting content and style were neutralized primarily by the portraits of the two children. Where one reviewer generally lamented Sargent's hastily painted surfaces, the sketchily rendered *Caspar Goodrich* was considered "rapid and triumphant" by the same reviewer and "frankly and charmingly painted" by another.[117] *Alice Vanderbilt Shepard* also stimulated positive responses and was described as "a very pleasant little girl, with inky hair and a fresh childish skin." The *Collector*'s columnist readily grasped the varied aspects of Sargent's work, claiming technical brilliance for *Carmencita*, the "over-advertised music hall freak," while appreciating the children's portraits: "The 'Portrait of Master Goodrich' is a superb little boy in a sailor's suit, with his arms folded, and that of the little daughter of Col. Elliott F. Shepard is one of the

sweetest and most lifelike child's portraits I can remember to have seen."[118] The ultimate vote of confidence was sounded with the statement that the "portrait of the little girl might hang, unconcerned for its credentials, in a picked gallery of Dutch and Flemish masters."[119] The association of the young girl's image with such an artistic pedigree was hardly accidental, since her refined, quiet beauty corresponded with the reserved mood of social propriety evinced in seventeenth-century northern European portraiture and realized in her own upbringing.

Alice Vanderbilt Shepard, like her portrait, could claim a remarkable heritage.[120] She was the great-granddaughter of Commodore Cornelius Vanderbilt, the famous (and famously wealthy) railroad tycoon whose name, by the end of the nineteenth century, was equated with money; the granddaughter of William H. Vanderbilt, who expanded and spent his father's fortune on sumptuously decorated palatial living establishments and art; and the daughter of the prominent New York attorney, businessman, and newspaper publisher Elliott Fitch Shepard and his wife, Margaret Louisa Vanderbilt. Alice Shepard was raised in the Vanderbilt environment, that is, in a narrow but privileged existence where privacy was strictly guarded and social interaction was kept to the large extended family and close friends. The Shepard household (which occupied part of the famed Vanderbilt Triple Palace on Fifth Avenue) was especially conservative owing to Elliott Shepard's strict religious views. Sargent entered the circumscribed Vanderbilt sphere in 1888, when he was commissioned to paint several female members of the family: Mrs. William H. Vanderbilt, Mrs. Benjamin Kissam (both 1888, The Biltmore Company, Biltmore House, Asheville, N.C.), and Alice's mother, Mrs. Elliott Shepard (1888, San Antonio Museum of Art, Tex.). The painter reportedly first encountered Alice Shepard when he was working on her mother's portrait and immediately sought permission to paint hers. Mrs. Shepard, who had suffered some forty sittings for her own portrait, was reluctant to inflict the same stress on her daughter and was also somewhat diffident about the cost of another painting. Sargent prevailed, however, but not without first agreeing to confine Alice's posing to a cumulative duration of only a few hours and to do it without charge.

A comparison of *Cara Burch* and *Alice Vanderbilt Shepard* is instructive inasmuch as both portraits feature American girls of roughly the same age (ten and thirteen, respectively) in similar compositional formats and poses. The two works are strikingly different, a condition that stems most probably from Sargent's overriding will to paint Alice Shepard, a person who may be seen as an object of his aesthetic desire. Indeed, she is presented as such. Her face is given in slightly more than three-quarter view and, although her expression suggests a lively intelligence, her gaze is slightly averted, thus permitting the viewer complete leave to examine her as if she were an object of fine art. Her *seeming* unawareness of being observed conforms to the niceties recommended for young women in polite society in that they

PL. 32 (OPPOSITE). *Alice Vanderbilt Shepard*, 1888, oil on canvas, 30⅛ x 22 in. (76.5 x 55.9 cm). Amon Carter Museum, Fort Worth, Texas

FIG. 31. *Carmencita*, 1890, oil on canvas, 90 x 54½ in. (228.6 x 138.4 cm). Musée d'Orsay, Paris/Lauros Giraudon–Bridgeman Art Library

were cautioned about exchanging looks, of being too open to even the slightest social overture. Although this is not to say that Cara Burch was anything but a properly raised child, Sargent was nonetheless dealing with girls of vastly different social status and upbringing. Thus, the reserve perceived in *Alice Shepard* is a condition entirely in keeping with her Vanderbilt heritage and the relatively cloistered life that it entailed. In formal terms this is a strong painting, filled with vivid contrasts of light and dark, sweeping lines, and rich textures. Yet it is eminently tender, as witnessed by the delicate modeling of the girl's face. Like the majority of Sargent's child sitters, she is presented without props but for the blue silk pillow that gives her support and justifies a stroke of clarifying color to delineate the form of her right arm against her body. And, as Marc Simpson has observed, it is that pillow that gives hint to the lavishly decorated Herter Brothers interiors inhabited by the Vanderbilts.[121] In essence, and in extension of Simpson's thoughts, the pillow itself functions as a discreet emblem of identity that would permit a sensation of recognition for family intimates but remains a decorative, meaningless prop for casual viewers. Apart from the obvious pleasure Sargent derived from painting this child, the portrait's display in 1890 provided assurance to a range of potential elite patrons that he could transcend his reputation as a painter of the "clever" and the "audacious" with portraits possessed of undeniable subtlety and propriety.

Sargent's American reputation as an artist sensitive to the psychology of his sitters was finally solidified with the 1890 display of two large double portraits of mothers and sons: *Portrait—Son of Mr. Saint-Gaudens* (pl. 66), shown at the Art Club of Philadelphia, where it received a gold medal, and *Portrait of Mrs. E. L. Davis and Her Son* (pl. 34), shown at the autumn exhibition of the NAD. The two works immediately became hallmarks of Sargent's American output. The origins of the first, a portrait of Homer, the son of Sargent's close friend the sculptor Augustus Saint-Gaudens, are discussed elsewhere in this volume (see "Posing Problems: Sargent's Model Children"), and here it will simply be noted that critical response to the painting was extraordinarily and universally positive. As the columnist for the *Art Amateur* declared about the boy's portrait, "The exquisite truth of its pose and the rare vitality of every line of the body, no less than the beautiful face itself, reveal the power of a master."[122] Thus, all focus was on Homer Saint-Gaudens—despite the presence of his mother, who functioned merely as an ancillary, defining element in support of the delineation of American boyhood. The canvas was the only one Sargent sent in 1891 to Paris, where it represented him at the Société nationale des beaux-arts, a move that may well be taken as proof of his plan to reorient his reputation in France as well.[123]

By then, however, Sargent's readjustment of his artistic persona had reached a triumphant climax at the 1891 SAA exhibition with *Beatrice Goelet* (fig. 32, pl. 49). The full-length portrait of the little

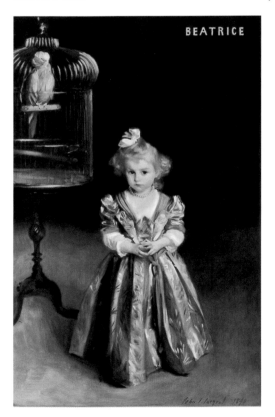

FIG. 32. *Beatrice Goelet*, 1890, oil on canvas, 64 x 34 in. (162.6 x 86.3 cm). Private collection. Photograph courtesy of Adelson Galleries, Inc., New York

daughter of one of New York's most illustrious families occupied the same place of honor given to *Carmencita* the previous year, and the contrasting impression of the vulgar but brilliantly painted dancer lingered in the memories of the critics, heightening their already favorable reactions to the Goelet canvas.[124] Vaunted by artists and critics alike, *Beatrice Goelet* took center stage in the New York art world.[125] The review from the *New York Times* typifies the general critical opinion of the painting:

> Accustomed to see Mr. Sargent represented by likenesses of sophisticated men and women, or by those to whom he has lent, for the purposes of sensation, a complexity which is foreign to their natures, it is a great pleasure to find him dealing with a little child in whom a pose, an affected contortion, a flower that does not and is not meant to agree in color with its surroundings, is not necessary to force a sensational triumph. Confronted by the simple naivete of a little child, Mr. Sargent acts more simply, and of a certainty he sets in a more masterly fashion. A gilt cage containing a cockatoo, beautiful in plumage, a dress for the small lady which recalls the streaked variety of tulips, and her name blazoned large in gold letters in one corner of the canvas—these are accessories which are novel and pleasing enough in themselves, but are not the best of the picture. Hair, face, and figure are most charmingly painted. The expectant, undismayed face, the small hands touching each other in front with a gesture which would be resignation in a grown person, the serious, waiting expression of childhood, are given here with the most delightful simplicity and truth. Mr. Sargent is represented at the Society, as he is not at the Academy of Design.[126]

It was presumably the same writer who had two weeks earlier complained of Sargent's NAD display (a portrait of an unidentified woman and *George Vanderbilt*). Citing the artist's unhealthy bravura manner that detracted from the truth of the sitter, the writer lamented, "Into such queer vagaries is a popular portrait painter driven in his endeavor to fabricate an extra dose of individuality."[127] A year later, *Beatrice Goelet* was still held to represent the best of what Sargent's art had to offer: "It is no fault of ours that it has become our duty now to point out that his present reputation is more or less hollow. It is founded mainly on his phenomenal cleverness. . . . But he has a keen, if not very profound insight into character, and his portraits are revelations. We might spare some of them; for he has a perverse knack of showing us what 'canaille' his sitters might become, rather than what respectable persons they are in existing circumstances. But innocence has sometimes a great charm for him; witness his portrait of little Miss Goelet—in all respects his best work."[128]

Sargent's current reputation as a giant among late nineteenth-century painters obscures the notion that he might ever have experienced moments of self-doubt or would have needed the comfort of praise. However, a letter from Sargent to the American writer Marianna Van Rensselaer reveals his sensitivity to critical opinion:

My dear Mrs. Van Rensselaer,

I am sure you must be the author of an article that has been sent me from N.Y. in which Mrs. Davis' picture [*Mrs. Edward L. Davis and Her Son Livingston Davis*] receives very high praise, because it seems to have touched a sentiment in the writer like what you expressed about the Goelet baby, and very few writers give me credit for insides so to speak. I am of course grateful to you for writing, but especially for feeling in the way you do, for it would seem that sometimes at any rate for you, I hit the mark. Please believe me, Yours sincerely, John S. Sargent.

I feel as if I ought to have written a much longer letter to give you any idea of how much pleasure and what kind of pleasure you have given me.[129]

Beatrice Goelet went on display again at the NAD in the 1895 *Loan Exhibition of Portraits for the Benefit of St. John's Guild and the Orthopaedic Hospital*, one of a series of charity exhibitions staged in New York and Boston in the 1890s that were inspired by London's "Fair Women" exhibitions.[130] These exhibitions deserve further investigation. Not only were they aesthetic barometers of historic and contemporary portraiture in the United States, but they were also mechanisms, couched in affirmative philanthropic aims, that confirmed the existence of an American aristocracy—artistic and social—that helped dispel fears of national decline. Such public exhibits uniquely joined the two aristocracies as they were linked in Sargent's *Beatrice Goelet*, which again earned considerable critical laurels in 1895. Royal Cortissoz, for example, found it "so lovely in its design and style, in its spirit and in its execution, that old or modern, there is very little to compare with it in its field. This is childhood in its quintessence, the flower of recent pictorial art in its relation to the most ravishing of models."[131]

Sargent's history of achieving unqualified success with his children's portraits may provide a rationale for his representation at the 1893 World's Columbian Exposition. There four works depicting American youth—*Katharine Chase Pratt* (pl. 33), *Alice Vanderbilt Shepard* (exhibited as *Portrait*; pl. 32), *Portrait* (*Homer Saint-Gaudens*; pl. 66), and *Mother and Child* (*Mrs. Edward L. Davis and Her Son Livingston Davis*; pl. 34)—tempered the view of Sargent as he was otherwise represented in the marvelously painted but "barbaric" *Ellen Terry as Lady Macbeth* (Tate Britain, London), the exotic and sensual *Study of an Egyptian Girl* (on loan to the Art Institute of Chicago), and the fine society portraits *Mrs. Charles Inches*, *Helen Dunham* (private collection), and *Alice Mason* (private collection). What is more, the element of domestic wholesomeness as purveyed in Sargent's paintings of children intersected with controlling issues that found a platform for discussion in the broader range of commentary devoted to the fair—primarily, nationalism and race.

The World's Columbian Exposition—the Chicago World's Fair—was a grand spectacle that assembled what was considered the best of American culture and industry and celebrated it in the context of the four-hundredth anniversary of Columbus's arrival in the New World. Using a subjectively chosen foil of representative world cultures, the fair's organizers ultimately strove to unify an increasingly diverse American

public by promoting a sense of national identity, counting on a groundswell of pride to be generated by the opportunity to compare American products, inventions, and arts in an international arena.[132] The fair exerted significant influence on American culture well before its official opening. Particularly germane to this study of child imagery is the importance that the fair's organizers placed on enlisting the interest and participation of the nation's children in the cause of patriotism. This goal was realized, in part, by the editors of the *Youth's Companion*, one of whom, Francis J. Bellamy, was head of the planning committee for the fair's dedication ceremonies. Working from the belief that the coming generation would be instrumental in proving the nation's superiority, Bellamy's public relations strategy was extraordinarily effective; he wrote the Pledge of Allegiance, the simple but moving oath of loyalty that was performed by children at the fair's dedication events and that would soon be recommended by the Federal Bureau of Education as an appropriate national ritual for the country's schools.[133] Given that the American child was positioned as the central receiver and distributor of national loyalties, it is of interest to consider here, however briefly, the iconography of Sargent's children in the context of other childhood images displayed at the fair.

PL. 33. *Katharine Chase Pratt*, 1890, oil on canvas, 40⅜ x 30⅛ in. (102.6 x 76.5 cm). Private collection. Photograph courtesy of A. J. Kollar Fine Paintings, Seattle, Washington

A survey of the American paintings exhibited in Chicago reveals that a significant number of works featured children in portraits and genre paintings. Whether this concentration was intentional on the part of the several selection juries responsible for the final list of works to be shown, the emphasis on youth was consonant with a portion of the thematic programming behind the fair's organization. As it would be expected, the genre paintings reflected each artist's particular training, subject specialty, or geographic base of operation. Thus, for example, the orientalist Frederick Bridgman (1847–1928) showed *Fellahine & Child—The Bath, Cairo*, Elizabeth Nourse (1860–1938) showed *A Family Meal* (1891) and *The Reader* (1889), both of which displayed European peasant children, and J. G. Brown (1831–1913) was represented by several canvases featuring his urban American street urchins. Sargent, of course, was represented by portraits (except for *Study of an Egyptian Girl*), and it is fair to say that his works, along with other portraits of attractive American children in the exhibition, accrued additional meaning from the contrasts provided by works depicting children of other cultures and/or American youngsters of desperate economic and social circumstances. Such contrasts were already a part of American visual and literary experience, and it is interesting to note that child imagery was a potent tool for generating

support of various social reforms. Jacob Riis's *How the Other Half Lives*, published in 1890, is perhaps the most famous example of this trend, and although he did not focus exclusively on the plight of children, his photographs of destitute urban waifs certainly buttressed the main thesis in his campaign for reform: "Nothing is now better understood than that the rescue of the children is the key to the problem of city poverty, as presented for our solution to-day; that a character may be formed where to reform it would be a hopeless task."[134] Among the fiction writers who took up reform causes was Stephen Crane. Crane's first novel, *Maggie: A Girl of the Streets*, traces the short and tragic life of a young girl of Irish immigrant parents and opens with a scene of graphic violence in which two gangs of little boys battle on New York's streets while nearby adults passively observe the fracas. Crane's descriptions of the bloodied combatants as "tiny, insane demons," "true assassins," "barbaric," and "blasphemous" conflicted with idealized presentations of childhood (for example, Louisa May Alcott's *Little Men*) that permeated the bulk of literary production at the time. Crane's introductory chapter set the tone for the novel, which was so shocking that the author initially resorted to publishing the book privately under the pseudonym Johnston Smith in 1893. A sanitized version was published under his name in 1896 by D. Appleton and Company.[135]

Acknowledging childhood's role as a platform for staging social arguments in one cultural arena—whether in fiction or journalism—entitles us to assume that comparable frames of reference shaped the reception of child imagery in the fine arts. But ascertaining levels of reception is a complicated and inexact process and can only be stated in generalities to form a picture of probable response. In that connection, the mother-and-child image provides a useful and clearly defined motif from which to launch a brief investigation of the meaning that two of Sargent's paintings may have held in the context of the World's Fair galleries. Although technically portraits, Sargent's *Portrait of a Boy* (pl. 66) and *Mrs. Edward L. Davis and Her Son Livingston Davis* (pl. 34) function within the broader mother-and-child theme that in Western art rests in associations with the Christian Virgin and Child. This in itself is a grand assumption, but it is validated by contemporaneous writing. In *Child-Life in Art*, of 1895, Estelle M. Hurll wrote, "The poetry of childhood is full of attractiveness to the artist. . . . The Christ-child has been his highest ideal. All that human imagination could conceive of innocence and purity and divine loveliness has been shown forth in the delineation of the Babe of Bethlehem. The influence of such art has made itself felt upon all child pictures."[136] In that light, then, any mother-and-child motif would, for some viewers (and especially an "art audience"), contain iconographic undercurrents linking the seen image with the foundational construct of the Madonna and Child. Yet if the motif is used as a baseline reading for meaning, then an array of nuanced thematic variations emerges from the paintings displayed at the fair. Considered in conjunction with Charles F. Ulrich's *In the Land of Promise—Castle Garden* (fig. 33), in which a young immigrant woman nursing a child commands the pictorial space, Sargent's mother-and-child portraits represent the ideals of that promise and act as vivid reminders that family heritage and economic advantage were mitigating factors in its fulfillment. And, depending on the political leanings of the viewer, Ulrich's Madonna

PL. 34 (OPPOSITE). *Mrs. Edward L. Davis and and Her Son Livingston Davis*, 1890, oil on canvas, 86⅛ x 48¼ in. (218.8 x 122.6 cm). Los Angeles County Museum of Art, Frances and Armand Hammer Purchase Fund, M.69.18. Photograph © 2004 Museum Associates/LACMA

and Child could be instrumental in arguments either for or against the nation's immigration policies: they can be read as persons deserving succor and sympathy or persons whose presence could threaten the stability of the privileged Anglo-Saxon power structure.

Similar discourses are stimulated by Cecilia Beaux's *Les Derniers Jours d'Enfance* (*The Last Days of Infancy*; fig. 34) and George de Forest Brush's *Mother and Child* (fig. 35), for neither captures the sensibility of American optimism present in Sargent's paintings. Beaux's work (a portrait of her sister and nephew) concentrates on the mother's bittersweet feeling of loss associated with her child's transition from one stage of development to another. Brush's composition—a portrait of his wife and son Gerome—is so reliant on Renaissance Virgin-and-Child predecessors that its iconography subverts a contemporary reading and defeats the notion of American inventiveness. None of this is to say that these paintings were not well received by critics, because they were. Of concern here is how Sargent's portraits of boys and their mothers registered within this assortment. Interestingly, reviewers also discovered connections with religious imagery in Sargent's mother-and-child portraits, and, as one writer noted about the portrait of Homer Saint-Gaudens, the painting "avows the divinity of the maternal tie as seen in the thoughtful boy leaning with simple trust at his mother's side. The costume sinks away, the accidents of time and place count nothing…it breathes the human significance which makes one soul stand for all."[137] The same words are equally applicable to the tender intimacy disclosed in *Mrs. Edward L. Davis and Her Son Livingston Davis*, and they gain even more relevance given the (perhaps) accidental halo effect

FIG. 33. Charles Frederic Ulrich (American, 1858–1908), *In the Land of Promise—Castle Garden*, oil on wood panel, 28$\frac{3}{8}$ x 35$\frac{3}{4}$ in. (72.1 x 90.8 cm). In the Collection of The Corcoran Gallery of Art, Museum Purchase, Gallery Fund

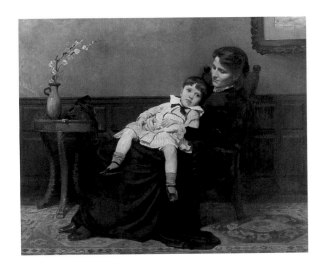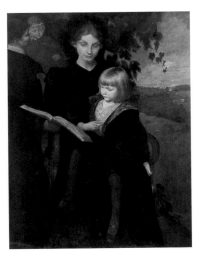

created by the hat that frames the boy's serene, intelligent face.[138] Although the painting's dramatic tenebrism and fluid brushwork endow it with a formal power equal to that of *Ellen Terry as Lady Macbeth*, the child subject matter relieved the visual tensions: "Many of his portraits are more facile than tasteful; but one full length, called 'Mother and Child,' cannot but meet with universal approval—it is so quiet in pose, so excellent in its color scheme of cool grays, in its sense of solidity, in its simple painting of textures. It is a model of refinement and good taste, beside which the not too successful experiment of 'Miss Terry as Lady Macbeth' becomes a mere falsetto note."[139] Refined and tasteful, Sargent's portraits of these American boys and their mothers conveyed a healthy positivism that boded well both for the sons portrayed and for the nation.

Although Sargent's portraits of Alice Vanderbilt Shepard and Katharine Pratt received far less critical comment, the manner in which they were installed in the American galleries at the fair also sent a message of positive promise embodied in America's children. Photographs of portions of the installation (figs. 36, 37) show that the portrait of Alice Shepard was placed on the left side of a doorway on the other side of which was Sargent's *Mrs. Charles E. Inches* (fig. 29). As viewers approached the threshold, they would have seen Alice "looking" across the space to the similarly scaled and similarly posed Mrs. Inches; they thus formed a set of images that suggests the girl looks toward the type of womanhood into which she would mature. Anchoring the opposite end of the same wall occupied by Alice was *Katharine Pratt*, an unusually Romneyesque portrait of an adolescent girl dressed in white and positioned against a landscape backdrop. Above her and to the right on the center of the wall was Sargent's wonderfully tension-filled *Helen Dunham*, whose scale and composition relate to *Katharine Pratt*. Here, too, these works seem to have been purposefully juxtaposed to accentuate a process of maturation, a message augmented by Beaux's *Les Derniers Jours d'Enfance* (*The Last Days of Infancy*), which topped the paintings grouped on that wall.

Although Sargent likely had no hand in the arrangement of his paintings at the fair, the hanging committee, headed by Charles Kurtz, appears to have responded as sensitively as possible to the large number of works it was charged with installing.[140]

In the instance of Sargent's paintings, the placement of *Mrs. Inches* across from the grouping of *Alice Shepard*, *Katharine Pratt*, and *Helen Dunham* suggests that the committee derived from Sargent's works a larger, cumulative meaning that harmonized with the goals of the organizers of the American display; that is, that American art, like the nation, was also maturing, leaving its infancy and entering a new phase of development. This theme was recalled numerous times in the reviews for the exhibition. Repeated as well was the question of whether there was a detectable "American school of art." Sargent scored significantly in this regard despite the fact that he had never actually lived in the United States. A chorus of American critics voiced a constant refrain, claiming that the art of Sargent, Winslow Homer, George Inness, Brush, and Thayer was distinctively American and showed "the influence of birth and heredity—this insistent unconscious patriotism." Sargent triumphed especially because of the marvelous flexibility he displayed: "His method and coloring are simple where his subject is simple, and complicated when he wishes to express varied emotions. Occasionally, as in the beautiful portrait of the son of St. Gaudens, he touches childhood as simply and reverently as Abbott Thayer himself; but his range is wider than Thayer's.... In the variety and beauty of the portraits he exhibits here and in their convincing, often impetuous life, Sargent proves himself one of the few great painters that America has produced."[141]

Since all but two of the nine works by Sargent on display were portraits of Americans whom he had painted in America, the strength of his European connections was downplayed. This further enabled critics to assert and justify Sargent's "Americanness," to which they could then attribute his originality and "distinct individuality."[142] The metaphors describing the nation's evolutionary passage from cultural infancy and childhood to maturity relied on associations of newness, freshness, energy, and independence. Sargent's portraits of children displayed at the fair reinforced those associations by presenting viewers with a vision of American childhood that was natural, dignified, and highly individualized. As such, they supported the belief that the nation's evolutionary progress was paralleled and, in fact, driven by a similar progression that could be traced in its children. For Sargent, it meant that his reputation in the United States was securely domesticated and nationalized.

"APPREHENDING THE PARTICULAR SIGNIFICANCE OF CHILDHOOD"

As this focused survey of Sargent's exhibition history shows, he put to good use portraits of children to create an alternative view of his reputation as a painter of clever, superficial portraits of high society beauties and matrons. This was noted by his biographer Evan Charteris, who summarized Sargent's position in the early 1890s: "He was already perhaps a little tired of the hackneyed view that his portraiture was deficient in

FIG. 36 (OPPOSITE, TOP). Gallery 3, north and east walls, United States section, showing Sargent's paintings hanging on opposite sides of the doorway. Photograph by C. D. Arnold, from Arnold, *Official Photographs of the World's Columbian Exposition*, vol. 8, pl. 83. Special Collections and Preservation Division, Chicago Public Library

FIG. 37 (OPPOSITE, BOTTOM). Gallery 3, west and north walls, United States section, showing three of Sargent's portraits on one wall and his *Ellen Terry* featured on the long (west) wall. Photograph by C. D. Arnold, from Arnold, *Official Photographs of the World's Columbian Exposition*, vol. 8, pl. 87. Special Collections and Preservation Division, Chicago Public Library

feeling and he was a pitiless revealer of his sitter's defects. It was therefore something to the good that when he set out to paint childhood he could satisfy critics on the lookout for emotional quality in his work. No artist deficient in tenderness of feeling, no artist not gifted with the power of finely apprehending the particular significance of childhood could have painted these two pictures [*Beatrice Goelet* and *Laura Lister*, the latter of which is discussed below]."[143]

The remainder of this essay explores how Sargent's reputation continued to be modulated by his display of child portraits and genre paintings featuring children after he had become established as a leading artist in France, England, and the United States. To that end it is necessary to break from the strict chronological exploration adopted in the first portion of this text, mainly to accommodate the changes in Sargent's exhibition pattern and also to permit a deeper discussion of his treatment of specific themes that demonstrate, in Charteris's words, the painter's "power of finely apprehending the particular significance of childhood."

Sargent's elevation to the company of the "great" American artists was accomplished during his absence from American soil. He had left the United States in late 1890 and did not return until April 1895, to supervise the installation of the first phase of the Boston Public Library mural cycle. In 1891, when *Beatrice Goelet* was accruing honors for him in New York and his portrait of Homer Saint-Gaudens was representing him in Paris, Sargent was still struggling in England to solidify his position in a highly competitive and conservative portrait market. His reputation for unpredictability and strangeness had persisted, understandably so in light of the often experimental works that he showed at various London venues. The year 1890 had been a discouraging one for him in London. The united critical response to his *Portrait of a Lady* (*Clementina Anstruther Thomson*, 1889, Mr. and Mrs. Stanley Cohen) judged it one of the most disappointing works in the summer Academy exhibition. Deeming it "a graceless figure in a hideous mauve dress," the *Illustrated London News* reviewer concluded, "we can only hope that its acceptance by the council is not intended to try the endurance of the public or to destroy the popularity which Mr. Sargent honestly earned by some of his earlier works."[144]

The next year, 1891, proved particularly confusing for critics who attempted to clarify Sargent's place in the arts; the Royal Academy audiences saw the fiery *Carmencita* (fig. 31) with the relatively unimpressive *Portrait of Mrs. Thomas Lincoln Manson*. Most puzzling was the *Miss Elsie Palmer* (pl. 35), his only work on view at the New Gallery (and the only other work he exhibited in London that year). Bewildered writers reacted to the hypnotic gaze of the teenage daughter of the wealthy Americans General and Mrs. William Jackson Palmer, who had moved to England in the 1880s and formed part of the circle surrounding Henry James. While generally conceding that the painting was "by far the most wonderful in its own way," the writer for the *Magazine of Art* continued, "She gazes straight out of the canvas at the spectator with an extraordinary, almost crazy, intensity of life in her wide-open brown eyes. Even here, the element of a perverse joy in mystifying the Philistine is not wholly absent; yet the irresistible force and fascination of this singular embodiment of youthful vitality cannot

PL. 35 (OPPOSITE). *Miss Elsie Palmer*, 1889–90, oil on canvas, 75⅛ x 45⅛ in. (190.8 x 114.6 cm). Colorado Springs Fine Arts Center. Museum Purchase, funds acquired through Public Subscription and Debutante Ball Purchase Fund

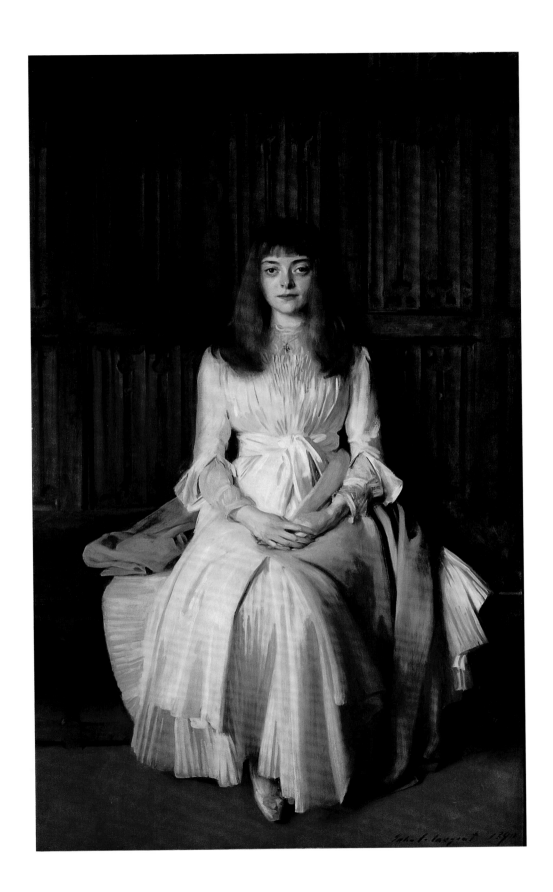

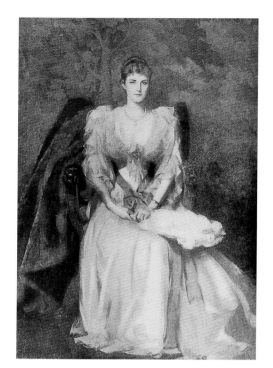

FIG. 38. James Jebusa Shannon (Anglo-American, 1862–1923), *Duchess of Portland*, c. 1891, from *Munsey's Magazine* 14 (November 1895), 134. General Research Division, The New York Public Library, Astor, Lenox and Tilden Foundations

be gainsaid."[145] Elsie Palmer's hieratic pose and blank, staring expression dominated the gallery, unnerving viewers who, as one critic offered, were almost "repelled by the directness and force" of the painting.[146] The critics' inevitable search for comparative works in the galleries usually established J. J. Shannon's *Duchess of Portland* (fig. 38) as having the closest kinship, but their findings were based only on similarities of pose and dress. In the end, Sargent's painting went unmatched because of the "merciless analysis of character which is the essence of Sargent's talent."[147]

The fascination exerted by *Miss Elsie Palmer* stems both from Sargent's response to the girl's actual wide-eyed appearance and from his interpretation of her as an adolescent. In the latter respect, Elsie's sibylline countenance corresponds with the mysterious emotional and physical transformations that were associated with that phase of life. The idea of adolescence achieved remarkable force in cultural and scientific arenas about 1890, when studies (both literary and scientific) focused on the years bridging childhood and adulthood and offered interpretations of it not only as a physical awakening of sexuality but also as an evolutionary stage in individual human consciousness that paralleled the development of the species itself. Although there existed no absolute definitions of adolescence, as a concept it offered compelling material for novelists, among them Henry James, the mutual friend of Sargent and the Palmers. James's novels and short stories are filled with child and adolescent characters whose impressions of their surroundings form the nexus of his plots. From his first serious novel, *Watch and Ward* of 1871, James had concentrated on the "riddle of formless girlhood," a subject that he submitted to exceptional interrogation in his novels of the 1890s through such characters as the all-seeing Maisie in *What Maisie Knew* and the morally compromised Nanda Brookenham in *The Awkward Age*.[148] If Elsie Palmer does not embody the outward vitality of James's characters, she nonetheless recalls "the idea of an inner self" that was central to James's portrayals.[149] Physically isolated and motionless, Elsie occupies that Jamesian "comparative dimness" where "female adolescence hovered and waited."[150] Emerging at the same time was the stereotype of adolescence as an emotionally stressful passage that compromised rational thought. As the pioneering psychologist G. Stanley Hall later wrote: "Puberty is the birthday of imagination.... in many sane children, their own surroundings not only shrivel but become dim and shadowy compared with the realm of fancy. This age is indeed sadly incomplete without illusions, and if the critical faculties which are later to slowly decompose them are not developed, the youth is rapt, apart, perhaps oblivious of his environment, and unresponsive to its calls, because his dreams have passed beyond his nascent and inadequate power of control."[151]

Although many of Hall's methods and his conclusions have since been dismissed, his groundbreaking efforts in the study of adolescence are important indicators of prevailing late nineteenth-century, upper-middle-class, urban attitudes about that phase of life. In general, there was no doubt as to the physical or mental stresses that

characterized the passage between childhood and adulthood, but there were constant debates about how to deal with them, as there are today. For the purposes of this essay, John Neubauer's theory of "interlocking discourses" must suffice to demonstrate the newfound relevance of adolescence in fin-de-siècle Western culture. Neubauer proposes "that adolescence 'came of age' in the decades around 1900, not only because the term itself had [had] little currency earlier, but [also] . . . because interlocking discourses about adolescence emerged in psychoanalysis, psychology, criminal justice, pedagogy, sociology, as well as in literature. . . . [T]he appearance of the interlocking discourses testifies that human life was perceived in terms of a new category by the end of the nineteenth century."[152] The central interpretative tool for Neubauer's methodology is the wealth of contemporary fiction that focused on adolescents as main characters, a strategy that he adopts because of his belief that "literary structures and narrative modes . . . encode social and historical issues."[153] Following Neubauer's rationale, it therefore seems valid to compare James's literary imagery to Sargent's visual imagery, not to find specific, consciously mechanized correspondences, but, rather, to see both stemming from a common cultural ground. Furthermore, it is equally justifiable to extend Neubauer's parameters to include the visual arts.[154] In that context, *Miss Elsie Palmer* takes on added, if not new, meaning when it is juxtaposed with such works as the Norwegian Edvard Munch's *Puberty* (fig. 39) and Abbott Thayer's *Virgin Enthroned* (fig. 40), for Sargent's image incorporates the psychic and physical sensibilities of the former and the sacralized view of the adolescent girl that informs the latter. The portrait's extended meaning as a representation of adolescence seems to have been generally understood in the English art community, as witnessed by Edward S. Harper's *Great Expectations*, a painting shown at the Royal Academy in 1895 (fig. 41).

From the beginning of his career, Sargent had portrayed adolescence as a special, separate condition. For example, the two older Boit girls and Edouard Pailleron Jr.

FIG. 39. Edvard Munch (Norwegian, 1863–1944), *Puberty*, 1894–95, oil on canvas, 59⅝ × 43¼ in. (151.5 × 110 cm). Nasjonalgalleriet, Oslo, Norway/Index/ Bridgeman Art Library

FIG. 40. Abbott Handerson Thayer (American, 1849–1921), *Virgin Enthroned*, 1891, oil on canvas, 72⅝ × 52½ in. (184.3 × 133.2 cm). Smithsonian American Art Museum, Washington, D.C./Art Resource, NY

FIG. 41. Edward S. Harper (English, 1878–1951), *Great Expectations*, c. 1895, from *The Academy Notes 1895 with Illustrations of the Principal Pictures at Burlington House*, ed. Henry Blackburn (London: Chatto and Windus, 1895), 82. Brooklyn Museum Library Collection

are detached from their younger siblings not only because of their compositional placement but also because they seem psychologically unapproachable. This same sense of emotional distance surfaces in *Olivia Richardson* (pl. 36), *Dorothy Barnard* (pl. 37), and *Katharine Chase Pratt* (pl. 33), works of differing styles and origins that nonetheless communicate the impression of the impenetrable interiority associated with adolescence. Sargent seems to have intentionally capitalized on the contemporaneous awareness of adolescence when he exhibited *On His Holidays, Norway* (pl. 38) and *Essie, Ruby, and Ferdinand, Children of Asher Wertheimer* (pl. 39) at the New Gallery in 1902, the art season that was declared Sargent's "year of triumph."[155] Indeed, with eight major works on display at the Royal Academy (including *The Acheson Sisters* [Devonshire Collection, Chatsworth, Bakewell, England], *The Misses Hunter* [Tate, London], and *The Duchess of Portland* [private collection]) and three others at the New Gallery, it was a banner year for the artist.[156]

Critics could not help but compare *On His Holidays* and *Essie, Ruby, and Ferdinand*. The two unusually large paintings were installed in the same gallery, both portrayed children of approximately the same age (all could roughly qualify as adolescents), and both were portraits of children whose fathers were noted collectors. The boy in *On His Holidays* was Alexander McCulloch, the son of the Glasgow-born George McCulloch, who had amassed a fortune in Australia and in 1893 retired to London, where he filled his Queen's Gate home with a collection of several hundred works by contemporary English and French painters.[157] Essie, Ruby, and Ferdinand were three of the ten children of Asher Wertheimer, a successful London dealer and collector, who was also Sargent's friend and patron. The reviewer for the *Spectator* praised both works as examples of the artist's "astonishing range" and anchored his

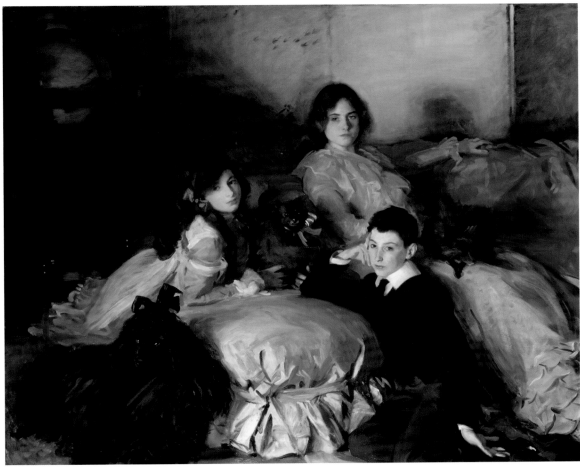

lengthy commentary on a subtext of hereditary difference (namely that the Wertheimers were Jews and the McCullochs were not) that surfaced in his discussion contrasting the artifice of the Wertheimer portrait and the naturalism of the other: "In the *Children of A. Wertheimer, Esq....* the moral atmosphere of an opulent and exotic society has been seized and put before us. So in *On His Holidays, Norway...* the freedom of life out of doors, and the joy of existence by those sounding waters, are fixed and made permanent."[158]

Such readings of difference were rooted in perceptions of ethnicity on which some reviewers focused to delineate the separateness of Jews from the mainstream of British society. The stereotyped Semitic "otherness" of the Wertheimers was also asserted by another critic who described the children as "variously and gaudily dressed; they lie about among cushions like odalisques in a harem."[159] Whether Sargent intended this kind of message is unknown, but the visual language of contrasts embedded in the two paintings certainly accommodated such racial interpretations in England's notoriously xenophobic and class-oriented social structure.[160] Moreover, given the fact that the sitters were children of well-known men of financial substance, a portion of the New Gallery audience would have been predisposed to considering issues of inheritance (whether of fortune or blood). What was not mentioned in the reviews of the paintings, however, is how Sargent connected these disparate images under the growing iconographic rubric of adolescence by showing these children in relaxed physical states—an approach that resonates with then popular attitudes about the prerequisites for a healthy adolescence.

PL. 40. *Shoeing the Ox*, c. 1910, oil on canvas, 22 x 28 in. (55.9 x 71.1 cm). Aberdeen Art Gallery & Museums, Scotland

One of Hall's principal tenets was that the energy expended as a result of the physical changes that occur during adolescence was paralleled by the mental energy exerted in the process of establishing identity. Those energies needed to be conserved, or balanced, for, as he contended: "We are progressively forgetting that for the complete apprenticeship to life, youth needs repose, leisure, legends, romance, ideal-ization, and in a word humanism, if it is to enter the kingdom of man well equipped for man's highest work in the world."[161] In this light, adolescence was a pivotal moment in human development inasmuch as the bal-ance between nurture and nature could be shifted and finally determined by the individual's opportunity for introspection (which would result in self-knowledge and self-determination). Thus, Essie, Ruby, and Ferdi-nand, regardless of their ethnicity, are posed in prepa-ration for adulthood; sequestered in a hothouse of exotic luxuries, yes, but the globe in the dim back-ground on the left foreshadows their entry into the larger world. To similar ends, Alexander McCulloch is posed in a landscape, as if to suggest the naturalness of his abstracted, dreamy state—one that is obliged by the

PL. 41. *A Spanish Interior*, c. 1903, watercolor on paper, 22½ x 18 in. (57.2 x 45.7 cm). Private collection. Photograph courtesy of Adelson Galleries, Inc., New York

solitude of fishing.[162] Both canvases display privileged, "sheltered" children whose lives followed a course separate from their working-class or rural counterparts in that they were afforded the opportunity to experience adolescence in the terms recommended by Hall and his colleagues. Evidence of Sargent's awareness of such distinctions surfaces in *Shoeing the Ox* (pl. 40), in which it is implied that a boy has already been initiated into the life of adult work without the luxury of the transitional, preparatory stage of development bridging childhood and maturity. This message is subtly prefigured in *A Spanish Interior* (pl. 41) in which a little boy shares the same compositional territory with two men while the sketchily rendered figures of a woman and an infant are rele-gated to the background.

Sargent had turned to the motif of the daydreaming youth in the first years of his career in *Low Tide at Cancale Harbor* (pl. 42), a painting Trevor Fairbrother has described in terms of a "sad and quiet longing" that may represent an "expression of something wanting in the life of the twenty-three-year-old artist."[163] That the painting held such personal significance can only be surmised, and it is just as likely that Sargent had actually observed a scene similar to this that he painted and/or drew on the common metaphor of the youth setting out on the sea of life, dreaming of what the future holds. In any case, much of the painting's meaning derives from the recognition of adolescence as a period prone to reverie. Decades later Sargent would address the theme with greater intensity in a series of works portraying his nieces, one of which,

PL. 42. *Low Tide at Cancale Harbor*, 1878, oil on canvas, 19⅛ x 11⅛ in. (48.6 x 28.3 cm). Museum of Fine Arts, Boston. Zoe Oliver Sherman Collection, 22.646. Photograph © 2003 Museum of Fine Arts, Boston

Two Girls Fishing (pl. 43), reiterates the content of *On His Holidays* in its contemplative mood, landscape setting, and anticipatory frame of mind associated with waiting for the tug on the line. The closed, almost claustrophobic composition suggests Sargent's intentions for a gendered interpretation, for it contrasts vividly with the panoramic (although also horizonless) view of the rushing water against which the length of Alexander McCulloch's reclining body is posed. These are iconographic differentiations with which Sargent is rarely credited, but he deserves to be so. Exhibited only once in the artist's lifetime and rarely discussed in the Sargent literature, *Two Girls Fishing* testifies to the artist's continuing fascination with portraying a particular state of girlhood. This was noted by Lorinda Munson Bryant, who commented on the canvas in 1923: "What magic has bewitched us in the picture of 'Two Girls Fishing'?... Is it English or is it American? Possibly those girls have less of the restless eagerness of our girls, but then the sound of the rippling water would be a soothing influence on girls of any nationality. Girls are fundamentally alike. Nationality makes no difference with the longing of girlhood. Their loves and their sorrows, their desires and their ambitions are as old as the human race. What a vital part of the secluded nook they are."[164] Bryant's prose depends on the language that developed in the late nineteenth century circumscribing childhood and adolescence. It rests on distinctions usually defined by nationality, the condition of nature (here the sound of rippling water therapeutically offsets the restless condition of adolescent emotions), and the hint of sexual awakening as evoked in the mention of the girls' loves, desires, and ambitions.

Two Girls Fishing qualifies as a genre painting and simultaneously functions as a portrait of Reine and Rose-Marie Ormond, the daughters of the artist's sister Violet. As such, it represents what has been characterized as Sargent's "personal" art since its origins rested in his own motives and taste—elements that emerged more distinctly in his work in the second decade of the twentieth century, when he determinedly painted fewer and fewer commissioned portraits. Reine and Rose-Marie were frequent members of the select entourage of friends and family who accompanied Sargent on his summer painting travels that mainly took him to Italy.[165] The girls' ages automatically inserted the subtext of adolescence into the content of the genre paintings that often depicted them lounging in exotic costumes beside Alpine streams. These fanciful

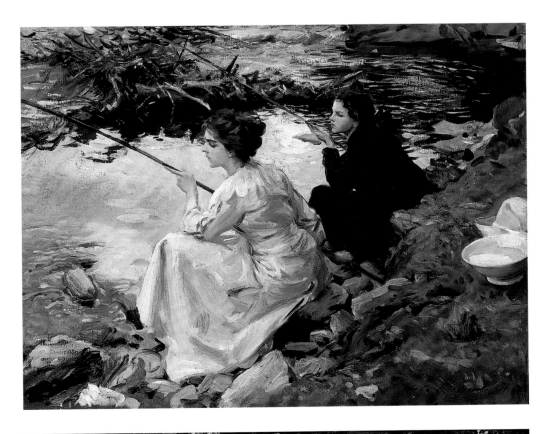

PL. 43. *Two Girls Fishing*, 1912, oil on canvas, 22 x 28¼ in. (55.9 x 71.7 cm). Cincinnati Art Museum, John J. Emery Fund, 1918.39

PL. 44. *The Brook*, c. 1907, oil on canvas, 21½ x 27 in. (54.6 x 68.6 cm). Private collection. Photograph courtesy of Adelson Galleries, Inc., New York

scenes, which are epitomized by *The Brook* (pl. 44), allowed the artist to indulge his fondness for a colorful, sensuous exoticism. Yet, at the same time, he de-orientalized the subject matter through the clear implication that these were English girls costumed to participate in painted theater whose sparkling landscape backdrop augmented the impression of unsullied freshness and voided the erotic associations linked with Near Eastern seraglios. The play of the imagination is paramount in these paintings. Based in Sargent's own creative fictions, the images intersect with the growing stereotype of the reposeful, daydreaming adolescent and promote a comparable frame of mind in the viewer.

Nowhere, however, is Sargent's focus on female adolescence as strong as it is in *Cashmere* (pl. 45), a painting that displays repeated images of the eleven-year-old Reine in a processional format that stretches the entirety of the wide composition.[166] Swathed in one of the familiar cashmere shawls with which Sargent often draped his models, the young Reine enacts a coming-of-age narrative.[167] She enters from the left, posed as if a novitiate approaching the altar, her movements guided and urged by her "double" to her left. The pair injects a sense of resignation coupled with the inevitability of progress that is repeated with greater force in the next two figures, one of whom turns toward the viewer with a penultimate look of farewell. Using a quasi-cinematic deployment of the figure through pictorial time and space, Sargent captures the girl in a moment of hesitation (on the right), allowing the viewer a final, hurried glimpse of her (and she of the viewer) before she crosses the threshold of the frame. She is last seen as the partially cropped figure whose arms and head are uplifted in what can be identified as a pose of awakening and acceptance.[168] The meaning expressed here lodges in the metaphoric transition we witness as the girl-child approaches physical maturity and "disappears" into womanhood on the right; in her various iterations she occupies a liminal space characterized by the fluidities and indeterminacies associated with the formation of identity and physical maturation. The verdant backdrop invests the scene with cyclical associations that call to mind the stages of life—here spring and youth are joined. When *Cashmere* was shown at the 1909 summer Royal Academy exhibition, reviewers were attracted by its "delicious fancy."[169] Its underlying meaning was immediately apprehended by the critic Lawrence Binyon, who detected in it a "touch of strangeness" and declared, "It is youth, it is charm, it is life. It is not easy to remember a picture in which the firm grace and buoyant poise of adolescence are so perfectly and winningly expressed."[170]

This thematic detour through Sargent's iconography of adolescence demonstrates one of several paths that may be taken to discover the means by which Sargent constructed his artistic identity. In general, his paintings of adolescents—whether portraits or genre subjects—confirmed to critics his amazing capacity to renew his art.[171] This he did not only by introducing new themes but also by pairing particular works in exhibition settings that would foreground the diversity of his vision (as he seems to have done, for example, with the portraits of the Wertheimer children and Alexander McCulloch). This display technique had emerged with particular strength in 1893, when Sargent staggered the critics with the seductive charm of *Lady Agnew of*

PL. 45. *Cashmere*, 1908, oil on canvas, 28 x 43 in. (71.7 x 109.2 cm). Private collection. Photograph courtesy of Adelson Galleries, Inc., New York

Lochnaw (fig. 53) at the Academy and the energetic aggressiveness of *Mrs. Hugh Hammersley* (fig. 54) at the New Gallery. The cumulative impact of the two portraits veritably eclipsed all other works of the season, and critics argued, not about the merits of the two, but merely over which was the better painting—*Mrs. Hammersley*, the "miracle of vivacity," or *Lady Agnew*, the "measure of all-round beauty."[172] The pairing of these works introduced what would become Sargent's consistent strategy of carefully placing works in exhibitions so as to reveal simultaneously opposing yet complementary aspects of his art. The sudden and overwhelmingly positive public acclaim generated by the two portraits that rivaled for attention in London in 1893 brought to Sargent an unprecedented parade of society patrons and opened the doors to Academy officialdom: he was elected to associate status in January 1894. Suddenly he was in a position to choose his sitters and no longer needed to prove the general merit (or acceptability) of his artistic skills. He did, however, need to maintain a public image of himself as an artist of independence and variety, realizing that the too frequent rehearsal of the society beauty or matron in his art would ultimately be just as deadly to his reputation as the perception of his art as being too unpredictable or bizarre.

Sargent used a variety of means to avoid being stereotyped as a mere painter of fashion and wealth, an aesthetic ravine into which a number of his contemporaries had slipped. Immediately after his election to the Academy's associate membership, he

downplayed his identity as a portraitist by showing portions of the mural decorations for the Boston Public Library with just one portrait (*Miss Chanler* [Smithsonian American Art Museum]). In 1895 he sent five portraits to the Academy, two of which were of women, two of the poet Coventry Patmore, and the fifth being the remarkable full-length *W. Graham Robertson, Esq.* (Tate Britain, London). Such carefully considered balances emerged with greater clarity as his career progressed, and he relied several times on childhood imagery with considerable effect. The pattern is pronounced and first took form in 1897 (the year of his election to full membership in the Royal Academy) with his two Academy exhibits, *Mrs. Carl Meyer and Her Children* (pl. 81) and *The Honourable Laura Lister* (fig. 42, pl. 50), which were greeted with a flood of critical approval. Proving the worth of Sargent's strategy, the *London Times* reviewer introduced his several hundred words devoted to the paintings saying, "Undoubtedly the chief success of 1897 lies with Mr. Sargent, whose portrait group of 'Mrs. Carl Meyer and Her Children' . . . and whose picture of Lord Ribblesdale's little girl will not only arouse the enthusiasm of his admirers, but will go far to controvert those old-fashioned people who think his Chantrey picture [*Carnation, Lily, Lily, Rose*] eccentric and his 'Carmencita' ugly."[173] Although united superficially by their child sitters, the two paintings appealed for distinctly different reasons. The triple portrait of Mrs. Meyer and her two children, Frank (later second baronet, succeeding his father who was made baronet in 1910) and Elsie, conveyed a worldly sensibility, presenting "a highly artificial moment of civilization" brought to life by the shimmering salmon-pink satins and long ropes of glowing pearls worn by Mrs. Meyer.[174] The artificiality apprehended by numerous critics was accentuated by the painting's intensely angled view, which was often interpreted as an expression of the family's position as relative newcomers in English society by virtue of their Jewishness. This reading also filtered into descriptions of the children who, as Henry James wrote, "with their dark heads together, show, over the back of the sofa, shy olive faces, Jewish to a quaint orientalism, faces quite to peep out of the lattice or the curtains of closed seraglio or palanquin."[175]

Critics were inevitably bound to discuss *Laura Lister*, Sargent's only other canvas in the exhibition, in conjunction with the Meyer portrait, and the differences between the two opened a subtle subtext founded on the perceived stability of aristocratic traditions versus the growing influence of the meritocracy in English society. Although such thoughts were not explicitly stated, the language used to describe the portrait of Lord Ribblesdale's daughter reinforced ideals of long-standing family traditions and their healthy continuation. The critical vocabulary was flush with such adjectives as "sober," "natural," and "fresh," which contrasted with the rhetoric used for *Mrs. Carl Meyer and Her Children*. Sargent's reliance on the Grand Manner portrait formula for *Laura Lister* enhanced the impression of enduring values in aesthetic terms, pitting the powerful Baroque legacies of Velázquez and Van Dyck against the ephemeral Rococo disposition that activated the Meyer portrait. Characterized by one writer as "an Infanta in the true Velasquez-style," Laura Lister's pedigree was apparent both artistically and in regard to her family's noble stature.[176] Above all, however, the portrait stood out as a remarkable representation of childhood itself, where the child's

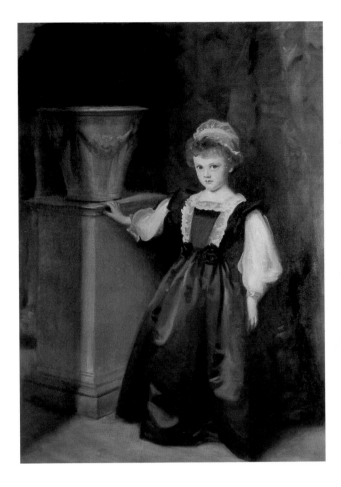

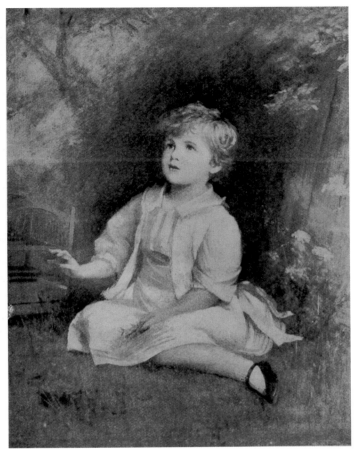

face revealed "the struggle between her native unconsciousness and the shyness imposed upon her by the occasion and by her new magnificence."[177] *Laura Lister's* "engaging simplicity" allowed the painting to prevail over child portraits by other noted artists in the exhibition, including J. J. Shannon's highly admired *Jill Rhodes* (unlocated) and Luke Fildes's *Master Jack Speed* (fig. 43), the latter of which failed to satisfy the critics because it too strongly reiterated the iconography of Romantic childhood established by Reynolds.[178]

Over the next two years Sargent's profile at the Royal Academy shifted, largely because of the nature of his commissions. In 1898 his Academy submissions consisted of an unusual concentration of men's portraits (five of seven paintings). The theme of family and social status established the previous year continued via the inclusion of the memorably animated painting of his friend the art dealer Asher Wertheimer and that of his wife (both Tate Britain, London), which together, in the wake of *Mrs. Carl Meyer and Her Children*, revived critical discussions guided by the subtext of the growing presence of Jews in English culture. These, with works on display at the New Gallery, solidified his reputation as England's premier portraitist, a view that was consolidated by the appearance of three presentation portraits at the 1899 summer Academy exhibition, thus marking his transition from "cleverness" to officialdom.[179]

FIG. 42. *The Honourable Laura Lister*, 1896, oil on canvas, 67½ x 45 in. (171.5 x 114.3 cm). Fogg Art Museum, Cambridge, Massachusetts. Bequest of Grenville L. Winthrop

FIG. 43. Luke Fildes (English, 1844–1927), *Master Jack Speed*, c. 1897, from *The Academy Notes 1897 with Illustrations of the Principal Pictures at Burlington House* (London: Chatto and Windus, 1897), 41. Brooklyn Museum Library Collection

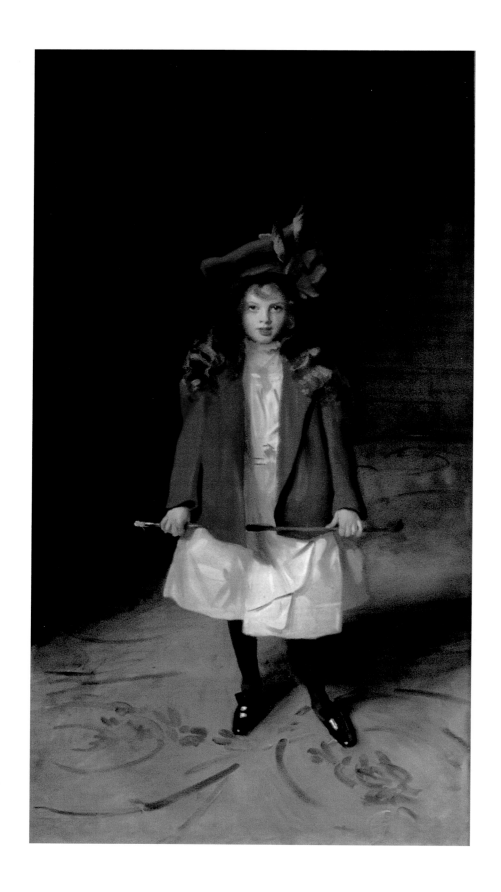

London audiences reawakened to the power of Sargent's art in 1900 with his startlingly direct *The Honourable Victoria Stanley* (pl. 46). The full-length portrait of the seven-year-old daughter of the seventeenth earl of Derby galvanized the critics, who almost universally declared it the star of the New Gallery exhibition and a worthy counterpart to his more "important" painting of the Wyndham sisters (fig. 44) that concurrently dominated the galleries at the Royal Academy. In contrast to Laura Lister, whose shy, tentative glance endeared her to her viewers, Victoria Stanley's self-assured stance revealed an entirely different, but no less appealing, representation of childhood. The reviewer for the *Times* described the painting at length: "She stands alone in a large room, holding in both hands a little hunting-crop; her bright eyes look straight out of the picture, and her lips are parted in a smile which seems just about to break into laughter.... The simplicity of this portrait is half its charm. The other half lies in the colour of the whole composition, in the alertness of the little figure, and in the bonny freshness of the child's face. Seldom has Mr. Sargent given us so much positive colour—red without a hint of decadence, set over against a cream-white that is dazzling in its brilliancy. The eyes, too, sparkle with life and are brimming with laughter."[180]

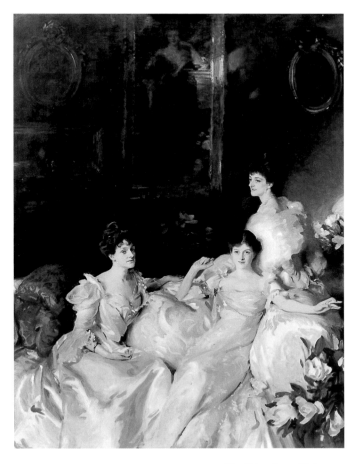

Certainly Sargent had forged new territory in this portrait of a little girl, since none of the commentators fell back on common associations with childhood—innocence, sweetness, delicacy—for their assessments of it. As one reviewer challenged, "Who but he [Sargent] could paint...the scarlet jacket and the white frock of the Hon. Victoria Stanley, a little girl of some six summers, standing in childish and unrestrained attitude, a whip in her hands, against an indeterminate background?"[181] The psychological presence exerted by the child significantly reduced the impact of other child portraits, regardless of how well they were executed. Ralph Peacock's portrait of Peggy Lewis suffered especially in this regard for, despite its "pleasing arrangement, very daintily treated," the dull expression of the little girl "does not bear us far beneath the surface of things."[182] Literally and figuratively, Victoria Stanley stands on her own, separate from the multitude of little girls whose portraits diminished their integrity by portraying them on the floor with dolls or pets (thus conceptually placing them just slightly above their playthings). Although the iconography of a little girl with a crop or whip was not unusual in late nineteenth-century painting, the object was generally associated with play or make-believe (for example, P. A. Cot's *Papa, je pose* [fig. 45] and Carolus-Duran's *Enfant au chien*, 1899 [fig. 46]). If common sense tells us that Victoria Stanley also wields the crop for purposes of the pose, there also exists in the image a hint that she is capable of

PL. 46 (OPPOSITE). *The Honourable Victoria Stanley*, 1899, oil on canvas, 77½ x 41½ in. (196.8 x 105.4 cm). Private collection. Photograph courtesy of Christie's Images Ltd. 2003

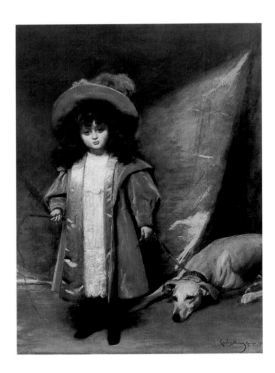

using the crop in an activity (managing a pony, for instance) that would call for directed, assertive behavior on her part. Sargent's emphatically unsentimental approach paralleled a recent call by a literary critic who demanded "a franker recognition of the truth that a child is a subject worthy in itself of the finest artistic portrayal, and that in the hands of a master it may be made admirable without being elongated into a prodigy, and highly entertaining without being broadened into a huge joke."[183] Interestingly, however, the critical community was not prepared to examine *The Honourable Victoria Stanley* in great depth; they skirted the issue of her power as it was implied by the whip in her hands and her confident, knowing expression (the latter a result of her having to look upward to meet an adult's gaze). Only D. S. MacColl ventured a clumsy attempt to explain the painting's effect: "'The Hon. Victoria Stanley' is a rather savage Sargent. Imagine a portrait of Little Red Riding Hood by the Wolf. Hungry devourer of human 'planes,' he has found too little to resist him in the child's face and we hear a growl and snap of the teeth in every stroke of the brush upon the bitter red and white of the dress."[184]

Whereas MacColl's introduction to his discussion about Sargent has its own rather savage tone, on close reading the extreme tactics the writer took underscored the gulf between Sargent's art and that of his contemporaries. In the same paragraph MacColl admitted that "these pictures [*Victoria Stanley* and Sargent's *Major-General Ian Hamilton*] are antipodal to the art that surrounds them; little attracted by a first glance, one comes back to them for a tonic draught.... It is fascinating art, though a bare one, because of the skill that reduces the drawing to so simple and sure an expression; and when one retreats for the third or fourth time abashed from the glances of Mr. Halle's nymphs, the business-like small person in Mr. Sargent's canvas is a great relief from so much unprovoked wistfulness...."[185]

Sargent continued to dazzle London audiences in 1901, chiefly with the display at the Royal Academy of seven important oils and the Crucifix from *The Dogma of Redemption*, a part of the decorative program for the Boston Public Library. By this time there was little he could do to surprise the critics; they expected superior work from his brush, and, as it was generally observed in the art columns, he stood head and shoulders above the rest of the artists.[186] He had been part of the London art scene for nearly twenty years, over which time he had witnessed and contributed to dramatic changes in the visual arts. At the turn of the century the generation of artists who had dominated the arts in England for decades were either dead (Leighton and Millais died in 1896; Burne-Jones in 1898) or soon would be (Watts died in 1904), leaving the field of painting bereft of major figures with whom a national art could be identified. The Grosvenor Gallery had closed in 1890, the Francocentric aesthetics of the New English Art Club no longer posed a threat to the Academy, and, indeed, the once insular tastes of English audiences and artists were breaking down and becoming international in scope.[187] Not only was 1901 the end of the Victorian age in the literal sense (Queen Victoria died that year), but the new century also marked the official passing of a formerly unified sense of a national aesthetic. Although Edward Poynter (a painter of classicizing nudes), who succeeded Millais as president of the Royal Academy in 1896, was well respected, he did not possess the inherent artistic or personal powers of his immediate forebears. Under these circumstances, Sargent was ideally positioned to become the stabilizing, heroic figure for the transition of power from one generation of artists to another in England. No longer avant-garde, his art was the standard against which the works of others were measured. This marked the successful integration of French facture into officialdom, signaling the end of England's stylistic xenophobia. At the same time, Sargent's intentional appropriation of portrait motifs from works by England's old masters (for the most part Reynolds) convinced viewers of the continuation of a strong English visual tradition.

Despite their attestations of his supremacy, critics were hungry to dissect Sargent's accomplishments. Not only did his images of childhood provide "relief from so much unprovoked wistfulness" that still defined child imagery, but they also offset his reputation as a painter of fashionable superficiality. Retrospective assessments of Sargent's work advanced this sentiment, with one writer going so far as to say that "No one has painted childhood and youth with a fuller realization of their charm. His pictures of children, lovely as they are, have no excess of tenderness, no effusive display of sentiment, and in the last analysis this sobriety of feeling constitutes the most enduring element of excellence."[188]

1. Marc Simpson, *Uncanny Spectacle: The Public Career of the Young John Singer Sargent* (New Haven and London: Yale University Press, 1997).

2. M. G. Van Rensselaer, "John S. Sargent," *Century Illustrated Magazine* 43, no. 5 (March 1892), 798.

3. "The Academy Exhibition," *Daily Graphic*, March 29, 1879, 207.

4. "Fine Arts," *New York Herald*, March 31, 1879, 5.

5. For an analysis of the early history of the Society of American Artists, see Jennifer A. Bienenstock, "The Formation and Early Years of the Society of American Artists: 1877–1884," Ph.D. diss., The City University of New York, 1983.

6. Raymond Westbrook, "Open Letters from New York," *Atlantic Monthly* 41, no. 248 (June 1878), 785.

7. "The Academy Exhibition," *New York Times*, April 21, 1878, 6. The painting portrays Thayer's daughter Mary.

8. "The Academy Exhibition," *Art Journal* 5 (May 1879), 159.

9. "Academy of Design," *New York Daily Tribune*, April 26, 1879, 5.

10. "Fine Arts," *New York Herald*, April 27, 1879, 12.

11. While still in the hands of its first owner, G. M. Williamson, the painting was displayed under the title *Innocence Abroad* at the Pennsylvania Academy of the Fine Arts in 1902.

12. "The Two New York Exhibitions," *Atlantic Monthly* 43, no. 260 (June 1879), 781.

13. M. G. Van Rensselaer, "The Spring Exhibitions in New York," *American Architect and Building News* 5, no. 176 (May 10, 1879), 148.

14. *Beatrix Chapman* was shown at the Pennsylvania Academy of the Fine Arts in 1881–82. Described as a "minor" bust-length portrait, it received little comment because it arrived late. It was paired with a portrait of Beatrix's older sister Eleanor in Boston in 1883. Trevor J. Fairbrother, *John Singer Sargent and America* (New York and London: Garland Publishing, 1986), 51. *Head of Ana-Capri Girl* was shown at the 1881 SAA exhibition in New York, where Earl Shinn (writing as Edward Strahan) wrote, "Sargent's 'Capri-Girl' is modeled like a head on a Syracuse coin.... it is a small thing, but a masterpiece of care and insight." "Exhibition of the Society of American Artists," *Art Amateur* 4, no. 6 (May 1881), 117.

15. For the most recent account of Sargent and Carolus-Duran, see H. Barbara Weinberg, "Sargent and Carolus-Duran," in Simpson, *Uncanny Spectacle*, 4–29. Carolus-Duran's birthdate is now authoritatively established as 1837 thanks to the recent research in connection with Annie Scottez-De Wambrechies and Sylvie Patry, *Carolus-Duran, 1837–1917* (Paris: Réunion des musées nationaux, 2003).

16. Richard Ormond and Elaine Kilmurray, *John Singer Sargent: The Early Portraits; Complete Paintings, Volume I* (New Haven and London: Yale University Press for the Paul Mellon Centre for Studies in British Art, 1998), 47.

17. The sketchy, comparatively unfinished quality of the girl's dress and arms may be accounted for by a revision reportedly made at the last sitting in which the dress was changed from black to pink. Ormond and Kilmurray, *John Singer Sargent: The Early Portraits*, 48.

18. For an examination of this aspect of Sargent's taste, see Trevor J. Fairbrother, *John Singer Sargent: The Sensualist* (New Haven and London: Yale University Press and the Seattle Art Museum, 2000).

19. Armand Silvestre, "Le monde des arts: Le Salon de 1880," *La Vie Moderne*, May 29, 1880, 340: "D'une saveur un peu étrange, ce dernier morceau m'a infiniment charmé; il fait penser à une poésie de Charles Baudelaire," as quoted in Simpson, *Uncanny Spectacle*, 91.

20. "Les deux personnages sont dans le même cadre; c'est évidemment un tableau de famille, et la grande personne est sacrifiée à la fillette. Elle est vue en face, toute vêtue de blanc, assise sur un canapé; elle a pris si au sérieux sa pose que ses mains sont crispées par la tension de la volonté la teint immobile; son regard est comme fatigué par la lumière qui frappe la rétine. Très gentille, très vivante et sérieuse comme il convient à un brave petit modèle, la tête, dans sa pâleur matte, est soigneusement et finement modelée." A. Genevay, "Salon de 1881 (Troisième article)," *Le Musée Artistique et Littéraire* 5, no. 21 (1881), 324, quoted in Simpson, *Uncanny Spectacle*, 133.

21. "Invention heureuse dans la disposition des deux figures, aisance des attitudes, intelligence des physionomies naturelles et comme au repos, liberté du faire, largeur de la touche dégagée, juste et franche, puis, par-dessus tout, ampleur de l'harmonie, et parfaite connaissance du jeu des valeurs, toutes ces qualités se trouvent dans cette oeuvre excellente. La petite fille, assise sur un canapé aux tons variés et rompus, où les verts dominant, vous regarde en face avec une crânerie enfantine." Roger-Ballu, "Le Salon de 1881," *La Nouvelle Revue* 10 (1881), 913.

22. Henry Havard. "Le Salon de 1881 (deuxième article)," *Le Siècle*, May 14, 1881, 1–2, quoted in Colin Bailey, *Renoir's Portraits: Impressions of an Age* (New Haven and London: Yale University Press in association with the National Gallery of Canada, Ottawa, 1997), 181.

23. See Nicole Savy, *Les petites filles modernes*, Les dossiers du Musée d'Orsay, 33 (Paris, 1989), in which she cites as examples *Les malheurs de Sophie* by la comtesse de Ségur, 1859; *Les misérables* by Victor Hugo, 1862; and *Alice au pays des merveilles* by Lewis Carroll, 1865. Savy's study, although brief, is an excellent summary of the rise of girlhood in late nineteenth-century France and includes an indispensable bibliography. Another excellent study on French childhood of the period is Chantal Georgel, *L'enfant et l'image au XIXe siècle*, Les dossiers du Musée d'Orsay, 24 (Paris, 1988), which also includes a valuable bibliography.

24. "Véritable héroïne, elle occupe le centre de l'intrigue dans un roman qui peut même porter son nom; ses aventures, ou ses malheurs, deviennent la matière même du récit; elle est dotée, au contraire des Petits Chaperons rouges, d'epaisseur psychologique, de complexité et d'autonomie. Simultané-ment se développe à grande échelle une littérature enfan-tine, à l'intérieur de laquelle se dessine très vite une sous-catégorie: celle du roman destiné aux fillettes, qui raconte volontiers leur existence entre mères et poupées. La petite fille devient à la fois sujet et destinataire du roman." Savy, *Les petites filles modernes*, 4–5.

25. Marie-Louise Pailleron, *Le paradis perdu: Souvenirs d'enfance* (Paris: Albin Michel, [1947]), 162.

26. Simpson, *Uncanny Spectacle*, 112–13.

27. For a detailed account of the painting and its reception, see Mary Crawford Volk et al., *John Singer Sargent's "El Jaleo"* (Washington, D.C.: National Gallery of Art, 1992).

28. "American Art at the Paris Salon," *Art Amateur* 7 (August 1882), 46.

29. This was noted by the reviewer for the *Illustrated London News*, who wrote, "Then we have John S. Sargent, the young painter, who last year startled us with his Spanish Dancing Woman, and who this year is almost equally impressive and original with his portraits of four children." J. F. R., "The Paris Salon," *Illustrated London News* 82, no. 2303 (June 9, 1883), 587.

30. Arthur Baignères, "Première exposition de la Société inter-nationale de peintres et sculpteurs," *Gazette des Beaux-Arts* 27 (1883), 190.

31. *Spectator*, quoted in Montezuma, "My Note Book," *Art Amateur* 9 (September 1883), 69.

32. M[argaret] B[ertha] W[right], "American Art at the Paris Salon," *Art Amateur* 9 (July 1883), 24.

33. J. F. R., "The Paris Salon," *Illustrated London News* 82, no. 2303 (June 9, 1883), 587.

34. Joséphin Péladan, "L'esthétique au Salon de 1883," *L'Artiste* 53 (May 1883), 385.

35. Péladan (1859–1918) was a poet, playwright, critic, and Rosi-crucian philosopher who was at the center of the French Symbolist movement. See Robert L. Delavoy, *Symbolists and Symbolism* (New York: Rizzoli International Publications, 1978) for a bibliography of Péladan's major works and stud-ies about him.

36. William C. Brownell, "American Pictures at the Salon," *Magazine of Art* (London), 6 (1883), 498. Trevor Fairbrother was the first to note Brownell's observations in his 1981 Ph.D. dissertation later published as *John Singer Sargent and America*, 67–68.

37. "Art and Artists," *Daily Evening Transcript* (Boston), May 28, 1883, 3, quoting from the *London Morning Post*. I am grateful to Sarah Elizabeth Kelly for bringing this to my attention.

38. These comments appeared in a lengthy article by James that summarized Sargent's career for the American public immediately before Sargent arrived in the United States for the first time since 1876. Henry James, "John S. Sargent," *Harper's New Monthly Magazine* 75 (1887), 683–91.

39. James, "John S. Sargent," 688–89.

40. See David M. Lubin, *Act of Portrayal: Eakins, Sargent, James* (New Haven and London: Yale University Press, 1985), 122; and Susan Sidlauskas, *Body, Place, and Self in Nineteenth-Century Painting* (Cambridge: Cambridge University Press, 2000), 61–91.

41. For studies on Sargent and Velázquez, see Katherine C. H. Nelson, "The Importance of Velázquez to Goya, Manet, and Sargent," Ph.D. diss., Boston University, 1993, and H. Bar-bara Weinberg, "American Artists' Taste for Spanish Paint-ing," in Gary Tinterow and Geneviève Lacambre, *Manet/Velázquez: The French Taste for Spanish Painting* (New York: Metropolitan Museum of Art, 2003), 259–305.

42. A variant English title is *Maids of Honor*. However, *Maids-in-Waiting* remains in common use in, for example, a stan-dard art history survey, *Gardner's Art through the Ages*.

43. Sargent may have seen the painting when he was in London in 1881. At that time Apsley House (the Wellington Museum), where the painting is held, was open to visitors by appointment.

44. Richard Ormond also points out that the pictorial space of the Boit portrait owes as much or more to Velázquez's *The Spinners (The Fable of Arachne)* (Museo del Prado, Madrid) as it does to *Las Meninas*. Richard Ormond to the author, e-mail, April 27, 2003.

45. James, "John S. Sargent," 686.

46. "Le Salon de Paris. Quatrième article," *L'Art Moderne* 3 (June 10, 1883), 184.

47. For a selection of reviews, see Simpson, *Uncanny Spectacle*, 140–41, and Ormond and Kilmurray, *John Singer Sargent: The Early Portraits*, 113–18, 248–49.

48. Sargent expressed these feelings in a letter of September 10, 1885, to Edwin Russell, a friend in Paris: "There is perhaps more chance for me there [London] as a portrait painter, although it might be a long struggle for my painting to be accepted. It is thought beastly french [sic]." The letter is in the Tate Gallery Archives and quoted in Ormond and Kil-murray, *John Singer Sargent: The Early Portraits*, 130.

49. The portrait of Dr. Pozzi received only passing mention in London. For example, "Another picture remarkable for technical skill is Mr. Sargent's 'A Portrait' (239) which is a daring study in reds." "The Picture Galleries," *Saturday Review* 53, no. 1383 (April 29, 1882), 531.

50. For a history of the painting and its commission, see James Hamilton, *The Misses Vickers: The Centenary of the Painting by John Singer Sargent* (Sheffield: Sheffield Arts Depart-ment, 1984). The sitters' nephew, Angus Vickers, supports the story of Mrs. Vickers going to the Salon to "shop" for a painter. Other possible means by which Sargent became connected with the Vickers family (mainly through an

intricate network of mutual friendships) are cited in Ormond and Kilmurray, *John Singer Sargent: The Early Portraits*, 130.

51. See, for example, "The Picture Galleries. III," *Saturday Review* 57, no. 1490 (May 17, 1884), 641, and "The Royal Academy. Second Notice," *London Times*, May 12, 1884, 4.

52. For details of Sargent's social activities at this time, see Marc Simpson, "Reconstructing the Golden Age: American Artists in Broadway, Worcestershire, 1885 to 1889," Ph.D. diss., Yale University, 1993, 144–59.

53. For Millais's paintings of children, see Malcolm Warner, "Portraits of Children: The Pathos of Innocence," in *Millais: Portraits*, by Peter Funnell, Warner, et al. (London: National Portrait Gallery, 1999), 105–25.

54. There is no major survey of child iconography in English art. A good, albeit brief, treatment of the topic is Susan Casteras, *Victorian Childhood* (New York: Abrams, 1986), which outlines the major ideas relating to images of childhood using selected paintings then in the Forbes Magazine Collection.

55. For a history of the reception of the nude in Victorian England, see Alison Smith, ed., *The Victorian Nude* (London: Tate Britain, 2001).

56. "Round the Royal Academy," *Pall Mall Gazette "Extra"* 26 (May 3, 1886), 2. The "British Matron" refers to the signatory of a letter to the editor of the *London Times* published on May 20, 1885 (10). The anonymous writer argued that the presentation of the nude at art venues would contribute to the moral deterioration of the nation. The "British Matron" is believed to have been the Royal Academician John Callcott Horsley.

57. For Elsley, see Terry Parker, *Golden Hours: The Paintings of Arthur J. Elsley, 1860–1952* (Somerset, Eng.: R. Dennis, 1998).

58. "Art. The Royal Academy. First Notice," *Spectator* 58, no. 2966 (May 2, 1885), 578.

59. "Art. The Royal Academy. First Notice," *Spectator* 58, no. 2966 (May 2, 1885), 579.

60. "Art. Royal Academy. Second Notice," *Spectator* 57, no. 2916 (May 17, 1884), 649.

61. The story is recounted in E. R. Pennell and J. Pennell, *The Life of James McNeill Whistler*, 6th ed. (Philadelphia: J. B. Lippincott Company; London: William Heinemann, 1919), 139.

62. H. S., "Art. The Academy. II," *Spectator* 94 (May 13, 1905), 712.

63. "The Salon, Paris," *Athenaeum*, no. 3005 (May 30, 1885), 702.

64. The same critic who bemoaned the "baby disease" praised Millais's "dainty little child in pink, holding up a muslin apron full of flowers" and continued, "This is as pretty a child-picture as any mother's heart could desire, and it has all Mr. Millais's happy knack of rendering the delicacy and innocence of childhood; and the painting, too, has an ease and brightness which is rather French." "Art. The Royal Academy. First Notice," *Spectator* 58 (May 2, 1885), 578.

65. For a fine survey of Impressionism in England at this time, see Kenneth McConkey, *Impressionism in Britain* (New Haven and London: Yale University Press in association with the Barbican Art Gallery, London, 1985).

66. Letter to Edwin Russell, September 10, 1885, Tate Gallery Archives, quoted in Ormond and Kilmurray, *John Singer Sargent: The Early Portraits*, 134.

67. Stanley Olson, *John Singer Sargent: His Portrait* (London: Barrie & Jenkins, 1989), 114.

68. For excellent essays concerning the origins and development of *Carnation, Lily, Lily, Rose*, see Richard Ormond, "Carnation, Lily, Lily, Rose," in Warren Adelson et al., *Sargent at Broadway: The Impressionist Years* (New York: Universe/Coe Kerr Gallery; London: John Murray, 1986), 63–75, and David Fraser Jenkins, "Pre-Raphaelite and Impressionist: Sargent's *Carnation, Lily, Lily, Rose*," *British Art in Focus*, Patrons' Papers 1, October 1998. Tate Gallery, London. For the most detailed survey of Sargent's time at Broadway, see Simpson, "Reconstructing the Golden Age."

69. Edmund Gosse, quoted in Evan Charteris, *John Sargent* (London and New York: Charles Scribner's Sons, 1927), 76–77.

70. Henry James to Henrietta Reubell, November 18, 1885, Harvard University, Houghton Library, bMS Am 1094 (1061), quoted in Simpson, "Reconstructing the Golden Age," 261–62.

71. Tessa Gosse to David McKibbin in 1948, quoted in James Lomax and Richard Ormond, *John Singer Sargent and the Edwardian Age* (Leeds, Eng.: Leeds Art Galleries, 1979), 40.

72. The lyrics to the song by Joseph Mazzinghi are provided in Simpson, "Reconstructing the Golden Age," 441: "Ye shepherds tell me have you seen / My Flora pass this way, / In shape and feature beauty's queen / In pastoral array. / Shepherds tell me have you seen, / My Flora pass this way? / A wreath around her head she wore / Carnation, lilly, lilly, rose, / And in her hand a crook she bore, / And sweets her breath compose. / Shepherds tell me have you seen, / My Flora pass this way? / The beauteous wreath that decks her head, / Forms her description true, / Hand Lilly white, Lips crimson red, / And cheeks of rosy hue. / Shepherds tell me have you seen, / My Flora pass this way?" Apart from the obvious link between the flowers named in Mazzinghi's verses and Sargent's title, there is the deeper connection residing in Botticelli's *Primavera*. As Richard Ormond has noted, the imagery of the female in the enclosed garden had its primary source in *Primavera*, a painting that was central to the Aesthetic movement. Ormond, "Carnation, Lily, Lily, Rose," 70. Mazzinghi seems also to have been inspired by the Italian painting, whose cast of characters includes the glorious Flora, the personification of spring. Bedecked with blossoms, Botticelli's Flora seems literally to pass through the pictorial space, her feet cushioned by a blanket of flowers. The song itself may have brought the

well-known Florentine painting—perhaps a special memory from his own childhood visits to the Uffizi—to Sargent's mind as he worked on *Carnation, Lily, Lily, Rose*.

73. Robert Louis Stevenson, "To Any Reader," from *A Child's Garden of Verses*, in Robert Louis Stevenson, *Selected Poems*, ed. Angus Calder (London: Penguin Books, 1998), 107.

74. The letter from Stevenson to Twain is quoted in Ormond and Kilmurray, *John Singer Sargent: The Early Portraits*, 141: "Just at this juncture, down comes a Distinguished Painter to do my portrait; he was very refined and privately French: and when I insisted that Huckleberry was to be read aloud at the sittings, he wilted, sir. But I told him he had to face it, and he did, and I believe it did him good."

75. "Fine Arts. The Royal Academy. Third Notice," *Athenaeum* 85, no. 3004 (May 23, 1885), 666.

76. "Art. The New English Art Club," *Spectator* 60, no. 3068 (April 16, 1887), 527.

77. Frederic Leighton to G. F. Watts, undated letter, Kensington and Chelsea Central Library Archives, quoted in Jenkins, "Pre-Raphaelite and Impressionist: Sargent's *Carnation, Lily, Lily, Rose*," 11.

78. Quoted in Lorinda Munson Bryant, "Our Great Painter John Singer Sargent, and Some of His Child-Portraits," *St. Nicholas* 51 (November 1923), 4.

79. The Chantrey Fund was established through the bequest of the sculptor Sir Francis Legatt Chantrey, R.A. (1781–1841), for the purposes of collecting contemporary British art for the nation.

80. "Fine Arts," *Athenaeum* 89, no. 3109 (May 28, 1887), 708.

81. Quilter's 1887 review, part of a compilation published in Harry Quilter, *Preferences in Art, Life, and Literature* (London: Swan, Sonnenschein & Co., 1892), 358.

82. "Fine Arts," *Athenaeum* 89, no. 3109 (May 28, 1887), 709.

83. Ormond and Kilmurray, *John Singer Sargent: The Early Portraits*, 144. On the testimony of Mrs. Donald (Virginia) Crawford (Helen Harrison's sister), Sir Charles Dilke was named corespondent in a divorce suit brought against Virginia Crawford by her husband. The veracity of Virginia Crawford's allegations is still open to question, but it is likely that Dilke was the victim of a conspiracy supported in some measure by Helen Harrison and a third sister who was the widow of Dilke's brother. For an account of the scandal and its political ramifications, see Roy Jenkins, *Victorian Scandal* (New York: Chilmark Press, 1965).

84. Montezuma [Montague Marks], "My Note Book," *Art Amateur* 15, no. 2 (July 1886), 24, and Penelope, "Our Ladies Column," *Evesham Journal and Four Shires Advertiser*, May 2, 1886, 2, the latter of which is quoted in Simpson, "Reconstructing the Golden Age," 416–17.

85. "Fine Arts. The Royal Academy," *Athenaeum* 89, no. 3059 (June 12, 1886), 786.

86. The possibility that the publicity surrounding the Dilke scandal affected the portrait's reception cannot be discounted.

The sordid details of the affair unfolded in the press at the very moment that Sargent's portrait of Helen Harrison appeared on the walls of the Academy. The coverage was international in scope. A *New York Times* report stated that in one day alone thirty-eight English newspapers devoted a total of 205¼ column inches to the Crawford divorce case. "Space Given to Scandal," *New York Times*, August 3, 1886, 5. The *New York Times* ran more than seventeen pieces on the matter over the period of a year.

87. See Henry James to Elizabeth Boott, January 7, [1886], in which James wrote: "The main artistic event is the exhibition of Millais's pictures [ever so many], out of which he comes on the whole very well. He is a wonderous painter of children—it is on that his fame must rest. Sargent is still here, and evidently intends to remain. He is painting a pretty woman—Mrs. Robert Harrison—if he only won't stick his brush down her throat. In the long run he will thrive here, I am sure, and his social existence will be much larger and more prosperous than in Paris." *Henry James Letters*, ed. Leon Edel, vol. 3, *1883–1895* (Cambridge, Mass: The Belknap Press, 1980), 106.

88. The New Gallery on London's Regent Street operated from 1888 to 1910. Apart from its less opulent decor, there was little to separate it from the taste promoted at the Grosvenor Gallery, whose managers, Charles Hallé and Joseph Comyns Carr, had defected to run the New Gallery.

89. "The Picture Galleries. Final Notice," *Saturday Review* 65 (May 20, 1888), 626.

90. Claude Phillips, "Fine Art. Royal Academy. II," *Academy*, no. 838 (May 26, 1888), 365.

91. Phillips, "Fine Art. Royal Academy. II," *Academy*, no. 838 (May 26, 1888), 365.

92. Shannon's subjects, Sholto and Angus, were the sons of Douglas Vickers and his wife, the former Katherine Chetwynd. Their father was a brother of the three Vickers sisters painted by Sargent.

93. G. Salmon, "What Boys Read," *Fortnightly Review*, n.s., 230 (February 1, 1886), 259.

94. Salmon, "What Boys Read," 248.

95. For a survey of children's literature, see Gillian Avery, *Behold the Child: American Children and Their Books, 1621–1922* (Baltimore: Johns Hopkins University Press, 1994), which includes a useful chapter comparing boys' fiction in the United States and Britain.

96. "Childhood," *Spectator*, September 3, 1887, 1179.

97. The exhibition, which ran from January 28 through February 28, 1888, included twenty-two works, among them *Ruth Sears Bacon*, *The Sons of Mrs. Malcolm Forbes*, *Caspar Goodrich*, and *The Daughters of Edward D. Boit*.

98. Greta, "Art in Boston," *Art Amateur* 18 (April 1888), 110.

99. Greta, "Art in Boston," *Art Amateur* 18 (April 1888), 110: "Again, he is a member of one of the most distinguished of old Boston families.... the first impression of many a

well-bred Boston lady was that she had fallen into the brilliant but doubtful society one becomes familiar with in Paris or Rome, and I should not be surprised if some of our matrons were still inwardly blushing."

100. William H. Rideing, "Boston Letter," *Critic* 9, no. 215 (February 11, 1888), 69.

101. When *Caspar Goodrich* was shown at the 1890 exhibition of the SAA one of the admiring critics found the "sketch of the boy rapid and triumphant." "Society of American Artists," *New York Times*, April 28, 1890, 4. Another declared it "frankly and charmingly painted." "The Society of American Artists Exhibition," *Art Amateur* 23 (June 1890), 3.

102. Montezuma, "My Note Book," *Art Amateur* 19 (June 1888), 4.

103. Montezuma, "My Note Book," *Art Amateur* 19 (June 1888), 4.

104. *Katharine Chase Pratt, Alice Shepard, Homer Saint-Gaudens,* and *Mother and Child (Mrs. Edward L. Davis and Her Son Livingston Davis)* were shown with *Helen Dunham, Mrs. Inches, Ellen Terry as Lady Macbeth, Alice Mason,* and *Study of an Egyptian Girl.*

105. "The National Academy," *New York Times*, May 6, 1888, 5.

106. "The National Academy of Design," *Art Amateur* 18 (May 1888), 132.

107. Caroline (Cara) Burch was named after her aunt, Caroline Montmollin Sargent, the wife of Sargent's paternal uncle, Dr. Gorham Parsons Sargent.

108. Cara Burch later recalled, "At first he painted my hands in my lap, but concluding they looked like radishes, he took them out." Cara Burch to David McKibbin, February 21, 1958, quoted in Ormond and Kilmurray, *John Singer Sargent: The Early Portraits*, 215.

109. "The Academy Pictures," *New York Times*, April 7, 1889, 5.

110. "Fine Arts. The Society of American Artists," *Nation* 124, no. 1247 (May 23, 1889), 433.

111. "The Society of Artists," *New York Times*, May 12, 1889, 5.

112. *New York Times*, April 8, 1888, 10.

113. The subject of *Carmencita* was the famous Spanish dancer Carmen Dauset (b. 1868), known as the "Pearl of Seville." After her arrival in the United States in 1889, she attracted notoriety for her performances at the popular New York nightspot Koster & Bial's, where her suggestive gyrations exerted a strange animal magnetism on a segment of high society.

114. "The Society of American Artists Exhibition," *Art Amateur* 23 (June 1890), 3.

115. "Society of American Artists," *New York Times*, April 28, 1890, 4.

116. "Society of American Artists," *New York Times*, April 28, 1890, 4.

117. "The Society of American Artists Exhibition," *Art Amateur* 23 (June 1890), 3.

118. "The Society of American Artists Exhibition," *Collector* 14 (May 15, 1890), 114–15.

119. "Society of American Artists Exhibition," *New York Times*, April 28, 1890, 4.

120. Biographical information on the sitter may also be found in Julia S. Falk, *Women, Language and Linguistics: Three American Stories for the First Half of the Twentieth Century* (London and New York: Routledge, 1999), 33–39.

121. I thank Marc Simpson for sharing the text of his talk, " 'What a Japanese Velázquez Might Do': John Singer Sargent and His Portrait of Alice Vanderbilt Shepard," delivered at the Amon Carter Museum, Fort Worth, Texas, October 27, 2001, in which he made this observation.

122. "The Philadelphia Art Club Exhibition," *Art Amateur* 24 (December 1890), 4.

123. "Brilliant Show at the Society," *New York Times*, May 1, 1892, 17.

124. For a detailed discussion of the painting, see Erica E. Hirshler's essay in this volume.

125. "What the Artists Think of Sargent's 'Beatrice,' " *Harper's Weekly* 35, no. 1794 (May 9, 1891), 345–47.

126. "Society of American Artists," *New York Times*, April 26, 1891, 5.

127. "Academy of Design," *New York Times*, April 19, 1891, 13.

128. "Infallibility in Art," *Art Amateur* 28 (December 1892), 3.

129. The letter, written from 33 Tite Street, Chelsea, London, December 15, year unknown, is quoted in Charteris, *John Sargent*, 109–10.

130. In 1894 the Grafton Gallery in London staged the first of a series of "Fair Women" exhibitions, the success of which led to the expanded theme of "Fair Children." Americans were quick to emulate the London format and held the *Portraits of Women Loan Exhibition* at the National Academy of Design in November 1894, with admission proceeds dedicated to the St. John's Guild and the Orthopaedic Hospital. These art events were supported by large patrons' committees whose membership lists included the same illustrious family names as those of the sitters whose portraits were on display. The 1894 exhibition had as its chairman Henry Marquand. William Coffin was manager and a member of the artists' committee that also included Francis Lathrop, J. Carroll Beckwith, William Merritt Chase, R. Swain Gifford, Benjamin C. Porter, and Stanford White. The introduction to the 1894 catalogue explained the project: "It has been the aim of the organizers of the Exhibition to make it representative of portrait painting of all schools, so far as time and opportunities permitted, and particularly to illustrate the development of the art in the United States." *Portraits of Women Loan Exhibition* (New York: National Academy of Design, 1894). Boston followed suit in March 1895 with *Loan Exhibition of Fair Women* shown at Copley Hall for the benefit of the Children's Aid Society and Sunnyside Day Nursery. The exhibitions subsequently included portraits of children from notable families.

131. Royal Cortissoz, "Loan Exhibition of Portraits," *Harper's Weekly* 39, no. 2030 (November 16, 1895), 1089.

132. For a contemporaneous assessment of the fair that consolidates these ideas, see Hubert Howe Bancroft, *The Book of the Fair: An Historical and Descriptive Presentation of the World's Science, Art, and Industry, as Viewed through the Columbian Exposition at Chicago in 1893*, 4 vols. (Chicago: Bancroft Company, 1893).

133. Robert W. Rydell, "Rediscovering the 1893 Chicago World's Columbian Exposition," in Carolyn Kinder Carr et al., *Revisiting the White City: American Art at the 1893 World's Fair* (Washington, D.C.: National Museum of American Art and National Portrait Gallery, 1993), 29, 35.

134. Jacob Riis, *How the Other Half Lives: Studies among the Tenements of New York* (1890; New York: Dover Publications, 1971), 143. As Charles Madison points out in the preface to the Dover edition, Riis's photographs were not included in the original publication because of lack of adequate reproduction technology. Some of the photographs were drawn by noted artists, including Kenyon Cox and Otto H. Bacher, for inclusion in the 1890 volume (viii).

135. The original 1893 text of the novel with background notes is published in James E. Miller Jr., ed., *Heritage of American Literature*, vol. 2, *Civil War to the Present* (San Diego and New York: Harcourt Brace Jovanovich, 1991), 618–56.

136. See, for instance, Estelle M. Hurll, *Child-Life in Art* (Boston: Joseph Knight Company, 1895), vi.

137. Unidentified review, quoted in Carr, *Revisiting the White City*, 149.

138. The plausibility of Sargent's having had a predilection for such hidden symbolism is strengthened by the fact that his own art collection included Ford Madox Brown's *Take Your Son, Sir* (1856–57, Tate, London). Although Sargent did not purchase the painting until 1910, and it is not known what about it appealed to Sargent specifically, the mother-and-child theme and the hidden symbolism endowing it with religious meaning are strikingly congruent with the iconography of *Mrs. Edward L. Davis and Her Son Livingston Davis*. For an introduction to Sargent's personal collection, see Trevor J. Fairbrother, "Possessions and Props: The Collection of John Singer Sargent," *Antiques*, February 2001, 314–23.

139. "Art at the Fair," *New York Evening Post*, July 31, 1893, 5.

140. For Kurtz's role in the organization of the American display at the Chicago World's Fair, see Carr, *Revisiting the White City*, passim.

141. Lucy Monroe, "Chicago Letter," *Critic*, no. 588 (May 27, 1893), 351.

142. "Art at the World's Fair," *New York Daily Tribune*, June 19, 1893, 5.

143. Charteris, *John Sargent*, 110.

144. "The Royal Academy. Third Notice," *Illustrated London News* 96 (May 17, 1890), 619.

145. M. H. Spielmann, "Current Art: The New Gallery," *Magazine of Art* 14 (1891), 261–62.

146. D. S. M., "Art. The New Gallery," *Spectator* 66 (May 16, 1891), 693.

147. "The New Gallery. Second Notice," *London Times*, May 8, 1891, 13.

148. For a recent study, see Thomas Joseph Allain Chapman, "Between Complaint and Awe: Female Adolescence in the Fiction of Henry James," master's thesis, King's College, University of London, 1996, in which Chapman integrates readings of James's adolescent characters with the era's general cultural preoccupation with adolescent behavior. I am grateful to Leonée Ormond for bringing this study to my attention.

149. The phrase is taken from Maisie's revelation or breakthrough to another level of consciousness: "It was literally a moral revolution and accomplished in the depths of her nature. The stiff dolls on the dusky shelves began to move their arms and legs; old forms and phases began to have a sense that frightened her. She had a new feeling, the feeling of danger; on which a new remedy rose to meet it, the idea of an inner self or, in other words, concealment." Henry James, *What Maisie Knew* (1897; London and New York: Penguin Books, 1966), 43.

150. Henry James, preface to *The Awkward Age* (1899; London and New York: Penguin Books, 1987), 6.

151. Hall, quoted in John Neubauer, *The Fin-de-Siècle Culture of Adolescence* (New Haven and London: Yale University Press, 1992), 148.

152. Neubauer, *The Fin-de-Siècle Culture of Adolescence*, 6.

153. Neubauer, *The Fin-de-Siècle Culture of Adolescence*, 10.

154. Neubauer devotes a chapter to the iconography of adolescence in his book but restricts his discussion to modernist art. It is contended here that, just as adolescence emerged as a major theme in literature in the 1880s, so, too, did the iconography of adolescence in high art.

155. "The New Gallery," *London Times*, May 1, 1902, 10. Referring to Sargent's portrait of the Wertheimer children, the critic wrote, "Let it suffice to say that this year is a year of triumph for him, and that this picture is among the most successful."

156. The complete list of paintings by Sargent shown at the R.A. in 1902 is *The Ladies Alexandra, Mary and Theo Acheson; Mrs. Endicott; Alfred Wertheimer; Lord Ribblesdale; The Misses Hunter; The Duchess of Portland; Mrs. Leopold Hirsch;* and *Lady Meysey Thompson*. At the New Gallery Sargent was represented by *The Children of A. Wertheimer, Esq.; The Late Mrs. Goetz;* and *On His Holidays, Norway*.

157. For information on McCulloch's activity as a collector, see Dianne Sachko Macleod, *Art and the Victorian Middle Class: Money and the Making of Cultural Identity* (London and New York: Cambridge University Press, 1996), 358–63, 448–49.

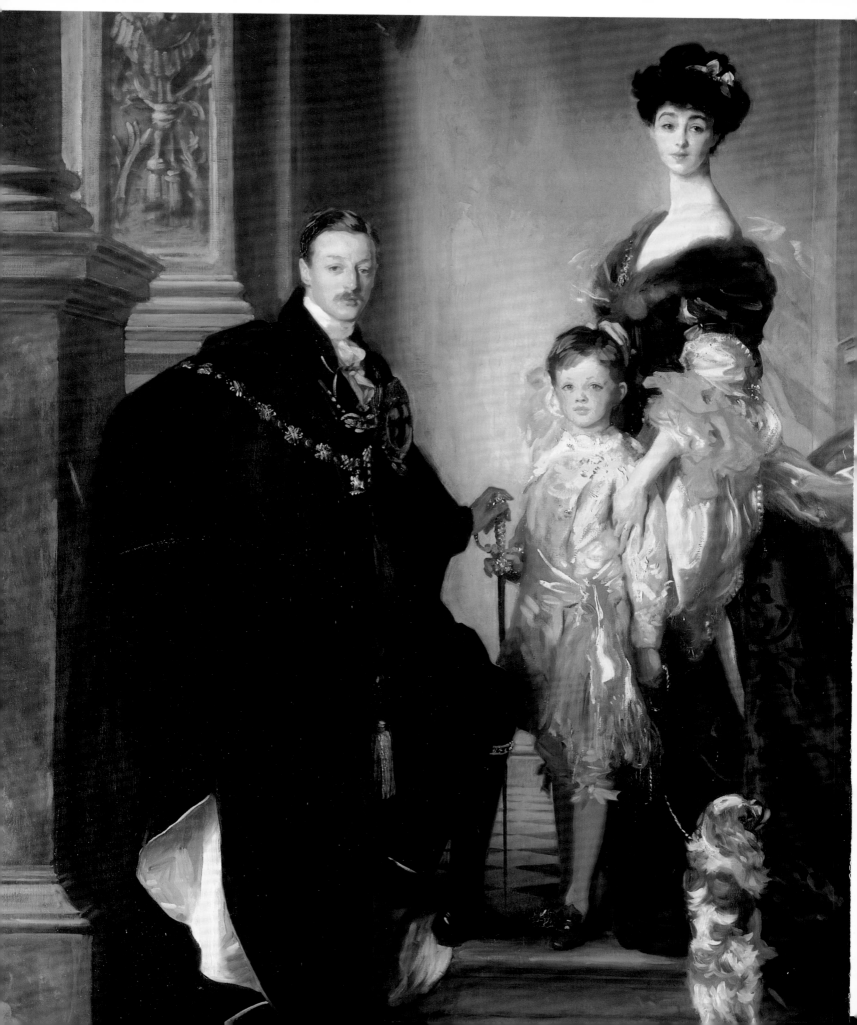

"A Prince in a Royal Line of Painters"

Sargent's Portraits and Posterity

ERICA E. HIRSHLER

In the summer of 1899, during a visit to the Listers' ancestral home at Gisburne in Lancashire, John Singer Sargent sketched the handsome twelve-year-old Charles (fig. 47), the younger son of his friend Thomas Lister (fourth baron Ribblesdale). Struck by the resemblance, Sargent posed Charles in front of a portrait of a youth from the family's collection by William Dobson, a seventeenth-century follower of Anthony van Dyck (fig. 48). The two boys are mirror images of one another. Past and present merge in their heavy-lidded eyes, smooth cheeks, and tousle of golden curls. There can be no skepticism about young Charles's Lister ancestry, nor any questions about his position within an illustrious family heritage. In this intimate drawing, Sargent also left no doubt of his own aesthetic patrimony. He had become, as his friend Frederic Vinton had remarked earlier that year, "a Prince in a Royal Line of painters."[1]

Sargent cultivated his artistic ancestors as much as any of his subjects cherished their genealogy. The very active role he played in fashioning his portraits has been disguised for some observers by the painter's shy public presence, self-deprecating wit, and particularly his very success at pleasing his constituency.[2] But Sargent was much more than a gifted craftsman serving the whims of his patrons—his facility at capturing a soft, shy smile or the brilliant flash of a buckle was matched by his uncanny ability to fulfill simultaneously both the dreams of his sitters and his own artistic ambition. The portraits, made on the orders of his elite clientele, served the painter in equal measure. They were deliberate steps in a trajectory Sargent devised to establish his artistic lineage.

Detail of plate 54

FIG. 47. *Charles Lister*, 1899, pencil on paper, 11 x 8 in. (27.9 x 20.3 cm). Private collection. Photograph courtesy of Christie's Images Ltd. 1996

FIG. 48. William Dobson (English, 1610–1646), *Thomas Lister*, oil on canvas, 35½ x 45 in. (90.2 x 114.3 cm). With Agnew's in 1947; photograph courtesy Agnew's, London

PL. 47 (OPPOSITE). *Mrs. Fiske Warren (Gretchen Osgood) and Her Daughter Rachel*, 1903, oil on canvas, 60 x 40⅜ in. (152.4 x 102.6 cm). Museum of Fine Arts, Boston. Gift of Mrs. Rachel Warren Barton and Emily L. Ainsley Fund, 64.693. Photograph © 2003 Museum of Fine Arts, Boston

Sargent's control over his work can be seen in the manner in which he constructed his pictures. He often refused to paint people in their favorite clothes or in the comfort of their own homes, insisting instead that he choose both costumes and furnishings. Thus Ruth Sears Bacon appears in her sturdy stockings and mud-brown shoes; Marie-Louise Pailleron entered into a "veritable state of war" with Sargent that started with his selection of her dress, stockings, and hairstyle;[3] and Gretchen Osgood Warren, who had hoped to pose in green, wears instead a frothy pink gown several sizes too large (pl. 47). After 1886 Sargent preferred that his sitters travel to London to pose in his Tite Street studio, no matter how great the inconvenience of the rented rooms they may have been forced to inhabit as a result. Most of his aspirants complied, for as much as his clients gave him in terms of income and imprimatur, Sargent gave them an equally appealing opportunity—a chance to participate in the legacy he was creating. Their forbearance was rewarded. "What an heirloom to pass down!" remarked one writer about *Mrs. Fiske Warren and Her Daughter Rachel*. "There are few portraits of the early English school, even by Sir Joshua Reynolds, which can be compared to this group."[4]

Critics had been quick to equate Sargent with artists of the past. In 1883, when Sargent was just twenty-seven years old, the American writer William C. Brownell had called him "Velasquez come to life again." Soon Sargent would also be dubbed the "avenger" of Goya, an admirer and heir of Frans Hals, and "the van Dyck of his time."[5] All of these masters had fired Sargent's artistic imagination from the very beginning. His French teacher Carolus-Duran had advised his students to study Velázquez above all others, and Sargent followed those instructions with enthusiasm, traveling to Spain in 1879 and producing at least nine copies of the Spanish painter's work.[6] His admiration for Velázquez helped to spark some of his greatest early pictures, including *El Jaleo*

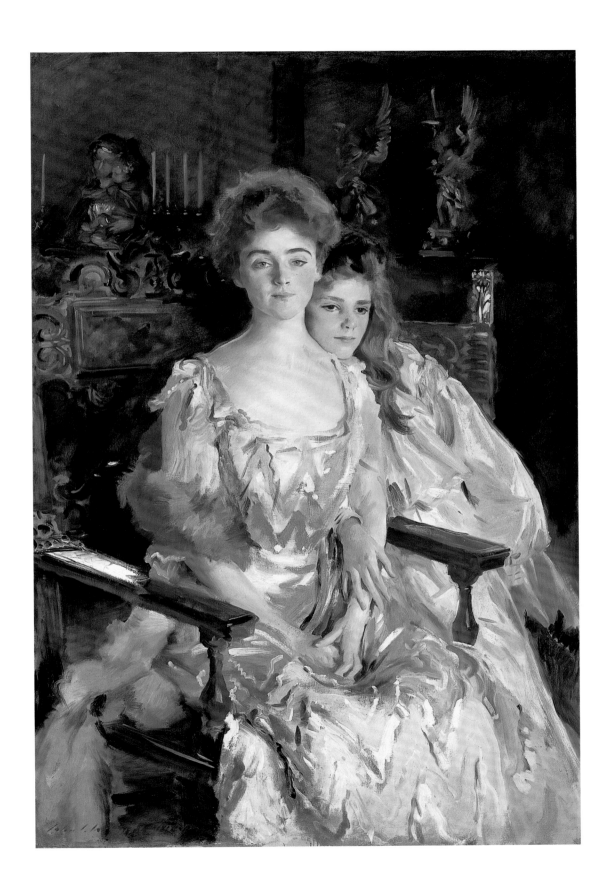

(fig. 20) and *The Daughters of Edward Darley Boit* (fig. 49, pl. 21). In 1880 Sargent went to Holland, again making copies, this time after Frans Hals, a portraitist he admired for the rest of his life. Four years later he made a trip to London, where, in the company of Henry James, he visited a large retrospective exhibition of the work of Joshua Reynolds. By the late 1890s he had developed an admiration for El Greco, calling him "one of the very most magnificent old masters."[7] These artists, among other great painters of the past, helped to educate Sargent's eye, influencing his handling of both paint and people and affecting his production at distinct moments in his career.

Sargent's continued engagement with the history of art led him on occasion to advise American collectors on old master purchases. While in the 1880s he had encouraged his friends to buy Impressionist paintings, as the century closed his recommendations often included earlier works. In 1903 Sargent saw a subdued and elegant Tintoretto portrait of a woman at Knoedler, the New York dealer, and brought it to the attention of his friend Isabella Stewart Gardner, for whom he also sought an El Greco. Shortly thereafter, he contacted the Museum of Fine Arts in Boston about an El Greco portrait of an influential Trinitarian friar and poet, Hortensio Felix Paravicino. Sargent described it as "most beautiful," one of the best examples of the artist's work he had ever seen, and the museum bought it at his suggestion in 1904.[8] Sargent's own collection also included an El Greco, *Saint Martin Dividing His Cloak* (c. 1605, John and Mable Ringling Museum of Art, Sarasota, Florida, now attributed to El Greco's son). The painter's opinion was eagerly sought, and like many artists of the period, he lent his expertise to a variety of collectors who trusted both his eye and his judgment.

Sargent's ceaseless study of the art of the past significantly shaped his approach to portraiture. He reinvented and reinvigorated the old masters, making likenesses that were both highly traditional and completely modern.[9] It was a perfect fit for the aspiring sitters of his day, who likewise sought to ally themselves with the great leaders of history and also to proclaim their station in contemporary society. As the American writer Leila Mechlin declared in 1924, Sargent never "disregarded tradition." "To the contrary," she said, "he has built upon it. He is all familiar with the masters of the past and their ways, but he speaks his own language."[10] Sargent used the vocabulary of the history of art while injecting his models with the nervous energy of modern life.[11] With these tools, the artist communicated the desire and pride he perceived in his sitters and in himself.

Sargent's portraits of children reverberate with all of the traditional and modern allusions seen in his images of adults, but they also embody the future. They radiate hope on the part of three constituencies—their own, their parents', and the painter's. The child's aspiration to play a unique role in the world, their parents' need to leave something of themselves behind them, and Sargent's goal to create a tangible legacy of talent are intricately linked in these canvases. This seems especially evident in the portraits that include adults—Homer Saint-Gaudens, Livingston Davis, Elsie and Frank Meyer, Rachel Warren, the group portraits of the Sitwell and Marlborough families, and others. Here children are both intimately connected with their parents (or with their grandparents, as in the case of Mrs. Henry Phipps, pl. 48) and proposed as

PL. 48 (OPPOSITE). *Mrs. Henry Phipps and Her Grandson Winston Guest*, 1907, oil on canvas, 71 x 49 in. (180.3 x 124.5 cm). Old Westbury Gardens, Inc., Old Westbury, New York

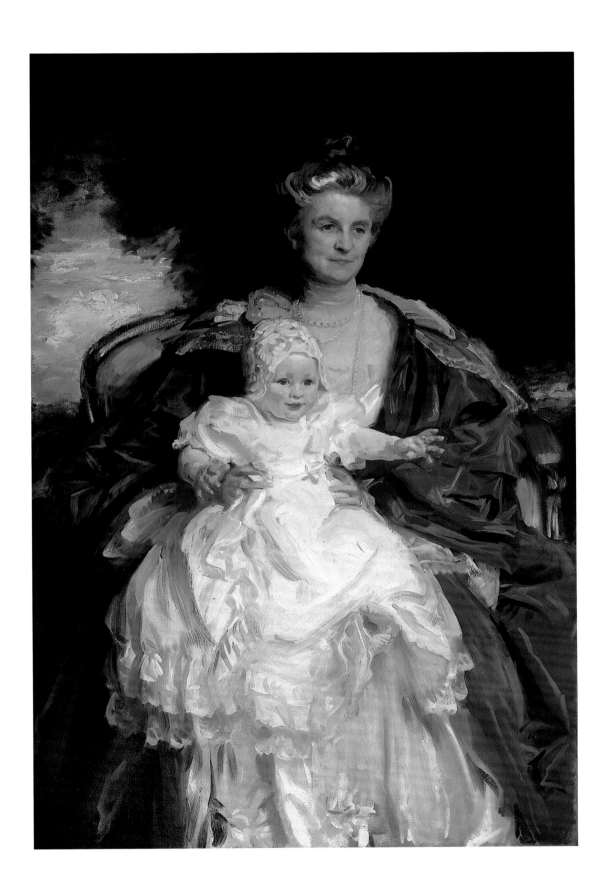

their successors; at the same time, they are treated as individuals with distinct, sometimes contrary, personalities. The placement of his portraits in homes with either ancestral or assembled collections similarly connected Sargent to a family of artists. Whether they were hung among the Van Dycks, Reynoldses, or Copleys of sitters with a household tradition of portrait commissions or added to the Raphaels, Rembrandts, and Manets purchased by avid collectors, Sargent's images became members of the clan. While the artist's desire to create an artistic legacy could be met with a variety of subjects, his ambitions coincided neatly with those of his patrons when it came to painting children.

As Barbara Dayer Gallati discusses elsewhere in this volume, children gained stature in a variety of ways at the end of the nineteenth century. No longer on the periphery of an adult world, simply to be seen and not heard, children were increasingly individualized, separated, and studied, their development entering the heart of cultural debates. "This is the age of the child," proclaimed the art critic Sadakichi Hartmann in a 1907 issue of *Cosmopolitan Magazine*. He added, "portraiture [of children] has almost become a necessity of modern life," noting that all elders had to have their progeny painted or photographed.[12] Sargent was hardly alone in capturing young people on canvas, and for many artists, children's portraits also proved to be good advertising. As one marketing expert remarked about the plethora of new goods aimed specifically at youthful consumers, "every attention shown the child binds the mother to the store."[13] While this shrewd advice was meant for ambitious vendors in the burgeoning new toy divisions of American department stores, the tactic was familiar to anyone, including portraitists, with something to sell. After teaching, painting portraits was the most reliable source of income for an artist. For a client, acquiring a painting to honor one's children avoided the charges of vanity that a portrait of oneself could incur.

Sargent's earliest works included several portraits of children, among them young Robert de Cévrieux, Jeanne and René Kieffer, Peter Jay, Beatrix Chapman, Beatrice Townsend, and the Pailleron children. These six likenesses constitute a full third of the portraits that might be counted as commissions, made by demand of the sitters (or their parents) rather than at Sargent's request. Sargent began displaying portraits of children in prominent exhibitions in 1881, when he showed *Edouard and Marie-Louise Pailleron* (pl. 20) at the Salon in Paris and *Beatrix Chapman* (destroyed during World War II) in Philadelphia. His first solo exhibition, held in Boston in 1888, also included four portraits of young sitters, nearly a quarter of the pictures on display.

Many of Sargent's early portraits of children are lively and distinctive, brimming with the individual personalities of his young sitters. He often allowed them to pose with a favored companion, like the wriggling dogs that appear in the tight grasps of Robert de Cévrieux or Beatrice Townsend or the well-loved dolls clutched by Julia Boit and Ruth Bacon. No one could doubt the particular force of Marie-Louise Pailleron, angry and regal as an Arabian princess on her carpeted throne. The Pailleron portrait was well received and discussed extensively by the critics, who immediately noted the dichotomy between Sargent's modern approach to painting and his loyalty to traditional forms of portraiture, the marriage of past and present that would characterize his entire career.[14]

Sargent's next important presentation featuring young models was the unusual composition he first exhibited at the Galerie Georges Petit simply as *Portraits d'enfants* (fig. 49, pl. 21). There is no written record to indicate that Edward and Isa Boit commissioned Sargent to paint their four daughters, although the canvas ended up in their possession. Boit was a friend of Sargent's and also an artist; it is possible that Sargent, interested in creating an adventurous exhibition picture, approached him with an idea already in mind. Boit's own work does not reveal such an unconventional artistic imagination, and this extraordinary image of his children is clearly Sargent's conception, not his. Whether or not the portrait was painted at the Boits' request, they gave Sargent considerable artistic freedom with it and allowed him to create a composition to his own specifications rather than to theirs, even to the point of obscuring the features of one of their daughters.

When the picture was first displayed, critics were struck by the mysterious shadowy room that enveloped the girls and by their detachment from one another. It was an entirely unusual idea for a group portrait, one that even Sargent's father had described as "four portraits of children in one picture." A French writer proposed that the painting had been "composed according to some new rules, the rules of the four-corners game,"[15] referring to a children's pastime similar to musical chairs in which five players vie for the four corners of a room or field. The girls appear in plain clothes and shoes suitable for such an activity; their simple dresses are worn without crinolines and are protected by pinafores. Henry James similarly implied that children's games might have inspired Sargent's unusual arrangement, when he characterized the painting as a "happy play-world of a family of charming children" after he saw it a few months later at the Salon of 1883. When the portrait was shown in

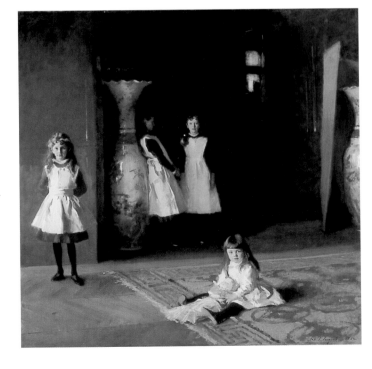

FIG. 49. *The Daughters of Edward Darley Boit* (originally exhibited as *Portraits d'enfants*), 1882, oil on canvas, 87 3/8 x 87 5/8 in. (221.9 x 222.6 cm). Museum of Fine Arts, Boston. Gift of Mary Louisa Boit, Julia Overing Boit, Jane Hubbard Boit, and Florence D. Boit in memory of their father, Edward Darley Boit, 19.124. Photograph © 2003 Museum of Fine Arts, Boston

Boston in 1888, it was also described in terms of a game. The painter and critic Susan Hale wrote, "the large one, of the Boit children playing in that ample room among great vases, is wonderfully lifelike and luminous." In 1899 the painting was still being described in the *Magazine of Art* as a "happy interior," the girls arranged "as if caught unconsciously at play."[16] More intense psychological interpretations of the image and of the girls themselves began to appear as both Freudian analysis and the newly defined, mysterious realm of adolescence began to enter the popular imagination, but it is not clear that Sargent deliberately incorporated them.

Whatever combination of childhood practice and modern painting Sargent may have intended, it took almost no time for the canvas to be connected to art of the past. Paul Mantz, writing about the Georges Petit exhibition, immediately linked Sargent's portrait with Velázquez, admiring the color juxtapositions of

LINFANTE. MARGVERITE

pink and green in the figure of young Julia Boit seated on the carpet. "There we find," Mantz declared, "a bouquet that demonstrates that Mr. Sargent has not studied the great *harmoniste* Velázquez in vain."[17] Many others followed suit, and in his review of the Salon exhibition, William C. Brownell declared that the painting must have been inspired by Velázquez's *Las Meninas*. He noted that the two paintings shared the "same absolute naturalness and unconsciousness in the children; the same intimate differentiation of characters without a shock to the ensemble of either character, interpretation, or artistic presentation; the same grave and decorous, almost grandiose pictorial treatment; with nothing in the accessories which is not happily subordinated to the main idea of the canvas; the whole resulting in a subtle fusion of the pictorial with the purely intellectual."[18] Brownell's description of the portraits of the Boit girls as "grave and decorous" after the example of Velázquez appropriately characterizes Sargent's relationship with the art of the past, for he did not copy the paintings he admired. Sargent's Julia Boit borrows neither stance nor costume from Velázquez's Infanta, but she nonetheless echoes the princess's poise, confidence, and authority.

Similar characteristics resonate in a number of other portraits of young girls that Sargent made over the course of his career. Ruth Sears Bacon, her dangling legs akimbo and her doll clutched to her side, is lost in a froth of energetically brushed fabric, but she confronts the viewer directly with all the aplomb of the Infanta with her voluminous handkerchiefs and farthingales (fig. 50). The portrait seemed to fulfill Henry James's desires, published in *Harper's Monthly* the same month young Ruth was painted, "to know just how the great Spaniard [Velázquez] would have treated the theme."[19] The conceit is further developed in *Beatrice Goelet* (pl. 49), in which Sargent depicted his five-year-old model in a striped gown of green and pink, her stiff skirts arrayed around her. The portrait is one of the most explicit of Sargent's homages to Velázquez, causing the New York critic Mariana Griswold Van Rensselaer to assure her readers that Sargent "did not 'costume' the child for the sake of pictorial effect. The dress is one she was in the habit of wearing."[20] Five years later, Sargent painted another American Infanta, Helen Sears (fig. 51, pl. 67), dressed in a starched white smock and beribboned shoes. As he had for his portrait of Beatrice, Sargent selected a slightly elevated vantage point for Helen, silhouetting his young model against a shadowy, indeterminate background. The serious expressions and undeniable presence of each of these young models are reminiscent of James's descriptions of Velázquez's princesses, whom he had characterized as "uncompromising," having "the same sort of firm, immitigable outline as an adult."[21]

In the same paragraph, which described his visit to the Wallace Collection, James compared Velázquez with Joshua Reynolds, another painter who had a tremendous effect on Sargent. James remarked that "Velázquez's children are the children of history; Sir Joshua's [are those] of poetry." Sargent likewise would distance himself from the marked admiration for Velázquez's technical brilliance that he had demonstrated

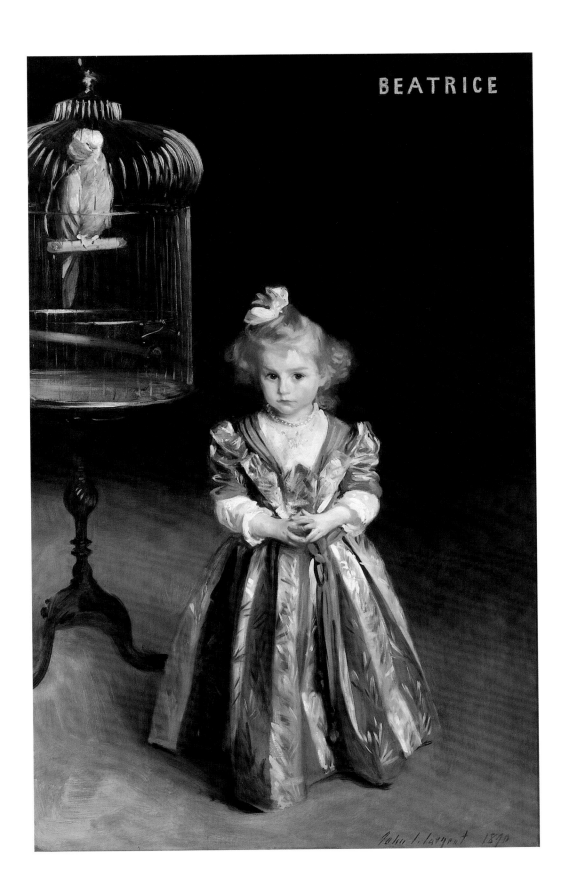

in his early career, admitting that the Spanish master excelled in painterly ability but lacked "spiritual qualities."[22] Perhaps his opinion reflected Sargent's own mindfulness of the criticisms leveled increasingly at his own work, which came to be faulted (by Roger Fry, Lewis Mumford, and others) for its brilliant surfaces lacking in soul.

Whatever the cause, Sargent began to turn away from Velázquez. During the first years of the 1890s, after a flurry of Impressionist experimentation, Sargent did not produce many portraits, painting fewer than fifteen in the three years between 1891 and 1893.[23] He had been preoccupied with his Boston Public Library mural commission, traveling, and with family matters. He was popular in America, but his great triumph as a portraitist in Britain came only after 1893, when he exhibited *Lady Agnew of Lochnaw* (fig. 53) and *Mrs. Hugh Hammersley* (fig. 54) in London to tremendous acclaim. By this time he had begun to adopt as a model the "poetic" portraits of Joshua Reynolds and his contemporaries. Some of Sargent's success with *Lady Agnew* undoubtedly stemmed from the painting's rapport with traditional British portraiture, for there was a history of sensuous half-length portraits of women by Reynolds, George Romney, and others. When *Lady Agnew* was sent to the "Fair Women" exhibition at the Grafton Galleries in 1894, it was praised in the company of its predecessors, which included Reynolds's *Collina*, a portrait of Lady Agnew's great-aunt and namesake, Lady Gertrude Fitzpatrick, a young girl posing out of doors as an enchanting Little Bo-Peep (fig. 52).[24] Sargent's own seductive fair woman in her *bergère* chair, modeled at least in part on eighteenth-century prototypes, proved to be an irresistible formula, and would-be sitters began to flock to his studio (fig. 55).

Sargent's increasing eighteenth-century vocabulary was closely bound to popular taste in England and America. In both countries, Rococo styles were revived in architecture, furniture, and fashion. The era was imagined to be one of elegance and nobility, a period as yet untainted by modern commerce. In this whitewashed form, the eighteenth century was full of beauty and rational thought. Populated by enlightened gentry and farmers versed in Cicero, it was far from the filth, immigration, and worker unrest that plagued the age of industry. In the United States, patriotism enhanced by the centennial added intensity to the revival. Families dusted off their grandmother's Chippendale high chests and gateleg tables and used

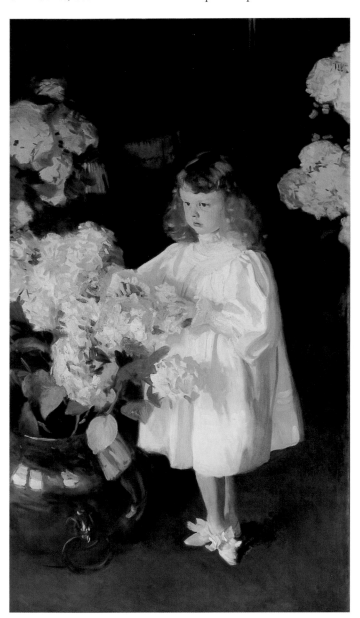

FIG. 51. *Helen Sears*, 1895, oil on canvas, 65⅞ x 36 in. (167.3 x 91.4 cm). Museum of Fine Arts, Boston. Gift of Mrs. J. D. Cameron Bradley, 55.1116. Photograph © 2003 Museum of Fine Arts, Boston

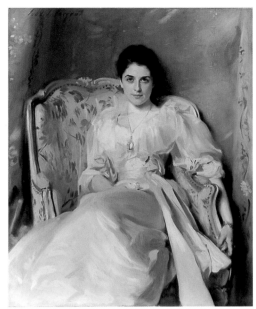

FIG. 52. Joshua Reynolds (English, 1723–1792), *Collina (Lady Gertrude Fitzpatrick)*, 1779, oil on canvas, 55½ x 49 in. (141 x 124.5 cm). Columbus Museum of Art. Museum Purchase: Derby Fund, 62.60

FIG. 53. *Lady Agnew of Lochnaw*, 1892, oil on canvas, 49½ x 39½ in. (125.7 x 100.3 cm). National Gallery of Scotland, Edinburgh. Purchased 1925, with funds from the Cowan Smith Bequest

them in modern interiors to confirm their connection to the society of the founding fathers. The most wealthy industrialists of both nations—the Astors, Vanderbilts, Rothschilds, and others—created eighteenth-century aristocratic pasts for themselves, constructing faux châteaux in Newport, North Carolina, or Buckinghamshire that were ornamented with genuine architectural fragments and French and British antiques.

Portraiture, both new and old, played a key role in establishing this identity. Some families had portraits of their ancestors, but many others began to buy them. Starting in the 1860s, eighteenth-century British portraiture began to attract renewed attention.[25] Among the collectors were newly monied captains of industry, like the American coke and steel tycoon Henry Clay Frick, who purchased portraits by Romney, Jean-Marc Nattier, and John Hoppner in the late 1890s; the financier J. Pierpont Morgan, who acquired works by Reynolds (fig. 59) and Romney; or the British soap baron William Hesketh Lever, who favored society portraits by Reynolds, Thomas Gainsborough, and others.[26] Some successful business magnates would enter the aristocracy, among them the recently ennobled earl of Iveagh (brewer Edward Cecil Guinness) who acquired works by Reynolds, Gainsborough, Hoppner, Henry Raeburn, and Romney in the 1880s and 1890s. Their sources for paintings were most often the nobility, who sold rather than bought, relinquishing small pieces of their family heritage to generate the large income necessary to maintain their estates or to pay the death duties introduced in 1894. The auction houses and galleries were full, and eighteenth-century British portraits began to sell for exorbitant sums. London's art dealers happily traded them, garnering significant profits that in some cases allowed them the financial security to collect art for themselves. Asher Wertheimer, a Bond Street dealer and a good friend of Sargent's, bought twenty-four eighteenth-century English portraits from

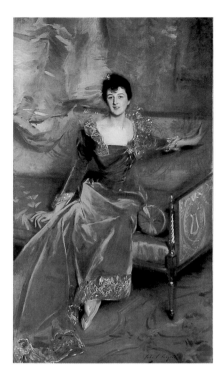

FIG. 54. *Mrs. Hugh Hammersley*, 1892, oil on canvas, 81 x 45½ in. (205.7 x 115.9 cm). The Metropolitan Museum of Art, Gift of Mr. and Mrs. Douglass Campbell, in memory of Mrs. Richard E. Danielson, 1998 (1998.365)

FIG. 55. Max Beerbohm (English, 1872–1956), *31, Tite Street*, from Charteris, *John Sargent*, unpag. Brooklyn Museum Library Collection

Christie's alone, which he in turn sold to a variety of collectors.[27] Both Wertheimer and others like Thomas Agnew operated at the top of the market, working with millionaires like Ferdinand de Rothschild, J. Pierpont Morgan, Henry Marquand, and P. A. B. Widener. Many of these collectors were also among Sargent's sitters.

In addition to their taste for Gainsborough and Reynolds, American and British collectors also savored the work of Anthony van Dyck, the aristocratic Flemish portraitist of the seventeenth century who earned such tremendous success in England. Van Dyck had inspired painters of the eighteenth century—in 1762 Horace Walpole wrote that the period had been "the first area of real taste in England." Gainsborough and Reynolds drew their imagery directly and deliberately from Van Dyck, and their artistic quotations were highly admired, for they served to elevate both artist and sitter with references to a noble tradition. Reynolds advised painters to study the masters and to embrace their spirit, but not to copy; instead, an artist should "enter into a competition with his original . . . [and] to improve what he is appropriating."[28] His recommendation might have been written for Sargent, who followed it with an equal desire for originality and enriching associations.

While in England Sargent's work could be considered directly in relation to its predecessors in dynastic collections, in the United States these associations were often consciously made. In 1884 a Norwegian visitor to America claimed that "in Washington, Boston, and New York, [a] sickly craving for social status is just as prevalent an illness as toothaches and nerves." By 1899 New York newspapers were already satirizing local collectors for their preference for portraits of people in ruffs, describing it as a form of social climbing. Collectors like Marquand and Widener bought portraits by

Van Dyck (fig. 56), Reynolds, and Gainsborough, fashioning legacies that would incorporate their Sargents; Widener deliberately hung his Sargent portrait in the Van Dyck gallery he created at his Pennsylvania estate. In this democracy, the trappings of nobility could be obtained by anyone with taste and money.[29]

Eighteenth-century art was not only to be found in the art market; there was also a small explosion in the numbers of books published about English portraiture between 1890 and 1910. There were seven texts concerning Reynolds's *Discourses* alone, and even Roger Fry, frequently Sargent's nemesis and a promoter of modern art, provided the commentary for a 1905 edition. Monographs on Reynolds were printed in 1856, 1865, 1874, 1894, 1899–1901 (a four-volume set), and 1905; on Gainsborough in 1856 and 1915; and on Romney in 1894. Gainsborough's *Blue Boy* was the subject of a small booklet printed in New York in 1898 with an introduction by Sargent's friend and fellow painter Frank Millet. These publications, readily available on both sides of the Atlantic, were joined by enough catalogues of aristocratic collections, diaries, and descriptions of country houses to satisfy even the most Anglophilic reader.

In addition, several important exhibitions of eighteenth-century art were mounted in London. The Royal Academy held annual loan shows that included old master paintings, and the Grosvenor Gallery (which, unlike the Royal Academy, specialized in displays of modern art) held a huge retrospective of the work of Reynolds in 1884. The following year the Grosvenor Gallery featured Gainsborough, and in 1887, Van Dyck. Another Van Dyck show was at the Royal Academy in 1899. These efforts can be read at least in part as a reaction against the Italian-inspired, highly finished works of the Pre-Raphaelite circle, whose aesthetic agenda had captivated Britain for years. In comparison, the eighteenth-century artists seemed loose and free, full of painterly bravado and an interest in the outdoors that allied them more closely with late nineteenth-century taste than initial expectations might presume. The Pre-Raphaelite Edward Burne-Jones despaired of the Rococo revival, complaining that Gainsborough "just scratches on the canvas over loose flimsy stains" and equating it with his distaste for Sargent's freely brushed style.[30]

Many Americans saw these exhibitions in London, and British books traveled immediately to the United States. But the American interest in eighteenth-century British portraiture was not only imported from abroad. In the late 1870s the Boston publisher Houghton, Osgood and Company printed Moses Sweetser's five-volume set of artists' biographies, which, along with Raphael, Leonardo, Titian, Rembrandt, and Claude, included both Reynolds and Van Dyck. Susan Cater's *Art Suggestions from the Masters*, which recorded tips drawn from Reynolds's writings, and George Brock-Arnold's monograph on Gainsborough were both published in New York in 1881. The Museum of Fine Arts in Boston featured Reynolds's work in 1895, and various galleries in New York and elsewhere displayed eighteenth-century portraits throughout the 1890s.

FIG. 56. Anthony van Dyck (Flemish, 1599–1641), *Clelia Cattaneo, Daughter of Marchesa Elena Grimaldi*, 1623, oil on canvas, 48⅛ x 33⅛ in. (122.2 x 84.1 cm). National Gallery of Art, Widener Collection. Image © 2003 Board of Trustees, National Gallery of Art, Washington

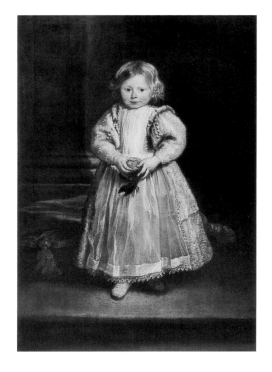

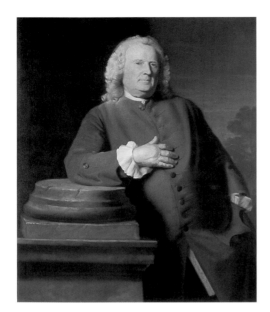

FIG. 57. John Singleton Copley (American, 1738–1815), *Epes Sargent*, c. 1760, oil on canvas, 49⅞ x 40 in. (126.7 x 101.6 cm). National Gallery of Art, Gift of the Avalon Foundation. Image © 2003 Board of Trustees, National Gallery of Art, Washington

Americans also sought to elevate their own, and John Singleton Copley's work markedly regained status. Fueled by the Colonial revival and an attempt to create a distinctive taxonomy of "American" culture in an age of increasing globalization, Copley was heralded both as the chronicler of an American aristocracy and as the country's first "old master." His work was included in shows at the Boston Athenaeum in 1863, 1864, and 1871, and he was praised in a variety of books during the 1860s. Even James Jackson Jarves, who promoted early Italian paintings, in 1864 admitted that Copley had captured "precisely qualities of coloring and design to please Londoners of rank and fashion."[31] Monographs about the artist were published in 1873 and 1883, and Bostonians in particular were enthusiastic about their native son, whose relatives still lived in town. The large public square in front of Boston's original Museum of Fine Arts, at first called Art Square, was dedicated to Copley in 1883. Local gentry took renewed pride in the Copleys on their walls and employed them as markers of their heritage. William Dean Howells defined the quintessentially Boston Corey family through such portraits, distinguishing them from the self-made Laphams, in his 1884 novel *The Rise of Silas Lapham*:

> Lapham leaned a little toward Mrs. Corey, and said of a picture which he saw on the wall opposite, "Picture of your daughter, I presume?"
>
> "No; my daughter's grandmother. It's a Stewart Newton; he painted a great many Salem beauties. She was a Miss Polly Burroughs. My daughter *is* like her, don't you think?" They both looked at Nanny Corey and then at the portrait. "Those pretty old-fashioned dresses are coming in again. I'm not surprised you took it for her. The others"—she referred to the other portraits more or less darkling on the walls—"are my people; mostly Copleys."[32]

A Copley portrait in the family became an emblem of heritage and taste.

Many of Sargent's Boston patrons had Copleys in their family trees, including Mrs. Charles Inches, Mrs. Charles Pelham Curtis, the Forbes family, Caleb Loring, and others, just like his English sitters who owned family portraits by Reynolds or Gainsborough. Even Sargent's own ancestor, Epes Sargent, had been the subject of one of Copley's most successful portraits, a picture displayed at the Museum of Fine Arts in Boston from 1888 to 1892 and then featured in the art display at the 1893 World's Columbian Exposition (fig. 57).[33] Although Copley had expected his fame to rest on the history paintings he considered superior to any portrait, the hierarchy of subject matter upheld by the eighteenth-century academy had all but disappeared by Sargent's day. Such distinctions had always been tenuous in the United States, but by the late nineteenth century such rankings had disappeared in Europe as well. Portraits of all kinds rose in stature and Copley's likenesses proved to be his legacy.

American critics, particularly Bostonians, drew a direct line of descent from Copley to Sargent. In 1895 an exhibition of portraits of women was organized in Boston to benefit the Children's Aid Society. The show included forty-one Copley portraits, described as "fine and vigorous old colonial types" whose "good-looking descendants" attended the opening. "Copley's army of splendid maids and matrons [are] on the west side; and on the east side there is John Sargent's group...the modern men are extremely smart; in both the English and Yankee sense of the word, nothing could be smarter, but," added the writer, distinguishing Sargent from his predecessor, "Copley had something in him that they have not!"[34] By 1903, however, Sargent's portrait of Mrs. Abbott Lawrence Rotch was described as having been "conceived quite as Copley would have conceived it." The *Boston Evening Transcript* credited Sargent with improving on Copley's attainments, noting that Copley "was ever-so-much of a painter, but he could never, in his palmiest days, have executed it with the superb breadth, ease and virtuosity which [Sargent] displays in every detail."[35]

In addition to providing artistic exemplars, the eighteenth century also afforded a quintessential ideal of childhood that held new appeal. Inspired in part by the French philosopher Jean-Jacques Rousseau's exploration of the nature of youth, writers, poets, and painters in the eighteenth century began to delve into new ideas about children and their unique experience of the world. They were separated from adults, allowed to wear different clothes and to act in a manner befitting their juvenile status. Joshua Reynolds was admired in particular for his sensitive images of young sitters, often out of doors, in poses and costumes that appealed to sentiment.[36] As these concepts gained renewed respect at the end of the nineteenth century, Sargent acknowledged the transformation in his own portraits. His stiff-skirted Infantas are joined in the 1890s by softer, more vulnerable interpretations of childhood. In such portraits as *The Honourable Laura Lister* (pl. 50) Sargent began to use an eighteenth-century vocabulary. Posed next to a jardiniere and an orange tree, she is at least figuratively placed outside, her black-and-white gown and little lace cap reminiscent of Reynolds's images of Lady Caroline Howard, Penelope Boothby, and others. The young girl's enchanting vulnerability caused Henry Adams to remark that the portrait "seems almost *felt*, a quality in painting and generally in art which...has ceased to exist."[37]

By the 1890s the most popular image of youth, and the most relentlessly reproduced, was Gainsborough's *Blue Boy*, which itself had been inspired by the regal portraits of Van Dyck (fig. 58). A portrait of Jonathan Buttall, son of a London ironmonger, *The Blue Boy* had been unveiled to great acclaim at the Royal Academy of 1770. The painting had been so highly praised that an envious Reynolds, Gainsborough's rival, derided the practice of dressing up sitters in costumes inspired by Van Dyck in his seventh *Discourse*, calling it "common."[38] Reynolds added, "this custom is not yet entirely laid aside" and "by this means...some very ordinary pictures acquired something of the air and effect of the works of Vandyke, and appeared, therefore, at first sight to be better pictures than they really were."[39] Reynolds had not been above using the formula himself, however, and he made a number of images of sitters, particularly boys, in Van Dyck dress. One of them was a full-length portrait of Thomas Lister, the first baron

Ribblesdale, an ancestor of Sargent's friend and patron (1764, Bradford City Art Galleries and Museum).

Reynolds's *Thomas Lister*, sometimes called *The Brown Boy*, had been included in the 1884 Grosvenor exhibition. It stayed in the Lister family only until 1889, when it was sold through Agnew's to Samuel Cunliffe-Lister, a wealthy relative.[40] A similar fate awaited Gainsborough's *Blue Boy*, which was owned by the first duke of Westminster, who for a number of years toyed with the idea of selling it. In March 1896 Bernard Berenson wrote to Sargent's friend Isabella Stewart Gardner that he had heard that both *The Blue Boy* and Reynolds's *Mrs. Siddons as a Tragic Muse*, "the most famous works of their famous masters ... may well be for sale before long." A month later, cheered by Gardner's enthusiasm for *The Blue Boy*, Berenson wrote, "I advise you to borrow, to do anything, but to get that picture." He confessed without modesty that "it will require cunning angling to bring that beauty to land," adding, "picture-owners are so absurdly capricious." The negotiations continued for a couple of months, with Berenson proposing a price of £30,000. Gardner replied that at such a sum she would be "steeped in debt—perhaps in Crime—as the result! ... I shall have to starve and go naked for the rest of my life; and probably in a debtor's prison." Gardner's fears went happily unrealized, for the duke of Westminster scorned the offer and refused to sell, pretending he had never been interested in such a prospect. "The only consolation," wrote Berenson to Gardner, "is that in our life-time *The Blue Boy* will not leave its present owner, without its going to you, if you continue to want it."[41] He comforted her with the purchase of Titian's *Rape of Europa*, and when at last *The Blue Boy* was sold in 1921 (by the second duke of Westminster), Gardner was no longer enticed. The famous portrait went to another American collector, Henry Huntington, for a record-shattering price of more than $700,000.

In the American popular imagination, Gainsborough's *Blue Boy* was conflated with Cedric, the main character in Frances Hodgson Burnett's *Little Lord Fauntleroy*, who also wore a suit and lace collar inspired by Van Dyck. The story, which was first serialized in 1885 and then followed by tremendously successful book and theater versions, appealed to American patriotism. The tale involved an English heir disinherited for his decision to marry an American woman. They live in poverty in New York with their son, but after his father's death, young Cedric is summoned back to England by his grandfather (Lord Fauntleroy). American readers delighted in their compatriot Cedric's success at assuming, through the native wit and moral courage instilled by his Yankee mother, the patrician title of his English grandfather. All ended happily when Cedric's mother was called from New York and welcomed into the family. Cedric became a model for young boys, at least as far as their mothers were concerned. The fashion for silk or velvet suits with lace collars persisted to the end of the century, although it became increasingly identified with overprotected mama's boys and eventually was replaced entirely by the perennially popular sailor suit, which appealed both to more masculine taste and to proponents of dress reform.[42]

FIG. 58. Thomas Gainsborough (English, 1727–1788), *Jonathan Buttall: The Blue Boy*, 1770, oil on canvas, 70⅝ x 48¾ in. (179.4 x 123.8 cm). Huntington Library, Art Collections and Botanical Gardens, San Marino, California, 21.1

PL. 50 (OPPOSITE). *The Honourable Laura Lister*, 1896, oil on canvas, 67½ x 45 in. (171.5 x 114.3 cm). Fogg Art Museum, Cambridge, Massachusetts. Bequest of Grenville L. Winthrop

FIG. 59. Sir Joshua Reynolds (English, 1723–1792), *Lady Elizabeth Delmé and Her Children*, 1777–79, oil on canvas, 94⅛ x 58⅛ in. (239.1 x 147.6 cm). National Gallery of Art, Andrew W. Mellon Collection. Image © 2003 Board of Trustees, National Gallery of Art, Washington

A variety of such fashions, with their connotations of eighteenth-century aristocracy, appears in Sargent's portraits of boys, from the knickers and elaborate bow tie of Homer Saint-Gaudens to the silk and lace ensemble of the Marlborough heirs. No doubt Sargent enjoyed them not only for their associations but also because they gave him something more interesting to paint. In addition to their details of costume, however, many of Sargent's portraits of children from the 1890s borrow the emotional sensibility of eighteenth-century works. Homer Saint-Gaudens, Livingston Davis, and Rachel Warren all appear in portraits with their mothers, for example, borrowing a notion that Reynolds had popularized in such images as *Lady Elizabeth Delmé and Her Children* (fig. 59). Reynolds had reinvented aristocratic portraiture, responding to the eighteenth century's new conceptions of childhood and making room in his dynastic images for tenderness. While at first still employing the restricted black-and-white palette he had admired in Velázquez, Sargent soon began to invest his portraits with new sentiment, inspired at least in part by Reynolds. Livingston Davis hovers near his mother's skirts and fondly clasps his mother's encircling hand. Homer Saint-Gaudens leans back into his mother's chair, intent not only on posing for Sargent but on the story he hears his mother reading. Rachel Warren snuggles against her mother in imitation of the sculpture of the Madonna and Child that appears behind them, an intimate and affectionate pose that both unites the two figures and links Sargent's composition to a long history of images of mother and child.

Not all of Sargent's portraits of the 1890s show children as the tender and malleable darlings of their loving parents. As Sadakichi Hartmann proclaimed, "in domestic affairs the child has always reigned supreme…there is no chance for either party to wield the scepter after the first baby has made its appearance. He takes entire command."[43] Sargent's image of seven-year-old Victoria Stanley is one of his most imperious images (pl. 46). With her bright red coat and riding crop, she radiates strength and authority disproportionate to her size and sex, a quality that some critics found disturbing. "Imagine," said D. S. MacColl in the *Saturday Review*, "a portrait of Little Red Riding Hood by the Wolf."[44] Sargent's portrait drew on a long history of full-length images of aristocrats garbed for the hunt, but the iconography had most often been used for adults, and mostly for men. The French portraitist Gaston Saint-Pierre's red-suited boy with a riding crop, shown at the 1884 Salon, provides a modern example of the custom applied to a male child, but Sargent reinvented it for his young female sitter. He thus linked the young girl both to the traditions of her patrician past and to her future role as a modern woman. It was a dialogue that had tremendous appeal.[45]

When Asher Wertheimer commissioned Sargent in 1898 to paint his family, he chose an artist at the height of his fame. Critics later noted the deliberate role they believed Sargent's portraits played in the social ascent they accused Wertheimer of engineering. But there were benefits for Sargent as well. Lucrative as the project was,

it seems doubtful that Sargent would have agreed to paint twelve portraits of the art dealer, his wife, and their ten children solely for financial reasons, or even in celebration of friendship. Instead, the artist may have been tempted by Wertheimer's ultimate ambition for the series—to present the paintings to the National Gallery after a carefully orchestrated campaign of exhibitions and publicity. The gift served Wertheimer, of course, who sought to place his family within the pantheon of British worthies that formed part of the British national collections.[46] But the plan assisted Sargent equally well, for through that gift to the National Gallery, he became the only living artist whose work was displayed in Britain's most prestigious art museum. He would thus place himself within Britain's national heritage, his paintings given the same status as the old masters he most admired (fig. 60).

Sargent increasingly sought opportunities to put his work in a historical context, linking his own art to that of the past. At the same time he was working on the Wertheimer portraits, Sargent accepted a commission to paint the aristocratic daughters of Percy Wyndham, three young women renowned for their wit and beauty (fig. 44). When the picture was exhibited at the Royal Academy in 1900, critics immediately compared it favorably with works by Reynolds, Lawrence, and Gainsborough. The writer for the *Times* commented that it seemed as if it had been painted "in obvious, if unavowed, rivalry with Sir Joshua."[47] While the contest with past masters might have been "unavowed" in the portrait of the Wyndham sisters, Sargent soon took on more forthright challenges. Two of his patrician commissions provide examples. The first was a group portrait of 1900, the Sitwell family, and the second a large dynastic image of the duke and duchess of Marlborough with their two sons, painted five years later (pls. 51, 54). In both cases, Sargent was asked to provide paintings that would do more than simply trigger the public's imagination about their resemblance to the old masters. These new works would associate immediately with their heritage, for they were to hang in close proximity to their eighteenth-century prototypes. Not only were the descendants of the family to be presented as worthy inheritors to the estate, but Sargent also could again offer himself as the direct heir to the acknowledged masters of art.

The Sitwell commission is particularly engaging, for in this instance there is a second layer of ambition. Here Sargent followed the course of Copley, another American who became a favored painter of English aristocrats. The confluence was deliberate, for Sargent's portrait of the Sitwells was intended from the beginning to complement Copley's charming conversation piece (pl. 52). Sir George Sitwell, scion of

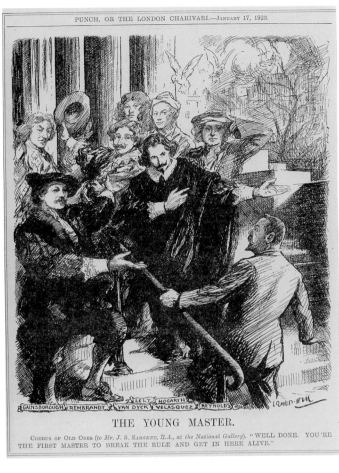

THE YOUNG MASTER.

Chorus of Old Ones (to Mr. J. S. Sargent, R.A., at the National Gallery). "WELL DONE. YOU'RE THE FIRST MASTER TO BREAK THE RULE AND GET IN HERE ALIVE."

FIG. 60. *The Young Master*, from *Punch, or the London Charivari*, January 17, 1923, 21. General Research Division, The New York Public Library, Astor, Lenox and Tilden Foundations

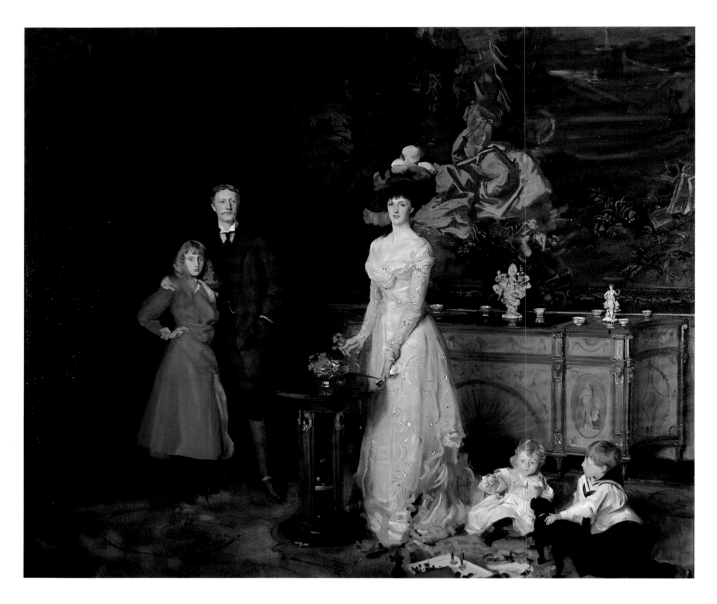

PL. 51. *Sir George Sitwell, Lady Ida Sitwell, and Family*, 1900, oil on canvas, 67 x 76 in. (170.2 x 193 cm). Private collection

Renishaw and an avid devotee of his ancestors, had spent almost a decade considering various artistic projects that would embellish the family legacy. By the end of the 1890s he had settled on the idea of commissioning a painting that would respond directly to the earlier canvas, and he sent the Copley to Sargent's London studio. Although Sargent professed himself unable to equal it, the Copley played a large role in his work.[48]

Copley had hoped to leave portraiture behind him when he left Boston in 1774, complaining that the colonies had afforded him no other commissions and that paintings were regarded there only as objects of craft, akin to well-made shoes, rather than admired as the fruit of a far more noble art. Nevertheless, Copley was ambitious and attentive to the demands of the marketplace, and he continued to accept portrait commissions in London, especially ones that enhanced his artistic reputation. The portrait he made for the Sitwell family was an experiment with a new kind of image, the conversation piece.

The figures were relatively small in scale, placed in a recognizable setting, and rather than posing solely for the delectation of the viewer, they were carefully arranged to imply an intimate glimpse of daily life. Conversation pieces had been popularized in England by the German painter Johann Zoffany, and when Zoffany left London in 1783, Copley may have hoped to garner a share of his business.[49]

Copley arrayed the Sitwell children within the comfortable surroundings of their elegant home. The boys, mischievous and lively, hold a mock battle over a house of cards, while their sister Mary provides a patient and watchful fulcrum at the center of the composition. The artist paid unusual attention to the play of light across the room, enhancing the relaxed atmosphere of his painting. While the work is replete with popular symbolism alluding to the ephemeral nature of human experience, Copley also emphasized the dynastic stability of the family, the attribute that led directly to Sargent's commission.

Sir George Sitwell was neither the first nor the last of Sargent's sitters to imagine a modern counterpart to Copley, although he may have been the most specific in his demands. Sir George intended Sargent to work within his guidelines, but Sargent refused to allow his client to dictate his art. He traveled to Renishaw but rejected the idea of painting his portrait of the Sitwells there, insisting instead on working in his Tite Street studio. While Sargent agreed to match the approximate size of Copley's canvas (Sargent's is slightly larger in each direction) and to undertake a similar format, he declined to re-create it. "It is evident that I cannot get what I want," complained Sir

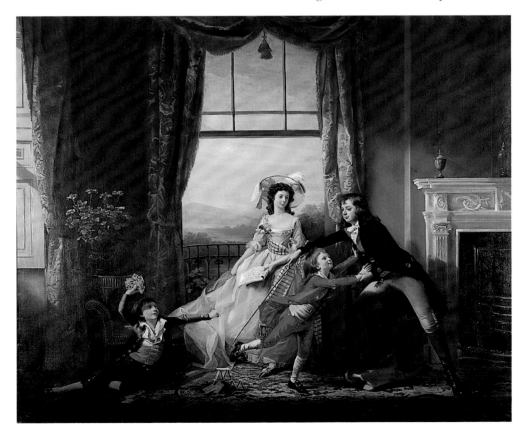

PL. 52. John Singleton Copley (American, 1738–1815), *The Sitwell Children*, 1787, oil on canvas, 61½ x 71 in. (156.2 x 180.3 cm). Private collection

George, "[but] I shall get the best the age has to offer." Perhaps to redeem his resistance and to compensate for the combative atmosphere that developed in the studio during the sittings, Sargent presented his finished painting to Sir George in a frame carefully matched to that of the Copley.[50]

Sir George had hoped to receive "a portrait group that will give information and tell its own story, and will hang and mezzotint as a pair to the Copley."[51] Many aspects of Sargent's portrait have their roots in the earlier painting. Lady Ida's position at the center of the composition imitates Copley's placement of young Mary. Both women wear white, and while Lady Ida's plumed hat seemed to her daughter Edith to be a peculiar complement to her sparkling evening gown, it clearly echoed Mary's similarly transparent and feathered confection. Sir George wears riding clothes ("he never rode," reported Edith[52]), another reference to the Copley portrait in which Sir Sitwell Sitwell, wearing buff trousers and boots, appears to have arrived from an equestrian tour of the family estate just in time to ruin his brothers' games. Through costume, Sargent linked Sir George directly to his illustrious ancestor, who had become the first baronet. Sir George's heirs, the toddlers Sacheverell and Osbert, are arrayed on the floor with toy soldiers and a dog, the modern counterparts to the similarly sprawled Francis and his fistful of playing cards. Edith, in a scarlet robe, recalls young Hurt, who lunges across Copley's composition in a bright red suit.[53]

By employing these correspondences, Sargent did provide Sir George with a painting that "gave information" and would "hang and mezzotint as a pair to the Copley." But Sargent left out Copley's narrative elements, clearly resisting the idea of a painting that would "tell its own story." While neither Copley nor Sargent commonly employed the conversation piece formula, it seems relevant to note that the two painters approached that convention from opposite ends of an age of anecdote. For Copley, the conversation piece was a daring experiment with a genre that had only recently gained popularity. In an early history of the subject (fittingly written by Sacheverell Sitwell), the invention of the English conversation piece was given to William Hogarth, with Zoffany and Arthur Devis as the most faithful practitioners of the art.[54] King George and Queen Charlotte adopted it for likenesses of the royal family, commissioning Zoffany to paint the queen "at home" with her children in 1764 (The Royal Collection). The portrait, while reminiscent of earlier examples by Van Dyck, also reflected the era's new attitudes about children.[55] Copley, newly arrived in London, immediately experimented with similarly informal images when he painted his own family in an interior backed by a pastoral landscape (1776, National Gallery of Art, Washington, D.C.). His interest in painting a conversation piece for Sitwell may have been motivated by Zoffany's success or he may have responded to his client's request for a fashionable image. In either case, and despite the fact that he did not continue to paint them, Copley was attempting a new and stylish motif.

By Sargent's day, that narrative formula was exhausted and laden with sentiment. An intermediate Sitwell family portrait illustrates the progression. In about 1828 the first Sir George (who had inherited the estate from Sitwell Sitwell) commissioned John Partridge, a fashionable London portraitist, to paint the first companion piece to

the Copley (pl. 53). Partridge depicted Sir George in the riding costume emblematic of his status, posing him in an elaborately furnished interior with his wife and three children, one a babe in arms and the other two disporting themselves among abandoned toys. Partridge's reliance on sentiment was indispensable to new definitions of childhood and the modern family, and it suited his era. By the twentieth century, however, Sacheverell Sitwell completely dismissed Partridge's picture, faulting its sweetness and calling it "no longer a work of art but . . . a curiosity of detail." Sitwell declared that the end of the conversation piece had come in the 1870s and 1880s, when it had disintegrated into saccharine anecdote, satirized in the illustrations in the popular journal *Punch*.[56]

In part, Sitwell wrote in reaction to the abundance of moralizing narratives that had characterized nineteenth-century painting in both Britain and America. From William Holman Hunt's *Awakening Conscience* (1853–54, Tate, London), with its intricate details and complex moralizing symbolism, to William Orchardson's melancholy *Mariage de convenance* (1883, Glasgow Art Gallery and Museum, Kelvingrove), thousands of narrative paintings were exhibited, described, and reproduced. Henry James had begun to find such imagery banal and depressing as early as 1877, mocking the Royal Academy exhibition for its concentration on "subjects addressed to a taste of a particularly unimaginative and unaesthetic order—to the taste of the British merchant and paterfamilias and his excellently regulated family." James added that such pictures

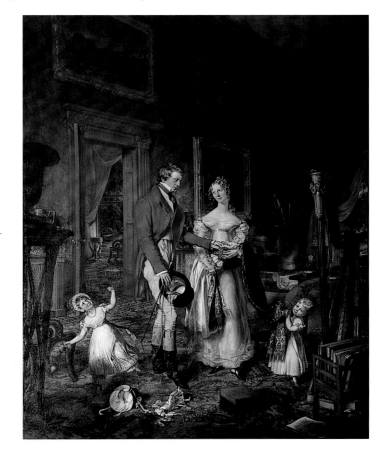

PL. 53. John Partridge (English, 1790–1872), *Sir George Sitwell and His Family*, c. 1828, oil on canvas, 75 x 59 in. (190.5 x 150 cm). Private collection

required a "title like a three-volume novel or an article in a magazine . . . some comfortable incident of the daily life of our period, suggestive more especially of its gentilities and proprieties and familiar moralities . . . [and] a long explanatory extract in the catalogue." He dismissed them with the sharp remark that they "belong[ed] to what the French call the anecdotal class."[57]

Sargent, once considered "beastly french [*sic*]"[58] and largely indifferent to anecdote, resisted Sitwell's request for a painting that would "tell its own story." By 1900 it would have seemed that all the stories had been told, and Sargent distinguished himself by refusing to manufacture another. In this way Sargent also set himself apart from the old masters he emulated. He discarded the idea of telling tales both in his rare conversation pieces and in his single portraits, never casting his young male sitters as Henry VIII, Puck, or Cupid, as had his predecessors. There are no small shepherdesses, historically costumed Infantas, or toga-clad cherubs. Marion Dixon noted the distinction in her 1899 article on Sargent's portraits, remarking that while "Romney and Reynolds were fully able to realise the dashing and

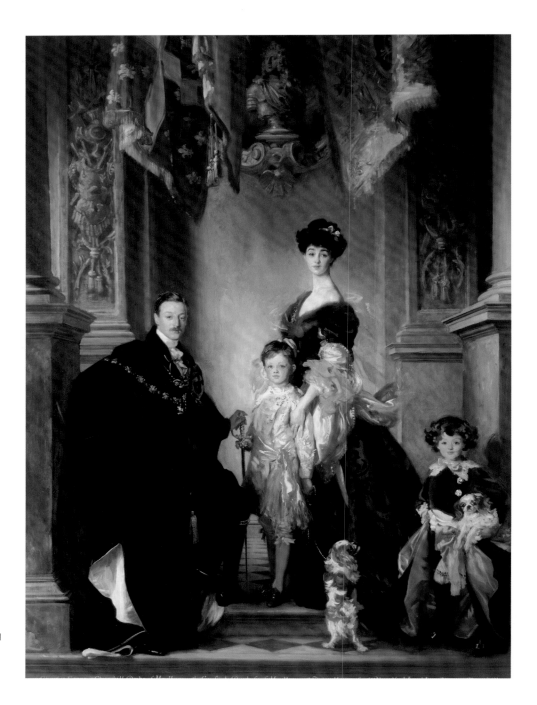

PL. 54. *The Family of the 9th Duke of Marlborough*, 1905, oil on canvas, 10 ft. 11 x 7 ft. 10 in. (3.3 x 2.4 m). Image courtesy of Blenheim Palace

buxom young matrons who came to pose to them as Hebe or Flora ... it is useless to suppose that the tense, 'prickly,' and complex woman of our present era could be summarised in any such off-hand way. Ladies no longer play at being goddesses."[59] Even for children, whose fond parents may have agreed to dress them in costume, Sargent borrowed vocabulary from the poetry of the past but avoided its prose.

Sargent escaped the problem of narrative in his portrait of the Marlborough family (pl. 54). As with the Sitwell commission, Sargent was asked to model his portrait

of the duke and duchess of Marlborough and their two sons after an eighteenth-century original. While in this case there was no expectation of story-telling, Sargent at first demurred, worried that the mammoth scale of the required canvas would be too large for his subjects. "When he realized there was no choice," recounted the duchess, "he began to study a composition that would place us advantageously in architectural surroundings."[60] Sargent's prototype was Reynolds's monumental portrait of the fourth duke (fig. 61), a huge painting with a panoply of eight figures, three dogs, draperies, twisted columns, plumes, theatrical masks, and a sculpture of the first duke holding a statuette of Victory.[61] Sargent had a smaller cast of characters to represent—only four people and two dogs—but his effort is equally grand. He borrowed Reynolds's stagelike setting, lending it a new air of gravitas by employing straight columns and military trophies in low relief and converting the billowing red curtains Reynolds had painted into the actual flags and banners that hung in the hall at Blenheim.

FIG. 61. Joshua Reynolds (English, 1723–1792), *The Family of the 4th Duke of Marlborough*, 1777–78, oil on canvas, 10 ft. 5 in. x 9 ft. 6 in. (3.2 x 2.9 m). Image courtesy of Blenheim Palace

The Marlborough portrait is an unabashed and undisguised proclamation of dynasty. The ninth duke, swathed in the Garter robes he had recently been awarded, may be the titular head of the family, but he is not the hero of the composition. The center of attention is instead his son John, marquess of Blandford and the much-desired heir, who stands at center dressed in gold and white and surrounded by a halo of light. Sargent placed the boy directly beneath the portrait bust of the first duke and painted him with a comparable sense of authority and assurance. Blandford confidently grasps the hilt of his father's sword, accepting the transfer of authority embodied in that ancestral symbol of power.

While the estate passed from father to son, Sargent understood that the strength of this dynasty also depended on its maternal line. Sargent's duchess was Consuelo Vanderbilt, an American of tremendous wealth who had been pursued by the duke of Marlborough, not for love, but to salvage the finances of his estate. Consuelo had capitulated to her mother's unflinching determination to link her with the aristocracy; she was a pawn in a game of money and power that was obvious to everyone. Her husband, intent on the survival of his house, told her she was "a link in the chain."[62] Sargent would seem to have been sympathetic to her situation, and he gave Consuelo a leading role in his painting. Although Reynolds had provided appropriate sanction for the central position of the duchess in his work, there is a crucial difference. Reynolds's duchess stands at the center of the canvas and is silhouetted against the archway, but she is preoccupied with her younger children. It is her husband who presents the heir, engaging the boy in his domain of books and power. In Sargent's portrait, it is the duchess who offers her son, and her encircling arms imply his allegiance to her.

Mother and son are further linked by costume, for Consuelo wears a black-and-pink gown she said was inspired by a Van Dyck in the Blenheim collection. Young Blandford's fancy dress (and that of his brother as well, visually uniting the heir and the "spare") is also derived from Van Dyck, filtered through Gainsborough. In his satin knee breeches, Blandford poses as Gainsborough's *Blue Boy* reborn, with all of his predecessor's elegance and swagger.[63] Perhaps there is also a nod to *Little Lord Fauntleroy*, for once again an American mother has provided a suitable heir to an aristocratic English house. The subject of Sargent's portrait is not only the Marlborough family, but, in one writer's words, it is also the "Apotheosis of the Vanderbilts."[64]

This preoccupation with history and heritage was not unique to his clients, for Sargent was carefully considering his own artistic legacy during the 1890s. His position as the court painter to Edwardian aristocrats and captains of industry was a triumph, much as Copley's had been a century before. As the writer Christian Brinton related in 1908, Sargent followed in a tradition of painters who similarly had captivated English audiences. Brinton noted that Van Dyck "had come across from Flanders to be the painter of aristocracy, John S. Sargent will go down to posterity as the painter of its latter day equivalent—plutocracy."[65]

For Sargent, however, these portraits were not enough. Perhaps it was not lost on him that his mannered and obvious painting of the Marlborough family, with its proper figures so ornately costumed and artificially posed, flirts with excess. By 1905 he had already tired of the relentless stream of would-be sitters who had made their way to his door, and soon he gave up portrait painting almost entirely. He had already started another project that linked his efforts to the masters of the past—mural painting. Like Copley before him, Sargent threw in his bid for immortality, not with portraits, but with history paintings. Sargent invested his legacy in the monumental decorations that he crafted for Boston's public library, museum, and the library at Harvard University. Trained in the academy, he regarded his murals as far more important than any of his likenesses, and these paintings, permanently affixed to architectural monuments, were meant to stand forever alongside both the literary and artistic treasures of the past.

Sargent's reputation did not rest on the works he felt were most significant, however. Only recently have his murals been reconsidered as an integral part of his achievement. Instead, like Copley, Sargent's fame rests on his portraits. He was the most successful image maker of his time, creating an astonishing number of pictures that satisfied the desires of both the people who paid for them and the painter who crafted them. Even Roger Fry realized that Sargent was "a brilliant ambassador between [his sitters] and posterity."[66] But it was not only the future position of his clients that the artist secured. He also guaranteed a legacy of his own. In his depictions of children, the dynastic aspirations of patrons were met and matched by those of Sargent himself.

NOTES

1. Frederic Porter Vinton, *Boston Evening Transcript*, February 18, 1899, 5. Vinton's comments were made in a letter to the editor.

2. Similarly, the "easy affability and gentle manners that had characterized [Joshua] Reynolds both socially and professionally throughout his career would ironically work against him within a biographical narrative." See Richard Wendorf, *Sir Joshua Reynolds: The Painter in Society* (Cambridge, Mass.: Harvard University Press, 1996), 204. See also Richard Ormond, *John Singer Sargent: Paintings, Drawings, Watercolors* (New York: Harper and Row, 1970), 64–65.

3. Marie-Louise Pailleron, *Le paradis perdu: Souvenirs d'enfance* (Paris: Albin Michel, [1947]), 159.

4. "The Sargent Portraits at the Museum of Fine Arts," *Boston Evening Transcript*, June 12, 1903.

5. William C. Brownell, "American Pictures at the Salon," *Magazine of Art* 6 (1883), 497–98; Maurice Du Seigneur, "L'art et les artistes au Salon du 1882," *L'Artiste* 52 (June 1882), 646; Un abonné Français, "Frans Hals et Manet," *L'Art Moderne* 3 (September 30, 1883), 311–12; "M. Rodin in London," *Daily Chronicle*, May 16, 1906, quoted in Richard Ormond and Elaine Kilmurray, *John Singer Sargent: The Early Portraits; Complete Paintings, Volume I* (New Haven and London: Yale University Press for the Paul Mellon Centre for Studies in British Art, 1998), 150. For further discussion of old master comparisons (up to 1887), see Marc Simpson, *Uncanny Spectacle: The Public Career of the Young John Singer Sargent* (New Haven and London: Yale University Press, 1997), 52–57.

6. Richard Ormond and Mary Pixley, "Sargent after Velázquez: The Prado Studies," *Burlington Magazine* 145 (September 2003), 633. See also Marc Simpson, "Sargent, Velázquez, and the Critics," *Apollo* 148 (September 1998), 3–12, and Gary Tinterow and Geneviève Lacambre, *Manet/Velázquez: The French Taste for Spanish Painting* (New York: Metropolitan Museum of Art, 2003).

7. Evan Charteris, *John Sargent* (London and New York: Charles Scribner's Sons, 1927), 195.

8. Philip Hendy, *European and American Paintings in the Isabella Stewart Gardner Museum* (Boston: Isabella Stewart Gardner Museum, 1974), 253; Mary Crawford Volk, et al., *John Singer Sargent's "El Jaleo"* (Washington, D.C.: National Gallery of Art, 1992), 85–87, 108. The Gardner Tintoretto, first given to Jacopo, has now been attributed to Domenico. Volk states that Sargent learned of the El Greco portrait from friends in Spain. Sargent's information was not private, however, for this painting was also mentioned in a letter of December 1903 from Paul Durand-Ruel to Harry Havemeyer as a possible purchase. Havemeyer preferred to pursue El Greco's *Portrait of a Cardinal* (c. 1600, The Metropolitan Museum of Art), which he was able to buy in June 1904. See Alice Cooney Frelinghuysen et al., *Splendid Legacy: The Havemeyer Collection* (New York: Metropolitan Museum of Art, 1993), 236–37. In 1924 Sargent also recommended an El Greco portrait and Michelangelo's charcoal study for the Libyan Sibyl to the Metropolitan Museum.

9. See Gary A. Reynolds, "Sargent and the Grand Manner Portrait," *Antiques* 130 (November 1986), 980–93, and Gary A. Reynolds, "Sargent's Late Portraits," in *John Singer Sargent*, ed. Patricia Hills (New York: Whitney Museum of American Art in association with Harry N. Abrams, 1986), 146–79.

10. Leila Mechlin, "The Sargent Exhibition, Grand Central Art Galleries, New York," *American Magazine of Art* 15 (April 1924), 170.

11. Simpson, *Uncanny Spectacle*, 130–31.

12. Sadakichi Hartmann [Sidney Allan], "Children as They Are Pictured," *Cosmopolitan Magazine* 43 (July 1907), 235.

13. *Toys and Novelties* 4 (April 1911), 10, quoted in William Leach, *Land of Desire* (New York: Vintage Books, 1993), 87.

14. For a wonderful analysis of Sargent's early exhibition strategies and a compilation of critical reviews, see Simpson, *Uncanny Spectacle*.

15. Fitzwilliam Sargent to Thomas Sargent, May 18, 1883, Archives of American Art, Smithsonian Institution, Washington, D.C., reel D317, frame 456; *Revue des Deux Mondes*, 1883, 616, as quoted in Ormond and Kilmurray, *John Singer Sargent: The Early Portraits*, 66.

16. Henry James, "John S. Sargent," *Harper's New Monthly Magazine* 75 (October 1887), 688; Susan Hale, "Susan Hale's Chit-Chat," *Boston Sunday Globe*, February 5, 1888, 13; Marion Hepworth Dixon, "Mr. John S. Sargent as a Portrait Painter," *Magazine of Art* 23 (1899), 115. William Merritt Chase's *The Ring Toss* (1896, private collection) has been compared with Sargent's *The Daughters of Edward Darley Boit* in terms of its similar inspiration from Velázquez (see H. Barbara Weinberg, "American Artists' Taste for Spanish Painting," in Tinterow and Lacambre, *Manet/Velázquez*, 288), but the theme of play may also link the two compositions.

17. Paul Mantz, "Exposition de la Société internationale," *Le Temps*, December 31, 1882, 3, as quoted in Simpson, "Sargent, Velázquez, and the Critics," 5, 11.

18. William C. Brownell, "American Pictures at the Salon," *Magazine of Art* 6 (1883), 498–99. Trevor J. Fairbrother noted that Brownell was the first critic to link the two paintings; see Fairbrother, *John Singer Sargent and America* (New York: Garland Publishing, 1986), 67.

19. James, "John S. Sargent," 686.

20. Mariana Griswold Van Rensselaer, "Open Letters, American Artist Series," *Century Magazine* 43 (March 1892), 798. It must be noted, however, that *Beatrice Goelet* also strongly resembles Van Dyck's portrait of Clelia Cattaneo (fig. 56), which was in a Genoese collection until 1907.

21. Henry James, "The Wallace Collection in Bethnal Green" (1873), in Henry James, *The Painter's Eye*, ed. John L. Sweeney (Madison: University of Wisconsin Press, 1989), 71.

22. Charteris, *John Sargent*, 52.

23. During the height of his practice in the 1890s, he painted twelve to fourteen portraits every year. See Richard Ormond and Elaine Kilmurray, *John Singer Sargent: Portraits of the 1890s; Complete Paintings, Volume II* (New Haven and London: Yale University Press for the Paul Mellon Centre for Studies in British Art, 2002), 79.

24. For Lady Agnew, see Julia Rayer Rolfe et al., *The Portrait of a Lady: Sargent and Lady Agnew* (Edinburgh: National Gallery of Scotland, 1997). Just the year before, Sargent had used an identical pose in a half-length portrait of a four-year-old boy, Master Skene Keith, who lolls in a *bergère* armchair with one hand in his lap (pl. 59).

25. My discussion is indebted to Margaret Maynard, "'A Dream of Fair Women': Revival Dress and the Formation of Late Victorian Images of Femininity," *Art History* 12 (September 1989), 322–41.

26. For Lever, see Alex Kidson, "Lever and the Collecting of Eighteenth-Century British Paintings," *Journal of the History of Collections* 4 (1992), 201–9.

27. For Asher Wertheimer's activities as a dealer, see Michelle Lapine, "Mixing Business with Pleasure: Asher Wertheimer as Art Dealer and Patron," in *John Singer Sargent: Portraits of the Wertheimer Family*, ed. Norman L. Kleeblatt (New York: Jewish Museum, 1999), 43–53.

28. Walpole and Reynolds as quoted in Deborah Cherry and Jennifer Harris, "Eighteenth-Century Portraiture and the Seventeenth-Century Past: Gainsborough and van Dyck," *Art History* 5 (September 1982), 287–309.

29. Knut Hamsun, *The Cultural Life of Modern America* (1889), ed. and trans. Barbara Gordon Morgridge (Cambridge, Mass.: Harvard University Press, 1969), 88; Nancy T. Minty, "Of Rembrandts and Van Dycks Family Trees Were Made: The Ennoblement of Gilded Age Collectors," paper presented at the College Art Association 90th Annual Conference, Philadelphia, February 2002.

30. For exhibitions of and renewed interest in eighteenth-century artists, see Ormond and Kilmurray, *John Singer Sargent: Portraits of the 1890s*, 1–9, 81. For Burne-Jones, see Mary Lago, ed., *Burne-Jones Talking* (New York: Columbia University Press, 1981), 101, 104 (quoted in Ormond and Kilmurray).

31. James Jackson Jarves, *The Art Idea* (1864), ed. Benjamin Rowland Jr. (Cambridge, Mass.: Belknap Press, 1960), 169. For Copley's reputation in nineteenth-century literature, see Carrie Rebora, "Copley and Art History: The Study of America's First Old Master," in Carrie Rebora and Paul Staiti, *John Singleton Copley in America* (New York: Metropolitan Museum of Art, 1995), 3–23, and Roger B. Stein, "Gilded Age Pilgrims," in William H. Truettner et al.,

Picturing Old New England: Image and Memory (New Haven and London: Yale University Press in association with the National Museum of American Art, 1999), 60–66.

32. William Dean Howells, *The Rise of Silas Lapham* (1884; Boston: Houghton Mifflin Company, 1937), 203.

33. Copley's *Epes Sargent* remained in a branch of the family until 1958; from 1876 to 1931 it belonged to Caroline Dixwell Clements (Mrs. George Henry Clements, 1856–1931), the sitter's great-great-great-granddaughter, who lived in New York. Copley's stature in England was also secure, for not only had he become a respected member of the Royal Academy but his son, John Singleton Copley Jr., became a successful lawyer and politician. Created Lord Lyndhurst in 1827, he served three times as Lord Chancellor of Britain.

34. *Boston Evening Transcript*, March 12, 1895, 5. See Fairbrother, *Sargent and America*, 188–89.

35. "The Sargent Portraits at the Museum of Fine Arts," *Boston Evening Transcript*, June 12, 1903.

36. See James Christen Steward, *The New Child: British Art and the Origins of Modern Childhood, 1730–1830* (Berkeley: University Art Museum and Pacific Film Archive, University of California, Berkeley, in association with the University of Washington Press, 1995).

37. Henry Adams, quoted in Ormond and Kilmurray, *John Singer Sargent: Portraits of the 1890s*, 107.

38. Michael Rosenthal, *The Art of Thomas Gainsborough* (New Haven and London: Yale University Press, 1999), 86.

39. Sir Joshua Reynolds, *Discourses*, with introduction and notes by Roger Fry (London: Seeley and Co., 1905), 216–17.

40. Nicholas Penny, ed., *Reynolds* (London: Royal Academy of Arts in association with Weidenfeld and Nicolson, 1986), 221; the attribution has been questioned, although a portrait of Lister is mentioned in account books. Reynolds also painted Thomas's sister Beatrix Lister.

41. *The Letters of Bernard Berenson and Isabella Stewart Gardner, 1887–1924*, ed. Rollin van N. Hadley (Boston: Northeastern University Press, 1987), 50–55.

42. See Ruth P. Rubinstein, *Society's Child: Identity, Clothing, and Style* (Boulder, Colo.: Westview Press, 2000), 144–46, and Jo Barraclough Paoletti, "Little Lord Fauntleroy and His Dad: The Transformation of Masculine Dress in America, 1880–1900," *Historic Fashions*, at http://www .sallyqueenassociates.com/fauntleroy.htm.

43. Hartmann, "Children as They Are Pictured," 235.

44. D. S. MacColl, "The New Gallery and Two Others," *Saturday Review* 89 (May 5, 1900), 555.

45. The conceit of using an established old master association in a similarly unexpected context may also have shaped Sargent's portrait of Edith Phelps Stokes (1897, The Metropolitan Museum of Art, New York). As originally conceived, with a large dog as Mrs. Phelps Stokes's companion, the Sargent portrait would have echoed the subject, color scheme, and pose of Van Dyck's portrait of James

Stewart with a greyhound, which Henry Marquand had given to the Metropolitan in 1889. As with *Victoria Stanley*, Sargent referred to a male image of authority and power to define his image of a modern woman.

46. Lapine, "Mixing Business with Pleasure," 50–51. Having his paintings represented at the National Gallery would have been considered more prestigious than having them at the Tate. Joseph Duveen purchased Sargent's *Ellen Terry as Lady Macbeth* and presented it to the Tate in 1906. Bernard Partridge's *Punch* cartoon (January 31, 1905), which shows Sargent and Velázquez walking arm-in-arm holding the paintings that were entering the Tate (Sargent's *Ellen Terry*) and the National Gallery (Velázquez's *The Toilet of Venus*) respectively must also have pleased Sargent.

47. "The Royal Academy, First Notice," *London Times*, May 5, 1900, 14.

48. See Sarah Bradford and Honor Clerk, "Childhood at Renishaw," in Bradford et al., *The Sitwells* (Austin: University of Texas Press, 1994), 12–30.

49. See William L. Pressly, "The Challenge of New Horizons," in Emily Ballew Neff, *John Singleton Copley in England* (Houston: Museum of Fine Arts, Houston, 1995), 54–57.

50. Elaine Kilmurray and Richard Ormond, eds., *John Singer Sargent* (London: Tate Gallery Publishing, 1998), 156–57; Bradford et al., *The Sitwells*, 30–31.

51. Quoted in Kilmurray and Ormond, *John Singer Sargent*, 156.

52. Bradford et al., *The Sitwells*, 30.

53. See the discussion of the Sitwell portraits in Reynolds, "Sargent and the Grand Manner Portrait," 985.

54. Sacheverell Sitwell, *Conversation Pieces* (New York: Charles Scribner's Sons, 1937), 47.

55. See Steward, *The New Child*.

56. Sitwell, *Conversation Pieces*, 84, 86–87.

57. Henry James, "The Picture Season in London" (1877), in James, *The Painter's Eye*, 148.

58. Sargent to Edwin Russell, September 10, 1885, Tate Gallery Archives, London, quoted in Ormond and Kilmurray, *John Singer Sargent: The Early Portraits*, 130.

59. Marion Hepworth Dixon, "Mr. John S. Sargent as a Portrait-Painter," *Magazine of Art* 23 (1899), 119.

60. Consuelo Vanderbilt Balsan, *The Glitter and the Gold* (New York: Harper and Brother Publishers, 1952), 185. See also the discussion of the Marlborough collection during the eighteenth century and of that duchess's desire to maintain an artistic genealogy to Van Dyck in Cherry and Harris, "Eighteenth-Century Portraiture and the Seventeenth-Century Past," 292.

61. For the iconography of the Reynolds portrait, see Penny, *Reynolds*, 279–81. As he had done in the Sitwell portrait, Sargent used a number of details that his predecessor had employed. In both paintings, the dukes wear the Order of the Garter, and both include a sculptural representation of the first duke.

62. Balsan, *The Glitter and the Gold*, 66. The unhappy story of the duke of Marlborough and Consuelo Vanderbilt (and others like it) inspired the theme of Edith Wharton's last novel, *The Buccaneers*, left unfinished at her death in 1937.

63. The duchess of Marlborough particularly admired *The Blue Boy*, which she had seen at Grosvenor House in London when she was first presented at court. Balsan, *The Glitter and the Gold*, 97.

64. Louis Auchincloss, *The Vanderbilt Era* (New York: Collier Books, 1989), 128. The duke and duchess separated the following year, an event of exceptional public interest. They were divorced in 1920 and the marriage was annulled in 1926.

65. Christian Brinton, *Modern Artists* (New York, 1908), 163, as quoted in Reynolds, "Sargent and the Grand Manner Portrait," 982.

66. Roger Fry, 1923, as quoted in Trevor J. Fairbrother, *John Singer Sargent* (New York: Harry N. Abrams, 1994), 131.

Posing Problems

Sargent's Model Children

BARBARA DAYER GALLATI

"But it's no use now," thought poor Alice, "to pretend to be two people! Why there's hardly enough of me left to make one respectable person!"
—Lewis Carroll, Alice's Adventures in Wonderland, *1865*

Lewis Carroll's fictional character Alice was inspired by the young Alice Liddell (1852–1934), who is arguably the most famous child model of the Victorian era (fig. 62).[1] Both Alices have remained forever young, not only through Carroll's poetry and prose but also through the photographs for which Alice Liddell posed—reportedly patiently—as herself and in roles devised by Carroll. Although in her later years Alice Liddell remembered posing for the photographs as a "joy" and "not a penance as it is to most children," it is not difficult to imagine that any eight-year-old, however willing and pliant a subject, might tire under the intensity of an observer's gaze and succumb to the stress of posing.[2] Such sentiments may be discovered in the fictional Alice's admission that it was "no use . . . to pretend to be two people," words uttered as she attempted to regain control of herself in the face of the unpredictable alterations of her body that occurred throughout the narrative. In the short passage quoted here it is possible to detect Carroll's acknowledgment of a standard human dilemma: that is, how to manage the conflict between desired and "natural" behavior and the frustration generated by that conflict.[3] Wonderland's Alice mediated her own negotiations in control and was able to reconcile herself to her ever-changing situation. In actuality, however, few children have the authority or ability to achieve such

Detail of plate 81

FIG. 62. Lewis Carroll (Charles Dodgson, English, 1832–1898), *Alice Liddell as "The Beggar-Maid,"* 1857. Morris L. Parrish Collection, Department of Rare Books and Special Collections. Princeton University Library

reconciliation independently and must surrender to adult control, happily or not.

The core elements for the fictive and real Alices—pretense, desired versus natural behavior, frustration, unpredictability, control, submission, and reconciliation—are common facets of human social experience. Yet they take on special relevance in the context of portraiture, a field of art that generally requires layered, personal interactions among artist, subject(s), and commissioner(s), and which (in Sargent's milieu) was intended to represent a particular person *and* function as a work of art. Accounts of the lives of many portraitists, Sargent included, contain references to numerous, often emotionally fraught and physically grueling sittings suffered by adults who, in turn, tested the patience and challenged the aesthetic desires of the painters. If a portrait sitting was an ordeal for many adults and the painters who recorded their features, what was it like for children (who traditionally had neither control in the matter nor vested interest in the outcome) and those charged with creating the work? Was the portrait process a penance or a pleasure for Sargent and the children he painted? What can be learned about Sargent, his art, and his relationships with his clients from examining the ways he portrayed his child sitters?

FAMILY CONNECTIONS

Two photographs of a young John Singer Sargent (figs. 63, 64) are vivid reminders of the vagaries of posing; although the photographs may have been taken at the same time and place, the results are so vastly different that one might be hard-pressed to recognize the subject as the same child. Indeed, we seem to see two individuals, one an uncomfortable little boy standing rigidly, mannequin-like and expressionless, and the other a personable little fellow adopting a pose with self-conscious grace. Yet both images are of the same individual, and the disparities between the two seem to lie in the subject's level of participation in the process of posing. We might suspect that, like Alice, the boy Sargent may have suffered some confusion in deciding how to present himself. In that connection it is difficult not to impose a chronology on the two images, for the likely sequence is that the photograph showing the awkwardly posed boy is the first, while the one of an ostensibly relaxed child is the second. There is, of course, no way of knowing in which order the photographs were taken. The fact that both show the same youngster posing with such incongruent results opens questions about child models and their awareness of self-presentation and about how portraiture is affected by the combined agencies of sitter and artist-photographer. In addition to introducing questions involved in looking at posed children, these photographs attest materially to the fact that most portraits of children, regardless of medium, are made

to satisfy the desires of adults. It is because of Sargent's parents' wishes for a likeness of their son that we have the privilege of seeing evidence of what may have registered as one of Sargent's earliest, albeit accidental, lessons about portraiture and the complexities of posing.

Portrait photographs were an important part of the Sargent family's life. This is demonstrated in a series of letters from Sargent's father, Dr. Fitzwilliam Sargent, to his parents and siblings in America. In them Dr. Sargent betrayed his fervent yearning to quit the nomadic expatriate European existence that he and his wife had led since leaving the United States in 1854 and revealed his anxious need to maintain strong family connections. These written exchanges were often accompanied by portrait photographs that were sources of great joy to their recipients. Writing to his father in 1865, Fitzwilliam Sargent expressed his appreciation for a recent delivery: "I have Winthrop, Gorham [his brothers] and yourself in effigy: I should like very much to have portraits of all, with the birthday of each written upon each....What a happy invention photography is! I never was so much pleased with it as since I have seen your portrait."[4] Two years later he urged his mother to visit them with the assurance, "you would have a warm and familiar welcome from big folks and little folks, for John and Emily know your photographs by heart."[5] It was equally essential to Fitzwilliam Sargent that the American branch of the family know his offspring as well as possible. Thus, in addition to detailing the growth and habits of each child in his letters, Fitzwilliam sent his share of photographs homeward, often supplementing them with poignant commentary. A particularly moving letter describes the physical decline of the Sargents' three-year-old daughter, Minnie, and Dr. Sargent's efforts to obtain a good photographic likeness of her (fig. 10):

Two weeks ago she was so ill that we had little hope she would recover. But God has been very kind to us … and now we hope she may get well. Mary [Mrs. Sargent] was very anxious to have a photograph of her; and so we took her, one day, to have her portrait taken. We tried her alone in a chair, but she would pucker her mouth so continually that we could not succeed in getting an impression, and we were obliged to give up the attempt. Finally I took her in my arms, and amused her with a picture & book which I held in my hands, and so we succeeded in having a more satisfactory likeness taken. I send you a copy. How different she looks from what she did 3 months ago! She was so rosy, & so healthy & solid looking then; & now she is so pale and so thin, so feeble!—a withered flower.[6]

Although the young John Singer Sargent, then just eight and a half, was unlikely to have been privy to his parents' intimate expressions of sadness connected with Minnie's frail condition, he may have gleaned the special significance attached to a family portrait at this time. Certainly his own posing sessions for these treasured family souvenirs would have instilled in him a rudimentary concept of how the impression of personality or identity could be shaped visually. The degree to which the young John Sargent mediated or constructed the poses for his own photographs is unknown, but a casual comment in one of his father's letters reveals that by 1867 John and Emily probably had considerable say about the way they were presented: "I enclose the last photographs of all of us excepting Emily, who was not pleased with her likeness & so did not accept it."[7]

Given the Sargents' reliance on photographic likeness to preserve family connections and to document the swiftly changing aspects of their children, it is likely that

FIG. 65. *Head of a Sleeping Child*, c. 1872–73, graphite on off-white wove paper, 11¹¹/₁₆ x 8¹⁵/₁₆ in. (29.8 x 22.5 cm). The Metropolitan Museum of Art. Gift of Mrs. Francis Ormond, 1950 (50.130.141y). All rights reserved

FIG. 66. Violet Sargent, c. 1872. Private collection

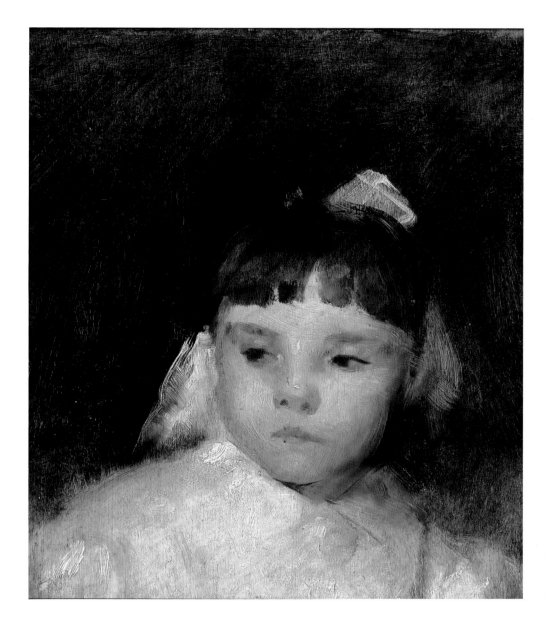

PL. 55. *Violet Sargent*, c. 1875, oil on panel, 10½ x 9¼ in. (26.7 x 23.5 cm). Private collection. Photograph courtesy of Adelson Galleries, Inc., New York

John Singer Sargent's early attempts at portraiture carried similar associations for him. His younger sister Violet was a convenient subject, and it was probably she who best introduced the artist to the practical issues of portraying children. A slight but charming drawing of the head of a sleeping child (fig. 65) is tentatively identified as Violet at the age of two or three (fig. 66).[8] For the budding artist a motionless figure would prove the easiest subject, and in that connection, the best child model is the one who slumbers. In contrast, Sargent's earliest surviving oil portrait (pl. 55) gives a spontaneous glimpse of Violet caught in motion, her attention apparently seized by something other than the dullness of sitting for her painter-brother. The physical and mental restlessness suggested in this painting were accommodated by the small size of the panel, the rapidity and sketchiness of the brushwork, and Sargent's own presumed expectations

that he could not hope to do more with such an active subject. As Violet grew older and developed a greater understanding of the exercise of sitting, her cooperation (or complicity) with her brother's efforts becomes apparent in his sensitive portraits of her that trace her growth from childhood to young womanhood (fig. 67, pls. 56, 57) and mark his own growth into an artist of great talent.

THE "UNPOSED" CHILD

A standard observation reiterated throughout the wealth of publications recently devoted to portraiture is that the content of the image relies not only on the degree of physical likeness achieved but also on the information about the sitter that is conveyed through the pose.[9] As Harry Berger Jr. has offered, "To pose is by definition to portray oneself, and painters must learn how to influence the acts of self-portrayal they are

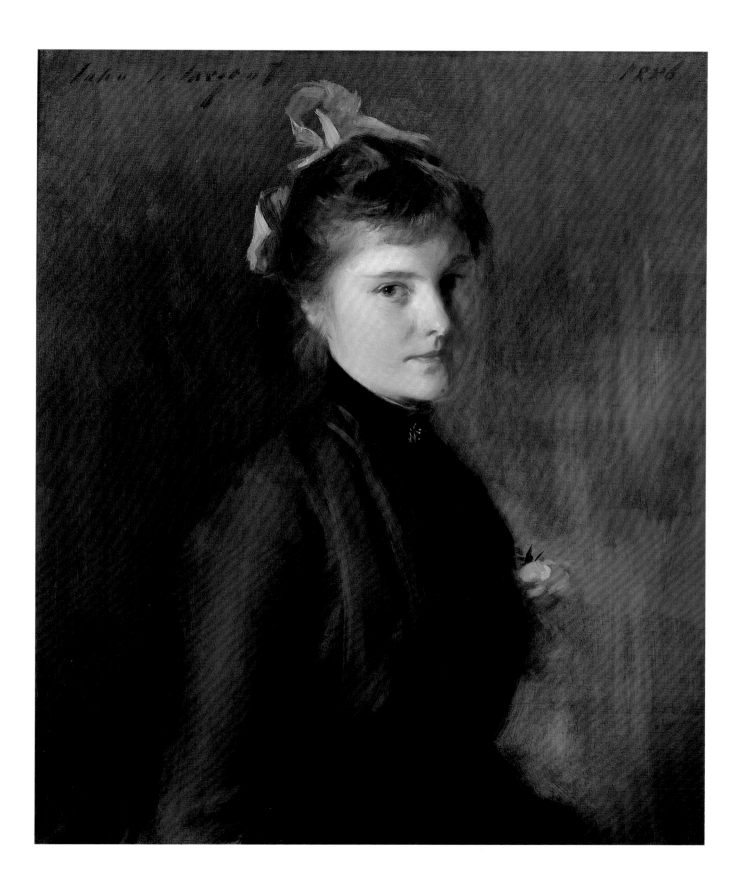

PL. 58. *Daniel de Mendi Macmillan*, 1887, oil on canvas, 16¼ x 14¼ in. (41.3 x 36.2 cm). The Trustees of the Macmillan Estates

commissioned to represent.... portraits can be viewed as imitations or likenesses, not of individuals only, but also of their acts of posing."[10] Like Berger's, most theoretical frameworks for discussing portraiture rely on the premise that the subject is capable of posing, that is, that the sitter possesses a concept of selfhood and can consciously select aspects of that self to reveal. Such a premise cannot apply to portraits of very young children and necessitates a different set of assumptions for looking at portraits of infants and toddlers, persons whose circumscribed, egocentric worlds do not allow for controlled presentations of varied, layered, or even falsely constructed aspects of personal identity.[11] Essentially, then, very young children are not capable of posing.

Sargent's *Daniel de Mendi Macmillan* (pl. 58) and *Dorothy* (fig. 68, pl. 3) qualify as "unposed" portraits, inasmuch as neither child could have consciously posed in Berger's sense of the word. Instead, to use "pose" in an alternative meaning, both children are "put" or placed in positions that are conducive to gaining a likeness easily and rapidly. It can be deduced in the case of the one-year-old Daniel Macmillan that he was physically supported and quieted by someone while Sargent painted. Dictated by the practicalities of portraying toddlers, both paintings verge on the perfunctory; the children are shown in minimal settings, against plain grounds, and on small canvases whose surfaces are devoted mainly to delineating their faces. Yet these paintings exert a surprisingly powerful impression, one that is activated by the unexpectedly elaborate frames that surround them. Positioned close to the picture plane and approximately life size, the two tiny sitters fill the pictorial space, their forms locked in stable, pyramidal compositions. They stare back at us with a strange, unfathomable intensity that somehow reminds us that our own childhood memories of being that age are lost to us. By depicting these youngsters in a strong, dignified manner (Daniel is shown as plainly as possible, and Dorothy, despite her preposterous bonnet, transcends the fashion imposed on her), Sargent forces us to confront the children as individuals with whom we are literally brought face to face. However, in the absence of the sitters' lived experience and achievement—the common biographical apparatus used to discuss portraiture—the portraits of Daniel and Dorothy forestall discussion about personality or accomplishments as they might or might not be revealed through artistic representation. Without biography, it is difficult to approach these portraits in a standard way, and this narrative void may account in part for the fact that little comment has been devoted to either work in the Sargent literature.[12] By the same token, the common iconography of childhood is also absent, so the images lack the usual associations of innocent play with toys or pets.

Contemporary response to the portrait of Daniel can be altered by the knowledge of his accomplishments as an adult: he was chairman of Macmillan & Company, the family's publishing firm—a fact that inspires us to search for evidence of the future man in the image of the child. For the most part, however, portraits of children elicit responses determined by knowledge of their parents, by the generalities of style, or, most often, by the "cuteness quotient." *Dorothy*, for example, was highly admired when the painting was displayed at the SAA in 1901, but the critic for the *New York Times* had only this to say: "The portraits are many and good, led easily by little Miss 'Dorothy' in the Vanderbilt Gallery, from the easel of John S. Sargent. Seen near by, the red paint on the lips, the white paint on the little girl's hat seem quite misplaced, but as one steps back a bit the magic stroke takes place, the red lips are all right, the white ribbon is just right."[13] *Dorothy* was more aptly characterized by Harrison Morris later that year in his *Scribner's Magazine* article "American Portraiture of Children," in which he separated Sargent's paintings of children from those of his contemporaries: "There is a babyhood which Sargent has painted with the buoyant technique and unbending truth that are his highest gifts. . . . he has stolen into the being of the pretty infants and betrayed the guileless mysteries of their brief existence. His is an art which does not so much look for sentiment as for reality. He has no madonnas in his list, and only a few compositions. He deals by choice with the portrait as a solvent of character and enjoys the biologic practice of revealing the secrets of life with a brush."[14] From a historical standpoint, the portrait of the little girl, Dorothy Williamson, gathers meaning with the knowledge that her father was one of Sargent's first American patrons, for it was George Millar Williamson who was the owner of *Neapolitan Children Bathing* when it was shown at the NAD in 1879.[15] These connections were alluded to in 1902, when *Dorothy*, *Neapolitan Children Bathing* (then titled *Innocence Abroad*), and Sargent's recent portrait of G. M. Williamson were displayed at the annual exhibition of the Pennsylvania Academy of the Fine Arts. Such groupings of linked works helped impart a biographical context that would have been absent had *Dorothy* been displayed independently.

FIG. 68. *Dorothy*, 1900, oil on canvas, 24⅛ x 19¾ in. (61.3 x 50.2 cm). Dallas Museum of Art, gift of the Leland Fikes Foundation, Inc.

THE PENANCE OF SITTING STILL

The challenges of painting slightly older children are manifold compared with those presented by toddlers. Patrons' expectations for a "more important" or sizable painting seem to increase commensurately with the age of the sitter. With that comes the demand for more complex compositional arrangements, which are complicated by the natural difficulties in inducing children to sit still for prolonged periods of time. Enforced immobility, of course, requires young sitters to overcome common associations of sitting still with disciplinary measures or, as one nineteenth-century child

PL. 59. *Skene Keith*, 1892, oil on canvas, 30 x 26 in. (76.2 x 66 cm). Private collection. Photograph courtesy of Adelson Galleries, Inc., New York

expert noted, with the confines of the dental chair.[16] Sargent's portrait of four-year-old Skene Keith (pl. 59) captures something of that feeling. The passive little boy withdraws into the curved shape of a *bergère* armchair and wears an expression that seems partly questioning and partly anxious—the result, perhaps, of being told to sit still without fully comprehending why he should do so. Then, too, understandably short attention spans necessitate entertaining diversionary tactics to transform sometimes fractious models into malleable subjects. Frances Winifred Hill Pedley, the sitter for the painting now known as *Expectancy* (pl. 60), remembered Sargent bribing her with oranges to encourage her cooperation, and how Sargent's energetic movements temporarily kept her attention while he painted.[17] Although Pedley did not detail her feelings about sitting, the painting itself testifies to her eagerness to leave the chair. Perhaps anticipating the difficulties he would encounter in getting a portrait of the little girl,

Sargent rejected the new dress her mother had selected for her sittings and finally approved the loose-fitting white one in which she appears—one that allowed for his usual painterly bravura and obviated the need for a detailed rendering of her body. This was a common compositional ploy in child portraiture that could be easily manipulated to suit artists' particular stylistic bents, as shown in Mary Cassatt's *Ellen Mary in a White Coat* (fig. 69), in which the broad white passage of the coat dominates the flattened, abstract design elements so characteristic of her work. At the same time these essentially shapeless fashions make the body illegible, consigning it to an amorphous state that accentuates the idea of the child as being "unformed" physically and emotionally.[18] But *Expectancy* also suggests the allowances Sargent made for his child sitters; he customarily incorporated their restlessness into the portrait rather than insisting on more settled or staged poses. This reconciliation is consistently revealed in his portraits of children between the ages of three and seven, the developmental stage in which social awareness generally begins to register—when children realize that certain behaviors are expected—but when they are not necessarily capable of complying fully with those expectations.[19] The charming portrait of Charlotte Cram (pl. 61) emphasizes the wriggling and squirming typical of children who are aching to move yet are mindful of the instruction to remain seated. In contrast, the portrait of Charlotte's young cousin Kate Haven (pl. 62) offers the impression of physical freedom through a gentle compositional dynamic that implies forward movement. As he did with adult subjects, Sargent captured and accentuated the natural tensions and actions

PL. 60. *Expectancy* (*Portrait of Frances Winifred Hill*), c. 1895, oil on canvas, 39½ x 33½ in. (100.4 x 85 cm). Private collection. Photograph courtesy of Adelson Galleries, Inc., New York

FIG. 69. Mary Stevenson Cassatt (American, 1844–1926), *Ellen Mary in a White Coat*, c. 1896, oil on canvas, 32 x 23¾ in. (81.3 x 60.3 cm). Museum of Fine Arts, Boston. Anonymous Fractional Gift in honor of Ellen Mary Cassatt, 1982.630. Photograph © Museum of Fine Arts, Boston

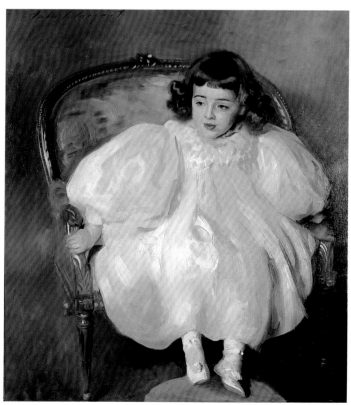

PL. 61. *Charlotte Cram*, 1900, oil on canvas, 34 3/4 x 24 in. (88.3 x 61 cm). Private collection

PL. 62. *Kate Haven*, 1903, oil on canvas, 26 x 20 in. (66 x 50.8 cm). From the Collection of Katharine Serena Carson, Granddaughter of Kate Haven. Photograph courtesy of Adelson Galleries, Inc., New York

of his child sitters to create images of genuine emotional resonance and aesthetic value. And, again, a layer of biographical information was imparted through the mechanic of display inasmuch as the portraits of the two cousins were displayed at the 1908 annual exhibition of the NAD along with Sargent's portrait of their grandfather, Henry Augustus Cram (private collection).

THREE-PRONGED PORTRAIT POLITICS: ARTIST, PARENTS, AND CHILD MODEL

A comparison of Sargent's 1887 portrait of Ruth Sears Bacon (pl. 63) and Frederick George Cotman's *Me Won't Sit!* (fig. 70), exhibited in 1887 at the Royal Institute of Painters in Oil-Colours in London, graphically brings the issues of child portraiture to the foreground. As witnessed here by the drawing after Cotman's now unlocated painting and the *Punch* cartoon devoted to the artist's *Revolution on the Throne* that was shown at the Royal Academy in 1884 (fig. 71), the subject of an unruly child model was somewhat of a popular novelty. Although Cotman's *Me Won't Sit!* qualifies as genre, the

recalcitrant child portrayed may easily be interpreted as a reflection of the painter's actual experience in the studio with children.[20] Sour-faced and withdrawn, the sulky little model slumps defensively, as if trying to escape from those who would impress on her (or him—it is difficult to tell the sex of the child) the fate of sitting upright and quietly. Ruth Sears Bacon slouches as well, but her expression is bright and direct, and her posture is dictated by the comfortable furnishings that enclose her. Nestled in vague and yielding swathes of fabric draped across an overstuffed sofa, her body is gently but firmly supported. She embraces a doll (likely a familiar companion) with a light touch that suggests emotional ease in this out-of-the-ordinary situation of posing. Indeed, the elements of physical and psychological comfort are keys to interpreting the two images. Cotman's little model is clearly in a studio that is presumably a strange and frightening environment. And, even though the presence of others can be assumed—the artist and the child's mother or nursemaid—the sitter is virtually alone, raised on a platform against a dark, blank background that isolates her from the larger space of the room. The potted plant, guitar, and sheet music nearby are standard studio props that have no relationship to her ordinary experience. Her chair is supremely uninviting; it has no arms to support her, a hard, carved wooden back, and a seat too deep for a small person's comfort. Not only will the child not sit, she cannot sit.

Next to Cotman's painting of a miserable child it may be tempting to read Sargent's portrait of the cheerful Ruth Sears Bacon as a product of relatively effortless sittings. Such a reading, however, is stalled by the tension in her legs and feet that causes her toes to turn inward. This slight bodily inflection (accentuated by the harsh, dark parallels of the legs and contrasted by the loose, dangling limbs of the doll) signals the child's pent-up energy, which, with the rapidly worked surface of the painting, attests to the pressures endured by both artist and model. Descriptions of the painting in progress survive, revealing that despite previous sittings, the painting changed radically and swiftly as it neared its finished state. Ruth's father, the New York physician Dr. Gorham Bacon, recalled:

> It was at the Hunt cottage [where the Bacons were staying in Newport, Rhode Island] that John Singer Sargent painted the portrait of Ruth. We came to know Sargent very well and my wife got up courage enough to ask him what he would charge to do a sketch of Ruth. He was very moderate in his price, as he knew we were young and our finances were not great.... He painted two pictures on the same canvas. In the first one, Ruth was standing with her hand on the arm of the sofa. The likeness was perfect and we were delighted with it. He came to look at it once more, and saw something in the picture that he did not like. Before my wife could stop him, he had painted out the whole picture except for the head and the shoulders, then painted the present picture.[21]

Oral family tradition expands the painting's history, pinpointing its beginnings to the Bacons' home in New York, where Ruth is said to have posed standing next to a parrot

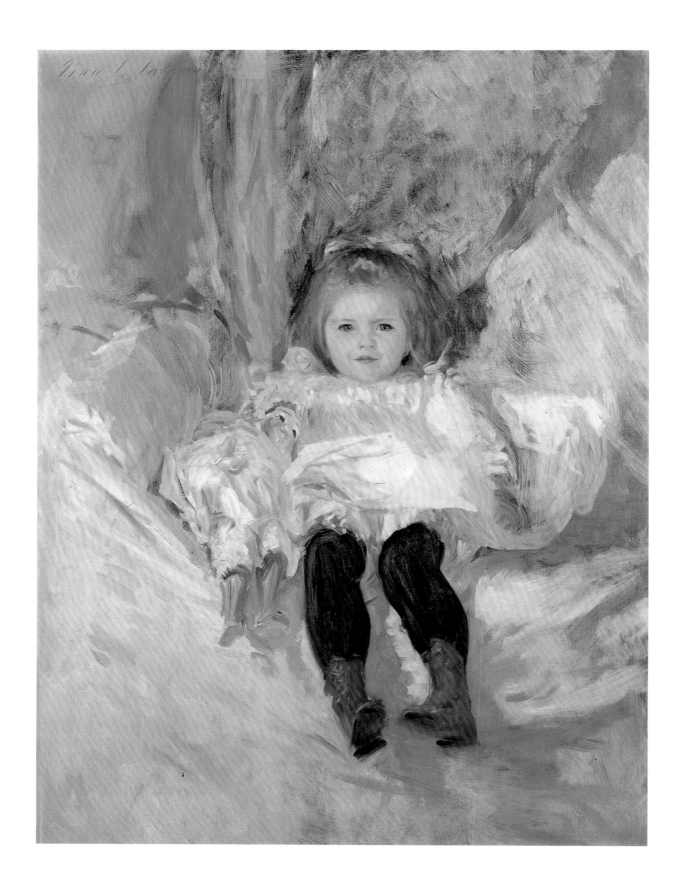

No. 351. Naughty Child frightened by Bogie. F. G. Cotman.

FIG. 70. Frederick George Cotman (English, 1850–1920), *Me Won't Sit!* from *Pall Mall Gazette "Extra" Pictures of 1887*, 79. General Research Division, The New York Public Library, Astor, Lenox and Tilden Foundations

FIG. 71. *Naughty Child Frightened by Bogie* from *Punch, or the London Charivari*, May 17, 1884, 232. Brooklyn Museum Library Collection

cage.[22] During the initial phases of the work's evolution Ruth and Sargent had presumably had the opportunity to establish a comfortable relationship. Whatever it was that sparked Sargent's displeasure in the original painting may never be determined, but it is known that he was moved to create the final version by the unrehearsed event of seeing Ruth after she returned from a walk for which her nurse had dressed her in black stockings and sturdy brown boots. The finished image is striking. The arresting visual dichotomy set up between the harsh, dark lashes of paint and the delicate meringue from which they emerge inserts a note of unexpected sharpness. Preserving only the head and shoulders of the first version of the painting, Sargent provided Ruth with a new but literally undefined body whose inchoate nature might imply that she is as manageable as her doll. Here Sargent seems to have uncharacteristically entered standard iconographic territory that centered on the relationship of girls and their dolls. As it is with Frances Pedley's amorphous form in *Expectancy*, our understanding of Ruth's foreshortened body is disrupted. Her physical being is experienced episodically through the phased investigation of the isolated elements of head, hands, and feet whose disconnectedness suggests the absence of coherence and personal agency. In this way Sargent opened the painting to conventional interpretations of girlhood that relied on the recognition of the doll as a dual sign of the child's lack of self-determination and of her future as a mother (fig. 72).[23] Yet unlike sitters in other contemporary portraits, Ruth does not seem to identify herself with the doll. She neither cradles it (as does the child in Millais's 1883 *The Young Mother—Portrait of Lady Elizabeth Manners*, fig. 73) nor clutches it for comfort (as does the girl in Berthe Morisot's *Little Girl with a Doll* of 1884).[24] Ruth's clear-eyed directness counteracts such standardized readings and is a reminder that the painting exists largely as an incidental revision of an earlier, more formal composition. And, rather than placing weight on the symbolic relationship of Ruth and her doll, Sargent's transformation of the painting might be

PL. 63 (OPPOSITE). *Ruth Sears Bacon*, 1887, oil on canvas, 48³/₄ x 36¹/₄ in. (123.8 x 92.1 cm). Wadsworth Atheneum, Hartford, Connecticut. Gift of Mrs. Austin Cheney, 1975.92

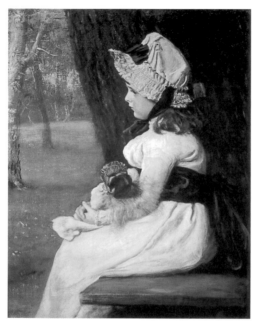

FIG. 72. Paul Renouard (French, 1845–1924), *"Little Mothers": A Study at an Infant School Drawn from Life*, from *The Graphic*, March 6, 1897, 289

FIG. 73. John Everett Millais (English, 1829–1896), *The Young Mother—Portrait of Lady Elizabeth Manners*, 1883, oil on canvas, 34 x 25 in. (86.3 x 63.5 cm). Private collection. Christie's Images Ltd. 2003

better interpreted as his dismissive response to a commissioned project that he brought to a rapid close by subverting the very subject of the portrait.

The agitated brushwork that eliminated most of what he had already painted intimates the depth of his frustration and impatience, feelings he communicated in a letter to his friend the painter Frank Millet: "Here I am [staying] but just about to go for Mrs. Marquand's portrait is finished and the other many things I am doing nearly so. A series of children that must be stopped.... Among them little Ruth Bacon whose sister you did a year or two ago. Her mother is in ecstasies or in despair after every sitting, confound it. She says you won't finish Mabel's smile and nags me to paint a companion to the others, but besides a hesitation at poaching on your premises, I don't think I can stand too much drama."[25]

Sargent's frank admissions to Millet bring to life the difficulties of his situation. He had left England somewhat reluctantly, having accepted a commission from the influential Henry Marquand to paint his wife's portrait.[26] Mrs. Marquand's sittings took place in Newport, where Sargent was ineluctably and willingly drawn into the tight circle of social privilege that promised future commissions. And, although the Marquand portrait was Sargent's principal objective, it was doubtless hard and injudicious for the ambitious young painter to refuse additional requests for his skills. As his letter proves, however, his patience had its limits, specifically with regard to meddlesome, emotional mothers (as he characterized Mrs. Bacon) whose children he had agreed to paint.[27] Thus, it seems that the cause for the abrupt revision of Ruth Bacon's portrait was Sargent's pressing desire to escape the troublesome emotional interplay with the girl's mother. In this light the portrait may now be seen as the painter's discreet yet rewarding revenge on a mother who had interfered once too often with his art.

WAR AND PEACE IN THE STUDIO
AND ON THE CANVAS

Edouard and Marie-Louise Pailleron, Portrait of a Boy (Homer Saint-Gaudens and His Mother), Helen Sears, and *Carnation, Lily, Lily, Rose* are united in that they feature children who were raised in decidedly artistic spheres and who were already acquainted with posing before they sat for Sargent. The accounts that follow here explore these works in terms of the children's prior experience and how their understanding of the portrait process may have undermined or promoted its success. At the same time, questions

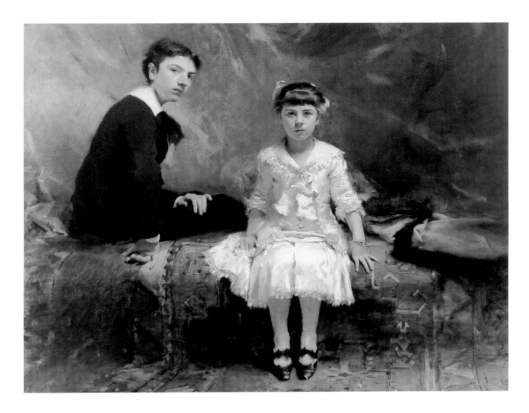

FIG. 74. *Edouard and Marie-Louise Pailleron*, 1881, oil on canvas, 60 x 69 in. (152.4 x 175.3 cm). Des Moines Art Center Permanent Collections; Purchased with funds bequeathed by Edith M. Usry in memory of her parents, Mr. and Mrs. George Franklin Usry, and funds from Dr. and Mrs. Peder T. Madsen Fund and Anna K. Meredith, 1976.61

arise about the validity of investing these images with content derived from retrospective, anecdotal commentary provided by some of the sitters and their adult contemporaries; and about whether Sargent intended his viewers to detect in these unique compositions an underlying narrative lodged in the idea of posing itself—a narrative that then inserts the relationship of artist and sitter(s) into the content of the work.

The Pailleron canvas, the large double portrait of Edouard and Marie-Louise Pailleron (fig. 74, pl. 20), the children of the French author Edouard Pailleron, is one of the most emotionally charged works of Sargent's career, its magnetism owing largely to the little girl's determined stare that rivets our eyes to hers. Sargent's connections with the Paillerons are fairly well documented, mainly through the published reminiscences of Marie-Louise in which she described the series of portraits Sargent executed of family members beginning with that of her father, Edouard Pailleron.[28] It is most likely that Sargent met the children in 1879 at their maternal grandmother's home in Ronjoux, Savoy, where he painted the portrait of their mother, Marie (the daughter of the founder of the influential *Revue des Deux Mondes*, François Buloz; pl. 64). At Ronjoux Sargent also painted several, more informal, oil portraits: *Madame François Buloz* (Los Angeles County Museum of Art), *Marie-Louise Pailleron* (private collection), and *Edouard Pailleron Jr.* (pl. 65). The last of these is doubtless the one referred to by Marie-Louise as the "ravishing" sketch Sargent gave to her grandmother of the "grandson she adored."[29] The small panel portrays the fourteen-year-old Edouard in a bust-length format with his head slightly turned, leaving one side of his face bathed in light and the other washed in shadow. Although still possessed of boyish softness, Edouard's face

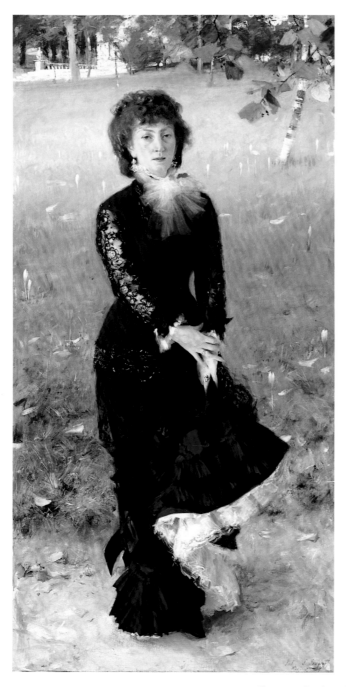

PL. 64. *Madame Edouard Pailleron*, 1879, oil on canvas, 82 x 39½ in. (208.3 x 100.3 cm). In the Collection of The Corcoran Gallery of Art, Museum Purchase and gifts of Katherine McCook Knox, John A. Nevius and Mr. and Mrs. Lansdell K. Christie

reveals the strong, arched brows, high cheekbones, and full, supple mouth that would gain greater definition within a year or two. Despite its simplicity, the painting is captivating; the dramatic chiaroscuro and serious, side-long glance lend a sense of moody reserve to the work and induce a parallel reading of the boy's personality. Ironically, little is known about Edouard.[30] He is mentioned only in passing in his sister's memoirs, possibly because of the friction that seems to have suffused their relationship.[31] While omitting comment on Edouard's relationship with Sargent, the otherwise voluble Marie-Louise recorded her own impressions of the artist: "I liked him very much that year [1879] and begrudged him only two faults: the first was his tiresome desire to make me pose…Sargent was always looking for an amusing detail, a spot of sunlight, etc., drawing and painting each time he had the chance….A prodigious worker, he created his studies without posing, with astonishing freedom. Thus, catching me by surprise when I was occasionally standing still, he left me with several portraits of the little savage that I was: they now illustrate, in a vital way, my lost paradise."[32]

Marie Louise's "lost paradise" was shaped by her highly respected, financially secure family, both sides of which claimed literary laurels and brought her into contact with many of the leading authors and artists of the time. Yet, as her memoirs attest, the family was not without its share of tragedy. She recounted her mother's enduring grief over the 1871 death of Henri, the Paillerons' youngest child who had died of fever during the Siege of Paris. Of her mother she wrote: "The most lasting image that I keep of my mother conforms exactly to her portrait painted by Sargent in 1879….When she was alone or with intimates, her look often became melancholy and she seemed to pursue some memory of the distant past, I knew then that she dreamed of the little infant she had lost."[33] Marie-Louise also confirmed her passionate affection for her father, whose attention she craved and whose long hours of writing removed him from her. She was particularly indulged by him, perhaps out of his wish to compensate for her mother's emotional distance, her grandmother's preference for her brother, or his own frequent unavailability because of his work.[34] Thus, when Sargent arrived at Ronjoux, he met an eight-year-old Marie-Louise (fig. 75) who was bright, precocious, spoiled, and, most likely, delighted with the prospect of the occasional company of an adult male, who, like her father, was an artist. Without going

too deeply into the area of psychological speculation, it is nevertheless possible to consider Marie-Louise's impending battle of wills with Sargent as a manifestation of her frustrations with a father whom she deeply loved and by whom she often felt ignored.

As Marie-Louise recalled, her father was obviously taken with Sargent's talent and because of that she knew that her turn would come for Sargent to paint a formal portrait of her. The commission, or "catastrophe" as she called it, soon came to pass, and with it she established "a veritable state of war" against the painter "who found before him a rebellious little girl, incessantly moving as she posed, chattering and disobedient."[35] Throughout the reported eighty-three sittings for the double portrait that took place in Sargent's Paris studio in 1881, affairs were strained, mainly thanks to Marie-Louise, who fought the painter on every front, objecting to the dress he selected, her stockings (they were cotton, not silk), and his preference for her hair to be worn up. In her own defense, she later emphasized what torture it was for a child of that age to sit for seemingly interminable periods. (The agonizing sessions did not reach a denouement until Carolus-Duran convinced her that the ordeal would soon cease if she would cooperate.[36]) Some of her resistance may have been rooted in prior experience, for she had already had an unsettling incident modeling for the French painter Gustave Jacquet (1846–1909) several years before.[37] At first things had gone well, for Jacquet's elaborate studio was filled with entertaining diversions, including a monkey. What is more, Jacquet—a fashionable society portraitist—was known for his skill in making his young subjects comfortable, taking care not to weary them with lengthy and challenging posing sessions. Even under those somewhat favorable conditions, Marie-Louise's tolerance for the project ended when, as she noted, one day Jacquet had become so absorbed in his work "that he totally forgot me and left me for such a long time on the platform that he was astonished, upon lifting his nose above the canvas, to see the young face of his model (then aged seven years) flooded with tears."[38] In Sargent's studio the girl was determined not to be ignored.

Sargent was so relieved on completing the painting that he reportedly celebrated by throwing things out the studio window.[39] He had been working under what must have been excruciating pressure to please Edouard Pailleron—his most important patron at the time—and to create a painting that would represent him well at the Salon.[40] Under these circumstances Marie-Louise's antics doubtless compounded his already considerable stress, yet the force of her personality and his response to it contributed substantially to the painting's final success. The composition is a brilliant melange of contrasts governed in broad terms by the dark contour of Edouard's body offset by the shimmering whites of Marie-Louise's dress. The boy's mannered pose is a study in affected nonchalance, punctuated by his expression of superiority and circumspect reserve. The artfully conceived attitude—part profile and part three-quarter view

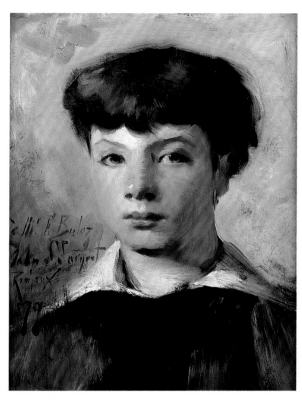

PL. 65. *Edouard Pailleron Jr.,* 1879, oil on panel, 13½ x 10½ in. (34.4 x 26.5 cm). Private collection

FIG. 75. Marie-Louise Pailleron, from Pailleron, *Le paradis perdu. Souvenirs d'enfance*, opp. 48. All rights reserved. Photograph, General Research Division, The New York Public Library, Astor, Lenox and Tilden Foundations

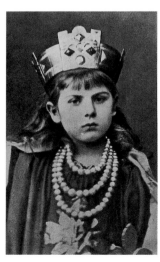

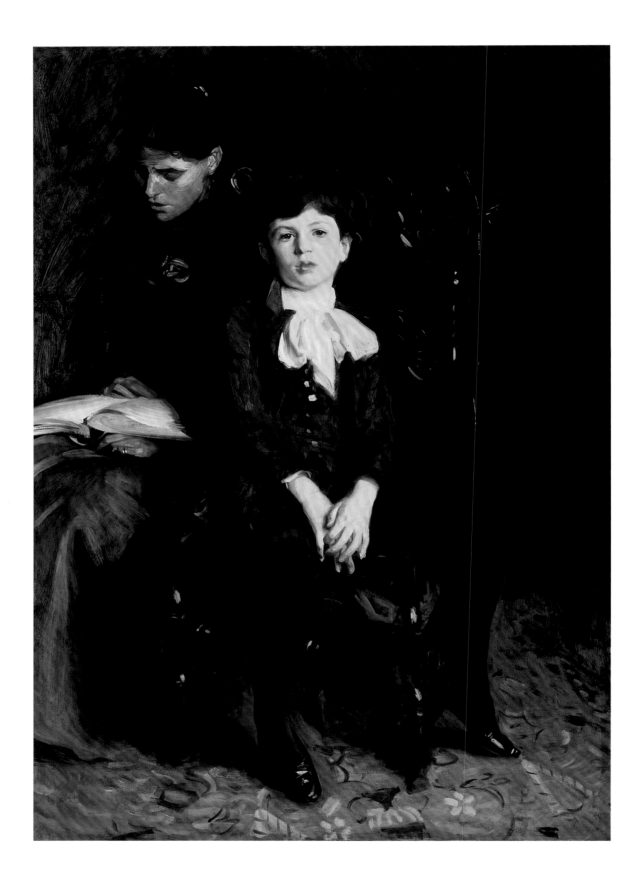

with his legs drawn up behind him on the couch—
reinforces the negative space separating the two figures
and conceptually denies the possibility of demonstrative
gestures of protection or affection on the part of the
elder brother—a motif common in sibling double por-
traits.[41] Although Edouard's body inclines toward the
center of the composition, it is as if he were trying to
assert his presence rather than to be near his minia-
ture virago of a sister. At the same time, the boy
appears guarded, reluctant to reveal himself, a person-
ality trait perhaps noted and capitalized on by Sargent
as he worked out a pose that obscures the legibility of
the boy's body. Marie-Louise, by contrast, is presented
and presents herself openly—emotionally and physi-
cally. The perfect frontality of her body counters the eccentric asymmetries of her
brother's. Similarly, Edouard's mannered, fluid elegance is contrasted with the almost
palpable tensions that course through Marie-Louise's body, ending in her rigid hands
and pointed toes. Sargent's composition allows Marie-Louise to claim priority over her
brother and simultaneously endows Edouard with his own "reserved" space. The two
are placed against a ground of reddish orange drapery, the flamelike tones of which
heighten the charged emotions that seem to radiate from the children. And, although
they stare at us from the same pictorial space, we are forced to choose which gaze to
return; it is impossible to look at Edouard and Marie-Louise at the same time, and so they
remain forever separate and in competition as they may have been in life.

Sargent knew full well, particularly from his experience with the Pailleron chil-
dren, that a child's recognition of parental wishes and general comprehension of (or
familiarity with) posing did not guarantee cooperation in the studio. He encountered a
similar situation when he executed *Portrait of a Boy* (pl. 66), a canvas featuring Homer
Saint-Gaudens, the son of his friend and colleague the sculptor Augustus Saint-Gaudens
(1848–1907). The painting's origins stem from Saint-Gaudens's proposal to sculpt Violet
Sargent, then an attractive twenty-year-old who had accompanied her brother to the
United States.[42] The two men agreed that in exchange for Saint-Gaudens's low-relief
portrait of Violet, Sargent would paint a portrait of the sculptor's ten-year-old son. Like
the Pailleron children, Homer Saint-Gaudens had considerable exposure to the art
world and had posed for his father when he was very young (fig. 76). The boy's inherent
restlessness and an excess of youthful disregard for the portrait project resulted in
some rather difficult sittings (reportedly a total of ten) in Sargent's New York studio.
As Homer Saint-Gaudens recalled decades later, "The small boy had no respect what-
soever and scant liking for John Singer Sargent, who squelched the small boy's
obstreperousness every few minutes by just plain sitting on him."[43] (Saint-Gaudens
wrote this passage in the third person, as if to acknowledge apologetically that the
adult he had become was not the same person as the child he described.[44]) A photo-
graph of the sculptor, his father, and young Homer that dates to about 1884 (fig. 77)

FIG. 76. Augustus Saint-Gaudens (American, 1848–1907), *Homer Saint-Gaudens,* bronze relief plaque, originally modeled 1882, 19⅞ x 10⅛ in. (50.5 x 25.7 cm). Brooklyn Museum. Robert B. Woodward Bequest Fund, 23.288.4

FIG. 77. Homer Saint-Gaudens with his father and grandfather, c. 1884. U.S. Department of the Interior, National Park Service, Saint-Gaudens National Historic Site, Cornish, New Hampshire

PL. 66 (OPPOSITE). *Portrait of a Boy (Homer Saint-Gaudens and His Mother)*, 1890, oil on canvas, 56⅛ x 39½ in. (142.6 x 100.3 cm). Carnegie Museum of Art, Pittsburgh; Patrons Art Fund, 32.1

shows Augustus's efforts to restrain a squirming Homer and may suggest that this level of vitality was characteristic of the child's behavior. Sargent's portrait highlights the boy's contrary nature, creating from it a memorable portrait of a child's consummate boredom and refusal to capitulate to the requirements of posing. Homer straddles a carved Baroque-style chair inelegantly, the lines of his body echoing its curved and twisting forms as if to emphasize his mental and physical restlessness. Oddly, the painting bore the title *Portrait of a Boy* from its first public display, despite the fact that it is a double portrait. The second figure, Homer's mother, Augusta (a cousin of Winslow Homer whose family name the boy was given), was included perhaps as a pointed reference to the need to entertain the boy as he sat or, perhaps, to underscore the importance of the mother's role in the formation of character. As Homer Saint-Gaudens remembered, however, he attributed part of his discontent to his mother's efforts to quiet him: "A small boy grew very restless in a studio chair *because* his mother, leaning to turn a page, read to him over and over again the account of the battle between the 'Constitution' and the 'Guerriere' as related in *The Blue Jackets of 1812*" (emphasis added).[45]

Clearly, this exercise in posing was a penance for Homer Saint-Gaudens, who was not prepared to assume the part assigned to him. The role-playing that was imposed, but not faithfully enacted, may also have had something to do with the clothing Homer wears, a variant of the Lord Fauntleroy suit that in turn emulated eighteenth-century designs of the type seen in Gainsborough's *Blue Boy*.[46] Fussy and plush, the outfit was at once de rigueur and *retardataire*. The costume's popularity reached its height about 1890, following the 1885 publication of Frances Hodgson Burnett's *Little Lord Fauntleroy*, which was quickly adapted for the hit theatrical production staged in New York in 1888. The eponymous Fauntleroy stood as every mother's ideal son, for he was sweet, devoted, and obedient—characteristics that some contemporary boys disdained because of their effeminate associations.[47] Homer Saint-Gaudens is likely to have been acquainted with *Little Lord Fauntleroy* (and, therefore, the popular associations attached to the Fauntleroy character) either through the book, its serialization in the popular children's magazine *St. Nicholas*, or from having seen the play.[48] Although Homer Saint-Gaudens's hair was no longer styled in the flowing "girlish" Fauntleroy locks of his babyhood, we may assume that the nostalgic and sissified dress was not the everyday wear of a rambunctious boy who was known to hitch his sled to Fifth Avenue buses for a "free ride" downtown.[49] In this light we may see in the painting not only a child who fights the stillness imposed on him but also one who may have resisted posing in an iconographic format having strong parallels with the Fauntleroy story. The frictions that occurred during the sittings and the maternal interventions to placate the boy (documented in the painting itself) yielded instead a portrait that contradicted and transcended stereotype. The same reviewer who saw in it a "youngster with a good deal of boy in his makeup" concluded, "Probably Mr. Sargent has not vulgarized his sitters, but one suspects that he has not complimented them. He has, however, made them live on the canvas and a look into the boy's bright humid eye is worth more than pretty exaggerations and polite restraints."[50]

Not all of Sargent's child subjects were as intractable as Marie-Louise Pailleron and Homer Saint-Gaudens. By 1895, when he painted the portrait of the six-year-old Helen Sears (pl. 67), she had already modeled for numerous watercolors, pastels, and fine art photographs by her mother, the Boston artist Sarah Choate Sears (1858–1935), and for a formal oil portrait by Abbott Handerson Thayer (1849–1921; fig. 78).[51] An 1895 photograph of Helen taken by her mother (fig. 79) bears an especially strong resemblance to the Sargent oil.[52] Given Sears's acknowledged admiration for Sargent's work, it is not difficult to suppose that her photograph was done in homage to his portrait of her daughter; both show Helen full-length, wearing the same outfit and occupying a space containing a few items either associated with or arranged in accordance with Japoniste aesthetics. Perhaps we may even interpret Sears's depiction of her daughter calmly inspecting a Japanese lantern as a reference to Sargent's famous *Carnation, Lily, Lily, Rose* (pl. 24). The photograph reproduced here was probably among those that Sears sent to Sargent that year. With typical modesty and courtesy, he thanked her, commenting: "The new one of Helen has a wonderfully fine expression and makes me feel like returning to Boston and putting my umbrella through my portrait. But how can an unfortunate painter hope to rival a photograph by a mother? Absolute truth combined with absolute feeling."[53]

For the sake of analyzing the two works—painting and photograph—some latitude is taken here in reading between the lines of Sargent's humble statement in which he invoked two monolithic concepts—"absolute truth" and "absolute feeling." The first may be interpreted to refer to the photographic medium, which, from the time of its invention, had generated arguments regarding the relative truthfulness of painted and photographed images and forced painters to reevaluate their philosophical and technical strategies in that respect. Sears, a practicing and intelligent artist, must certainly have been aware of the pointed extravagance of Sargent's flattering remarks, for she would have known the underlying subjectivity of the supposedly "truthful" photographic process and the impossibility of achieving absolute truth through that means. Sargent further separated his work from Sears's by characterizing the photograph as the product of a mother's (not an artist's) vision. Hence, the "absolute feeling" to which he referred becomes associated with sentimentality, a quality that is noticeably absent in his own work. Essentially, then, Sargent's lavish praise serves, not to establish which is the better of the two superficially similar works, but to illuminate the paradoxes separating them on the grounds of medium, subjectivity, and emotional connection.

But where does little Helen figure in this matrix of truth and feeling? Her familiar role as amateur model assures us of her awareness of the "activity" of stillness. She had seen, undoubtedly regularly, the results of past sittings—Thayer's and her mother's images of her—and such encounters with past versions of herself must have made her, even at the age of six, more conscious of the act of self-presentation than most children. Assuming that Helen was more comfortable with her mother, and because posing for a photograph is generally less time-consuming and therefore less strenuous than posing for an oil portrait, it might follow that the photograph would be the more natural of the two images. Ironically, however, it is the painting that seems

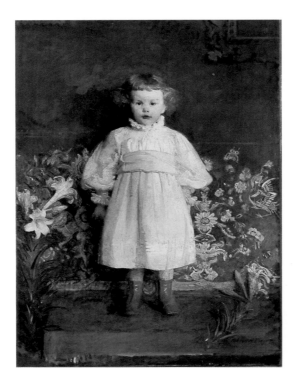

FIG. 78. Abbott Handerson Thayer (American, 1849–1921), *Helen Sears*, 1891–92, oil on canvas, 54½ x 38½ in. (138.4 x 97.8 cm). The Toledo Museum of Art. Purchased with funds from the Florence Scott Libbey Bequest in Memory of her Father, Maurice A. Scott, 1958.26

FIG. 79. Sarah Choate Sears (American, 1858–1935), *Helen Sears with Japanese Lantern*, 1895. Platinum print (from an album) 9⁵/₁₆ x 5³/₁₆ in. (23.7 x 13.2 cm). Descendants of Sarah Choate Sears. Courtesy Museum of Fine Arts, Boston. Photograph © 2003 Museum of Fine Arts, Boston

PL. 67 (OPPOSITE). *Helen Sears*, 1895, oil on canvas, 65⅞ x 36 in. (167.3 x 91.4 cm). Museum of Fine Arts, Boston. Gift of Mrs. J. D. Cameron Bradley, 55.1116. Photograph © 2003 Museum of Fine Arts, Boston

less posed than the photograph. The photograph's artificiality is first discovered in the camera's point of view, which lowers the viewer's height to Helen's. Sargent, by contrast, portrayed the child from above as she would be seen by adults, a device that emphasizes the existential and physical distances separating childhood from adulthood. Dwarfed by masses of hydrangeas, Helen registers as a small child in a world of large things. She appears to be distracted from what might have been her tentative explorations of the floral beauty before her and stares absently, her eyes possibly tired from the light streaming through the windows reflected in the brass planter at her feet. Her awkward stance, with the heel of one foot resting on the other (a natural thing if one stands too long in one place), indicates Sargent's disdain for the type of graceful but conventional attitude we may assume she was instructed to take by her mother. If Sarah Sears's photograph records a child self-consciously posing (and consciously pleasing), then Sargent's painting seems to represent a child so used to posing that she has forgotten her part in the role-playing and suddenly become herself. Although the painting received scant, albeit generally positive critical reaction, one writer found the pose to be a notable defect: "The work is dexterous, of course, and is painted with great breadth and no little force. Nevertheless, it is not entirely successful, the feet being awkwardly arranged and the pose by no means happy."[54]

In contrast to the situations in which the Pailleron children, Homer Saint-Gaudens, and Helen Sears posed for their formal portraits, *Carnation, Lily, Lily, Rose* was literally carved out of the day-to-day events of the Broadway artists' community over two consecutive annual campaigns of outdoor painting (fig. 80, pl. 24).[55] Not only were the physical circumstances of the painting's episodic plein-air origins vastly different

FIG. 80. *Carnation, Lily, Lily, Rose*, 1885–86, oil on canvas, 68½ x 60½ in. (174 x 153.7 cm). Tate, London. Presented by the Trustees of the Chantrey Bequest 1887. © Tate, London, 2003

from works painted in the studio, but the nature of the painting differed as well. Certainly this grand experiment in creating a poetic evocation of an idyllic English summer twilight evening had no dependence on the viewer's recognition of the children. Even so, Sargent's individualized treatment of the children's faces disposed one reviewer to comment, "Enough has been said to indicate the daringness of Mr. Sargent's experiment with light and color. From the description would one not suppose that the result would be to sacrifice the portraits? No sacrifice of the kind is involved. The little girls are charmingly painted and the charm is enhanced rather than diminished by the accessories."[56] As the reviewer intuited, the work functioned as portraiture for the private, intimate group of the artist's Broadway friends.[57]

Inspiration for *Carnation, Lily, Lily, Rose* has been traced to Sargent's fascination with a scene he observed—"the effect of the Chinese lanterns hung among the trees and the bed of lilies"—while boating with the expatriate American artist Edwin Austin Abbey on the River Thames at Pangbourne, in August 1885.[58] A chance sequence of events that followed—Sargent's injury from a swimming accident at Pangbourne took him to Broadway for recuperation—immediately placed him in an environment conducive to exploring the subject on canvas. By early September, he wrote to his friend Edwin Russell, "I am trying to paint a charming thing I saw the other evening. Two little girls in a garden at twilight lighting paper lanterns among the flowers from rose-tree to rose-tree."[59] The extensive literature devoted to *Carnation, Lily, Lily, Rose* indicates the artist's relative indifference to which of the children from the close-knit Broadway group would pose for the painting. Lucia Millet's August 24 letter to her parents announced that it was her niece Kate (the daughter of the artist Frank Millet) who had been designated.[60] The six-year-old Kate (pl. 68), whose dark hair Sargent had covered with a golden wig, was soon replaced by Frederick Barnard's daughters, whose coloring was supposedly more pleasing.[61] Kate Millet may not have been up to the modeling task in any case, for even a year later Sargent had misgivings about her ability to pose, because of her liveliness, for the small portrait reproduced here.[62] Polly and Dolly Barnard, however, were somewhat seasoned models, having sat for their father's *Geoff, Polly, Dolly, and Toto* shown at the Royal Academy in 1884.[63]

Sargent found in the Barnard sisters exactly what he needed: two attractive youngsters who were old enough to tolerate his demands and to enjoy their involvement in the making of the painting. His early satisfaction with them is documented in a letter to his sister Emily, in which he related the progress of the canvas: "I am still here and likely to be for some time, for I have two good little models and a garden that answers the purpose."[64] For the children it must have been like putting on a play. And, as Richard Ormond has noted, a portion of the garden was transformed from its natural state to a stagelike setting filled with the unnatural combination of carnations, lilies,

and roses.[65] Sargent labored over the garden elements, directing the shifting of plants already in the garden and, for the second painting season, ensuring his ample supply of flowers by supervising the spring plantings in a special bed made for his purposes. At Sargent's request, Lucia Millet, Mrs. Barnard, and her sister made the white dresses for the girls.[66] With set, costumes, and cast in place, the final theatrical touch was the audience that was constantly in attendance to monitor the newest installment of the artist's transfer of the twilit scene to canvas. The American painter Edwin Blashfield (1848–1936) remembered: "We would all leave our tennis for a time and watch the proceeding. Little Pollie and Dollie Barnard...would begin to light the Japanese lanterns among the tall stemmed lilies. For just twenty-five minutes, while the effect lasted, Sargent would paint away like mad, then would carry the canvas in, stand it against the studio wall and we would admire it."[67] Edmund Gosse, another intimate of the Broadway group, couched his descriptions of the painting's evolution in terms of its entertainment value: "The progress of the picture, when once it began to advance, was a matter of excited interest to the whole of our little artist-colony."[68]

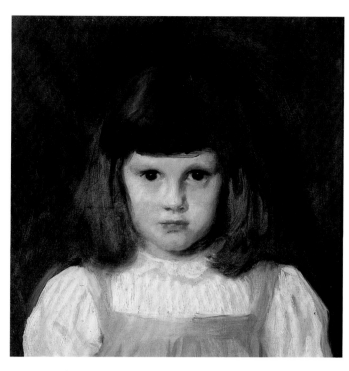

PL. 68. *Kate Millet*, 1886, oil on canvas, 16 x 14 in. (40.6 x 35.6 cm). Private collection. Photograph courtesy of Adelson Galleries, Inc., New York

The ritual aspect of the brief but intense sittings that extended over two seasons allowed Polly and Dolly Barnard to take center stage in the domestic theater of a friend's garden for a familiar and sympathetic audience on a regular basis. The supportive attention of family and friends doubtless enhanced the girls' awareness of their importance in the painting's creation, thereby encouraging their cooperation. Posing reinforced their special places within a loving, appreciative community and perhaps made them more tolerant of Sargent's frequent interruptions of their play for the purposes of art.[69] The Broadway interlude in Sargent's career sealed the bond for a lasting and close friendship between the Barnard sisters and the artist.[70] Even without such testimony, the evidence is contained in Sargent's art. More than twenty years later, both sisters were still sitting for their friend, playing dress-up and posing in the out-of-doors for fanciful, albeit more exotic, paintings that nonetheless rehearsed the same therapeutic aesthetic process of *Carnation, Lily, Lily, Rose*.

PROFESSIONAL CHILD MODELS

Although Sargent and his contemporaries often employed professional models as a matter of course, little attention has been devoted to the children who were among the ranks of those professionals. A small but significant group of works from Sargent's

hand bears witness to the professional and quasi-professional child model, a notable example of which is *Neapolitan Children Bathing* (fig. 81, pl. 14).[71] The painting left critics with the impression of immediacy and serendipity, and they delighted in the "young boys who sprawl upon the sand, joyously and comically playing together."[72] Yet several oil studies (pls. 69–71) confirm that the painting was the product of considerable preparatory work. What is more, the studies suggest that the oldest boy posed several times, and he may appear again in *The Little Fruit Seller* (pl. 72). Thus, although Sargent first may have casually observed these children on the Italian beaches, he apparently enlisted particular boys to pose for him. This was a common practice among artists who frequented the popular resorts of Naples and Capri, and, in view of this, it is likely that Sargent's models were familiar with the exercise and accustomed to being paid for it. As Sargent's contemporary the English artist Henry Scott Tuke (1858–1929) recalled about them, "They sit till they are incapable of keeping still any more, and are richly rewarded with 2d [2 pence]."[73] It is also quite probable that these boys never saw the interior of a studio and simply saw posing for the steady stream of visiting plein-air painters as a fortuitous means of easy money. Nevertheless, it can be surmised that Sargent's older Neapolitan boys knew the value and rudiments of posing and viewed it as work, however pleasant that work may have been.

Far more atypical is *Study of Three Figures* (pl. 73). The carefully composed studio interior with figures—an exceedingly rare subject in Sargent's art—falls into an amorphous category in his oeuvre in that it seems neither finished enough to qualify as a completed work nor sketchy enough to serve as a study. Just where it was painted is open to question. On the one hand, it may have been done in a temporary studio in Italy, for it displays the same tenebrism as the 1878 *Head of an Italian Girl* (pl. 74) and includes the figure of a woman whose clothing suggests that she is of Italian peasant

FIG. 81 (ABOVE). *Neapolitan Children Bathing*, 1879, oil on canvas, 10½ x 16¼ in. (26.8 x 41.2 cm). Sterling and Francine Clark Art Institute, Williamstown, Massachusetts, 1955.852

PL. 69 (BELOW, LEFT). *Boy on the Beach*, 1878, oil on panel, 7½ x 12 in. (19.1 x 30.5 cm). Unlocated. Photograph courtesy of Adelson Galleries, Inc., New York

PL. 70 (BELOW, RIGHT). *A Nude Boy on a Beach*, c. 1878, oil on wood, 10½ x 13¾ in. (26.7 x 34.9 cm). Tate, London, bequeathed by John Tillotson, 1984. © Tate, London, 2003

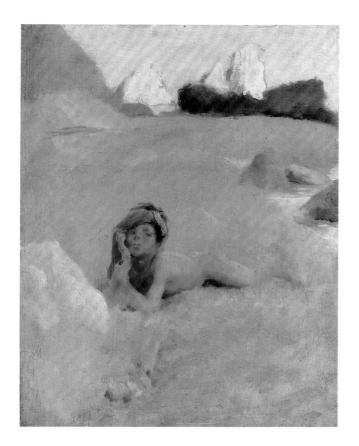

stock. On the other hand, both works may have been painted in Paris, where Italian models were readily available.[74]

The strangely disquieting *Study of Three Figures* exerts an odd allure stemming mainly from the perceived exoticism of the workplace in which children are paid to display their bodies.[75] Despite the unquestionably commonplace situation presented (models in a studio), the image conjures issues of propriety and exploitation by virtue of the ages of the boys, their states of undress, and the fact of their professional status in a field tainted by the whiff of the demimonde. At the heart of the matter is the almost disconcertingly self-possessed stance of the principal figure, an adolescent whose relaxed, assured pose implies years of experience (an impression encouraged by his juxtaposition with a much younger boy who has already entered the modeling profession). *Study of Three Figures* provides a vivid contrast to Sargent's sun-splashed little boys on a Neapolitan beach, not only in formal terms but also in terms of its seeming challenge to the notion of childhood innocence. (We may assume Sargent's prudent anticipation of possible negative reactions to a potentially sexualized portrayal of a child, for as one figure study for *Neapolitan Children Bathing* proves [pl. 69], he took care in the finished painting to obscure the genital area of the boy who lies on his back by interrupting the view of the body with another figure.) The relocation of nude or partially nude boys from the sunlit beach to the relative privacy of the studio injects the image with the notion of commerce and also contradicts the desired view of childhood as a sacred and

PL. 71. *Nude Boy on Sands*, 1878, oil on panel, 13 x 10 in. (33 x 25.4 cm). Private collection. Photograph courtesy of Adelson Galleries, Inc., New York

PL. 72. *The Little Fruit Seller*, 1879, oil on board, 14 x 10³/₄ in. (35.6 x 27.3 cm). Private collection, Courtesy of Guggenheim, Asher Associates

separate sphere. The older boy's open stance suggests his availability (as, indeed, he was to the artist for the purposes of his job as a model). But that same stance on the street might suggest sexual availability, an association heightened here by the unusual drapery that simultaneously hides and calls attention to his genital area and is then caught between his legs as it falls loosely to the floor. The younger boy sits with his back to the viewer, his little body hunched protectively, thus making him doubly unavailable to our gaze since he is turned away and also covers himself. Sargent's calculated restraint in presenting these working children is plainly revealed by the fact that neither boy is shown in a pose of complete frontal nudity—unlike the unabashedly nude beach boys that critics eagerly read as signs of joyous innocence.

Study of Three Figures is wholly unconventional in its direct and sensuous treatment of boy models; it is not simply a study, nor can the boys be viewed as if they were formally posing in a standardized context of academic training that foregrounds the art process as in Sargent's *Boy in Costume* and *The Model* (pls. 75, 76) or as represented in Marie Bashkirtseff's 1881 *In the Studio* (Dnepropetrovsk State Art Museum, Dnepropetrovsk), which shows a partially clothed boy posing as the young Saint John the Baptist for female art students at the Académie Julian, Paris.[76] Instead, these working boys are the subject matter. Sargent's decision not to explore the theme again may

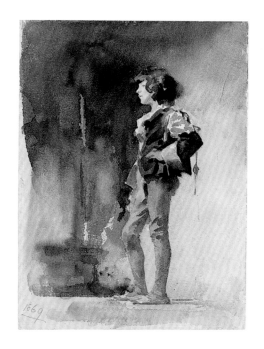

merely indicate his lack of interest, but it is also just as likely that he was sensitive to the possibility that such imagery—the commodified child's body—occupied a tenuous position in high art. Granted, *Neapolitan Children Bathing* had clearly escaped condemnation, but it was largely because the sunny outdoor Mediterranean locale allowed for the idea of innocent play; the picturesque little fellows on the beach may have received payment due, but the image conceals the transaction. Such visual tourism was obstructed by the studio setting, the privacy of which implicates the viewer in a voyeuristic mode of looking for which he or she becomes morally responsible. Perhaps all too aware of the difficult social territory this particular theme occupied, Sargent may have intentionally relieved *Study of Three Figures* of its full potential to discomfort viewers; whatever questions may linger about propriety are erased by the formidable woman on the left, who fills the role of chaperone in this studio narrative.

Sargent's exquisite *Head of Ana-Capri Girl* (pl. 77) and the enigmatic *Carmela Bertagna* (pl. 78) pay compelling tribute to the exotic beauty of the two girls and display far different approaches to portraying youthful professional models. The long, supple figure of Rosina, a favorite model for artists who visited Capri in the late 1870s and early 1880s, features in a number of the paintings Sargent executed on his trip to the island in 1878.[77] In *Head of Ana-Capri Girl*, however, Sargent focused on the contours of her face

PL. 78. *Carmela Bertagna*, c. 1880, oil on canvas, 23½ x 19½ in. (59.7 x 49.5 cm). Columbus Museum of Art, Ohio: Bequest of Frederick W. Schumacher [57] 1943.011

and the soft perfection of her skin to capture a feral essence that one writer later tried to define when he referred to her as "the tawney-skinned, panther eyed, elf-like Rosina, wildest and lithest of all the savage creatures on the savage isle of Capri."[78] Carmela, a Parisian model purportedly of Spanish heritage (but more likely an Italian girl), registers as a similarly untamed creature, whose wary look of distrust gives her a hunted, animal-like alertness.[79] Although neither model can be classified as a child, both have chameleon-like qualities that make it difficult to determine whether they are girls or women. Even somewhat later, Sargent's friend the English artist Adrian Stokes referred to the Capriote models as "grown-up girls," nomenclature that suggests his confusion in trying to categorize them. The ambiguous nature of such child-women grew from the cultural and class disparities that Sargent and his painter colleagues

confronted in the models available to them. Whether rural Capriote or urban Parisian, the girls exuded an elemental wildness based in natural feeling and instinct rather than in the artificiality of the civilities practiced in Sargent's social sphere. The animal-like or primitive natures assigned to these "grown-up girls" rested in typological attitudes that were contemporaneously instrumental in outlining Euro-American definitions of societal differences. The notion of the uncivilized also extended to childhood, which was also linked with unrefined behavior. On a more personal level, the sheltered, proper upbringing of Emily and Violet Sargent, whose ages bracketed those of Rosina and Carmela, must have intensified for Sargent the exotic "otherness" that these fascinating creatures of indeterminate age and experience held for him.

Sargent's portraits of Rosina and Carmela bear eloquent witness to his passion for them as models. Rosina's finely wrought, disembodied profile floats in a golden ground, divorced from temporal or spatial referents as if it were a rare and foreign specimen of humanity preserved in amber. Her features are in this way completely open to detailed inspection, for this is an abstracted vision of Rosina that depersonalizes the experience of looking. The absence of a resistant gaze encourages a level of visual study that objectifies her, depriving Rosina of personality and consigning her to the category of aesthetic artifact. She is, indeed, unapproachable as Sargent depicted her, a beauty forever removed from the real world of physical and emotional connections.

In contrast to the psychological distance that protects Rosina from the probing eyes of her viewers, *Carmela Bertagna* vividly betrays the artist's will to translate onto the canvas the mysterious dualities of attraction and avoidance that her image communicates. The soft pliancy of the fabric backdrop and the textures of her clothing and her unruly mane of fine, long hair seem to extend an invitation to touch. Her plush pink stole leads the eye into the pictorial space, offering a sensuous introduction to her body that is abruptly halted by her expression of wary examination. Through such means the portrait becomes a visual essay based in the conflict between the allure of sensual delight and the assumed conditions of the "look but don't touch" business arrangement between model and painter-viewer. Carmela's expression—a mixture of vulnerability and toughness—manifests the tensions of the artist-model relationship; as a model, she is paid to be scrutinized and portrayed at the painter's discretion. But the invasiveness of the artist's visual inquiry of her body is implicit and is reciprocated by the girl's controlled and defensive gaze. Echoes of their artist-model relationship resonate in *A Parisian Beggar Girl* (pl. 79), a painting in which a more childlike Carmela is shown in the fictive guise of genre. With her left hand extended, palm open, and her right hand positioned on her hip, her body language simultaneously suggests a standard studio pose blended with a gesture demanding payment for that pose. Whether intended as a subtle reference to the model's demand for payment or not, Sargent's dedication of *A Parisian Beggar Girl* to fellow artist Albert Gustaf Edelfeldt (1854–1905) acts as a reminder that a professional model's body was communal visual territory. And, although there is no evidence that Edelfeldt either knew or hired Carmela Bertagna to work in his own Paris studio, it is possible that Carmela's image was a souvenir of Sargent's and Edelfeldt's common experience as figure painters.

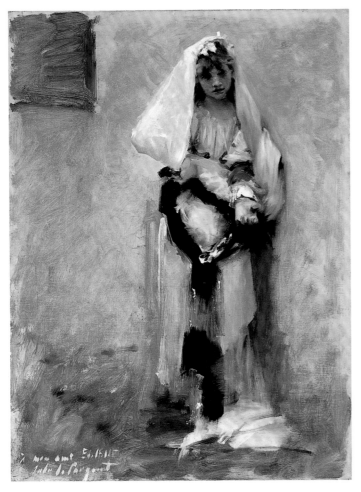

Other artists working in Paris doubtless availed themselves of Carmela's services, and it may have been she who modeled for *Wild Flower* (fig. 82), a work by the English painter William Stott (1857–1900) that was executed in Paris over the winter of 1880–81. Although Stott's model has not been identified, her distinctive jawline, slightly cleft chin, wide mouth with thin, Cupid's-bow lips, and wavy golden-brown hair styled loosely with bangs are remarkably like those of Sargent's Carmela. If Stott's model was Carmela, then *Wild Flower* provides another view of her professional experience in which her adolescent body is enmeshed in an iconography of lost innocence. Matters of identity aside, Stott's portrayal of this disturbingly childlike and passive girl not only literally exposes her but also exposes his transgression of an unspoken prohibition against depicting models of such tender age in the nude in works intended for public exhibition. The painting's title, *Wild Flower*, symbolically merges the girl's budding maturity with the wilted roses at her side and intimates the uncivilized, wanton nature of the model who has entered the presumably civilized (but sometimes morally questionable) space of the studio. Knowingly or not, Stott encouraged viewers to focus on the commodification of youthful flesh, transferring a normally forbidden object of desire from the range of covert imagery into the realm of fine art. Stott's recognition of the highly provocative nature of *Wild Flower* is indicated by his withdrawal of it from public view after its only display at the Cercle des arts libéraux in 1882.[80] Despite their obvious differences, Sargent's *Carmela Bertagna* and Stott's *Wild Flower* rely on the same polarities to construct meaning; both painters present a young model against pastel foils of rich, soft textures that promote a sensuous response in the viewer. Yet the aesthetic reaction is determinedly compromised, made ambivalent because it is a childlike model that occupies the arena of sensual feelings.

IMPOSING FAMILY VALUES

By the 1890s Sargent was accustomed to the constraints of commissioned portraiture, especially with respect to anticipating and sometimes battling patrons' demands for works that would harmonize with ways they wished to present themselves. Portraits depicting two or more members of the same family were particularly complex undertakings

because, in addition to achieving likenesses, these images were meant to communicate the intricate relationships that would advertise a set of ideals espoused by that family. In the case of aristocratic families, the task was exceptionally challenging because the client-sitters often had well-established public personas that entered the scope of celebrity. Because children, then as now, were considered reflections of their parents—products and extensions of family values—their inclusion in these paintings often gave Sargent the opportunity to insert levels of meaning that opposed or added to the primary content of the work.

The Family of the 9th Duke of Marlborough (fig. 83, pl. 54) exemplifies Sargent's commissioned work at its grandest, not only in its size but also in its conformance to aristocratic traditions in dynastic and aesthetic terms. (See Erica E. Hirshler's essay in this volume for a comprehensive discussion of the painting.) As an iconographic statement of family power the painting could not have achieved its intended meaning without the scrupulous care Sargent devoted to the representation and placement of the two boys. Sargent's emphasis on the elder son, John, the marquess of Blandford, is clear, for the boy occupies the center of the composition and stands directly below an ancestral bust denoting his status as the next inheritor of dynastic power. The marquess also connects his parents (whose difficult relationship had prompted rumors of estrangement as early as 1901) and thus further acts as the nexus of dynastic continuation. The idea is again transmitted in the sword that the duke controls and that the young marquess grasps just below the hilt. The message of the boy's nascent power is underscored by the small Blenheim spaniel whose leash he clasps lightly—a motif that forecasts his future as a benevolent but masterful adult. In contrast to his elder brother, whose life will be circumscribed by duty, little Ivor Spencer-Churchill reads as comparatively unimportant within the family structure: he is connected to the main group only because he grasps his mother's voluminous skirts as if to clear a foothold for himself. By the same token, Sargent posits this child's relatively carefree future and personal mobility (in that he is not designated to bear the responsibilities of heading the family and its holdings) in his cheerful countenance, the implied movement of his figure, and his apparent accessibility (as suggested by the dog in his arms and the other dog that looks to him rather than to the brother who controls the leash).

In addition to considering the Marlborough portrait as a mechanism for conveying emblematic meaning, it is worth examining the painting in more fundamental terms; that is, as a portrait of individuals. Once presented with the essential requirement of the

PL. 79 (OPPOSITE, TOP). *A Parisian Beggar Girl*, c. 1880, oil on canvas, 25³/₈ x 17¹/₄ in. (64.5 x 43.8 cm). Terra Foundation for the Arts, Daniel J. Terra Collection, 1994.14. Photograph: Courtesy of Terra Foundation for the Arts

FIG. 82 (OPPOSITE, BOTTOM). William Stott (English, 1857–1900), *Wild Flower*, 1881, oil on canvas, 32¹/₄ x 19¹/₈ in. (81.9 x 48.6 cm). Oldham Art Gallery & Museum, UK

FIG. 83. *The Family of the 9th Duke of Marlborough*, 1905, oil on canvas, 10 ft. 11 in. x 7 ft. 10 in. (3.3 x 2.4 m). Image courtesy of Blenheim Palace

commission (that of painting a pendant to the Reynolds canvas, fig. 61), Sargent was nominally free to do as he chose with setting, costumes, and poses. Still, there were certain restrictions, one of which was that he was barred from portraying the duchess smiling because such affability would mar the grandeur of the presentation.[81] In her 1952 autobiography, the duchess (writing then under her name by her second marriage, Consuelo Vanderbilt Balsan) recalled that Sargent "seemed in no wise daunted" by the task given him.[82] But, as she also remembered, the boys' sittings at Sargent's Tite Street studio were emotionally fraught events: "During the sittings...he [Sargent] was always agitated and smoked endless cigarettes. He was very self-conscious, and his conversation consisted of brief staccato remarks of a rather caustic nature. Viewing his sitter from afar, he would cock his head to one side, screw up his eyes, and with posed brush and extended palette would rush at his canvas and paint in short jerky movements. Children made him nervous; he had no idea how to manage them. Since mine were temperamental and mercurial, I had to supervise all their sittings. And as I got to know him better, I came under the spell of his kindheartedness, which not even his shyness could disguise."[83] The scenario presented in Consuelo Balsan's retrospective observations, although honest in tone, seems mildly understated. She neglected to mention that one of the boys had, during one session, broken an ankle jumping from the artist's sofa.[84] Since the painting was executed when Sargent was becoming increasingly resistant to accepting formal portrait commissions and resentful of the formulaic nature of such "high-style" obligations, his encounters with the "temperamental" John and Ivor must have aggravated him.[85]

Because Sargent was bound by the nature of the commission to cast the boys within the pictorial format of the Grand Manner, the question arises as to the extent to which he was concerned with portraying them as personalities. Two childhood photographs of the marquess of Blandford and Lord Ivor Spencer Churchill (fig. 84a, b)—one a formally posed portrait and the other an informal snapshot—may yield a kernel of evidence that the elder was generally more inclined to present himself in a dignified fashion and that the younger was generally more animated. The difference in their ages notwithstanding, this contrast of reserve versus exuberance was likely a reflection of personality traits, both inborn and taught. The elder boy was bullied constantly by his father (who reportedly had no great fondness for children) and was especially groomed to behave in a manner befitting the heir to a historic legacy. On the surface, Sargent's depiction of the brothers promotes such readings. The marquess is resolutely poised between his parents, whose arranged marriage was sustained largely for the purpose of ensuring an heir for the line and buttressing the duke's finances with Vanderbilt money, while the puckish Ivor is left to play on the sidelines. Yet the emotional balance of the painting is weighted toward maternal connections, as substantiated by the duchess's tender, proprietary hold on her elder son and the compositional void that separates him from his father.

Opinion was and still is divided regarding the aesthetic merit of the Marlborough portrait.[86] In terms of its official purpose it is eminently successful on the grounds that it provides likeness and elucidates the dynastic continuum. To be sure, the duke and

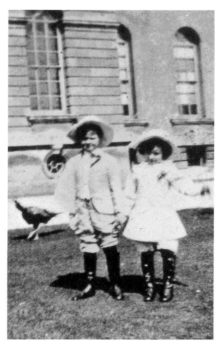

FIG. 84a, b. Photograph of the duchess of Marlborough with her sons, the marquess of Blandford and Lord Ivor Spencer Churchill, 1900; photograph of Blandford and Ivor at Blenheim, c. 1901, from Balsan, *The Glitter and the Gold*, unpag.

duchess are the principal figures in the composition, but because of Sargent's icono-graphic strategies, the boys hold their own by virtue of their roles in amplifying dynastic meaning and, what is more important, by mapping the emotional gulfs that separated husband and wife, children and father. What is more, they succeed as like-nesses, with little Ivor especially adding a needed note of energy to what would other-wise be an intellectually rich, but spiritless, canvas.

Given the cultural priority of family life in the Victorian and Edwardian eras (both in Europe and the United States) it is somewhat surprising that so few oil por-traits of entire families were commissioned at a time when the painted portrait enjoyed notable market resurgence.[87] Such rarity may be attributed in part to the difficulties entailed in bringing family members together for the expensive, numerous, and lengthy portrait sittings that literally disrupted domestic life for weeks on end. Thus, economic reality and tradition were not the only deciding factors in whether an elabo-rate family portrait would be undertaken; the family's capacity to withstand the logisti-cal upheavals of such a project also had to be considered. The extremes to which a patron would go to satisfy his own wants and to comply with an artist's requirements are illustrated in the circumstances of the commission for *Sir George Sitwell, Lady Ida Sitwell, and Family* (fig. 85, pl. 51). Fine (albeit subjective) records of the painting's ori-gins are provided in the autobiographies of Edith and Osbert Sitwell (fig. 86) who, with their brother Sacheverell, are shown with their parents in the family portrait. The painting was the culmination of Sir George Sitwell's quest for an "ancestor-descendant" portrait that began at the time of his 1886 marriage to Lady Ida Emily Augusta Denison (c. 1868–1937), the daughter of the earl of Londesborough.[88] Sir George's mis-sion to obtain a work that would match the family's *The Sitwell Children* painted in

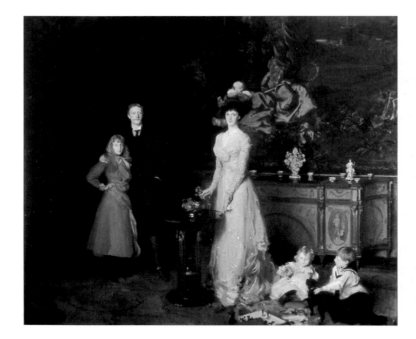

1786 by John Singleton Copley (pl. 52) entered its closing phase in 1897, when he had his sights tentatively set on Sargent:

> I believe I have settled with Sargent for next year, but "there's many a slip". Sargent is very much the kind of painter MacColl [the art critic D. S. Mac-Coll] recommends. He will only paint in his own studio in London, won't hear of a motive for the group or an outdoor picture, and will please himself.... At the same time Sargent *is* a great artist, and I shall get the best this age can offer, if all goes well. What I am afraid of is that Sargent has not studied the principles which have to be considered in dealing with portrait groups, an art by itself, and that he will presently realise that five figures can't be grouped without a motive, and will "chuck" the picture before it is half finished. Sargent and the modern school seem actually proud of not being able to paint what they can't see. But what a misfortune that is, for that is where the highest art comes in. Sir Joshua and the old English painters were always doing it, and how much one would have preferred even a second-rate painter of that age who could give one a conventional landscape without too vivid greens and blues.[89]

Sir George may have taken a long time in deciding who would paint the family portrait, but he never suffered from lack of opinion. His grandson Sir Reresby Sitwell recently characterized him, writing: "He spent most of his life in study of medieval history, genealogy and heraldry, architecture and gardening, only occasionally emerging from his ivory tower to have yet another book of indigestible content printed on his private press, or to pick fault with his family and dependants and play the tyrant. An

unsympathetic husband and trying and difficult parent, he is also revered as a benevolent and understanding grandfather."[90]

Once the deal was struck between Sir George and Sargent, preparations moved quickly. Under Sir George's watchful eye selected furnishings from Renishaw Hall (the family home in the north of England) were sent to Sargent's London studio along with the Copley painting for reference and inspiration.[91] The Sitwells also relocated, taking up temporary residence at 25 Chesham Place (owned by Mrs. Moreton Frewen, a sister of Lady Randolph Churchill's), which was within convenient reach of Tite Street, where their sittings took place "every second day for five or six weeks."[92]

Sitting for Sargent surely was a great event in the lives of the three children, whose otherwise quiet day-to-day routines were interrupted by the new rhythms of London life (fig. 87). Uprooted from Renishaw Hall's familiar haunts, where, as Osbert remembered, "children and servants often found themselves in league against grown-ups and employers," the two older Sitwell siblings did their lessons in a bedroom filled with photographs of Winston Churchill as he was in infancy, childhood, and heroic young manhood: "Wherever we looked, that face, already so well known, followed us with intent gaze, determined and dramatic. It was impossible to work while those eyes followed us, and my sister was obliged several times to screen them with newspapers and exercise-books."[93] Edith, by this time, was known and faulted for her sensitivity and imagination, qualities that lowered her in the esteem of her pragmatic parents, who insisted that she become a miniature version of them.[94] Osbert, by the luck of being the prized firstborn son, received greater measures of parental indulgence.

Raised in a family where position mattered, Edith and Osbert were sharp observers of the discrepancies between the realities of their lives and the fictions presented in the painting. Moreover, as Edith Sitwell wrote decades afterward, she was conscious of her father's strong hand in the development of the painting:

> When I was about twelve years old, my father determined that He (I must really use a capital letter in this connection) must be portrayed for posterity.... After a good deal of fussing, he decided that Sargent was to be the artist whom he would take under his wing, and he set about teaching the gentleman in question his business. My father was portrayed in riding-dress (he never rode), my mother in a white-spangled low evening gown and a hat with feathers, arranging, with one prettily shaped, flaccid entirely useless hand, red anemones in a silver bowl (she never arranged flowers...). The colour of the anemones was repeated in my scarlet dress. I was white with fury and contempt, and indignant that my father held me in what he thought was a tender paternal embrace. (I was freed from my

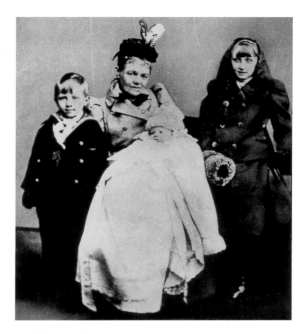

FIG. 87. Osbert, Sacheverell, and Edith Sitwell with their nurse, Davis, in 1898, from Edith Sitwell, *Taken Care Of* (New York: Atheneum, 1965), opp. 50. Permission arranged through David Higham Associates Limited

Bastille during the period of the sittings.) Osbert and Sacheverell, sitting on the floor, playing with my mother's black pug, were the only beings that seemed to have any trace of life....The portrait was painted against the background of one of the great Renishaw tapestries—depicting Justice, as it happened.[95]

The Bastille to which Dame Edith referred was a steel brace that she wore throughout her childhood to correct a spinal curvature. The unusual mechanism was an extraordinarily horrific device that she described as a tool of incarceration:

> This imprisonment began under my arms, preventing me from resting them on my sides. My legs were also imprisoned down to my ankles, and at night-time these, and the soles of my feet, were locked up in an excruciating contraption. Even my nose did not escape...and a band of elastic surrounded my forehead, from which two pieces of steel...descended on each side of the organ in question, with thick upholstered pads at the nostrils, turning my nose very firmly to the opposite way which Nature had intended, and block-ing one nostril, so that breathing was difficult. This *latter* adornment, how-ever, was only worn during my long hours in the schoolroom, as it was thought that it might arouse some speculation—even, perhaps, indigna-tion—in passers-by if worn in the outer world.[96]

Edith's crooked nose was also a great source of despair for her father, whose conception of female beauty allowed for only the conventionally delicate and pretty.[97] A dispute about this feature grew into a power struggle between artist and patron: Sir George, who had a hand in every aspect of the painting, instructed Sargent to accentuate the flawed shape of Edith's nose. Osbert recalled, "This request much incensed Sargent, obviously a very kind and considerate man; and he showed plainly that he regarded this as no way in which to speak of her personal aspect in front of a very shy and super-sensitive child of eleven....At any rate, he made her nose straight in his canvas and my father's nose crooked, and absolutely refused to alter either of them, whatever my father might say."[98] Edith Sitwell's experience sitting for Sargent paralleled the "suffocating" (her word) atmosphere against which she continually rebelled. The image of her father's hand resting on her shoulder must have brought home all the more the illusory nature of art and its potential to manipulate the truth. Just as she later found delicious irony in the fact that the family is shown against the tapestry of Justice, it is perhaps equally ironic that it is she who registers as the most compelling personality in this conversation piece. Sargent's sympathy for Edith may simply have been aroused by the debates with her father, but his compassion may also have been rooted in associa-tions of Edith's spinal problems with those of his sister Emily.

Whereas Edith struggled with the emotional and factual dishonesties she per-ceived in the painting, her brothers experienced far less psychological distress during their sittings. Osbert's memories fixed on the physical discomfort of posing (for him

"sitting still for more than a second or two . . . [was] the chief terror of childhood") and the lengths to which Sargent went to pacify him and Sacheverell. Sargent's now famous *The Wyndham Sisters* (fig. 44) stood at one end of the studio, its large scale and elegant sitters supplying an avenue of escape for Osbert: "[A]s I sat there, with my head screwed round at the uncomfortable angle at which Sargent wished it to be held for the portrait, and gazed at the picture of the sisters, envying them in my heart, for I knew that their likenesses were finished and they could now enjoy themselves once more, move freely, away from the cramping range of the artist's transfixing eye." Still, he concluded, "I think Sargent must have liked children. . . . Certainly he was very patient, would go to almost any trouble, consistent with being allowed to paint, to amuse us. When the first fascination of watching him at work, a conjurer drawing effects out of the void, had worn off, we became restless—especially Sacheverell who was only two years old."[99] The entertainment value of Sargent's rapid movements and dramatic sotto voce mutterings was short-lived, and he then resorted to whistling and reciting a "Young Lady of Spain." Yet, as Osbert remembered, "Even this, however, did not serve to keep him [Sacheverell] quiet indefinitely, and, being so young, his fidgeting was such that eventually a doll had to be made, of exactly his size and colouring, so that it could pose for him."[100]

Sir George was evidently pleased with the painting: the likenesses were accurate (except for his and Edith's noses), and more important, he could see in it his own imprimatur, having established the Copley as the pattern on which it was to be made, insisted on the unlikely and incongruent costumes, and chosen the furnishings and objets d'art that would flesh out the composition and bestow additional meaning to the family portrait. Sargent's skillful homage to Copley's precedent is revealed in the simple but effective retention of the general figure grouping in which he maintained the central, dominant female figure but reversed the placement of the younger games-playing children on the floor with two intermediate figures (whose costumes, by no coincidence, provide the same vivid contrasts of bright red, blacks, and browns). Yet, for all their calculated formal harmonies, the two works oppose each other in their presentation of family relationships. Whereas Copley strove to confirm the strength of family connections (an aim achieved largely by a chain of physical contact that unites the group), Sargent seems to have intentionally dismantled the idea of kindred attachments. This was noted by a number of critics when the painting was displayed at the Royal Academy in 1901. Although one reviewer pronounced the head of Sir George "a fine piece of painting," he found the portrait otherwise lacking:

> Had the figures been as satisfactory as the cabinet and the tapestry behind
> them, the picture would have been a very fine one. Unfortunately the
> figures standing in curious isolation have an odd appearance difficult to
> describe, but suggestive of marionettes. The eye does not seem to be able
> to take in the whole canvas as one group, but wanders from the very small
> children on the floor to their very tall mother, and then on again. . . . Mr.
> Sargent is said to have desired to make this picture a pendant to an

existing family group of the eighteenth century. The sacrifice of absolute freedom by the artist may, perhaps, account for the unsatisfactory qualities of the work.[101]

Apart from the critic's mistaken belief that it was Sargent's idea to create a pendant for the Copley, he was reasonably on target. His suspicion of the painter's "sacrifice of absolute freedom" was warranted, but, where he found it to be the cause of the "curious isolation" of the figures, the isolation was in fact Sargent's invention and purpose. Even though the painting caters to Sir George's idea of his family, Sargent cut through the artifices prescribed for him by portraying the emotional and physical divides that constituted the family's inner life and, in so doing, captured the essence of their relationships. Thus, Sargent wove into the governing structure of Copley's composition information based on his responses to each of the Sitwells as he had come to know them over weeks of intense observation. The figures of Sir George and Lady Ida do exhibit the static, mannequin-like characteristics remarked by the critic, while those of the children infuse the painting with emotive and physical vitality. These distinctions between parents and children must be interpreted as intentional, for Sargent was too talented an artist to leave such things to chance and likely wanted to inject elements of artistic freedom into a process hampered by Sir George's relentless interference.[102] Deprived of the discretionary power to modify even the slightest detail without precipitating a debate, Sargent turned a sympathetic eye to the children. As Osbert testified, Sargent "always tried to avoid implicating us in any trouble, when trouble arose because we had been 'difficult.' He championed us, and especially my sister, who could not do very much that was right."[103] Is it possible, therefore, to read Edith's stony gaze as Sargent's means of manifesting her resentment of her father's counterfeit display of affection and her awkward stance as a reference to the spinal curvature that ordinarily imprisoned her in the Bastille? And, in a similar vein, is it reasonable to see the two playful boys as exempt from the tensions of family pressures because their marginal position in the composition precludes interaction with their parents and Edith? Perhaps the truthful chord of disharmony struck by Sargent's *The Sitwell Family* prompted a reviewer to comment, "The strenuous grip of the observed fact is nowhere relaxed.... Most striking of all is the fact that he has abated nothing of his pitiless sincerity, a sincerity which only misses being ironical."[104]

An ironic undercurrent may also be detected in *Lady Warwick and Her Son* (pl. 80), a Grand Manner portrait laden with the full apparatus of the Georgian revival mode to which Sargent had greatly contributed.[105] Replete with the Romantic landscape backdrop and a magnificently gowned, statuesque full-length figure, the painting is a modern application of the formula perfected by Van Dyck and Reynolds. As such it was eminently suited to join its seventeenth- and eighteenth-century predecessors in the Greville family's Warwick Castle.[106] Modern reprises of the Grand Manner, however, were often labored pastiches of the original style, and Sargent himself was aware of the pitfalls of engaging in such a *retardataire* aesthetic. Indeed, without her little son Maynard, whom she tenderly supports on his pedestal, the countess would

PL. 80 (OPPOSITE). *Lady Warwick and Her Son*, 1905, oil on canvas, 106 x 60¼ in. (269.2 x 153 cm). Worcester Art Museum, Worcester, Massachusetts, Museum Purchase, 1913.69

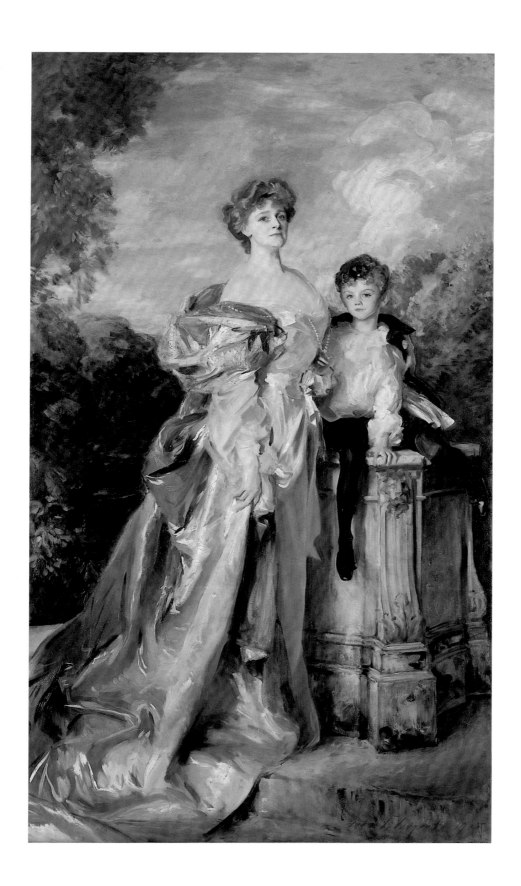

be a rather lifeless imitation of an outdated aristocratic visual vernacular. To be sure, this visualization of older artistic and social codes clashed with the highly publicized reality of the sitters' lives; although Frances Evelyn "Daisy," countess of Warwick (1861–1938), was firmly rooted in the English aristocracy through birth and marriage, hers was a thoroughly modern outlook.[107] Having converted to Socialism in 1895, the countess devoted herself to political causes in aid of child welfare and was instrumental in the reform of workhouses and secondary education. At the time Sargent painted the portrait, she was particularly active in the Hungry School-Children Crusade, and, as she later wrote: "The plainest common sense of caring for the children as a nation's greatest asset has always been sufficient motive to rouse me to action. I remember with great satisfaction a campaign in 1905 in which I was able to take a share. With others I toured some of the great industrial centres of the country with the object of getting a law passed for feeding necessitous school-children."[108] The modernity of the countess's life was also underscored in photographs published in popular periodicals. One that appeared in the June 18, 1902, issue of the *Car* (fig. 88) not only reinforced her identity as a mother (it is Maynard next to her) but also announced that she was one of England's first women to take to the roads in cars.[109] Other photographs more explicitly perpetuated her reputation as a loving mother (fig. 89), as if to confirm to mass audiences that even aristocrats had maternal feelings. This, too, comes through in Sargent's portrait in which Maynard is portrayed as a child who is utterly secure in his mother's affections. Her close embrace of him is matched by his proprietary grip on her pearls. The boy's satisfied, knowing look, addressed to the viewer, asserts the priority of his claim for his mother's attention.

The painting was not well received in 1905 at the Royal Academy, where it was one of six works by Sargent on view, among them, *The Marlborough Family*. Critics rejected Sargent's reliance on old master precedents and, when they found merit in the painting, their focus was on the child. As one writer put it, "Neither in expression nor in colour is this a pleasant picture, though the little boy in white shirt and black stockings is a charming element in it."[110] The *Nation*'s columnist was less reticent in voicing her displeasure and mocked Sargent's Grand Manner style, accusing him of "trying to outdo seventeenth-century posing by presenting her [the countess] as a fashionable Hagar, defending an extremely well-clad, well-fed Ishmael from visionary dangers."[111] Perhaps unwittingly, the reviewer struck at the heart of the painting's message; the countess was, indeed, a champion of children, and the critic's perception of her as the biblical Hagar lends an ironic note to the painting's reception.

Within the boundaries of the Grand Manner aesthetic, *Lady Warwick and Her Son* successfully functions as material evidence of the continuation of a genre that

spurred England's first steps toward developing a national school of art. The Grand Manner tradition yielded a seemingly unbroken visual history of noble families validating the idea that English society itself was stable and unchanging. The need for such assurances may have been responsible, in part, for the late nineteenth-century surge in demand for old master portraits, whose popularity may be seen as a general reaction to the tremendous social changes that occurred in the last decades of the Victorian era. Sargent's particularly cosmopolitan experience in social as well as artistic spheres emancipated him from forming or having to maintain primary allegiance to national aesthetics or to a unified national cultural view and, while *Lady Warwick and Her Son* endorsed England's artistic, social, and familial continuities, Sargent was also free to infuse these sacrosanct themes with ambiguity and strange tensions.

The dexterity with which Sargent maneuvered the iconographic framework of the Grand Manner is borne out especially in *Mrs. Carl Meyer and Her Children*, a magnificently painted portrait group that calls up notions of temporality, fashion, and personal extravagance (pl. 81). What is more, it displays a physical divide between mother and children, where normally would be found legible gestures asserting warm, intimate connections. As discussed elsewhere in this volume (see "From Souvenir to High Art: Childhood on Display"), the painting was often seen to reinforce the stereotype of the rich Jew as the interloper in a rigid societal structure whose position was established by virtue of money and not tradition. The canvas is suffused with a foreign (French) Rococo sensibility expressed in the shimmering pastel palette, rich fabrics, Louis Quinze settee (whose patterned upholstery supplies a Watteauesque scene), and delicately carved wall paneling, all of which align the work with an era of French history famous for its artifice and social instability. The radical perspective from which Mrs. Meyer is viewed (a dramatic compositional device that Sargent is believed to have used especially to disguise her short stature) invests the painting with the disquieting sensation that she would slip out of the painting were it not for her tenuous grasp of her son's hand and the little stool under her feet. Whereas these elements (furnishings and compositional devices) had become familiar elements in Sargent's art, here they particularly contributed to the "otherness" of the sitters, underscoring perceived difference by likening the Meyers' characters with the formal qualities of the painting—materialism, foreign style grounded in artifice, and lack of solid, steadying foundations. This sentiment was blatantly expressed in the *Spectator*, where personal bias inflected the writer's assessment: "Mr. Sargent has had recourse again to his *Empire* sofa, of which it is possible to get a little wearied, especially as it is always slipping down the floor in acute perspective. *Mrs. Carl Meyer* . . . and her two children, all dressed in great splendour and with an air of *haute finance*, are no doubt in harmony with this kind of furniture. Even Mr. Sargent's skill has not succeeded in making attractive these over-civilised European Orientals. We feel that these people must go to bed in satin and live upon ices and wafer biscuits."[112] Some critics fixed on the children to validate their impressions of separateness or isolation. Half hidden behind the settee, the brother and sister aim cautious looks toward the viewer. Together they present

a unity, mutually protective and enclosed, that telegraphs the tensions of being an outsider in society, whether that outsider is the child set apart from the adult or, as some interpreted it, the Jew set apart from the Anglo-Saxon mainstream. The painting also indirectly led to questions about the substance of the mother-child relationship. Absent the traditional poses that openly and firmly establish maternal bonds, the children are left to hover above their mother's form as if they—like her jewels—might be mere accessories to her life. This was implicit in the popularized reading of the painting's content, as witnessed in a *Punch* cartoon (fig. 90) that lampooned the artist's treatment of space and in doing so also accentuated the fragility of mother-child connections. Yet Sargent challenges such a reading through the sitters' gazes, which denote shared experience; all three are united by their collective focus on the same point outside the pictorial space. And, where one might first see maternal detachment, in the torsion of Mrs. Meyer's body and the slight turn of her head is a narrative subtext suggesting that she has not quite settled into a pose and, instead, has suddenly removed her attention from her children to the artist-outsider who interrupts them. The sensation of fluid motion counteracts the static finality commonly experienced in viewing portraits such as *Lady Warwick and Her Son*. In this respect Sargent interjects the activity of posing within the portrait: although Mrs. Meyer, Frank, and Elsie are portrayed with exquisite precision, we seem to witness the living moment prior to the frozen stillness of an "official pose." Perhaps it was the Meyer family's ethnic heritage and new wealth that inspired Sargent to portray them as he did. Certainly the commission gave him considerable freedom to go beyond the confines of Neo-Georgianism, for he chose a visual language as vital and ambiguous as the Meyers' position in English society. For all the commentary focusing on the "oriental" roots of his sitters, the overwhelming majority of critics declared Sargent's portrait of Mrs. Meyer and her children the "one undoubted masterpiece of the exhibition."[113]

Lady Warwick and Her Son and *Mrs. Carl Meyer and Her Children* respectively represent the conservative and radical extremes of Sargent's mother-and-child portraits. This observation, as straightforward as it is, nonetheless underscores one of the reasons for Sargent's success, for each of his patrons could be assured of receiving a painting that pointed to their singularity, interpreted, of course, by the artist. Sargent seems to have decided how to present his sitters partly on the basis of class. (We may assume this to have been the case with the Warwick and Meyer canvases.) The imposing formality of *Mrs. Cazalet and Her Children* (pl. 82) may also be attributed to the social and economic status of the commissioners (she was Maud, a daughter of Sir John Heron-Maxwell, seventh baronet of Springkell, and the wife of William Marshall Cazalet, High Sheriff of Kent, whose family had realized considerable commercial wealth). The commission required Sargent to produce a pair of works to fit extant frames set into the paneling of the couple's dining room (fig. 91).[114] Faced with the task of painting the

No. 291. The Perils of Steep Perspective! "Hold up, mother: it's only like the switchback!" J. S. Sargent, R.A., Elect.

FIG. 90. *The Perils of Steep Perspective*, from *Punch, or the London Charivari*, May 8, 1897, 227. General Research Division, The New York Public Library, Astor, Lenox and Tilden Foundations

PL. 81 (OPPOSITE). *Mrs. Carl Meyer and Her Children*, 1896, oil on canvas, 79½ x 53½ in. (201.9 x 135.9 cm). Private collection/ Bridgeman Art Library

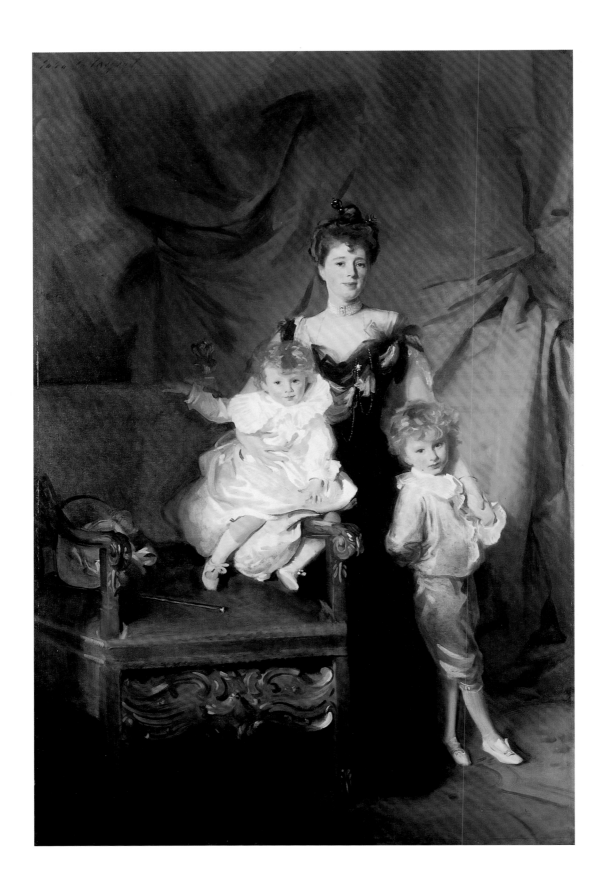

portraits of husband and wife to suit an awkwardly proportioned architectural setting, Sargent solved one-half of the problem by portraying William Cazalet in a landscape, wearing riding costume, and standing next to a horse.[115] For Maud Cazalet, the artist took an appropriate and wholly conventional route by enlisting two of her children—four-year-old Edward and two-year-old Victor Alexander—to enliven the otherwise minimal composition that consisted of a mass of carefully arranged drapery and an Italian Renaissance chair of substantial size. Gentle but legible tensions are found in Sargent's sympathetic rendering of Mrs. Cazalet, whose maternal attentions are divided between Edward,

FIG. 91. Photograph showing Sargent's portrait of Mrs. Cazalet and her sons in the dining room of Fairlawne, from *Country Life* (London), July 20, 1918, 51. General Research Division, The New York Public Library, Astor, Lenox and Tilden Foundations

who holds her hand as he leans against her, and Victor, who also benefits from her steadying hand as he straddles the arm of the chair in a pose that echoes the equestrian theme of his father's portrait. Occupied by these precious distractions, Mrs. Cazalet nonetheless seems utterly composed, wearing motherhood as gracefully as she does her pearls and gown. Despite the contrived backdrop, the portrait is convincingly natural if one chooses to recognize Sargent's incorporation of the act of posing into the content of his portrayal of the mother and her two sons.

As with the Meyers' portrait, it is the Cazalets' collective reaction to being observed that raises their image to a level of realism rarely detected in society portraiture. Although little Victor, by virtue of his age, is blissfully unaware of posing, he is nonetheless portrayed responding to the person (Sargent) whose space we now occupy. Edward also gazes in our-Sargent's direction, but his stance and expression evince a complicated mixture of boredom and obedient conciliation induced by remaining still. Mrs. Cazalet looks at us as well, presenting herself with appropriate measures of dignity and maternal warmth. These observations take us back to Berger's comments, particularly with respect to his assertion that portraits not only provide likenesses of individuals "but also of their acts of posing." In this sense, then, Sargent appears to have deliberately invested this painting and, indeed, many of his portraits with the content of posing that underscores the unique dynamic of portraiture as an interactive artistic process. Sargent strips away the pretense that his sitters are seen as they would be in private and that we are simply unnoticed spectators. Instead, he references a set of experiences—the sitters' varied experiences of posing and our experience of watching them pose—to produce the impression that we take part in the "real" event of portrait making. Our recognition of that content is facilitated especially by the contrasts articulated in the images of the children, whose differing levels of self-awareness and reaction call attention to the "act of posing." Essentially, Sargent meant his sitters to be caught posing. The lines of difference are best illustrated by comparing the Sargent portrait with Philip Alexius de Laszlo's 1914 portrait of another Cazalet son, Peter (1907–1973; fig. 92), which, though perfectly competent, lacks the psychological presence

PL. 82 (OPPOSITE). *Mrs. Cazalet and Her Children*, 1900–1901, oil on canvas, 100 x 65 in. (254 x 165.1 cm). Private collection. Courtesy of Berry-Hill Galleries, Inc., New York

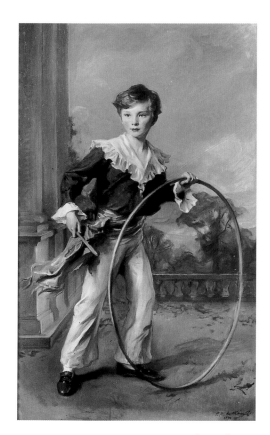

FIG. 92. Philip Alexius de Laszlo (Hungarian, 1869–1937), *Peter Cazalet*, 1914, oil on canvas. Private collection. Photographic Survey, Courtauld Institute of Art, London

PL. 83 (OPPOSITE). *Mrs. Knowles and Her Sons*, c. 1902, oil on canvas, 72 x 59½ in. (182.9 x 151.1 cm). Butler Institute of American Art, Youngstown, Ohio

Sargent achieved for his sitters and is posed to look as if he were not (a tack that reduces the painting's realist potential).

The Cazalet portrait was critiqued in tandem with the Sitwell group (the two were on view with five others by Sargent at the Royal Academy in 1901). Although both works were lauded for the "feeling for the charm of childhood," neither drew universal approbation on grounds of larger issues.[116] The *Athenaeum*'s columnist, after determining that "Mr. Sargent's pictures stand out from all the others with startling effect—he has the air of being the one professional painter, the one master of his craft, among a crowd of amateurs," proceeded to fault his art, saying, "The rapidity and certainty of Mr. Sargent's observation are indeed marvellous; unfortunately, observation unguided by imagination or a love of beauty cannot produce a great work of art."[117] The complaint was founded in a continuing debate surrounding portraiture, namely, how to resolve a realist vision with the subjective idea of beauty. The established codes for society portraiture permitted little latitude, and critics, eager to stir the aesthetic waters, used Sargent's art as a platform for staging their arguments. The critic's complaint centering on Sargent's lack of both imagination and a love of beauty does not lend itself to a literal translation in formal terms, but it is worth considering that Sargent's insertion of posing as part of the content of this and other canvases is the very element that the critical community found disturbing. For the most part, however, *Mrs. Cazalet and Her Children* fared well, and if one writer was "left cold" by the portrait, another declared it "very delightful" in its depiction of a "lady, who, if we are to trust her expression, is enjoying about as full a mead of happiness as ever falls to the lot of poor humanity, and of her two young children."[118]

Given the parameters of the Cazalet commission, Sargent produced an admirable result—a painting on a grand scale that nonetheless transmitted a palpable sense of familial affection and retained an appropriate air of reserve and grandeur. If a high Baroque formality characterizes *Mrs. Cazalet and Her Children*, Sargent's *Mrs. Knowles and Her Sons* (pl. 83) initially seems markedly less premeditated in its presentation of another young mother and her two sons. Emotional buoyancy is signaled immediately by Mrs. Knowles's smile—a rare thing in formal portraiture—investing the painting with a lightness that is in harmony with the delicate furnishings and palette.[119] Mrs. Knowles's unusual demonstrative expression yields an air of casualness that is further supported by such pleasing touches as the elder John's bare feet and the younger Richard's sweetly clinging attachment to his mother. What is more, the picture book and toy horse direct our thoughts to childhood activities and intimate that Mrs. Knowles's life is dedicated to raising her sons (unlike the message conveyed by Mrs. Cazalet's evening wear that places her in a social world separate from the domestic sphere). These distinctions are likely founded in the matters of class: Mrs. Cazalet's titled family background is detectable in the stateliness of the portrait, imagery that

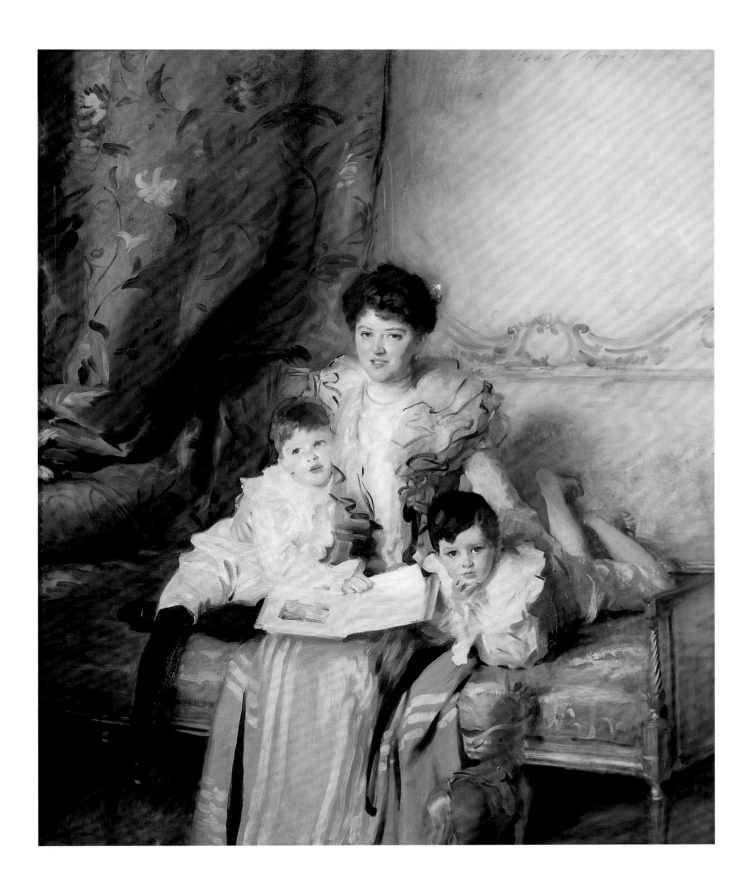

FIG. 93. *Mrs. Fiske Warren (Gretchen Osgood) and Her Daughter Rachel*, 1903, oil on canvas, 60 x 40³/₈ in. (152.4 x 102.6 cm). Museum of Fine Arts, Boston. Gift of Mrs. Rachel Warren Barton and Emily L. Ainsley Fund, 64.693. Photograph © 2003 Museum of Fine Arts, Boston

would be too pretentious for portraying Mrs. Knowles, whose family, although prosperous, had no claim to such visual tradition. To be sure, *Mrs. Knowles and Her Sons* also carries echoes of the Grand Manner, but because the mother and children sit together, they form a less imposing group. Despite these differences, the paintings share a great deal. Their vitality stems primarily from the younger boys: in the Cazalet portrait spontaneity is conveyed by Victor's precarious perch on his makeshift cushion-cum-saddle, and a comparable sense of the momentary is captured in the Knowles canvas through Richard's turning the page of his book. Most important, however, is that the pyramidal compositions of both reinforce the ideals of a stable society founded on the strength of maternal bonds. In an era concerned with the emergence of the "New Woman," such images of mothers and children helped allay fears of societal breakdown growing specifically from women's "transgressive" behavior in addition to confirming generally the continuing strength of family and the health of the coming generation.

Unlike the Cazalet and Knowles canvases, *Mrs. Fiske Warren and Her Daughter Rachel* (fig. 93, pl. 47) is filled with ambiguities. Although Mrs. Warren's status in Boston society was unassailable (she was wellborn, well educated, and well married), Sargent's depiction of her and her twelve-year-old daughter is disconcerting in its suggestion of maternal ambivalence. Through a curious mixture of tensions and relaxation, their bodies convey a multitude of contradictions. Mrs. Warren sits stiffly erect. Her arms rest gracefully at her sides, but her hands do not rest lightly in her lap. The left hand is tense and, grasping the other, seems to exert a forceful downward pressure. Her facial expression is one of calm containment—pleasant, but inexpressive as if cast in the Romantic mold of flushed prettiness reminiscent of the portraits of Thomas Lawrence. In all, Mrs. Warren is psychologically disconnected from the viewer (whose gaze she does not meet) and from her daughter, to whom she seems remarkably oblivious.

Rachel's body, like her mother's, is an essay in contradictions. Her head rests on her mother's shoulder, a pose that brings their faces into such close proximity that their physical resemblance is startling. Not only do they share the same high coloring, large, heavily lidded eyes, and luxuriant honey-brown hair, but they also manifest comparable states of mental and emotional remoteness. Where Rachel's awkward, unnatural pose might first be taken to reveal an intense yearning for maternal attention, further inspection yields a strong impression of adolescent disaffection. The emotional divide between the two assumes even greater proportions when mother and daughter are considered against the tender intimacy embodied in the

Renaissance sculpture of the Madonna and Child located in the upper-left portion of the canvas.

The sittings took place at Isabella Stewart Gardner's recently completed Fenway Court (now the Isabella Stewart Gardner Museum in Boston), where Sargent was allowed the use of the Gothic Room, Mrs. Gardner's inner sanctum that was accessible only to a select few. A photograph showing the artist at work and Mrs. Warren and Rachel as they posed foregrounds the pragmatic atmosphere of art making (even if the photograph itself might be a contrived re-creation of a posing session; fig. 94). Both subjects appear less glamorous, more vulnerable, and certainly less mentally abstracted than their painted counterparts. Rachel's physical discomfort is conspicuous as she crouches and twists into position (in the painting she has a chair that offers a somewhat flimsy rationale for her ability to hold this essentially untenable pose). The question remains: Were the striking emotional ambiguities that Sargent brought to life on the canvas aesthetic fictions or were they derived from a conscious response to his sitters? Was the sculpture that so inflects the painting's meaning an inspiration, or was it a paradoxical afterthought that occurred to Sargent as he manipulated the interaction of form and content?

FIG. 94. Photograph by Sarah Choate Sears (?), John Singer Sargent painting in the Gothic Room, Fenway Court, 1903. Isabella Stewart Gardner Museum Archives, Boston

When the canvas was first on public display in Boston in 1903, it was said to compete with the best paintings by Reynolds and was admired especially "for the note of genuineness and human tenderness that emanate from it."[120] For the most part reviewers adopted the same tactics, asserting the work's superiority but refraining from examining it deeply. By 1916 a more analytic approach sought to outline the features that distinguished the artist's early work from his later productions. Citing the "severe, dignified and vital likenesses of Mrs. Edward L. Davis and her son" as the high standard, one reviewer continued, "Enough of the exhibition . . . is early [enough] to give a good conspectus of the sincerity of effort that evolved a youthful art as fine and mature as anything of its kind in modern times. The foundation was laid in these pieces of very direct, forceful painting; on it have been built such preciosity, such attention to manner, as one may note in, say, the 'Mrs. Fiske Warren and Daughter'. . . ."[121] Perhaps this mannered "preciosity" was the source of Mrs. Warren's reported displeasure with Sargent's depiction of her, for she is said to have claimed that the painting failed to capture her as the woman of intellectual substance that she was.[122] To be sure, the strength of the painting derives from the psychological frictions introduced by Rachel, discordant notes that accentuated the opacity and autonomy of her inner life. Here Sargent entered what may be considered a grand experiment in

gauging the relative powers of technique and image in the construction of content. His portrayals of Gretchen and Rachel Warren contradict expectations of maternal affection and a daughter's devotion—information that is communicated vividly in their poses. Yet the majority of the critics failed to acknowledge this rupture in mother-child iconography and, instead, treated the painting to vapid, circumspect commentary that focused largely on Sargent's bravura technique.[123]

EPILOGUE

In his review of the 1916 loan exhibition of Sargent's "Boston" work held at the Museum of Fine Arts, Boston, the critic William Howe Downes singled out the *Boit Children*, *Mrs. Edward Davis and Her Son*, and *Mrs. Fiske Warren and Her Daughter Rachel* as the "star" portrait groups of the installation. Of added significance was his opinion that Sargent "has almost invariably been at his best in painting the portraits of children."[124] Even when he no longer wanted to paint commissioned portraits, his images of children remained fresh and vital, infusing the works with a spirited liveliness they would otherwise have lacked. A special case in point is the portrait *Mrs. Percival*

FIG. 95. *Mrs. Percival Duxbury and Her Daughter*, 1918, oil on canvas, 56⅞ x 38¼ in. (144.5 x 97.1 cm). Manchester City Art Gallery, UK, 1945.41

Duxbury and Her Daughter (fig. 95), painted in 1918 as a result of Percival Duxbury's offer to donate £10,000 to the Red Cross relief fund if Sargent would paint a portrait of his wife. Sargent undoubtedly complied with the offer only because of its charitable motives and, as he wrote in 1918, he did not relish the process: "Plugging away at my Red Cross mug, very uphill work, although the unfortunate victim is patient and not bad looking."[125] The situation evidently brightened for the artist when he decided to include the sitter's young daughter Ailsa in the portrait.[126] Certainly it is Ailsa who brings the painting to life and helps to remind us of Downes's assertion that Sargent was usually at his best when he painted portraits of children. Just as Sargent liberated his child sitters from reenacting the stock Romantic or trivial roles that still characterized child imagery in the arts, the process of painting children freed Sargent from dealing with the pretensions or expectations of adult subjects. Whether these model children appear to us as sulky, cheerful, shy, confident, or simply lost in thought, we are compelled to respond to them as distinct personalities and not as types. Indeed, Sargent saw and reacted to them as individuals, often incorporating their personal mechanisms for coping with the process of sitting for their portraits into the painted image and thus leading us to believe that they—unlike Lewis Carroll's Alice—were not forced to be anything but themselves. At the same time they fascinate us, for these portraits communicate the intense inner life of childhood that was then becoming a subject unto itself.

1. For recent studies of Charles Lutwidge Dodgson (writing as Lewis Carroll) and his photographs of Alice Liddell and other children, see Carol Mavor, *Pleasures Taken: Performances of Sexuality and Loss in Victorian Photographs* (London: I. B. Tauris, 1995), and Diane Margaret Waggoner, "In Pursuit of Childhood: Lewis Carroll's Photography and the Victorian Visual Imagination," Ph.D. diss., Yale University, 2000.

2. Caryl Hargreaves, "Alice's Recollections of Carrollian Days, as Told to Her Son," *Cornhill Magazine*, July 1932, reprinted in Morton N. Cohen, ed., *Lewis Carroll: Interviews and Recollections* (London: Macmillan, 1989), 84–85 and quoted in Waggoner, "In Pursuit of Childhood," 126.

3. This conflict is succinctly described in terms of the development of mental health: "Theoretically, then, mental health depends upon the maintenance of a balance within the personality between the basic human urges and egocentric wishes on the one hand and the demands of conscience and society on the other hand. Under ordinary circumstances we are not aware of these two forces within our personality. But in times of conflict an impulse or a wish arises which conflicts with the standards of conscience or which for other reasons cannot be gratified in reality. In such instances we are aware of conflict and the ego takes over the role of judge or mediator between these two opposing forces." Selma H. Fraiberg, *The Magic Years: Understanding and Handling the Problems of Early Childhood* (New York: Simon & Schuster, Fireside, 1996), 8.

4. Fitzwilliam Sargent to his father, February 21, 1865, Archives of American Art, Smithsonian Institution, Washington, D.C. (hereafter AAA), reel D317, frame 48.

5. Fitzwilliam Sargent to his mother from Paris, June 12, 1867, AAA, reel D317, frame 94.

6. Fitzwilliam Sargent to his mother, Switzerland, near Geneva, July 25, 1864, AAA, reel D317, frames 35, 36. Minnie (Mary Winthrop Sargent) was born February 1, 1861, and died April 18, 1865.

7. Fitzwilliam Sargent to his mother, Nice, October 20, 1867, AAA, reel D317, frame 103.

8. See the entry for the drawing in Stephanie L. Herdrich and H. Barbara Weinberg, *American Drawings and Watercolors in the Metropolitan Museum of Art, John Singer Sargent* (New York: Metropolitan Museum of Art, 2000), 114–15.

9. Among the provocative studies recently devoted to portraiture are Richard Brilliant, *Portrait* (Cambridge, Mass.: Harvard University Press, 1991); Joanna Woodall, ed., *Portraiture: Facing the Subject* (Manchester and New York: Manchester University Press, 1997); and Harry Berger Jr., *Fictions of the Pose: Rembrandt against the Italian Renaissance* (Stanford, Calif.: Stanford University Press, 2000).

10. Berger, *Fictions of the Pose*, 4–5.

11. See Jean Piaget, *The Child's Conception of the World*, especially the chapter "Realism and Idea of Participation" in which Piaget stated, "That the child shows a keen interest in himself, a logical and no doubt a moral, eccentricity, does not prove that he is conscious of his self, but suggests, on the contrary, that he confuses his self with the universe, in other words that he is unconscious of his self." First published in English in 1929, the edition cited here is the translation by Joan and Andrew Tomlinson (Boston: Littlefield Adams Quality Paperbacks, n.d.), 125.

12. *Daniel Macmillan* has been exhibited only once, in Sargent's memorial exhibition of 1926 at the Royal Academy, a fact that accounts for the portrait's general lack of published comment.

13. "The American Artists," *New York Times*, April 3, 1901, 8.

14. Harrison S. Morris, "American Portraiture of Children," *Scribner's Magazine* 30, no. 6 (December 1901), 650–51.

15. How G. M. Williamson, a collector of rare books, fits into the suspiciously apocryphal account of the painting's ownership in 1879 is unknown. Edward Strahan, perhaps in his eagerness to aggrandize the merits of Sargent's *Neapolitan Children Bathing* and the promise of his artistry, waxed long about the visit of "an elderly, modest man" to Sargent's Paris studio, which supposedly resulted in his first sale. Strahan continued, "When the picture was applied for, for this exhibition, the messenger was directed to one of those hopeless addresses far beyond the ends of the most endless streets of Brooklyn, to attain which street-cars fail and cabs are a mockery. There, in a suburban wilderness, in a small house, he found the small Paris visitor hugging the solitary picture. Instead of being an art-patron with a collection, he was simply a man who had fallen in love with an artist's work and concluded to treat himself. So the 'Children Bathing' went to a Brooklyn art-lover who had perhaps never bought a picture and never did again. And a young painter's vocation was settled; for Sargent determined to become a professional artist." Edward Strahan, "The National Academy of Design. First Notice," *Art Amateur* 1, no. 1 (June 1879), 4–5.

16. Marion Harland, *Common Sense in the Nursery* (New York: Charles Scribner's Sons, 1885), 79.

17. Richard Ormond and Elaine Kilmurray, *John Singer Sargent: Portraits of the 1890s; Complete Paintings, Volume II* (New Haven and London: Yale University Press for the Paul Mellon Centre for Studies in British Art, 2002), 97–98.

18. Sargent's choice of the flowing Liberty dress for Frances Pedley also reverberates with Romantic associations that lodged childhood in a timeless zone of asexual innocence. Such costumes served to "disembody" the wearer, thereby placing the child outside the realm of adult temptation and sin. For the iconography of child costume, see, for instance, Marcia Pointon, *Hanging the Head: Portraiture and Social Formation in Eighteenth-Century England* (New Haven and London: Yale University Press, 1993), 177–226, and Anne Higonnet and Cassi Albinson, "Clothing the Child's Body," *Fashion Theory* 1, no. 2 (1997), 119–44.

19. This period of development is noted for the emergence of the child's ability to identify with or empathize with another living being. This identification construct "becomes an important factor in governing...behavior, in restricting aggressive and destructive acts. This capacity for identification is implicit in our concept of the civilized person." Fraiberg, *The Magic Years*, 191.

20. Frederick George Cotman (1850–1920) exhibited frequently at the Royal Academy, the Society of British Artists, and the Royal Institute to which he was elected in 1882.

21. Ruth Bacon Cheney, ed., *Recollections: Gorham Bacon* (Hartford, Conn.: Finlay Brothers, 1971), 53–55.

22. See Elizabeth R. McClintock's entry for the painting in *American Paintings before 1945 in the Wadsworth Atheneum*, by Elizabeth Mankin Kornhauser (New Haven and London: Yale University Press, 1996), 645–46.

23. For an insightful analysis of the girl-doll iconography, see Greg M. Thomas, "Impressionist Dolls: On the Commodification of Girlhood in Impressionist Painting," in *Picturing Children: Constructions of Childhood between Rousseau and Freud*, ed. Marilyn R. Brown (Aldershot, Eng.: Ashgate, 2002), 103–25.

24. The girl in Morisot's *Little Girl with a Doll* is identified as either Morisot's daughter Julie (b. 1878) or a cousin, Jeannie Gobillard. Thomas, "Impressionist Dolls," 111.

25. Sargent to F. D. Millet, October 20, 1887, AAA, reel 5460, frames 422–31. Millet's portrait of Ruth's sister has not been located.

26. Henry Gurdon Marquand (1819–1902) was a powerful New York banker and influential art collector. He served as president of the Metropolitan Museum of Art from 1889 to 1902. Sargent's portrait of him (painted in 1896) is now in the Metropolitan Museum of Art's collection. It has been theorized that Sargent, hoping to remain in England, quoted Marquand an exorbitant price for Mrs. Marquand's portrait to quash the deal.

27. Other paintings of children from this stay in Newport include *Caspar Goodrich* (pl. 30) and *LeRoy King* (private collection).

28. Marie-Louise Pailleron, *Le paradis perdu: Souvenirs d'enfance* (Paris: Albin Michel, [1947]). For additional details on the Pailleron portraits and that of Madame Buloz, see Richard Ormond and Elaine Kilmurray, *John Singer Sargent: The Early Portraits; Complete Paintings, Volume I* (New Haven and London: Yale University Press for the Paul Mellon Centre for Studies in British Art, 1998), 36–37, 45–47, 51–53.

29. Pailleron, *Le paradis perdu*, 159. "En revanche, elle fut bien heureuse de recevoir des mains de Sargent une esquisse 'ravissante' de son petit-fils qu'elle adorait."

30. There is no additional biographical information available on Edouard; even his death date remains unknown.

31. Ormond and Kilmurray note this as well and cite a letter from Madame Buloz to her sister describing the children and revealing that Edouard was his grandmother's favorite: "...[H]e is a darling whom I love with all my heart. His sister is very pretty, but there is a sharpness about her. He has a kind and open manner, placid and innocent. Marie-Louise is spoiled too much by her father and that makes her too forward." Pailleron, *Le paradis perdu*, 159.

32. Pailleron, *Le paradis perdu*, 157. The second objection Marie-Louise had about Sargent that summer was his delight in catching butterflies, describing him in his quest as an "assassin" who, "when he was able to catch one, asphyxiated his victim in a glass with the fumes from his cigar" (158).

33. Pailleron, *Le paradis perdu*, 48.

34. Edouard Pailleron wrote a poem dedicated to Marie-Louise titled "The Doll," in which he attempted to explain why he locked himself away to write and affirmed his love for her. It is reproduced in her book, *Le paradis perdu*, 58.

35. Pailleron, *Le paradis perdu*, 159.

36. Pailleron, *Le paradis perdu*, 163. This anecdote is repeated in Stanley Olson, *John Singer Sargent: His Portrait* (London: Barrie & Jenkins, 1989), 80.

37. "I had already known this torture at G. Jacquet's. But what a difference; Jacquet, the painter of children par excellence, knew how to amuse them and only demanded very brief sittings.... I perceived then that Jacquet would paint a very good likeness, without having any style." Pailleron, *Le paradis perdu*, 161.

38. Pailleron, *Le paradis perdu*, 161.

39. Olson, *John Singer Sargent*, 80.

40. Carol Troyen has also observed that Edouard Pailleron served to benefit substantially from the portrait's public success since it would validate his cultural position as a discerning patron of one of the most promising artists in Paris. See her entry for the painting in *John Singer Sargent*, ed. Elaine Kilmurray and Richard Ormond (London: Tate Gallery Publishing, 1998), 91–92.

41. See, for example, the photograph of Sargent with Emily (fig. 11).

42. For details of the exchange, see Donald Miller, "Inspired Friendship: Sargent and Saint-Gaudens," *Carnegie Magazine* 53, no. 4 (April 1979), 4–11.

43. Homer Saint-Gaudens, *The American Artist and His Times* (New York: Dodd, Mead & Company, 1941), 140. Homer Saint-Gaudens also recounted his childhood memories of theater-going, listening to chamber music in the Rembrandt Room of the Henry O. Havemeyers' Fifth Avenue home, and Sunday afternoons when "the Kneisel Quartet played in my father's studio, with an accompaniment of beer and pretzels, to men of art and men of affairs," and added, "I took so much for granted at the time and regard that past with such astonished appreciation now" (141).

44. For a clearly written summary of "childhood amnesia," see Gareth B. Matthews, *The Philosophy of Childhood* (Cambridge, Mass., and London: Harvard University Press, 1994), 81–88. Matthews focuses on the philosophical question of

whether the infant who matures to an adult may be considered the same person, especially if the adult has no recollection of events occurring in his early years. Matthews cites Sigmund Freud as the first to investigate seriously the phenomenon of the adult's inability to remember most of his childhood or of being a child. Freud's attentiveness to these gaps in memory helped form the foundation of his psychoanalytic theories in which recapturing meaningful memories is considered therapeutic. Matthews discusses the role of memory in the formation of personal identity and argues against the idea of the child-adult identity division: "Perhaps a Freudian or other account of amnesia might help us understand why some of these gaps are there. But it isn't that our childhoods are, in general, unrelated to us through memory. And so we do not have this reason for feeling, as a general thing, alienated from our childhood. The memory link that connects us with our very early selves may be convoluted, but then so are the links that connect us with the day-to-day existence we enjoyed last year, or last month, or even yesterday" (88).

45. Saint-Gaudens, *The American Artist and His Times*, 140.

46. See Erica E. Hirshler's summary of the late nineteenth-century popularity of Gainsborough's *Blue Boy* in her essay in this volume.

47. For boys' resistance to the Blue Boy/Fauntleroy outfit, see Higonnet and Albinson, "Clothing the Child's Body," 133, and Jo Barraclough Paoletti, "Little Lord Fauntleroy and His Dad: The Transformation of Masculine Dress in America, 1880–1900," 4, at http://www.sallyqueenassociates.com/fauntleroy.htm.

48. Homer Saint-Gaudens credited his father with introducing him to contemporary theater as a child.

49. Saint-Gaudens, *The American Artist and His Times*, 140.

50. C. M. S., "Gallery and Studio. The Exhibition of the American Artists' Society," *Brooklyn Daily Eagle*, May 15, 1892, 17.

51. See Erica E. Hirshler, "The Fine Art of Sarah Choate Sears," *Antiques*, September 2001, 320–29, in which the career of Sears is summarized. A more detailed account of Sears's career is found in Hirshler, *A Studio of Her Own: Women Artists in Boston, 1870–1940* (Boston: MFA Publications, 2001). The latter publication reproduces the photograph of Helen Sears discussed here and an earlier photographic portrait of her that roughly corresponds in date to Thayer's painting of her.

52. Hirshler, *A Studio of Her Own*, 59.

53. Sargent to Sears, Biltmore, Asheville, North Carolina, August 7, 1895, quoted in Hirshler, "The Fine Art of Sarah Choate Sears," 323.

54. "Society of American Artists," *New York Times*, March 28, 1896, 5. In keeping with the practice of emphasizing paternal connections, the critic referred to Helen as "the daughter of Mr. Sears" and made no mention of the fact that Sarah Sears had a work on display in the same exhibition.

55. However, the reception of the work changes with knowledge of the girls' identities and the circumstances of the painting's making. Thus, it can be read as a portrait depending on the information possessed by the viewer.

56. James S. Harding, "The Royal Academy Exhibition," *Art Amateur* 17, no. 2 (July 1887), 32.

57. And, judging from a number of preparatory studies of the children's heads (private collections) portraiture does deserve to be included among Sargent's aims for the picture.

58. See E. V. Lucas, *Edwin Austin Abbey, Royal Academician: The Record of His Life and Work*, 2 vols. (London: Methuen and Company; New York: Charles Scribner's Sons, 1921), vol. 1, 151, where Abbey's letter of September 28, 1885, to Charles Parsons refers to Pangbourne, stating that it was "here that he saw the effect of the Chinese lanterns hung among the trees and the bed of lilies." This is cited as well in Marc Simpson's thorough account of the painting in "Reconstructing the Golden Age: American Artists in Broadway, Worcestershire, 1885 to 1889," Ph.D. diss., Yale University, 1993, 325, and in Richard Ormond, "Carnation, Lily, Lily, Rose," in Warren Adelson et al., *Sargent at Broadway: The Impressionist Years* (New York: Universe/Coe Kerr Gallery; London: John Murray, 1986), 65.

59. Sargent to Edwin Russell, September 10, 1885, Tate Gallery Archives.

60. Lucia Millet to her parents, August 24, 1885, Sharpey-Schafer Papers, AAA, unmicrofilmed, quoted in Simpson, "Reconstructing the Golden Age," 326.

61. Charteris writes, "At first he took as his model Mrs. Millet's small daughter, aged five, covering her dark hair with a fair golden wig and sketching her in the act of lighting a Chinese lantern at the moment when the sun had set and a flush still hung in the sky." Evan Charteris, *John Sargent* (New York: Charles Scribner's Sons, 1927), 74. Simpson speculates that "It was, perhaps, the increased tensions possible in the depiction of two figures that prompted Sargent's decision to paint the Barnards and abandon the earlier scheme." "Reconstructing the Golden Age," 330.

62. See Ormond and Kilmurray, *John Singer Sargent: The Early Portraits*, 172, where Lucia Millet's October 8, 1886, letter to her parents telling of the portrait is quoted: "The likeness he had of her yesterday was wonderfully like her. She poses very well but he was sure she would not for she has grown most lively and restless."

63. A line drawing of the painting is reproduced in "The Exhibition of the Royal Academy," *Art Journal* 10 (1884), 280, where it was described as "Evidently capital portraits of a set of youngsters, who seem to be hardly restrained from a game of romps, which would render the painter's task an impossible one."

64. Sargent to Emily Sargent, possibly 1885; facsimile reproduction in Charteris, *John Sargent*, between 76 and 77.

65. Ormond, "Carnation, Lily, Lily, Rose," 64.

66. Lucia Millet to her parents, September 6, 1885, Sharpey-Schafer Papers, AAA, unmicrofilmed, quoted in Simpson, "Reconstructing the Golden Age," 326.

67. Edwin H. Blashfield, "John Singer Sargent—Recollections," *North American Review* 221, no. 827 (June 1925), 644.

68. Letter from Edmund Gosse (c. 1886) to Evan Charteris, quoted in Charteris, *John Sargent*, 74–75.

69. Charteris states: "Never for any picture did he do so many studies and sketches. He would hang about like a photographer to catch the children in attitudes helpful to his main purpose. 'Stop as you are,' he would suddenly cry as the children were at play, 'don't move! I must make a sketch of you,' and there and then he would fly off, leaving the children immobile as Lot's wife, to return in a moment with easel, canvas and paint-box." Charteris, *John Sargent*, 74. There is some disagreement about the relationship of two drawings of Polly and Dolly (Tate, London) to the painting. Marc Simpson suggests that the drawings are based on the finished canvas, made as illustrations for publication and then given to the girls as souvenirs of their contribution to the painting. "Reconstructing the Golden Age," 334.

70. See Elaine Kilmurray, "Traveling Companions," in Warren Adelson et al., *Sargent Abroad: Figures and Landscapes* (New York, London, and Paris: Abbeville Press, 1997), 55–56, where she notes that the Barnards were beneficiaries in Sargent's will.

71. See pages 65–70, where this painting is discussed in another context.

72. "The Academy Exhibition," *Art Journal* (New York), 5, no. 5 (May 1879), 159.

73. Maria Tuke Sainsbury, *Henry Scott Tuke R.A., R.W.S.: A Memoir* (London: M. Secker, 1933), 50.

74. Although the older boy wears what seems to be the same sash as that worn by the model in *A Parisian Beggar Girl* (pl. 79), the prop was easily portable and does not serve as reliable evidence in pinpointing where *Study of Three Figures* was painted.

75. Although the artist's studio was a frequent subject in high art by the late nineteenth century, it was usually depicted as a sign of the aestheticized artistic space (as in William Merritt Chase's series of paintings showing portions of his many studios). Few late nineteenth-century artists portrayed the studio as a true workplace. Even Thomas Eakins, in his series of studio pictures, transformed the studio into a metaphor of artistic freedom by simultaneously historicizing (and fictionalizing) the creative environment of the Philadelphia sculptor Thomas Rush (Philadelphia Museum of Art and Brooklyn Museum).

76. Bashkirtseff's *In the Studio* is reproduced and briefly discussed in Gabriel P. Weisberg and Jane R. Becker, eds., *Overcoming All Obstacles: The Women of the Académie Julian* (New York: Dahesh Museum; New Brunswick, N.J., and London: Rutgers University Press, 1999), 18–19.

77. For biographical information on Rosina Ferrara, see Elaine Kilmurray's entries for *A Capriote* and *Head of Ana-Capri Girl*, in *John Singer Sargent*, ed. Kilmurray and Ormond, 66–68. See also "Biographical Index of Child Sitters" in this volume.

78. *Art Amateur* 7 (August 1882), 46, quoted in *John Singer Sargent*, ed. Kilmurray and Ormond, 68.

79. Richard H. Finnegan has pointed to the likelihood that Carmela was Italian. Letter to the author, July 15 and 22, 2003.

80. See the entry for the painting in Alison Smith, ed., *Exposed: The Victorian Nude* (London: Tate Gallery Publishing, 2001), 251.

81. Olson cites a 1909 letter from Sargent to his friend Paul Helleu in which Sargent wrote, "I fear you will not like the enormous canvas of the Marlboroughs very much, because, to begin with, the Duchess is something of a failure as I was obliged to make her solemn: her face loses all its charm in this grandiose picture." Olson, *John Singer Sargent*, 222.

82. Consuelo Vanderbilt Balsan, *The Glitter and the Gold* (New York: Harper and Brother Publishers, 1952), 185.

83. Balsan, *The Glitter and the Gold*, 186.

84. James Brough, *Consuelo: Portrait of an American Heiress* (New York: Coward, McCann & Geoghegan, 1979), 143, states that it was Ivor who injured himself. David Green states that it was John who broke his leg "and, to his father's annoyance, held up the sittings." *The Churchills of Blenheim* (London: Constable, 1984), 130.

85. Stanley Olson noted: "The grand tradition brought a change in the terms of his formulas; it also brought repetition and with it a souring of his attitude towards portraiture. Ingenuity and surprise were unwelcome....The deeper he got into the pages of *Debrett* [a standard biographical directory of English nobility], the staler the job became, and portraiture had become a job with all the excitement rubbed clean, even from the edges." Olson, *John Singer Sargent*, 223.

86. For example, the critic for the *Athenaeum* admired the painting for its "masterly" effect. Nevertheless, he found fault, saying that it was "the most ambitious composition which Mr. Sargent has yet produced, and it is extremely interesting to see how he has faced the problem of a *portrait d'apparat* on this scale." Yet, the "forms [are] too meager, and cut out harshly upon the cold light of the wall behind...the color perhaps too pretty—too slight—for the scale of the composition." "Fine Arts. The Royal Academy (First Notice.)," *Athenaeum*, no. 4045 (May 6, 1905), 567.

87. For a survey of family life in the modern era, see Philippe Ariès and George Duby, gen. eds., *A History of Private Life*, vol. 4, *From the Fires of Revolution to the Great War*, ed. Michelle Perrot (Cambridge, Mass., and London: Belknap Press of Harvard University Press, 1990). In iconographic terms, father literally left the picture in the late nineteenth century. This paternal absence may reflect greater rigidity in upper-class social customs that defined male vs. female spheres. However, paterfamilias was always implied (i.e., as commissioner of mother-and-child portraits, titles of works

refer to sitters as Mrs. So-and-so and children or the children of Mr. So-and-so).

88. Lady Ida was reportedly annoyingly mindful of having married beneath her social station. She was the daughter of an earl, and her maternal grandfather was the seventh duke of Beaufort.

89. Osbert Sitwell, *Left Hand Right Hand!* (London: The Reprint Society, 1946), 223.

90. Sir Reresby Sitwell, *Renishaw Hall and the Sitwells* (Derby: Derbyshire Countryside, 1989), 7.

91. These items included the thirty-by-twenty-foot Louis de Vos Brussels tapestry that hangs behind the Sitwells, the "commode" said to have been designed by Robert Adam and made by Chippendale and Haig for Francis Hurt Sitwell in 1776 on the occasion of his marriage, and the silver racing cup won at the Chesterfield races by a Sitwell ancestor in 1747.

92. Sitwell, *Left Hand Right Hand!* 231.

93. Sitwell, *Left Hand Right Hand!* 229.

94. Osbert sympathetically recorded his impressions of the relationship between his sister and their parents: "I doubt whether any child was ever more mismanaged by her parents; they failed entirely to comprehend the sort of being who was in process of flowering before their eyes, they mistook nervous sensibility for awkwardness, imagination for falsehood, and a capacity for throwing the cloak of drama over everyday events—often the sign of an artist—for 'being affected.'" Sitwell, *Left Hand Right Hand!* 95.

95. Edith Sitwell, *Taken Care Of: The Autobiography of Edith Sitwell* (New York: Atheneum, 1965), 48–49.

96. Sitwell, *Taken Care Of*, 35.

97. Referring to the female type popularized in the illustrations of George du Maurier, Osbert noted, "My father…only admired in a female small du-Maurier-like features." Sitwell, *Left Hand Right Hand!* 232.

98. Sitwell, *Left Hand Right Hand!* 232.

99. Sitwell, *Left Hand Right Hand!* 236–37.

100. Sitwell, *Left Hand Right Hand!* 237.

101. H. S., "Art. The Academy.—III," *Spectator* 86, no. 3804 (May 25, 1901), 768. The painting also received harsh comment in the *Athenaeum*: "In the *Sir Charles* [sic] *Sitwell and Family*…[Sargent] is scarcely fortunate. No doubt, in the rather sharp perspective of a group seen near at hand, the figures appear literally as they are rendered here, but the effect is to make the lady seem of monstrous proportions; nor is this mollified by the blank rigidity of her pose and the harsh illumination." "Fine Arts. The Royal Academy. First Notice," 117, no. 3837 (May 11, 1901), 601.

102. Sitwell, *Left Hand Right Hand!* 231: "That my father believed this painter to be a great artist at his greatest in no wise relieved him of his duty as patron, which was to offer an opinion upon every matter, whether of taste, of feeling or of technique, with an air of absolute and final authority, and to distract him by starting a new theory every instant, and then swiftly abandoning it or, alternatively, by suddenly behaving as though it were Sargent's theory and not his own at all, and by consequently opposing it with startling vigour just as the artist had agreed to accept it."

103. Sitwell, *Left Hand Right Hand!* 238.

104. "Fine Arts. The Royal Academy. First Notice," *Athenaeum* 117, no. 3837 (May 11, 1901), 601.

105. Sargent places a new emphasis on the mother-child relationship in the Grand Manner format; for example, the motif of a full-length standing female figure with a child is unknown in Reynolds's art. Sargent's placement of Maynard Greville on a pedestal may be a veiled visual pun referring to the countess's dedication to child welfare.

106. The family's considerable art collection grew especially during the lifetime of the second earl of Warwick, George Greville, who was a major patron of George Romney. Two works in the Greville collection—Romney's portrait *Henrietta, Countess of Warwick and Her Children* (Frick Collection, New York) and Van Dyck's *Paola Adorno Marchesa Brignole-Sale and Her Son* (National Gallery of Art, Washington, D.C.)—may have influenced Sargent in his conception of his 1905 portrait of the countess and Maynard. See David Buttery, "Portrait of a Lady," *Apollo*, August 1986, 104–9. I am grateful to Marcus P. M. Lynch, Head of Collections, Warwick Castle, for directing me to this and other information.

107. See her autobiography, *Life's Ebb and Flow* (London: Hutchinson & Co., 1929).

108. *Life's Ebb and Flow*, 227–28.

109. See Terence Pepper, *High Society Photographs, 1897–1914* (London: National Portrait Gallery, 1998), 48, where it is also noted that the countess's sister, Millicent, duchess of Sutherland (another Sargent sitter), was the first president of the Ladies' Automobile Club.

110. "The Royal Academy (First Article.)," *London Times*, April 29, 1905, 14.

111. N. N. [Elizabeth Pennell], "The Royal Academy and The New Gallery, London, April 29, 1905," *Nation* 80, no. 2082 (May 25, 1905), 411.

112. H. S., "Art. The Academy. II," *Spectator* 78, no. 3895 (May 22, 1897), 732.

113. "The Exhibition of the Royal Academy.—I," *Magazine of Art* 21 (1897), 58.

114. Martin Conway, "Country Homes—Gardens Old and New: Fairlawne—I. Near Tonbridge, Kent, the Seat of William Marshall Cazalet, J.P., D.L.," *Country Life* 44, no. 1124 (July 20, 1918), 55–56. The richly illustrated article traces the history of Fairlawne from the time of its construction during the reign of William and Mary to its relatively recent acquisition by the Cazalet family (William Cazalet's father had purchased it.)

115. Joshua Reynolds's *Captain Robert Orme* (National Gallery, London) has been cited as the compositional precedent for Sargent's portrait of William Marshall Cazalet. Andrew

Wilton, *The Swagger Portrait* (London: Tate Gallery, 1992), 200. Wilton also cites Thomas Gainsborough's *Mrs. Samuel Moody and Her Children* (Dulwich College Picture Gallery, London) as a possible source for the composition of *Mrs. Cazalet and Her Children*.

116. H. Hamilton Fyfe, "Mr. Sargent at the Royal Academy," *Nineteenth Century* 49 (June 1901), 1023.

117. "The Fine Arts—The Royal Academy. First Notice," *Athenaeum* 117, no. 3837 (May 11, 1901), 601.

118. "It is very wonderful, and perhaps no one else could have done it, but at the same time, it leaves one cold." H. S., "The Academy III," *Spectator* 86, no. 3804 (May 25, 1901), 768; "The Royal Academy," *London Times*, May 4, 1901, 13.

119. The critical reception accorded to Sargent's *Mrs. Edward Darley Boit* (1888, Museum of Fine Arts, Boston) provides a notable example of the perception of the smiling sitter as a sign of vulgarity. For a summary of the responses to the portrait, see Ormond and Kilmurray, *John Singer Sargent: The Early Portraits*, 207.

120. "The Fine Arts. Sargent Portraits at the Museum of Fine Arts," *Boston Evening Transcript*, June 12, 1903 (clipping from departmental files of the Museum of Fine Arts, Boston, kindly provided by Erica E. Hirshler).

121. "Sargent in Retrospect," *Boston Herald*, May 14, 1916 (clipping from departmental files of the Museum of Fine Arts, Boston, kindly provided by Erica E. Hirshler).

122. See Trevor J. Fairbrother, "Painting in Boston, 1870–1930," in *The Bostonians: Painters of an Elegant Age, 1870–1930* (Boston: Museum of Fine Arts, 1986), 66, in which he cites his conversation with Misses Aimée and Rosamond Lamb, who remembered Mrs. Warren's reaction to the painting.

123. The painting was exhibited frequently throughout the first quarter of the twentieth century. It was one of six paintings by Sargent shown at the 1912 Fourth Exhibition of American Paintings at the Corcoran Gallery of Art. Markedly overshadowed by *Portrait of Joseph Pulitzer* and *Nonchaloir*, the painting, when it was mentioned, was captioned simply as a "work of rare refinement and beauty" ("Art in Washington," *New York Globe and Commercial Advertiser*, December 19, 1912); or, in one instance, deemed "typical of the decadence of his style, and is an unfortunate selection for [the] present exhibition" (Helen W. Henderson, "The Fourth Exhibition of the Corcoran Gallery," *Arts and Decoration* 3, no. 4 [February 1913], 117). When the portrait was shown at the 1924 Sargent retrospective at New York's Grand Central Art Galleries, the reviewer Rose V. S. Berry obliquely alluded to the problematic psychologies of the sitters: "In the treatment of Mrs. Fiske Warren and Daughter there is something new to consider. . . . Many find the portrait pleasing, even though they do not know what the artist has achieved for them." "John Singer Sargent: Some of His American Work," *Art & Archaeology* 18 (September 1924), 103.

124. William Howe Downes, "Mr. Sargent's Paintings," *Boston Evening Transcript*, May 10, 1916, sec. 2, 12.

125. The painting files at the Manchester City Art Gallery contain correspondence of December 29, 1950, from David McKibbin in which this quote is provided and cited from a letter from Sargent dated May 31, 1918.

126. Ailsa Duxbury Holden's account of her experience as Sargent's last child model for a commissioned portrait provides one of the most detailed impressions of sitting for Sargent as a child, from notes compiled by Mrs. Ailsa Holden (née Duxbury), reproduced by kind permission of her niece, Mrs. Honor Lewis.

The Portrait was originally to be of Mrs. Duxbury alone and Sargent posed her sitting at first. He did not like it and then he posed her standing, but did not like that either saying she looked "lonely."

He asked if she had any children and as my Brother was at school I was brought into the picture. I seem to remember he began and painted us with me standing in a brown velvet dress and once again he did not like it. We went back home to Lancashire for a while, possibly because he had certain other commitments.

When we next came to London, my Mother had bought me two special new dresses for him to choose from. By this time I knew him and on arrival at the studio came running in to greet him wearing the grey squirrel coat and hat now seen in the finished portrait. He immediately said "I will paint her in that" and although we tried on the dresses, he did not change his mind.

I recall that he said:

"Of course, people will say 'What a peculiar idea, the mother in evening dress and the child in a fur coat', but I like to think that you were ready to go out to a dinner party and your daughter, coming in from her walk, runs up to greet you."

Mrs. Duxbury's dress was an "old one", but the one she had worn when she had first met Sargent at dinner with my Father and Sir Alex Martin. Sargent asked her if she still had it (just as well I was asked into the picture as it was a tedious job to do up all the little hooks and eyes at the back of the dress!). During the painting, Sargent draped a piece of gold flimsy material over her left shoulder which gives the soft appearance at that side.

Two not very important recollections were that I had a loose tooth which I fidgeted with my tongue pursing up my mouth (which is small anyway) and he threatened to paint it so if I did not stop. Well, perhaps he did. It was Spring as the portrait was finished and I complained of being hot in my fur coat. Sargent suggested that I went to the dressing room and removed my frock and replaced the coat. This I did and on my return he enquired if it was better that way adding "You see I am not such a fool as I look" to which I replied after due consideration "No" and this quite amused him.

Biographical Index of Child Sitters

This index provides biographical data about Sargent's child sitters whose portraits are reproduced in this volume. Although valuable information is given in the two published volumes of the John Singer Sargent catalogue raisonné, most of it concerns the children's parentage and not what became of them in later life. Much of the new information presented here is gleaned from a wide variety of newspaper and archival sources, the citations for which are now available in the files of the Department of American Art, Brooklyn Museum.

BACON. Ruth Sears Bacon (1884–1987) was one of four daughters of the New York surgeon Dr. Gorham Bacon and his wife, the former Elisabeth Simpkins. She was educated at Miss Porter's School in Farmington, Connecticut, where one of her classmates was Ruth Cheney, through whom she met her future husband, Austin Cheney (1876–1948). Austin Cheney was a son of one of the founders of Cheney Brothers, the internationally known silk factory based in South Manchester, Connecticut. They married in 1903. The couple resided with their four daughters in one of the Cheney family mansions on Hartford Road in Manchester. Both Ruth and Austin Cheney were active in local charitable organizations. Her death in 1987 marked the end of her generation of the Cheney family dynasty. Photographs of her as an adult reveal that Sargent's portrait of her not only captured a physical likeness but also transmitted the spirited nature that seemed to be hers throughout life.

BARNARD. Marion "Polly" (1874–1946) and Dorothy "Dolly" (1878–1949) Barnard were the daughters of the English painter-illustrator Frederick Barnard (1846–1896). The Barnard family was an integral part of the Broadway colony, with their place in the community memorably documented in the girls' posing for *Carnation, Lily, Lily, Rose*. Frederick Barnard had an emotional breakdown about 1894, precipitated perhaps by the combination of grief over his son Geoffrey's death (1871–1892) and alcoholism. Surviving letters mentioning him and his family suggest that his wife (the former Alice Faraday) and daughters increasingly relied on friends for physical and emotional sustenance. When Frederick Barnard died in a fire in 1896, Alice Barnard and her daughters remained within Sargent's circle of intimates, traveling frequently with and modeling for him. Polly and Dolly never married; they and their mother were beneficiaries under Sargent's will.

BERTAGNA. According to the best available information, Carmela Bertagna was a professional model of presumably Spanish (but more likely Italian) origin. She may have lived at 16, rue du Maine, Paris, the address inscribed on Sargent's portrait of her of about 1880 (pl. 78). Physical resemblance encourages the conclusion that she was also the model for *A Parisian Beggar Girl* (pl. 79) and William Stott's *Wild Flower* (fig. 82).

BESNARD. Robert Besnard (1881/82–1914) was the eldest of the four children of the French painter Albert Besnard (1849–1934) and his wife, the sculptor Charlotte-Gabrielle Dubray (b. 1855). According to Albert Besnard's 1928 letter to Armand Dayot published in *L'Actualité, The Birthday Party* was painted in 1885 in the Besnards' Paris home on rue Guillaume-Tell, but there is some doubt as to the accuracy of Besnard's dating. Robert was the third generation of Besnards who were professional artists. He studied painting and printmaking with his father and exhibited at the Société nationale des beaux-arts (of which he was an associate member) from 1901 to 1914 and also at the 1913 Salon d'Automne. He was killed in the fighting of World War I.

BOIT. Florence (1868–1919), Jane (1870–1955), Mary Louisa (1874–1945), and Julia (1878–1969) Boit were the daughters of the wealthy Bostonians Edward Darley Boit (1840–1915) and his first wife, the former Mary Louisa Cushing (1846–1898). Edward Boit set aside law to study art in Paris, where it is likely he met Sargent in the early 1880s. The family's movements were governed by Boit's pursuit of a career as a painter, and they lived a privileged cosmopolitan existence in both Boston and Paris. The girls never married, and all four are reported to have been either mentally or emotionally unstable in adulthood.

BURCH. Caroline (Cara) Van Cott Burch (1878–1961) was the only child of the lawyer and newspaper editor Robert Burch (1832–1895) and the former Lizette Montmollin. Over the course of his career, Burch held positions at the *New York Evening Post* and the *Brooklyn Daily Eagle*. Although Lizette Burch had reportedly met Sargent in Florence, the commission for her daughter's portrait was probably arranged through the child's maternal aunt, Caroline Montmollin, the wife of Sargent's uncle, Dr. Gorham Parsons Sargent. Both Sargent and Cara were said to have been frequent visitors to their shared aunt's home, in Bryn Mawr, Pennsylvania. The Burch family lived at 281 Henry Street in Brooklyn Heights, Brooklyn, New York. By 1893 society columns in the *Brooklyn Daily Eagle* listed Cara as a member of the "younger heights set" (referring to Brooklyn Heights), a designation for "those that are not out in society yet, but almost on the verge." Her name appeared in the paper frequently beginning in the mid-1880s, when she was listed as a donor to the Seaside Home for Children, Coney

Island (through the Sunday school class at Brooklyn's Church of the Pilgrims). She was an associate member of the Asacog Club (a Brooklyn association formed to aid "all sorts and conditions of girls"). In a letter to David McKibbin written in 1958, she stated that her family did not consider the portrait to be a good likeness and that she sold it in 1942 to purchase a house on Mount Desert Island. Cara Burch never married; she later lived in Manhattan and was reportedly a pianist of some ability.

CAZALET. Edward (1894–1916) and Victor Alexander (1896–1943) Cazalet were two of the four children of William Marshall Cazalet and his wife, Maude Lucia, a daughter of Sir John Heron-Maxwell. Edward Cazalet was a lieutenant in the Welsh Guards and died in action in 1916. Victor was a Unionist member of Parliament for Chippenham beginning in 1924. In 1940 he was appointed liaison officer attached to General Wladyslaw Sikorski, Polish prime minister and commander in chief, with whom he died in a 1943 helicopter crash shortly after taking off from Gibraltar. At the time of his death he held the rank of lieutenant colonel. His obituaries noted that he was a fine squash player, reporting that he won the national amateur championship four times.

CÉVRIEUX. Robert de Cévrieux (b. 1872?). Nothing is known of the French sitter Robert de Cévrieux (or Civrieux) except that he sold the Sargent portrait of him to Knoedler & Co. in 1921.

CRAM. Charlotte Agatha Winthrop Cram (1894–1970) was born in England to American parents, Harry Spencer Cram and Charlotte Troup Bronson Winthrop, who had married in 1892. Her mother died two weeks after her birth, and her father, who contracted tuberculosis, died in 1895 in Egypt, where he was convalescing. Her upbringing was undertaken by her grandparents, Mr. and Mrs. Henry Augustus Cram and Mr. and Mrs. Egerton Leigh Winthrop, and various aunts and uncles. Sargent also painted the portraits of both of her grandfathers (Henry Augustus Cram's in 1893 and Egerton Leigh Winthrop's in 1901). Charlotte Cram was raised with her younger cousin, KATE HAVEN (pl. 62), whose portrait Sargent painted in 1903. The two cousins remained close throughout their lives, often speaking on the telephone several times a day. (Charlotte's father was a brother of Kate Haven's mother, Henriette Cram.) Charlotte married Robert Ludlow Fowler Jr. about 1915. The couple first lived at 28 East Seventy-fifth Street, New York, and later resided in Katonah, New York. Robert Fowler, a 1910 graduate of Columbia, subsequently attended the Harvard School of Landscape Architecture and opened a business in New York. They had three children.

DAVIS. Livingston Davis (1882–1932) was the only son of the prominent Worcester, Massachusetts, couple Edward L. and Maria Louisa Robbins Davis. Edward Davis was associated with the Washburn Iron Company of Worcester and was active in politics, serving as mayor of Worcester and as state senator. The double portrait of Livingston Davis and his mother was painted in the stable on the Davises' Worcester property. Remembered as a "delicate" child in his early years, Livingston Davis attended All Saints' School in Worcester and the Noble and Greenough School before going to Harvard, from which he graduated in 1904. He served as assistant secretary to Franklin D. Roosevelt (the assistant secretary of the Navy) during World War I and was later in charge of the Adriatic Division of the American Relief Administration under Herbert Hoover. His first marriage ended in divorce. A second marriage is recorded in 1927 to Georgia Appleton, the daughter of Daniel Appleton, once head of the London branch of D. Appleton & Sons, Publishers. At the time of his death Davis was Belgian consul in Boston. His death, judged a suicide, was the result of a gunshot wound. Although he left no note, he was believed to have been despondent over recent ill health. He was survived by his widow and an adopted son, James Davis, a student at St. Paul's School, Concord.

DUXBURY. Ailsa Marian Holden (née Duxbury; 1913–2000) was the daughter of Percival Duxbury of Bury. Described as a bookworm, she was also a physically active child, said by her niece to have enjoyed kicking balls with her brother Gordon. Although she aspired to become a doctor, she was discouraged by her "Victorian" father. She was educated in Paris. At the outset of World War II she became a nurse and later developed a specialty in radiography, for which she won prizes. She married and had no children.

FAIRCHILD. Gordon Fairchild (1882–1932) was the youngest of eight children in the family of the Bostonians Charles and Elizabeth Nelson Fairchild. Charles Fairchild was Sargent's financial adviser with whom he frequently stayed while in the United States. Gordon Fairchild attended the Volkman School, graduated from Harvard in 1904, and immediately went to law school, graduating in 1907. After practicing law briefly in Boston, he went to the Philippines with the Honorable W. Cameron Forbes, governor general of the Philippines. He practiced law in the Philippines for approximately nine years. In 1915 he took a position as a master at St. Paul's School, Concord, Massachusetts, where he taught Spanish and Latin until 1929, when he went into business in Boston with the firm of Hutchins & Parkinson. During World War I he worked in the intelligence service. He died at sea on the steamer San Bruno in 1932, while returning from a trip to Honduras, where it is believed he was studying tropical plants. Newspaper accounts mention his premonition of death and instructions for burial at sea. He was survived by his sister, Sally Fairchild (with whom he lived at 241 Beacon Street) and several nephews.

FERRARA (or FERRARO). Rosa Ferraro (1860?–1928) was the daughter of Bartolomeo Ferraro of Capri. Rosa was often referred to as "Rosina" by the many painters for whom she modeled during their visits to the island. She married the American artist George Randolph Barse (1861–1938) in Rome in 1891 and lived with him in Katonah, New York. Later in life Barse

adopted her niece, Maria Primavera, the wife of Pompeius Michael Bernardo (Maria was possibly the illegitimate child Rosa was rumored to have had in her youth).

FORBES. Gerrit (1880–1964) and Henry (1882–1968) Forbes were sons of the sailing and horse racing enthusiast J. Malcolm Forbes and his wife, the former Sarah Jones. Raised in Milton, Massachusetts, the boys attended Milton Academy. Gerrit graduated from Harvard in 1904 and while still an undergraduate sailed around Cape Horn to Hong Kong on the four-masted square rigger *Atlas*. This excursion was the first in a life marked by adventure. In 1907 he embarked on a career as a big game hunter, exploring previously unvisited areas of Africa. Theodore Roosevelt remarked that Gerrit Forbes was the only man he considered a better hunter than himself. He fought with Pancho Villa in 1911; joined the Royal Flying Corps in 1914; and later served in the Royal Air Force. In 1916 he was in Africa on a special mission for the British War Office. He is also credited with developing specialized vehicles for travel in desert and jungle areas. When the United States entered the war he joined the Signal Corps and was commissioned a captain in 1917. He remained active in his old age, shooting his last elephant when he was eighty. Unlike his brother, Henry Forbes lived a relatively quiet life in his native Milton. After receiving his B.A. from Harvard in 1905, he entered the university's medical school and received his M.D. in 1911. He was based in Serbia as a Red Cross physician during World War I and was later stationed in a French hospital. He married the former Hildegard Cobb, with whom he had four daughters. Most of his professional life was spent researching anoxia (the depletion of the oxygen supply to the brain and circulatory system). After retiring in 1942 from the research faculty at Harvard University Medical School, he became active in the Association of Indian Affairs, for which he was the chairman of the Alaska Committee. He traveled a number of times to Alaska, where he was instrumental in establishing the *Tundra Times*, the first Eskimo newspaper.

GOELET. Beatrice Goelet (1885–1902) was the only daughter of the New York real estate magnate Robert Goelet and his wife, Harriet Louise Warren Goelet, a talented amateur painter who briefly occupied a studio in Stanford White's Madison Square Garden tower. Sargent was probably introduced to the Goelets through White, Augustus Saint-Gaudens, or Thomas Wilmer Dewing, the latter of whom had painted a portrait of Beatrice's brother in 1886. Reported to have had generally fragile health over her short lifetime, Beatrice Goelet died suddenly of pneumonia contracted as a complication of the measles. At the time of her death, her family was emerging from mourning her father, who had died in 1899, leaving her one of the wealthiest heiresses in the nation.

GOODRICH. Caspar Goodrich (1881–1907) was the son of Rear Admiral Caspar Goodrich and his wife, Eleanor Milnor, with whom Sargent stayed at Newport, Rhode Island, in the fall of 1887. He served in the United States Navy and was killed in an explosion on board the USS *Georgia*.

GOSSE. Emily Teresa "Tessa" Gosse (1877–1951) was the daughter of the literary critic Edmund Gosse (1849–1928), a frequent visitor at Broadway, where Sargent painted her portrait during the summer of 1885. She attended Newnham College, Cambridge, and later received a degree in psychology from Bedford College, London.

GREVILLE. Maynard Greville (1898–1960) was one of the five children and the youngest of the three sons of Frances Evelyn "Daisy," countess of Warwick (1861–1938), and Francis Richard Charles Guy Greville, Lord Brooke, who became fifth earl of Warwick in 1893 (d. 1928). Maynard Greville served as a lieutenant in the Royal Air Force during World War I. He married Dora Pape, of Moor Hall, Sussex, in 1918 and with her had a son and two daughters. As a young man he was a correspondent specializing in motoring and country life topics for weekly magazines and newspapers. After inheriting Easton Lodge and its extensive gardens (near Dunmow, Essex) from his mother, he focused on botany, and he developed a reputation as one of England's most learned amateur horticulturalists, a hobby, as he stated, that entailed "listing and measuring every remarkable or unusual tree in these islands [Great Britain]" (Maynard Greville, "Trees in London," letter to the editor, *London Times*, May 7, 1957, 11). In 1950, after the British army relinquished its wartime use of the Easton Lodge property, Greville began to design and plant an arboretum to revitalize the land, which had been radically altered during World War II when the United States Air Force destroyed 10,000 trees in the making of runways. On February 25, 1960, the *London Times* printed an obituary mourning the passing of a "true English eccentric." The writer stated that Greville had fallen to his death from one of the trees on his own property. A month later an Inquest Verdict officially recorded his death a suicide; he died in hospital on February 22, five days after being admitted with a knife wound.

GUEST. Winston Frederick Churchill Guest (1906?–1982) was born in England, the son of the former Amy Phipps and Frederick E. Guest. His American mother was a daughter of the philanthropist Henry Phipps, a partner of Andrew Carnegie. (It is Mrs. Henry Phipps who holds young Frederick in the portrait by Sargent [pl. 48].) Frederick Guest was a first cousin of Winston Churchill (who was Winston Guest's godfather and with whom he shared descent from the first duke of Marlborough). Winston Guest graduated from Yale University in 1927 and from Columbia University School of Law in 1932. His 1934 marriage to Helena Woolworth McCann (granddaughter of F. W. Woolworth), with whom he had four children, ended in divorce. He later married Lucy (C. Z.) Cochrane in 1947. Frederick Guest ran unsuccessfully in 1936 in New York for the United States Senate on the Republican ticket, at which time his American citizenship was challenged by the Democrats. His right to United States citizenship was subsequently confirmed through

a lawsuit. He was noted internationally as a champion polo-player during the 1930s and maintained the Templeton racing stables at his estate in Old Westbury, Long Island, New York.

HARRISON. E. Cecil Harrison (1878–1915) was the son of Sargent's friends Robert and Helen Harrison, who lived at Shiplake Court, Henley-on-Thames, England. He married in 1912 and died in the action of World War I while serving as a major in the army.

HAVEN. Katharine "Kate" Sergeant Haven (1898–1974) was the daughter of J. Woodward Haven and his wife, the former Henriette Cram. The family lived in New York, keeping a summer home—Howland's—at Newport, Rhode Island. She was raised with her orphaned cousin, CHARLOTTE CRAM, whose portrait Sargent also painted (pl. 61). She married Johnston L. Redmond of New York City and had four children and seventeen grand-children. During the Depression she was chairman of the Adopt-a-Family Committee, organized under the Emergency Unemployment Relief Committee, to aid unemployed "white collar" families.

HILL. Frances Winifred Pedley, née Hill (1891–1991), was the granddaughter of John Maddocks, a collector of contemporary English art. His money derived from business concerns in or near Bradford, England. Sargent's portrait of Frances was owned and likely commissioned by Maddocks, as it was included in the 1910 sale of his collection.

KEITH. Skene Keith (1888–1966) was the son of Dr. Thomas Skene Keith and his wife, the former Laetitia Parsons. The portrait, painted in Sargent's London studio, probably came about as a result of Sargent's close friendship with Alfred Parsons, who was related to the boy's mother.

KIEFFER. Jeanne Kieffer (1872–1923) was the daughter of Eugène Kieffer. She and her brother, René (1870–1940), were born and raised in Paris. Sargent reportedly received the commission to paint her portrait and the companion portrait of her brother (private collection) through their mother's cousin, the painter Louis de Camus. Jeanne Kieffer married Edouard de Valcourt about 1896; the couple had two daughters.

KNOWLES. John Buchanan (1895–1936) and Richard Arthur Lees (c. 1897–1918) Knowles were the sons of the wealthy industrialist and horse breeder Arthur Knowles (c. 1858–1929) and his wife, the former Clare Mildred Buchanan (1870–1913), the youngest daughter of Captain John Maxey Buchanan of Shropshire. The boys were raised at Alvaston Hall (originally called the Grove), a large property in Nantwich, Cheshire, purchased by Arthur Knowles in 1896, which was extensively remodeled by the architect Edward Salamons in an eclectic country house style. (The house is now a hotel.) The family also had a London residence. Mrs. Knowles, who died of ptomaine poisoning at the age of forty-two, was remembered for her work for the National Society for the Prevention of Cruelty to Children (she was the

honorary secretary of the society's branch association in South Cheshire) and for her performances in local amateur theatricals for charitable causes. Richard Arthur Lees Knowles was educated at Stanmore Park and Eton. He was mortally wounded at the Salonika front, while serving as a lieutenant in the King's Royal Corps. John Buchanan Knowles served as a lieutenant with the Royal Fusiliers during World War I and was discharged after being wounded. He never married and died of a self-inflicted gunshot wound at the age of forty.

LISTER. Laura Lister, later Lady Lovat (1892–1965), was the daughter of the fourth baron Ribblesdale (whose portrait Sargent painted in 1902) and Charlotte Monkton Tennant, the daughter of Sir Charles Tennant. In a reminiscence published in the *London Times* and written by her friend Sir Compton Mackenzie, she was described as "one of the few exquisite figures left of the 'Great War for Civilisation.' " Sir Compton noted that she had taken on the role of hostess for her father before she was seventeen and was "a few months later married to Lord Lovat who at the age of 40 had fallen in love with her at first sight." The couple were married from 10 Downing Street in a ceremony arranged by the bride's aunt, Margot Asquith (wife of Britain's prime minister).

McCULLOCH. Alexander McCulloch (1887–1951) was the son of the Glasgow-born George McCulloch, a noted collector of contemporary art who had made his fortune through the Broken Hill Mines in Australia before settling in London in 1892. Alexander McCulloch was educated at Winchester and Oxford, where he gained a reputation as a prizewinning sportsman with a special talent for rowing. He married Lesley Cecil-Wright in 1907, and the couple had two children, a son and a daughter. Although he made his living as joint managing director of the Tubex Engineering Company, McCulloch maintained a high profile in amateur sports, serving as a second-string representative for England at the Olympic Games in Stockholm. As an adult he would occasionally return to the same fishing waters in Norway where Sargent portrayed him in his 1901 portrait.

MACMILLAN. Daniel de Mendi Macmillan (1886–1965) was the eldest of the three sons of Maurice Crawford Macmillan and his American wife, Helen Tarleton Belles. Most biographical accounts of the family describe his mother "Nellie" as controlling and ambitious for her boys. Daniel and Arthur (who became a solicitor) reportedly disappointed her, for their personalities did not conform to her visions for their futures. She considered her greatest success to have been the career of the youngest child, Harold, who became prime minister of England. Educated at Eton and Balliol College, Oxford, Daniel Macmillan was a brilliant classics scholar. His student years and early manhood were characterized as filled with "desperate dissipation, drinking, chasing women and sitting up late to play poker for high stakes with young blades like Duff Cooper and Alan Lascelles" (Richard Davenport-Hines, *The Macmillans* [London: Heinemann, 1992], 131). He joined the army in 1914

and, after suffering a wound in 1915, served in the admiralty from 1916 to 1919. Daniel Macmillan entered the family publishing business, Macmillan & Company, serving as chairman for many years. His friend EDITH SITWELL described him in later life as a reserved character "whose temper… needs a little sugar adding."

MARLBOROUGH (see SPENCER-CHURCHILL).

MEYER. Elsie Charlotte Meyer (1885–1954) was the daughter of the banker Carl Ferdinand Meyer (1851–1922), who represented the Rothschilds and was chairman of De Beers, and his wife, the former Adèle Levis (c. 1861–1930) (see below). She married St. John Murray Lambert in 1909 and was widowed in 1926. In 1927 she married Captain Harry Hulbert, O.B.E., of Box Farm, Bracknell, Hertfordshire.

MEYER. Frank Cecil Meyer (1886–1935) was the son of the banker Carl Ferdinand Meyer and his wife, the former Adèle Levis (c. 1861–1930). Carl Meyer became a naturalized British citizen in 1877 and was made baronet in 1910. In addition to his banking activities, Carl Meyer was especially involved in providing substantial financial support toward the founding of the Shakespeare Memorial Theatre. He was also one of the lieutenants for the City of London. Adèle Meyer was a popular and vivacious London hostess whose patronage extended to music, theater, and art. Frank Meyer's early schooling at Eton was followed by study at New College, Oxford, from which he graduated with a degree in modern history in 1908. At school he was noted as a good host and fine rider, and as having refined musical and artistic tastes. He became a lawyer in 1910 but never practiced law seriously. During World War I he served with the Essex Yeomanry and Signal Corps. He was Conservative Member of Parliament for Great Yarmouth from 1924 to 1929, when he lost his seat. He stood as candidate for Blackpool in 1931 but withdrew from campaigning when he was appointed deputy chairman of De Beers Consolidated Mines. His business interests also included chairmanships of Diamond Corporation, Gold Coast Banket Areas, and Rivoli Cinemas. He married Georgina, daughter of Frederick Seeley of Hale, Cheshire. The couple lived at Ayot House, Ayot St. Lawrence, Hertfordshire. Their only son, Anthony John, succeeded to the baronetcy in 1935, on Sir Frank Cecil Meyer's death from injuries sustained in a riding accident.

MILLET. John Alfred Parsons Millet (1888–1976) was Sargent's godson and the youngest child of the artist's close friends the American painter Frank Millet and his wife, Lily (Elizabeth Merrill). He was born at Broadway, educated at Marlborough College, England, and Harvard University, where he received his medical degree in 1914. John A. P. Millet had a distinguished career with specialties in psychiatry and psychoanalysis; he practiced in New York City and resided in Nyack, New York. He was a member of numerous professional associations and served for a time as chairman of the executive committee of the World Federation for Mental Health. His first marriage to Alice

Murrell (1913) ended in divorce. He married Carmen deGonzalo Manice in 1914.

MILLET. Katherine "Kate" Francesca Millet (1880–1958) was the daughter of the American painter Frank Millet and his wife, Lily (Elizabeth Merrill), and the sister of LAURENCE and JOHN ALFRED PARSONS MILLET. She married the Gloucestershire paper mill owner Francis W. Adlard.

MILLET. Laurence Frederick Millet (1884–1945) was the son of the American painter Frank Millet and his wife, Lily (Elizabeth Merrill), and the brother of KATE and JOHN ALFRED PARSONS MILLET. He graduated from Oxford in 1907, received a law degree from Harvard in 1910, and practiced law in New York City. He married the New Yorker Eugenie Bissell in 1915.

ORMOND. (Henri Eric) Conrad ORMOND (1898–1979) was one of the six children of VIOLET SARGENT ORMOND and a nephew of the artist. He married Dorothea Charlotte Gibbons in 1934. The couple had three sons and a daughter.

ORMOND. Reine Violet Ormond (1897–1971) was one of the six children of VIOLET SARGENT ORMOND and a niece of the artist. She studied art at the Slade School, London, before marrying Hugo Pitman in 1924. The couple had two daughters.

ORMOND. Rose-Marie Ormond (1893–1918) was one of the six children of VIOLET SARGENT ORMOND and a niece of the artist. She married Robert André Michel, who died in the early fighting of World War I (1914). Rose-Marie, who was a nurse, was killed in Paris in 1918, when a German bomb hit the Church of Saint-Gervais, where she was attending a concert.

PAILLERON. Edouard Pailleron Jr. (b. 1865) was the son of the French poet-playwright-critic Edouard Pailleron and his wife, the former Marie Buloz (see below). To date no facts have been discovered to enhance this sparse biographical entry.

PAILLERON. Marie-Louise Pailleron (1870–1950) was the daughter of the French poet-playwright-critic Edouard Pailleron (1834–1899) and his wife, the former Marie Buloz (1840–1913). She continued the family tradition, writing novels as well as essays about French literary history and criticism. She was made chevalier of the Legion of Honor, was a member of the Society of the Men of Letters, and served as vice president of the Chateaubriand Society.

PALMER. Elsie Palmer (1872–1954) was one of the three daughters of the railroad developer General William Jackson Palmer (a founder of Colorado Springs) and his wife, Mary Lincoln "Queen" Mellen. Part of Henry James's circle of friends, the Palmers spent considerable time in England starting in 1887, when they leased Ightham Mote House near Sevenoaks in Kent (where Sargent began Elsie's portrait in 1889). Elsie Palmer married the English novelist Leopold Hamilton Myers (1881–1944) in 1908. The two had met seven years before when Myers and his father were touring the United States. Myers, who was

instantly smitten with Elsie, immediately proposed marriage. Nine years his senior, she eventually accepted him in 1908. After spending a year or so in Denver, the couple moved to England. Myers, who was prone to melancholia, committed suicide in 1944, survived by Elsie and their two daughters.

POIRSON. Suzanne Poirson (1871–1926) was the daughter of Paul Poirson, brother of the painter Maurice Poirson, and Seymourina Cuthbertson, the illegitimate daughter of the fourth marquess of Hartford, and Madame Oger. According to unconfirmed anecdote, the portrait was painted in exchange for rent on Sargent's 41, boulevard Berthier studio that Paul Poirson owned. Suzanne Poirson was the godchild of Richard Wallace, whose famed art collection (The Wallace Collection, London) was left to the nation by his widow in 1897. She married Pierre Giroud, in 1891, and had a daughter, Jacqueline. Family history indicates that Suzanne's 1926 death resulted from an illness contracted shortly after World War I. The Girouds were central figures in French artistic, literary, and diplomatic circles, and Suzanne Poirson Giroud was the subject of portraits by Jacques-Emile Blanche and Marie Laurencin. Sargent's 1885 portrait of her mother is in the collection of the Detroit Institute of Arts.

PRATT. Katharine Chase Pratt (1875–1942) was the daughter of Frederick Sumner Pratt (1845–1924), owner-director of Sumner Pratt & Co., makers of cotton and woolen mill machinery and supplies in Worcester, Massachusetts. Sargent met Pratt in 1890, while in Worcester executing other commissions. An avid supporter of the arts, Pratt engaged Sargent to paint his daughter. The sittings resulted in the one reproduced in this volume (pl. 33) and another that is unfinished and now in the collection of the Worcester Art Museum. Katharine Chase Pratt married a young doctor, Alfred L. Shapleigh, in 1896, and the two immediately went to China as Christian missionaries, staying there until 1897. In 1904 they returned to China, taking with them their two young sons. Alfred Shapleigh and the boys died in China; Katharine stayed on until 1907. She returned for two extended periods, 1910 to 1920 and 1925 to 1929.

RICHARDSON. Olivia Alger Richardson (1866–1956) was the daughter of an American couple, Thomas Francis Richardson and his wife, Ellen Phelps. The portrait, a gift to the girl's mother, was painted on one of Sargent's visits to his family in Nice (where the Richardsons lived near his parents). In 1893 Olivia Richardson married Dr. Charles James White, who had just received his medical degree from Harvard. The couple spent the next two years in Europe while White did his graduate work in dermatology and pathology in Vienna and Paris. On their return to America, White continued his affiliation with Harvard (where he was appointed chief of the Dermatology Service in 1925), and they established domestic life in Boston's Back Bay area, where they raised their three children, James Clark (b. 1895), Ellen Phelps (b. 1903), and Richardson (b. 1904). The family usually summered at Cohasset, Massachusetts.

SAINT-GAUDENS. Homer Schiff Saint-Gaudens (1880–1958) was the son of the sculptor Augustus Saint-Gaudens and his wife, the former Augusta Frederika Homer. Homer Saint-Gaudens was born in Roxbury, Massachusetts, and spent a good portion of his youth in Europe. After receiving his preparatory education at the Lawrenceville School (in New Jersey) and at the Cardwell School, in Paris, he entered Harvard University, graduating in 1903. He immediately began a career as a reporter, working for the New York Sun and soon after became associate editor of the Critic and then the Metropolitan Magazine, developing a specialty in art criticism and also contributing short stories to a variety of periodicals. His interest in theater led him to acting and stage design. From 1908 to 1916 he was stage director for the famed actress Maude Adams. In 1920 he designed the stage set for Beyond the Horizon, Eugene O'Neill's first full-length play. In 1921 he became assistant director of the fine arts at the Carnegie Institute and was appointed director the following year (a position he held until he retired as director emeritus in 1950). A noted lecturer on the arts, he also wrote two memorable books, The Reminiscences of Augustus Saint-Gaudens (1913) and The American Artist and His Times (1941). Saint-Gaudens fought in World War I and, after being wounded in action, was discharged in 1919. He was a specialist in military camouflage techniques and lectured on the subject between the two world wars. He held the post of chief of the camouflage section for the chief engineer in the European Theater of Operations during World War II. He received numerous military orders of merit. In 1905 he married Carlota Colley of Nassau, Bahamas (d. 1927), with whom he had three children. He married Mary Louise McBride of Pittsburgh in 1929.

SARGENT. Violet Sargent Ormond (1870–1955) was the younger of Sargent's two surviving sisters and one of his favorite models. She married Louis Francis Ormond in 1891; the couple had six children including ROSE-MARIE, REINE, and CONRAD.

SEARS. Helen Sears (1889–1966) was the daughter of the Bostonians Joshua Montgomery Sears (a businessman of considerable inherited wealth) and his wife, Sarah Choate Sears (a talented professional artist). Serious art patrons, the couple extended support and friendship to Mary Cassatt, John La Farge, Abbott Thayer, and Sargent, among others. Helen Sears modeled frequently for her mother. She married James Donald Cameron Bradley in 1913. The couple had two sons, Cameron and Montgomery, and had a permanent residence on Arlington Street, Boston, and a country home in Southboro, Massachusetts. James Bradley, a 1906 graduate of Harvard, and director of the New England Trust Company of Boston, died in 1928 after a long illness at the age of forty-five. Helen Sears Bradley never remarried; she died unexpectedly while traveling in the West Indies.

SHEPARD. Alice Vanderbilt Shepard (1874–1950) was the daughter of the conservative New York attorney and owner of the New York Mail and Express, Elliott Fitch Shepard. Her mother, Margaret Vanderbilt, was the daughter of the wealthy

industrialist William Vanderbilt and the granddaughter of Commodore Vanderbilt. Alice Shepard married Dave Hennen Morris in 1895 in what the press called a "runaway match," so-named because the couple wed without permission of the bride's family, reportedly because the groom's family background included the unsuitable pursuits of horse racing and gambling. However, Alice and her family reconciled soon after her marriage. Alice Morris attended classes at Radcliffe while her husband completed courses at Harvard. Dave Morris was later appointed ambassador to Belgium and Luxembourg. Alice balanced domestic and social duties with intense interest in language studies, particularly Esperanto. She was a founder of the International Auxiliary Language Association. The couple had six children.

SITWELL. Edith Sitwell (1887–1964), the noted poet and critic, was the eldest of the three children of the antiquarian Sir George Reresby Sitwell and his wife, Lady Ida Emily Augusta Denison, daughter of the first earl of Londesborough. She and her brothers, OSBERT and SACHEVERELL, constituted a formidable triad of literary genius throughout the first half of the twentieth century. Known for her virtuoso command of language and expert handling of varied literary styles, she was equally admired as a remarkable figure of eccentric fashion and flashing conversational wit. Her magnetic personality and unique modes of dress put her in great demand as a subject for photographers and painters. She received numerous honorary doctorates in literature (from Oxford, Leeds, Durham, and Sheffield). Appointed Dame of the British Empire in 1954, she became a Companion of Literature in 1963. Like that of her brothers, much of her writing was autobiographical in nature.

SITWELL. Sir Francis Osbert Sacheverell Sitwell, fifth baronet (1892–1969), was the elder son and second of three children of Sir George Reresby Sitwell and his wife, Lady Ida Emily Augusta Denison, daughter of the first earl of Londesborough. He attended Eton (1906–9) and, after purposely failing his entrance exams to Sandhurst, was commissioned in the Sherwood Rangers (1911). He transferred to the Grenadier Guards (Special Reserve) in 1912 and was mobilized during World War I. He left the army in 1919 and settled at 2 Carlyle Square, London, where he maintained residence for most of his life. He also had great affection for the medieval castle Montegufoni, near Florence, that his father purchased in 1909 and subsequently restored. A talented writer of poetry, satirical and travel essays, and novels, Osbert Sitwell conjured in his writings the distinct aura of the social and intellectual mood of his times. Like his siblings, he had little patience for what he considered the conventional and philistine. He received honorary degrees from St. Andrews and Sheffield and was a trustee of the Tate Gallery from 1951 to 1958. He suffered from Parkinson's disease late in life. He succeeded to the baronetcy in 1943.

SITWELL. Sacheverell Sitwell (1897–1988) was the youngest of the three children of the antiquarian Sir George Reresby Sitwell and his wife, Lady Ida Emily Augusta Denison, daughter of the first earl of Londesborough. He and his two siblings, EDITH and OSBERT, were raised mainly at the family home, Renishaw Hall, Derbyshire. Educated at Eton, he left in 1915 to become an ensign in the Grenadier Guards. He was stationed at Aldershot barracks during World War I, kept from fighting because of his weak heart. After the war, he entered Balliol College, Oxford, but soon left to live with OSBERT in London, where they became central figures in avant-garde artistic and intellectual milieus. Even before that, he had published a volume of poetry (*The People's Palace*, 1918), the first of a long line of publications that testified to his wide range of interests and expertise. In 1925 he married Georgia Doble, the daughter of a Montreal banker. The couple lived at Weston Hall near Towcester.

SPENCER-CHURCHILL. John Albert Edward William (1897–1972) and Ivor Charles (1898–1956) Spencer-Churchill were the sons of Charles Richard John Spencer-Churchill (1871–1934) and Consuelo Vanderbilt (1877–1964). The boys' father succeeded as ninth duke of Marlborough in 1892. They were raised at the family's ancestral home, Blenheim Palace, in Oxfordshire. The elder, John, was educated at Eton. He served in France and Belgium in the Life Guards during World War I and, during World War II, was Military Liaison Officer to the Regimental Commander, Southern Region, and later Lieutenant Colonel Liaison Officer to the U.S. Forces from 1942 to 1945. He married Alexandra Mary Cadogan (d. 1961), daughter of Viscount Chelsea, son of the fifth earl of Cadogan, in 1920. He succeeded as the tenth duke of Marlborough in 1934. His second wife was Laura Charteris, whom he married in 1972. At the time of his death, a friend recalled, "The Late Duke of Marlborough was like nobody else. Over six foot six tall, with a splendid if somewhat petulant appearance, he seemed in scale to the great Palace and Park at Blenheim to which he devoted the latter half of his life. There he lived the life of a nineteenth-century country gentleman—shooting . . . gardening, and following with fascination the vagaries of British weather: he went his way" ("Duke of Marlborough," *London Times*, March 15, 1972, 16).

Lord Ivor Charles Churchill (who dropped the hyphenated Spencer from his name) lived a life of great contrast to his brother's. He was educated at Eton and Magdalen College, Oxford, and served in the R.A.S.C. during World War I. He drew little attention to himself and was known chiefly for his interest in modern French art, collecting works by Claude Monet, Camille Pissarro, Henri Matisse, and Pierre Bonnard. During World War II he moved home and collection to the village of Steep, near Petersfield, and took up fruit farming. Throughout his life he promoted the positive development of Anglo-French relations and received the French Legion of Honor commemorating his efforts. He was survived by his wife, Elizabeth (née Cunningham, whom he married in 1947), and a son.

STANLEY. The Honourable Victoria Stanley (1892–1927) was the daughter of Edward George Villiers Stanley (later the seventeenth earl of Derby) and Lady Alice Maud Olivia Montagu.

She was widowed in 1917 with the death of her first husband, the Honourable Neil Primrose (son of the fifth earl of Rosebery) and in 1919 married Captain Sir Malcolm Bullock, Bt. As an adult she sat for John Lavery, who depicted her as having the same mesmerizing beauty that Sargent saw in her as a child. She died from injuries suffered in a riding accident.

TOWNSEND. Beatrice Townsend (1870–1884) was the daughter of John Joseph Townsend, a New York attorney and politician (1825–1889), and his wife, the former Catherine Rebecca Bronson (1833–1926). The Bronsons are recorded as part of the Sargent family's circle of American friends in Florence, and it is likely that connection that led to the portrait of Beatrice and those of her parents (see Ormond and Kilmurray, *John Singer Sargent: The Early Portraits*, cat. nos. 43–46), all of which were probably painted in Paris, where the Townsends had a home. Beatrice was the sixth of the Townsends' seven children. She died of peritonitis approximately two years after her portrait was painted.

VICKERS. Edith Dorothy Vickers (c. 1878–1949) was the eldest daughter of the Sheffield arms industrialist Albert Vickers and his second wife, the former Edith Foster. Her parents were particularly supportive Sargent patrons in the mid-1880s, and their collection of the artist's pictures was noted in Albert Vickers's 1919 obituary in the *London Times*. In 1900 Dorothy (as she was known) married the Honourable Stuart Pleydell-Bouverie (the second son of the fifth earl of Radnor), who had joined the Vickers Engineering Company following his apprenticeship with the Eastern Railway Company. They lived at High Barn in Godalming, where they raised four sons.

VICKERS. Vincent Cartwright "Billy" Vickers (1879–1939) was the son of Albert and Edith Vickers (see above). He was educated at Eton and Magdalen College, Oxford. His first wife, Mairi (daughter of John Kerr-Clark) whom he married in 1905 and with whom he had one daughter (later Lady Cawdor), died in 1908. In 1910 he married Nannette Leslie, with whom he had two sons and four daughters. In the public and professional spheres he served as deputy lieutenant of the City of London and as a director of the Bank of England and Vickers, Limited. His private life was colored by ill health from which he reportedly suffered for many years. At the time of his death he was remembered as a connoisseur of the arts (he was a talented amateur draftsman in colored inks), a lover of nature (he studied birds and was an excellent mimic of a variety of bird calls), and as a devoted proponent of economic reforms for the general improvement of humanity and the prevention of war.

WARREN. Rachel Warren (1892–1975) was the eldest daughter of Fiske Warren and his wife, Margaret "Gretchen" née Osgood (1871–1961), who married in 1891 and made their home in Brookline, Massachusetts. Fiske Warren's wealth derived from the family-owned S. D. Warren Paper Company. Gretchen Osgood's father was a physician whose research took him to Europe, where she and her sister spent much of their early life. Privately schooled, Gretchen Osgood developed into a cultured young woman whose talents in music and drama were highly regarded. (She received vocal training in France from Gabriel Fauré, one of Sargent's favorite composers.) Accustomed from youth to being part of a stimulating intellectual milieu, Gretchen Osgood Warren created the same type of environment for her three children. Rachel accompanied her parents on a world tour when she was four. When they returned to Brookline, their home became a gathering place for a variety of world-renowned figures, including Booker T. Washington and William James. In 1904 the family moved to Oxford, England (the year after Sargent painted the portrait of Gretchen and Rachel Warren), where Fiske Warren studied law and his wife embarked on a three-year course in philosophy and metaphysics. Little is known about Rachel's schooling, but her parents doubtless encouraged her intellectual development. She married the archaeologist Samuel K. Lothrop of Boston in 1914 and accompanied him on expeditions to Central and South America and the West Indies—travels that clearly assisted her in her work organizing school exhibits on Latin America for the Pan American Society of New England. Rachel and Samuel Lothrop, who had three children, divorced in 1929. In 1950 she married the political activist and signatory of the 1921 Anglo-Irish Treaty, Robert Childers Barton (1881–1975), with whom she lived in Ireland.

WERTHEIMER. Essie, Ruby, and Ferdinand were three of the ten children of the influential London art dealer Asher Wertheimer (1844–1918) and his wife, the former Flora Joseph. The family lived in a splendid home at 8 Connaught Place, London. Sargent's triple portrait of Essie, Ruby, and Ferdinand is one of the twelve portraits Asher Wertheimer commissioned from Sargent of himself and his family. Despite the critical acclaim accorded to this group of works and the sociological interpretations to which they have been treated, little has come to light about the actual lives of the Wertheimer children.

WILLIAMSON. Dorothy Williamson (c. 1899–after 1965) was the daughter of George Millar Williamson (1849–1921), a collector of art, rare books, and stamps. George Williamson was the owner of Sargent's *Neapolitan Boys Bathing* when it was shown at the NAD in 1879. Dorothy was presumably brought up in Sparkill, New York, where in 1874 her father had built a large shingle house (Heart's Desire) in an area called Grand View. Sargent also painted a portrait of her father about the time that Dorothy's portrait was done. The two paintings were shown along with *Neapolitan Boys Bathing* at the Pennsylvania Academy of the Fine Arts in 1902. She married Vernon F. Byer. The Byers were last known to be living in St. Petersburg, Florida, in 1965.

Selected Bibliography

Adelson, Warren, et al. *Sargent Abroad: Figures and Landscapes.* New York, London, Paris: Abbeville Press, 1997.

———. *Sargent at Broadway: The Impressionist Years.* New York: Universe/Coe Kerr Gallery; London: John Murray, 1986.

Berger, Harry, Jr. *Fictions of the Pose: Rembrandt against the Italian Renaissance.* Stanford, Calif.: Stanford University Press, 2000.

Berry, Rose. "John Singer Sargent: Some of His American Work." *Art and Archaeology* 18, no. 3 (September 1924), 83–112.

Brinton, Christian. "Sargent and His Art." *Munsey's Magazine* 36, no. 3 (December 1906), 265–84.

Brown, Marilyn R., ed. *Picturing Children: Constructions of Childhood between Rousseau and Freud.* Aldershot, Eng.: Ashgate Publishing, 2002.

Bryant, Lorinda Munson. "Our Great Painter John Singer Sargent, and Some of His Child-Portraits." *St. Nicholas* 51 (November 1923), 3–7.

Burns, Sarah. "Under the Skin: Reconsidering Cecilia Beaux and John Singer Sargent." *The Pennsylvania Magazine of History and Biography* 124, no. 3 (July 2000), 317–47.

Cable, Mary. *The Little Darlings: A History of Child Rearing in America.* New York: Charles Scribner's Sons, 1972.

Caffin, Charles. "Some American Portrait Painters." *Critic* 44, no. 1 (January 1904), 31–48.

Calvert, Karin. *Children in the House: The Material Culture of Early Childhood, 1600–1900.* Boston: Northeastern University Press, 1992.

Chapman, Thomas Joseph Allain. "Between Complaint and Awe: Female Adolescence in the Fiction of Henry James." Master's thesis, King's College, University of London, 1996.

Charteris, Evan. *John Sargent.* London and New York: Charles Scribner's Sons, 1927.

Cortissoz, Royal. "John S. Sargent." *Scribner's Magazine* 34, no. 5 (November 1903), 514–32.

Cunningham, Hugh. *Children and Childhood in Western Society since 1500.* London and New York: Longman, 1995.

DeMauze, Lloyd, ed. *The History of Childhood: The Untold Story of Child Abuse.* 1974. Reprint. New York: Peter Bedrick Books, 1988.

Downes, William Howe. *John S. Sargent: His Life and Work.* Boston: Little, Brown and Company, 1925.

Fairbrother, Trevor J. *John Singer Sargent and America.* New York and London: Garland Publishing, 1986.

———. "Sargent's Genre Paintings and the Issues of Suppression and Privacy." In *American Art around 1900: Lectures in Memory of Daniel Fraad.* Edited by Doreen Bolger and Nicolai Cikovsky Jr., 29–49. *Studies in the History of Art* 37, Center for Advanced Study in the Visual Arts, National Gallery of Art, Washington, DC., Symposium Papers XXI. Hanover and London: University Press of New England, 1990.

———. *John Singer Sargent.* New York: Harry N. Abrams in association with the National Museum of American Art, Smithsonian Institution, 1994.

———. *John Singer Sargent: The Sensualist.* New Haven and London: Yale University Press and the Seattle Art Museum, 2000.

———. "Possessions and Props: The Collection of John Singer Sargent." *Antiques,* February 2001, 314–23.

Fraiberg, Selma H. *The Magic Years: Understanding and Handling the Problems of Early Childhood.* New York: Simon & Schuster, Fireside, 1996.

Gardner, Augustus K. *Our Children: Their Physical and Mental Development.* Hartford, Conn.: Belknap & Bliss, 1872.

Gorham, Deborah. "The 'Maiden Tribute of Modern Babylon' Re-examined: Child Prostitution and the Idea of Childhood in Late-Victorian England." *Victorian Studies* 21 (spring 1978), 353–79.

Hall, G. Stanley. *The Contents of Children's Minds on Entering School.* New York and Chicago: E. L. Kellogg & Co., 1893.

Harland, Marion. *Common Sense in the Nursery.* New York: Charles Scribner's Sons, 1885.

Heininger, Mary Lynn Stevens, Karin Calvert, et al. *A Century of Childhood, 1820–1920.* Rochester, N.Y.: The Margaret Woodbury Stong Museum, 1984.

Hendrick, Harry. *Children, Childhood and English Society, 1880–1990.* Cambridge and New York: Cambridge University Press, 1997.

Heywood, Colin. *A History of Childhood.* Cambridge: Polity Press, 2001.

Higonnet, Anne. *Pictures of Innocence: The History and Crisis of Ideal Childhood.* London: Thames & Hudson, 1998.

Hills, Patricia, ed. *John Singer Sargent.* New York: Whitney Museum of American Art in association with Harry N. Abrams, 1986.

Hurll, Estelle M. *Child-Life in Art.* Boston: Joseph Knight Company, 1895.

James, Henry. "John S. Sargent." *Harper's New Monthly Magazine* 75 (October 1887), 683–91.

———. *Picture and Text.* New York: Harper and Brothers, 1893.

Jenkins, David Fraser. "Pre-Raphaelite and Impressionist: Sargent's *Carnation, Lily, Lily, Rose.*" In *British Art in Focus,* Patrons' Papers 1, Tate Gallery, October 1998.

Jenks, Chris. *Childhood.* London and New York: Routledge, 1996.

Kett, Joseph F. *Rites of Passage: Adolescence in America, 1790 to the Present.* New York: Basic Books, 1977.

Key, Ellen. *The Century of the Child.* New York and London: G. P. Putnam's Sons, 1909.

Kilmurray, Elaine, and Richard Ormond, eds. *John Singer Sargent.* London: Tate Gallery Publishing, 1998.

Kincaid, James R. *Child-Loving: The Erotic Child and Victorian Culture.* New York and London: Routledge, 1992.

Kingsbury, Martha. "John Singer Sargent: Aspects of His Work." Ph.D. diss., Harvard University, 1969.

Lomax, James, and Richard Ormond. *John Singer Sargent and the Edwardian Age.* Leeds, Eng.: Leeds Art Galleries, 1979.

Macleod, David I. *The Age of the Child: Children in America, 1890–1920.* New York: Twayne Publishers, 1998.

Matthews, Gareth B. *The Philosophy of Childhood.* Cambridge, Mass., and London: Harvard University Press, 1994.

Morris, Harrison S. "American Portraiture of Children." *Scribner's Magazine* 30, no. 6 (December 1901), 650–51.

Mount, Charles Merrill. *John Singer Sargent: A Biography.* New York: W. W. Norton & Company, 1955.

Neubauer, John. *The Fin-de-Siècle Culture of Adolescence.* New Haven and London: Yale University Press, 1992.

Olson, Stanley. *John Singer Sargent: His Portrait.* London: Barrie & Jenkins, 1989.

Ormond, Richard. *John Singer Sargent: Paintings, Drawings, Watercolors.* New York: Harper and Row, 1970.

Ormond, Richard, and Elaine Kilmurray. *John Singer Sargent: The Early Portraits; Complete Paintings, Volume I.* New Haven and London: Yale University Press for the Paul Mellon Centre for Studies in British Art, 1998.

——. *John Singer Sargent: Portraits of the 1890s; Complete Paintings, Volume II.* New Haven and London: Yale University Press for the Paul Mellon Centre for Studies in British Art, 2002.

Pollock, Linda A. *Forgotten Children: Parent-Child Relations from 1500 to 1900.* Cambridge, London, and New York: Cambridge University Press, 1983.

Postman, Neil. *The Disappearance of Childhood.* New York: Vintage Books, 1994.

Ratcliff, Carter. *John Singer Sargent.* New York: Abbeville Press, 1982.

Robson, Catherine. *Men in Wonderland: The Lost Girlhood of the Victorian Gentleman.* Princeton, N.J., and Oxford: Princeton University Press, 2001.

Savy, Nicole. *Les petites filles modernes.* Les dossiers du Musée d'Orsay, 33. Paris, 1989.

Sidlauskas, Susan. *Body, Place, and Self in Nineteenth-Century Painting.* Cambridge: Cambridge University Press, 2000.

Simpson, Marc. "Reconstructing the Golden Age: American Artists in Broadway, Worcestershire, 1885–1889." Ph.D. diss., Yale University, 1993.

——. *Uncanny Spectacle: The Public Career of the Young John Singer Sargent.* New Haven and London: Yale University Press, 1997.

Steedman, Carolyn. *Strange Dislocations: Childhood and the Idea of Human Interiority 1780–1930.* London: Virago Press, 1995.

Steward, James Christen. *The New Child: British Art and the Origins of Modern Childhood, 1730–1830.* Berkeley: University Art Museum and Pacific Film Archive, University of California, Berkeley, in association with the University of Washington Press, 1995.

Strickler, Susan E. "John Singer Sargent and Worcester." *The Worcester Art Museum Journal* 6 (1982–83), 19–39.

Index

ITINERARY
Brooklyn Museum
October 8, 2004–January 16, 2005

Chrysler Museum of Art, Norfolk
February 25–May 22, 2005

Portland Art Museum, Oregon
June 18–September 11, 2005

Published on the occasion of the exhibition *Great Expectations: John Singer Sargent Painting Children* at the Brooklyn Museum, New York

This exhibition is made possible in part through the generosity of Jan and Warren Adelson, with additional assistance from the *Great Expectations* Leadership Circle. The Federal Council on the Arts and the Humanities has granted an indemnity for this project.

Publication of this volume was organized at the Brooklyn Museum
James Leggio, Head of Publications & Editorial Services
Project Manager: Joanna Ekman
Editor: Fronia W. Simpson

Bulfinch Press
Time Warner Book Group
1270 Avenue of the Americas, New York, NY 10020
Visit our Web site at www.bulfinchpress.com

Library of Congress Control Number 2004100934

ISBN 0-8212-6168-1
ISBN 0-87273-149-9 (Brooklyn Museum)
ISBN 0-8212-6170-3 (Bulfinch)

Photograph Credits
Pl. 29, Craig Smith; pl. 30 and front cover, R. H. Hensleigh; pls. 51, 52, and 53, Trevor Smith Photography; pl. 61, Glynn Clarkson Photography; pl. 65, Sue Tallon Photography.

Front cover: *Caspar Goodrich* (detail), c. 1887. Collection of C. Michael Kojaian (pl. 30)

Back cover: *Cara Burch*, 1888. New Britain Museum of American Art. Charles F. Smith Fund, 1942.2 (pl. 31)

Title page: *The Birthday Party* (detail), c. 1885. The Minneapolis Institute of Arts. The Ethel Morrison and John R. Van Derlip Funds, 62.84 (pl. 2)

Page 4: *Essie, Ruby, and Ferdinand, Children of Asher Wertheimer* (detail), 1902. Tate, London, presented by the widow and family of Asher Wertheimer in accordance with his wishes (pl. 39) © Tate, London, 2003

Designer: Laura Lindgren

Printed in Italy